Indian Art Vidya Dehejia

ART&IDEAS

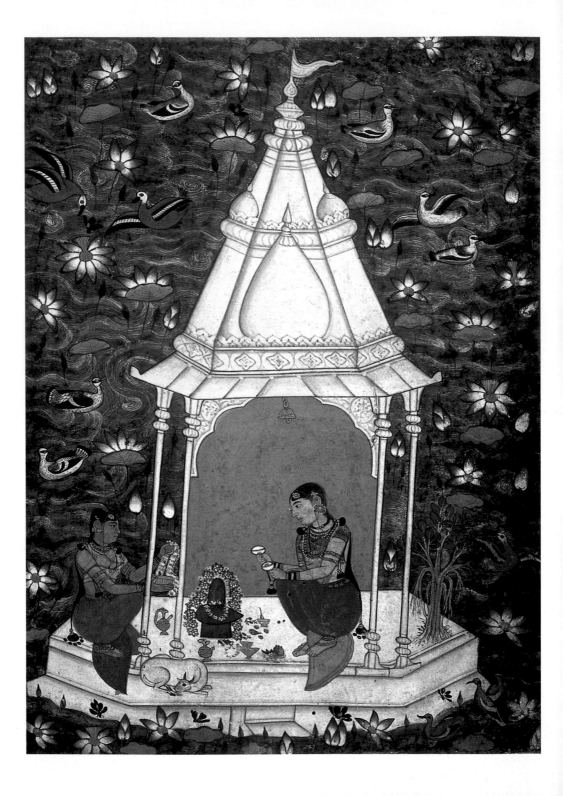

Indian Art

Opposite
Women
worshipping
at a shrine,
a page from
the Manley
Ragamala,
c.1610.
Gouache on
paper;
28 × 18 cm,
11 × 7 in.
British
Museum,
London

Diversity and continuity are twin themes that run through the story of the Indian subcontinent, which is effectively isolated from the rest of the land mass of Asia by the mighty mountain chain the Himalayas, or 'Abode of Snow'. Shaped like an inverted triangle, the subcontinent extends from those lofty heights to the equatorial waters of the Indian Ocean. It is traversed by expansive rivers, which have played a determining role in the life of the people. Three rivers are more important than the rest. Rising in the Himalayas and flowing into the Arabian Sea in the west is the River Sindhu or Indus, from which the word 'India' is derived. Having its source in those same glacial reaches, but flowing east into the Bay of Bengal, is the sacred Ganges; the Jamuna also rises in the mountains but merges eventually with the Ganges. These two life-giving rivers were deified as goddesses and invoked in carvings at the entrance to sacred shrines. The Himalayas are regarded as the hallowed mountain home of the Hindu gods.

The Indian subcontinent is the size of Europe minus Russia, and has as many, if not more, distinct geographic, ethnic, linguistic and cultural boundaries. While palm-fringed beaches and verdant tropical jungles abound in the south, there are snow-bound peaks in the north and sandy desert in the west. Wheat thrives in the dryer climate of the north where the diet revolves around unleavened bread, while the lush paddy fields of the south dictate a diet based on rice. In the deserts of western Rajasthan, women wear vibrant colours enlivened with rich embroideries as if to enhance the muted sand tones of their surroundings; by contrast, in the lagoon stretches of southern Kerala, women wear pure white, woven with an occasional gold thread. In the stark, sub-Himalayan mountain regions artists created plain, undecorated stone temples, while those working

in the fertile plains produced shrines adorned with exuberant sculptural figures of gods and humans.

Today this region, known also as South Asia, consists of a series of nation states – India, Pakistan, Bangladesh, Nepal, Bhutan, Sikkim and Sri Lanka. In ancient literature the land was called *Bharata-varsha* or Land of Bharata, mythical ancestor of the heroes of India's influential epic, the *Mahabharata*. Early inscriptions, such as one in a first-century Buddhist cave at Karle, speak of the land as *Jambudvipa* or Island of Rose-apple Trees. The geographical boundaries implied by the use of these ancient terms were extremely fluid: at times, *Bharata-varsha* and *Jambudvipa* seem to have extended beyond Afghanistan; at other times, the Indus was the farthest extent. Down the ages, the subcontinent assimilated successive waves of people who entered the country through precarious mountain passes. The central Asian Aryas, Persians, Greeks, Scythians, Shakas, Turks and Afghans all contributed towards the eclectic character of Indian civilization and art. And those who came by sea – the Romans, Arabs, Africans, Portuguese and English – left no less a mark. After all, along with Hindi, India's official and national language, English has continued to serve as a linguistic link between various communities.

The region has been home to several major world religions of which three, Hinduism, Buddhism and Jainism, were initially formulated here. Each of these faiths constructed exquisite and distinctive monuments in honour of its gods and religious leaders. Islam, founded in the Arabian peninsula, reached the western fringes of the subcontinent by the ninth century, and by the thirteenth was well established. Taken as a whole, the subcontinent today houses the world's largest Islamic population (Indonesia being second, and Iraq third). During the centuries of Muslim rule, major Islamic monuments were erected, one such being India's most renowned, the Taj Mahal. The area's latest religion is Sikhism, formulated in the sixteenth century, and a singular outcome of the Hindu–Islamic encounter.

Christianity made its way to the subcontinent, possibly with St Thomas, within years of the death of Christ; when the Portuguese, Dutch, French and British entered the country from the fifteenth century, bringing a variety of denominations, they found Syrian Christians already established in India's south. Today, in St Thomas's cathedral in Madras, the Virgin Mary is clad in a sari while Christ stands on a lotus flanked by peacocks.

In the course of its history, the cultures of the subcontinent also contributed to various foreign cultures with which they came in contact. The profitable Central Asian silk route provided an avenue of contact with China, which regarded its neighbour with respect as the sacred homeland of the Buddha whose faith China had adopted. The eastern sea route, initiated to trade with the various peoples of Indonesia, Thailand, Malaysia, Cambodia and Vietnam, was also the conduit by which the religions Hinduism, Buddhism and the Sanskrit language were exchanged. To this day, the Sanskrit word for art, *shilpa*, is visible in the Thai term *sinhipa* used for art, while Indonesia's shadow puppet plays and live stage performances revolve around India's two great epics, the *Mahabharata* and *Ramayana*.

This book explores the subcontinent's artistic heritage over some 4,500 years. As terms such as Pakistan and Bangladesh belong to modern history, I have decided, in most cases, to use 'India' for the pre-modern period in place of the more cumbersome 'Indian subcontinent' or 'South Asia'. It is also important to realize that the cultures of the subcontinent share certain common characteristics that frequently override religious distinctions. For instance, Muslims in the Deccan city of Hyderabad share more in cultural terms with their Hindu neighbours than with their Islamic counterparts in, say, far-off Iraq.

The earliest artistic remains belong to the brick cities of the Indus civilization of the third and second millennia BC. For a

considerable period thereafter, until the construction of Islamic cities during the thirteenth century AD, the art of India seems to be almost exclusively religious. All ancient monuments and sculptures that have come down to us in the lasting medium of stone are sacred dedications of the Buddhists, Hindus and Jains. However, these surviving remains are somewhat misleading. Early literary works speak eloquently of the magnificent palaces of the monarchs, while ancient narrative sculptures frequently depict intricately constructed city architecture. It would seem that cities and palaces were built of brick and wood, and adorned with sculptures in wood, stucco and terracotta, and with wall paintings, none of which has survived the heat and humidity of the region.

Scholars have often remarked that during this early period India lacked a Western sense of history, as no accurate records of past events were kept. India's cyclical rather than linear concept of time, which was conceived as a vast revolving wheel with cycles of creation, destruction and re-creation, perhaps contributed to an indifference towards historical documentation. Added to this was the immense importance given to the oral tradition; sacred texts, legendary histories and bardic poetry were passed down as chants from one generation to the next. If one defines a sense of history as a consciousness of past events, then India certainly possessed a sense of history. The closest Indian word to indicate history is *itihasa* or 'thus it was'. In India, *itihasa* is embedded in mythology, in genealogies and historical narratives, and these three categories often overlap and blend.

However, ancient rulers left extensive dedicatory inscriptions engraved on stone monuments, as well as sets of copper-plate charters commemorating the donation of lands, villages and cash endowments. While these inscriptions need cautious treatment since they tend to be panegyrics in honour of the monarch and his dynastic line, they yield much information on the economic, political and religious conditions of the time. India's

ancient history is supplemented by a range of ancillary sources that includes allusions in poetic and dramatic works, and the contextual evidence of artistic and archaeological material. For instance, ancient trade routes have been mapped by plotting the location of artistic monuments, especially Buddhist monastic centres.

The picture changed radically with India's Islamic rulers who had a passion for documentation; Mughal emperors, for instance, ordered their every act be recorded, and these annals were then selectively put together to form regnal histories. Post-fifteenth-century Hindu rulers too concerned themselves with recording the major events of their reign. Royalty dominated all such histories in which the common people remained largely invisible. Following the advent of Islamic rule on the subcontinent, fortified cities and palaces began to be built of stone, and the later Hindu rulers followed suit so that the post-twelfth-century architectural remains present a more diverse picture. Painted manuscripts too survive, first on palm leaf and later on paper, often providing a glimpse into the range of artistic tastes of Hindu and Islamic courts and their atmosphere of elegance and luxury.

A European presence became increasingly apparent from the seventeenth century until, finally, the subcontinent became a British possession. The architecture, sculpture and painting produced into the mid-twentieth century reveal the growing impact of Western taste. Today, after fifty years of independence, a new aesthetic is apparent in the subcontinent as artists respond to two equally vital stimulae: the need to reclaim a neglected and dormant artistic heritage, and the desire to establish itself as modern culture. Today's art does not make a sharp break with the past; rather, the past is reinterpreted and reinvented in unique and innovative ways.

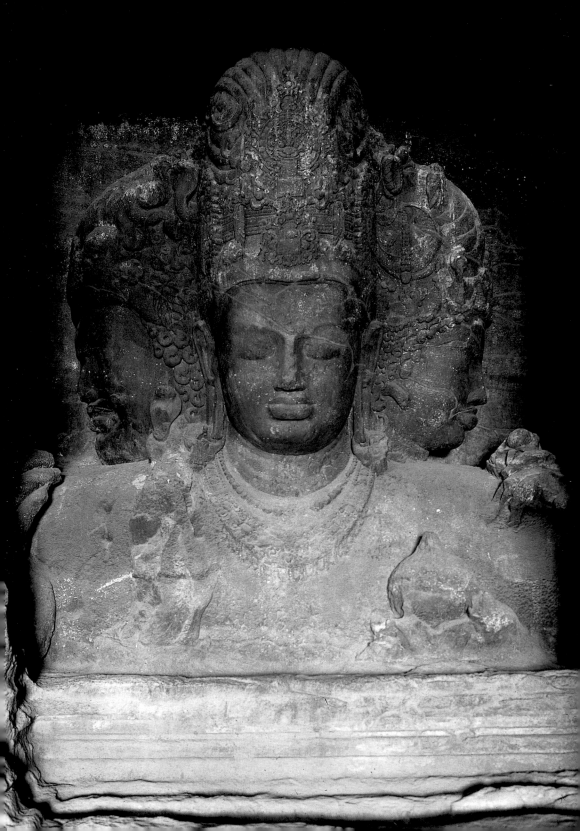

Some 1,500 years ago, ancient thinkers formulated a theory of art and aesthetics that centred around the viewer's role in the appreciation of art. They postulated that the aesthetic experience rests not with the work of art, nor with the artist who created it, but with the viewer. By way of analogy, the ancient writers pointed out that the taste of wine rests not in the jug that contains it, nor with the vintner who produced it, but with the person who tastes it. This viewer–response theory of art is known in Sanskrit as *rasa*, and responsive viewers are called *rasika*s or connoisseurs. This indigenous theory of aesthetics, which became predominant by the ninth century, is clearly of relevance to an appreciation of India's art, but before we explore *rasa* further it would be useful to consider the role of art and artists in early India.

The modern approach to art that emphasizes the role of individual artists and applauds their works as valid in their own right is a concept alien to pre-modern India. As in medieval Europe, art in ancient India was created largely to adorn sacred structures. Visual magnificence was indeed a major objective in the creation of towers and spires, relief panels and sculptures. But in equal measure was the artists' commission to instruct and edify, to evoke the appropriate aesthetic response and thereby heighten religious awareness. Art worked hand in hand with myth and religion. At the Shiva cave temple at Elephanta, for example, which we shall encounter in Chapter 5, viewers were intended to feel the emotion of wonder and to intuit peace upon seeing the giant triple head of god Shiva (1). Such grand sculptures thereby heighten religious experience.

However not all religious art was intended to be viewed in the same way. The bronze image of dancing Shiva (2), known as

1
Triple
manifestation
of the god
Shiva,
c.550–75.
Cave 1,
Elephanta

Nataraja or King of Dance – and described by the nineteenth-century French sculptor, Auguste Rodin, as the perfect embodiment of rhythmic movement – would have been viewed draped with silk, adorned with jewels and decorated with flower garlands, all but masking it. Seeing the image in worship would have been very different from seeing it in a museum.

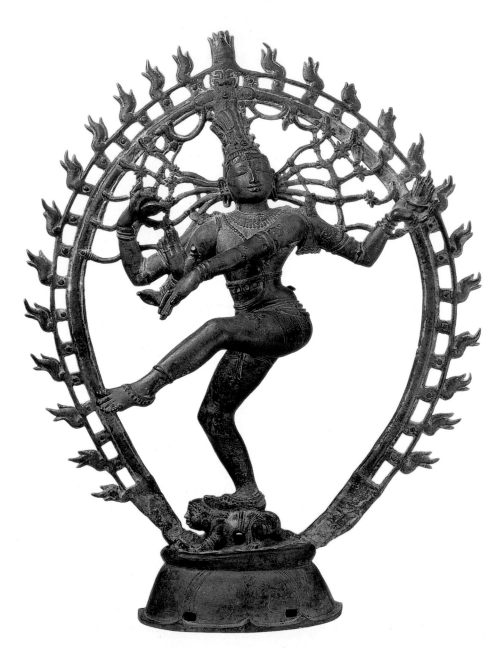

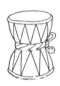

In ancient India, art was a hereditary profession. Artists entered guilds on a system of apprenticeship, and they belonged to the same social level as other craftsmen such as the potter, blacksmith or weaver. New apprentices learned largely by following the instructions laid down in art texts known as *shilpa shastra*s, which provided a series of formulae for constructing the human form, it being the central theme of early Indian artistic tradition. One such compilation transformed into drawings by Ganapati Sthapati for use in the traditional sculpture school now flourishing near Madras has been adapted for figures 3–6. The model for the female torso was the hourglass-shaped *damaru* drum held by Shiva, or the double-headed *vajra* or thunderbolt of Indra (3). Women's arms, invariably elongated and slender, were visualized as either pliant, green bamboo or the edible root of the palmyra palm (4). A fish or lotus petal was the prescribed model for elongated eyes, which were considered the epitome of beauty (5). The frontal view of a bull's head was the model for the male torso (6). The prescriptions of the *shilpa shastra*s were a starting point for the newly apprenticed and ensured that a certain consistent artistic standard was maintained. While inspired artists were always able to create masterpieces, individual experimentation was not encouraged; rather the repetition of an idealized formula was extolled and prized. Naturalism was not a valued concept.

Art texts also laid out detailed instructions for temple architecture. The elegant grouping of roofs on a Khajuraho temple, for example, and the crescendo of curves created by the increasingly elevated pyramidal roofs of the various halls forming the pinnacle of the shrine tower (7) were created by ancient architects who were following texts that termed such towers as *shikhara*s (literally mountain peaks).

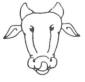

Early scholars, such as the renowned Stella Kramrisch, suggested that craftsmen when making images of the gods and goddesses went into a yogic trance, visualized the deity and created an image in a moment of transformation. Perhaps this

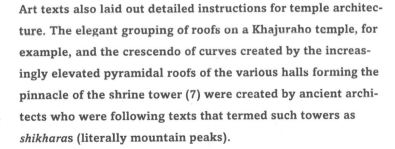

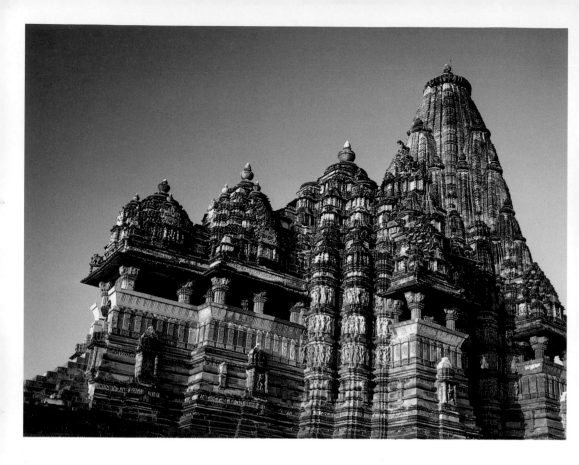

happened occasionally (setting aside the Tibetan artist–priest scenario). In general, however, craftsmen worked mainly as part of a guild team and largely as a means of earning their livelihood. Irrespective of individual religious affiliations, artists would work for any patron who commissioned their services. It is possible, for instance, to identify the hand of the same eighth-century Orissan guild on the Sisireshvara Shiva temple at Bhubaneshvar and in the Ratnagiri Buddhist monastery some 120 km (74 miles) to its north. A parallel situation exists today in the environs of Jaipur, not far from Delhi, where a group of Muslim craftsmen regularly makes carvings for Hindu temples.

The names and lives of the many artists, and indeed the master architects, responsible for the Khajuraho temples, or the Great Temple at Tanjavur in South India, remain unknown. It is only

in the past fifteen years that the identity of the Taj Mahal's architect has come to light, enabling firm closure to a seventeenth-century report that the monument was the creation of a Venetian jeweller named Vereneo Geronimo. A vastly different situation exists with regard to fifteenth- and sixteenth-century Renaissance Italy: ground plans, elevations and even wooden models exist for cathedrals built in Rome and Florence by designing architects such as Leon Battista Alberti, Donato Bramante and Filippo Brunelleschi; we also have biographical details of their lives.

One reason for a degree of anonymity in the artistic history of India was that much work was of a joint nature, with architecture and sculpture being inseparable companions. When large ambitious temples were built, not only architects and sculptors but also guilds of stone masons, plasterers, painters and woodworkers moved to the site for a decade or more. In a manner paralleled by the building of a medieval European cathedral, the monument arose as the combined product of several experts; in such circumstances, names and personalities faded into insignificance.

Another reason underlying this anonymity may rest in artists' low status in the hierarchical caste system of India. The brahmins or priestly class held pride of place, followed by the kshatriyas or ruling community, the vaishyas or traders, and lastly the shudras or manual labourers. It is to this last category that artists were assigned; all who laboured with their hands, whether they built a mud embankment or carved a fine statue, belonged to the lowest caste. Paradoxically, these same artists often had privileged access to wealthy and influential patrons including the royal family, so that the best among them received acknowledgement.

However, the anonymity of artists was not so much self-imposed as a by-product of the exalted status of the patron. Inscriptions at Khajuraho and Tanjavur elaborate upon the Chandella monarch Yashovarman and the Chola king Rajaraja,

7
Kandariya
Mahadeo
temple,
Khajuraho,
c.1004–35

and seventeenth-century documents glorify the Mughal emperor Shah Jahan. Artists were treated as paid workers; the accolades went to the patron who initiated the project and paid for its realization. This is not as extreme a situation as it might seem at first sight; after all, most contemporary museum galleries and concert halls are named after their patrons.

Nonetheless, in certain geographic areas, such as the southern state of Karnataka, the names of artists emerge vividly in the inscribed records of specific periods. Each of forty-two female bracket figures in an exquisitely carved twelfth-century temple at Belur seems to have been created by a different artist, and most of the brackets carry inscriptions giving the sculptor's name, guild and home town, and also applauding his individual achievements. One is 'like a pair of scissors to the necks of titled sculptors'; another is 'champion among rival sculptors'. An inscription in an eleventh-century temple at nearby Gadag uses parallel phraseology to proclaim the glory of its architect:

Triumphant in the world is Udega, the disciple of Sri Kriyasakti Pandit, who is equal to god Brahma in expounding the various arts and sciences; … who could overcome the opponent architects just as a lion would overpower a rutting elephant; who would break the pride of jealous architects as an expert paramour would do to a harlot.

Despite the lack of historical or personal information, we are left in no doubt about Udega's high repute. Further research may explain the curious scenario in eleventh- and twelfth-century Karnataka whereby architects and sculptors could broadcast their skills.

The patronage of art was inspired by a variety of aspirations, one of which was the concept of spiritual merit. Also of significance in the medieval Christian world, this is accompanied in India by the deep-seated belief in karma, which states that deeds performed in the present life determine a future birth. Indian belief systems (Buddhist, Jain, Hindu and Sikh) hold that human beings are too impure to achieve closeness to

the divine in a single birth. Instead, they are born repeatedly, each time with the chance to better their position, so that ultimately they are pure enough to achieve freedom from the cycle of rebirth. The *Bhagavad Gita*, an influential Hindu sacred text, enunciates this belief (ch 2, v 20):

As a man discards
worn-out clothes
to put on new
and different ones,
so the embodied self
discards
its worn-out bodies
to take on other new ones.

Karma, or the sum of one's own deeds, determines the nature of a future birth; one certain way of achieving good karma was to support the construction of religious monuments. The generous

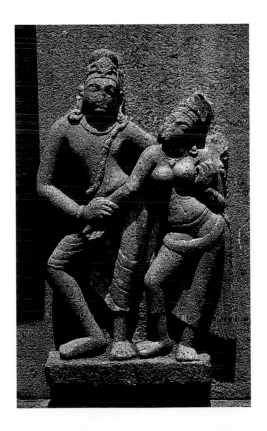

8
Figures on the
rear wall of the
Svarga Brahma
temple,
Alampur, *c.*700

sponsorship of the innumerable sacred monuments of the Buddhist, Hindu and Jain faiths was in large measure the result of this deep conviction.

Despite the sacred nature of ancient art in stone, sculptures of a sensuous and apparently 'profane' nature often decorate sacred monuments. Curvacious women and provocatively poised couples appear frequently and were clearly not considered problematic by either artist, patron or priestly monastic author-ities (8). How did temples and monasteries incorporate such imagery? Kramrisch made the memorable remark that the ancient art of India was neither religious nor secular, 'for the consistent fabric of Indian life was never rent by the Western dichotomy between religious belief and worldly practice'. Her pithy comment may best be understood in the context of the holistic attitude of ancient Hindu India, in which the goals of life were fourfold. *Dharma* implies the pursuit of virtue and

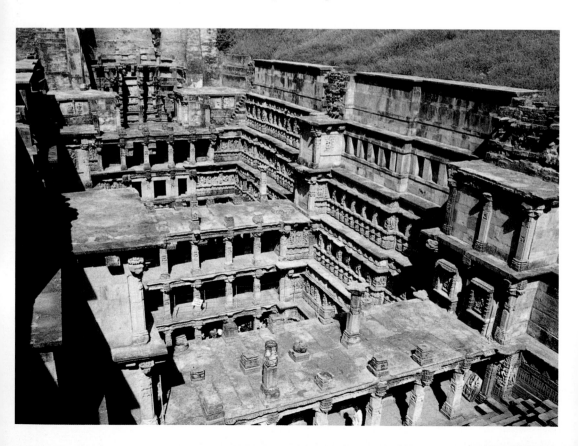

duty; *artha* refers to wealth acquired through the ethical pursuit of one's profession; *kama* or love encompasses familial and sexual/marital love; while *moksha* envisages liberation. These goals were extended also to art so that images pertaining to all four goals had a place on the walls of both sacred and secular structures. Sculptors working on a sacred structure created images intended to turn the thoughts towards the divine; but it was equally right and proper that their imagery pertain to wealth and love. In turn, the secular palaces and mansions of the rich gave prominent place to sacred mythology in their murals and sculpted decoration. However, as we shall see, no simple explanation accounts for the profusion of sensuous imagery on sacred structures.

An example of the harmonious coexistence of the sacred and 'profane' in art is seen in an extraordinary sandstone structure built in the eleventh century at Patan in western India (9). This

9–10
The Queen's
step-well,
Patan,
*c.*1064–90
Left
General view
from the
southeast
Right
God Vishnu as
Varaha flanked
by women,
third terrace

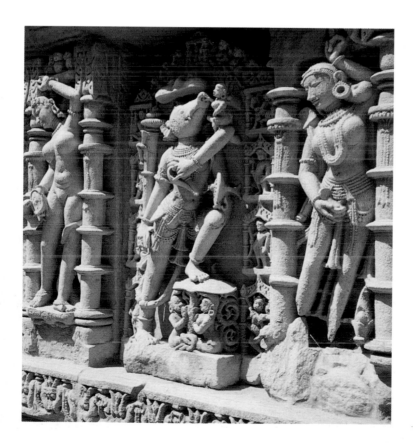

colossal underground monument, in seven elaborately carved subterranean levels, resembling both a palace and a temple, is known as the Queen's step-well. Each level housed a pillared pavilion that led down a wide flight of steps to the next level, resulting in a total of 300 ornamented pillars. The well served a practical purpose, even incorporating an overflow tank for surplus water; it was also used, as are the myriads of step-wells across India, as a cool, overnight halting place for travellers.

But there is much more to the Queen's step-well. It is covered with sculpted images, both sacred and secular, of which some 400 survive. The terrace on the third level, for instance, portrays images of Hindu god Vishnu, each flanked by slender, vivacious women (10). The circular well-shaft is totally covered with figures of gods, though pride of place is given to an image of Vishnu reclining upon his serpent couch, which is repeated on the central recess of the three lower levels of the well. According to a Hindu creation myth, Vishnu slumbers on his serpent that rests upon the waters of the cosmic ocean prior to the creation of the world. The artists and the queen responsible for this 'well' decided to recreate this imagery by repeating it on three different levels, thereby ensuring that the serpent couch would always rest upon water, regardless of the level of the water table. This monument effectively and imaginatively combined a functional element like water, of enormous impor-tance in the arid regions of India, with appropriate sacred mythology to produce a structure that defies any neat classifi-cation in the seamless weave that is the fabric of Indian life.

To relate to Indian art in the manner proposed by indigenous theoreticians, we must grasp the ancient theory of *rasa*. Literally, *rasa* means the juice or extract of a fruit or vegetable; it implies the best or finest part of a thing. In the aesthetic context, *rasa* refers to a state of heightened awareness evoked by the contemplation of a work of art, drama, poetry, music or dance. A performance is criticized as *ni-rasa* (without *rasa*) or praised as *rasavat* (imbued with *rasa*).

Rasa theory was enunciated by the ancient writer Bharata (not related to Bharata of *Bharatavarsha*), perhaps in the fourth century, in his work on dance and theatre entitled *Natya shastra*, or 'Science of Dance'; it seems to have had even earlier roots since Bharata acknowledged his debt to previous masters. Drama best demonstrates the number of factors that must coalesce to produce *rasa*. For example, for the viewer to experience the erotic *rasa* known as *shringara*, Bharata stressed the need for an evocative performance by the lovers, intensified by gestures, embraces and sidelong glances; complementary emotions like envy, anxiety and anticipation were consequential, while other factors like costume, make-up and stage setting played their own subsidiary roles. While the emphasis throughout is on the spectator, with theorists affirming emphatically that the actor, like the vessel which holds the wine, is only the means necessary for the viewer to taste *rasa*, it is acknowledged that *rasa* is evoked only by inspired actors, as indeed by distinguished works of art.

Admittedly, there are specific problems in applying a performance theory to static forms of art. Some of the variables involved in the creation of *rasa* in drama are capable of being transformed and expressed in painting and sculpture, the main problem being the absence, in art, of the time factor involved in a stage performance. Perhaps this is one reason why the narrative mode held such a predominant position in the sculpture and painting of India. Stories unfolding gradually over an entire length of stone wall, or in the course of twenty painted pages, have greater scope to create the nine types of *rasa*. The erotic sentiment of *shringara*, described as king of *rasa*s, has a high visibility in the fine arts. The other eight *rasa*s are the comic or *hasya*, the pathetic or *karuna*, the furious or *raudra*, the heroic or *vira*, the terrible or *bhayanaka*, the odious or *bibhatasa*, the wondrous or *adbhuta* and the quiescent or *shanta*. The *Vishnudharmottara Purana*, an important text written between the fifth and seventh centuries, contains a section devoted to painting which specifies that art works in public buildings may

exhibit all nine *rasa*s, but that only the erotic, comic and quiescent should be evident in paintings and sculptures that decorate homes. *Rasa*s were also assigned colours, although such categories are extremely porous. The erotic *rasa* was blue-black; the comic, white; the pathetic, dove-coloured (grey-white); the furious, red; the heroic, yellow; the terrible, black; the odious, blue; the wondrous, gold; and the quiescent the colour of jasmine and the moon (silvery). Some of the colours are specific to India whose archetypal lover and hero, the god Krishna, has a blue-black complexion and yellow robes.

Regarding the spectator or *rasika* and the work of art that invokes *rasa*, theorists maintained that to be attuned and receptive to the artistic experience is as much a *sine qua non* in the spectator as to be skilful and eloquent is a necessity in the work of art. The cultivation of *rasa* seems to have been an intellectual and emotional experience that was completely available to only the sophisticated segment of the population.

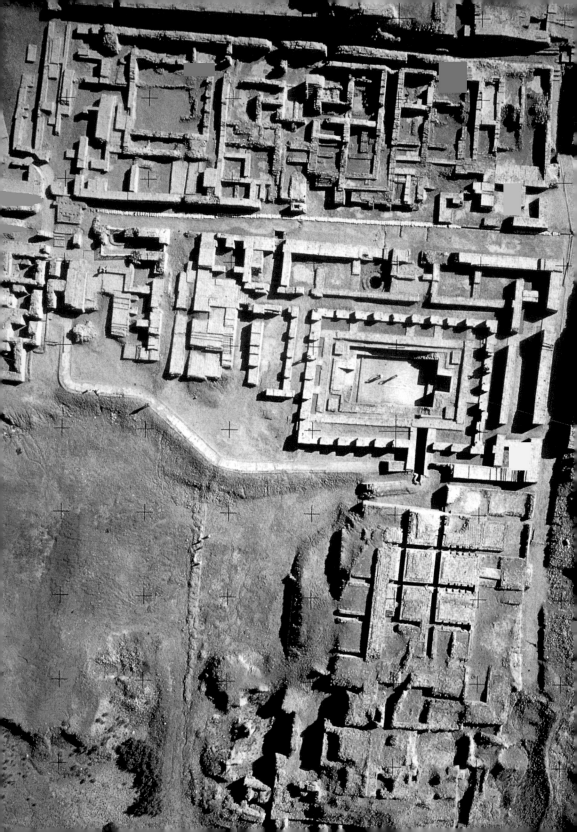

The mighty River Indus, which gave its name to the subcontinent of India, rises in the snows of the Himalayan ranges and travels 2,000 miles before joining the Arabian Sea. Along the banks of this river, and its five great tributaries, a sophisticated urban civilization arose during the third millennium BC. Its inhabitants had contacts with the Persian Gulf and Central Asia, possessed a unique writing system, had an advanced concept of town-planning (11), and had an aesthetic sense clearly displayed, for example, in the finely carved steatite seals used in ritual and trade. The Indus civilization is not classified as prehistoric since its people possessed a form of writing; neither does it belong to the historic period since the inscriptions have defied all attempts at decipherment. It belongs, rather, to that nebulous realm of protohistory, in which the prime data are tangible excavated archaeological material. The fascination of archaeology lies in its ability to bring us closer to a people by revealing their dwellings, the jewellery they wore or the utensils they handled.

The discovery of the Indus cities was accidental. In 1865, the British administrators of India under Queen Victoria decided to build a railroad to connect the port city of Karachi with land-bound Lahore. Needing rubble to build a firm embankment on which to lay the rails, workers made use of masses of large, well-fired bricks of uniform measurement found in mounds at such sites as Harappa. As a result to this day the Karachi–Lahore train thunders across bricks made over 4,000 years ago. Subsequent excavations revealed that the bricks belonged to an ancient civilization which prevailed across an expanse of more than 1 million sq. km (c.386,000 sq. miles), an area approximating to Britain, France and Spain combined. It extended from the highlands of Afghanistan to the mouth of the Indus, and beyond

11
Mohenjodaro, c.2600–1900 BC. Aerial photograph taken from a hot-air balloon at a height of 80m (262ft). The crosses superimposed on the photograph enable any distortions in the image to be corrected by computer to produce accurate maps. The Great Bath can be seen right of centre

this to the coastal stretches of Gujarat and to the far side of the Jamuna (Jumna) River. Several large, urban centres existed in this area, which today comprises Pakistan and northwestern India. The most famous are Mohenjodaro on the banks of the Indus, Harappa along an Indus tributary known as the Ravi, Kalibangan on the banks of the now dry Ghaggar River, and Lothal along the coast of Gujarat. Across this vast area, a common mode of cultural expression was sustained during the Mature Phase of this civilization, which carbon-14 analysis dates to between 2600 and 1900 BC.

Recent excavations indicate the need to revise or adjust many previously accepted ideas about the Indus civilization, one being that its major cities consisted of an elevated citadel to the west and a lower residential city to the east. Instead it seems many of the cities were surrounded by walls and consisted of two or more areas built on mounds. In some cases, gigantic artificial substructures were created of sun-dried brick and rubble to raise buildings above the plains. The architect-engineers who planned the cities were clearly familiar with the annual flood pattern of the Indus. The threat of floods must have been outweighed by the advantages of transport and trade facilities offered by the river system. The Indus peoples were efficient agriculturalists, sowing the summer crop on ground drenched by the receding monsoon floods and digging and maintaining irrigation canals.

The cities housed a variety of public buildings. The Great Bath at Mohenjodaro is a finely built brick structure with a layer of bitumen as waterproofing, an adjoining well that supplied water and an outlet that led to a large drain (12). Surrounding the bath were porticoes and sets of rooms, while a stairway led to an upper level. Extrapolating from later practice, it seems probable that the edifice was connected with some form of ritual bathing. Large structures, hitherto identified as granaries, seem to have no connection with grain and are best described as halls. Other buildings have been loosely described as assem-

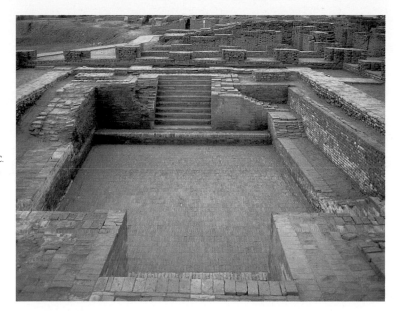

12
Great Bath,
Mohenjodaro,
c.2600–1900 BC.
11·3 × 6·7 × 2 m,
37 × 22 × 6½ ft

bly halls and colleges, while a series of large cooking hearths at Kalibangan may have been fire-altars.

The well-planned residential areas were laid out on a grid pattern, with main thoroughfares aligned north–south. The people lived in multi-roomed houses built of mud or baked brick, most with a bathing room containing a brick bath platform connected to a street drain. An estimated 700 wells supplied Mohenjodaro residents with water, and even the smallest house was connected to the drainage system. The impressive infrastructure of the Indus cities suggests an effective central authority. Mohenjodaro covered an expansive area, and its estimated ancient population of 35,000–40,000 would make it a larger than Pompeii in Italy, a city with a population of 25,000. Recent research indicates that parts of Mohenjodaro were rebuilt several times during its Mature Phase, though the theory that this was necessitated by disastrous flooding is now being abandoned.

Detailed exploration at Harappa reveals that earlier ideas about definite areas of the city being allocated to specific craft activities must be re-considered. It may be better to think of multiple

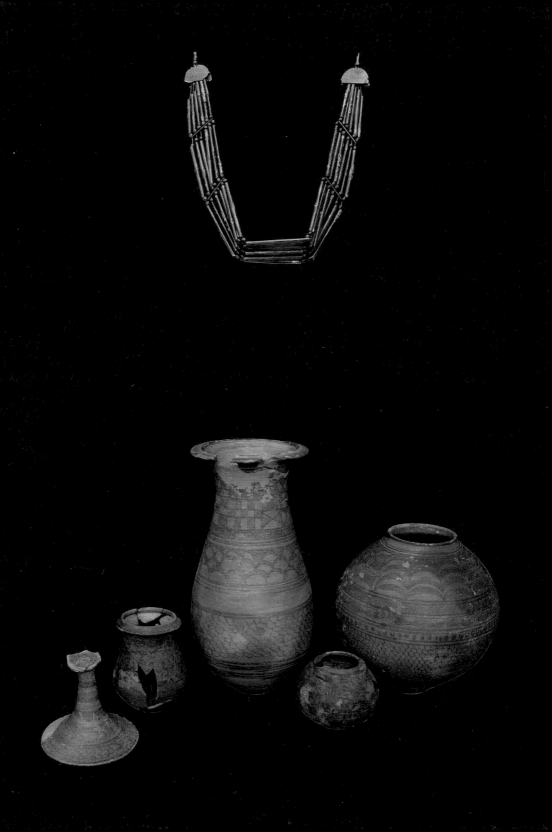

centres at which potters' kilns, bead makers' drilling workshops, dyers' vats, metal workers' firing areas and shell carvers' workshops were located. Indus metal workers produced copper and bronze vessels, as well as a variety of tools that included axes and spearheads. The Indus people adorned themselves with beads and ornaments of shell and terracotta, as well as silver and gold fillets, necklaces, pendants, amulets, and buckles. Among many creations showing bead makers' high level of technical skill are long, barrel-shaped carnelian beads of a deep red-brown, often strung together to form spectacular, heavy belts (13). Potters used a foot wheel to hand-throw clay vessels in a variety of elegant as well as practical forms, of which many were given a red slip and black painted decoration (14). Geometric motifs such as intersecting circles were favoured, as were birds, fish, animals and plants, especially the leaf of the pipal tree, which was to become India's sacred tree and acquire the name *Ficus religiosa*.

13–14
Crafted goods from the Indus civilization, *c.*2600–1900 BC
Above
Belt of carnelian beads, Mohenjodaro. Each bead is 12–13 cm, 4¾–5 in, long
Below
Painted pots, Harappa. h. *c.*13–50 cm

The most striking works of art from the Indus cities are small steatite seals carved with a copper burin, coated with alkali, and baked to glaze the surface. One commanding image is of the Indian humped bull with a heavy dewlap and pronounced muscularity (15), which despite its diminutive size conveys an impression of monumental strength. The most popular subject was a creature termed a unicorn (16), which often has an 'incense-burner' or 'trough' placed before it. While some have described the creature as an ordinary non-humped bull depicted consistently with overlapping horns, it may indeed be a unicorn since terracotta figurines of such a creature have been found. Other animals on the seals include the elephant (17), bison, rhinoceros (18) and crocodile, as well as two- and three-headed animals of indeterminate, possibly mythical type.

A few Indus seals depict images that appear to have a religious or symbolic significance beyond that suggested by the animals. One portrays a figure, perhaps with three heads, seated cross-legged in a yogic posture of meditation, with two deer beneath

his seat and a few pictograms engraved along the upper edge (19). Resonating strongly with this image is the composition of later images of the preaching Buddha (70), with similarly placed deer to identify the site as the deer park where the event took place. The fact that the yogi wears a head-dress with curved horns and is surrounded by animals has led to the suggestion that the figure is a prototype for the later Hindu god Shiva in his aspect of Lord of Beasts. It is intriguing to find that the ascetic figure seated in a yogic posture – India's unique contribution to the vocabulary of world art – should have such ancient origins. Other Indus seals depict tree spirits, female figures and animals in association with trees, which are usually of the pipal species.

Vast numbers of inscribed tablets and seals were produced for use in trade and perhaps in ritual, and more than 4,000 have been recovered from excavations. Traces of matting and cord

15–19
Seals from the Indus civilization, c.2600–1900 BC. Steatite; h.c.2·3–3·8 cm, c.1–1½ in
Top
Humped bull. Islamabad Museum
Middle above
'Unicorn'. National Museum, Karachi
Middle below
Elephant. Mohenjodaro Museum
Bottom
Rhino. National Museum, Karachi
Right
'Yogi' seal. National Museum, New Delhi

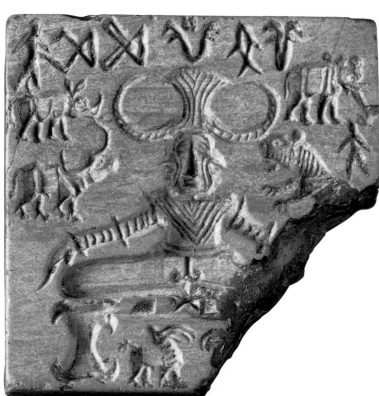

that adhere to clay sealings confirm their application to bales of merchandise. Most seals are inscribed with between three and ten characters, the longest using twenty-seven. In all likelihood the inscriptions identify individuals, families or guilds of traders who used the seals to signify their ownership of traded merchandise, while the animals may be tribal emblems. Indus seals have been discovered along the Persian Gulf and in Central Asia; in turn, 'button' seals of Persian Gulf type, and a few cylinder seals typical of Central Asia, have been found in the Indus region. Despite the existence of over 4,000 short inscriptions, the Indus script continues to baffle scholars. It has been possible to establish from the overlapping of letters that the script was usually written from right to left. The diverse attempts to decipher the Indus script agree only that each uses a different 'key'. Scholars have considered the signs variously as pictograms, ideograms, homophones, logo-syllabic and even alphabetic. They have also associated the script variously with a variety of language groups including the Indo-Aryan, Dravidian and Elamite. Perhaps a solution will be possible only with the discovery of a bilingual inscription, like the famed Rosetta Stone, now in the British Museum, London, which enabled the deciphering of Egyptian hieroglyphic because its inscription was repeated in familiar Greek.

Also part of the trading scenario are sets of accurately graded stone weights that double from one to sixty-four, and then increase in a complex decimal series that makes expert use of the number sixteen. It is intriguing to note the continued resonance of this number; prior to the decimalization of Indian currency in the 1950s, the rupee was made up of 16 annas. The weights and seals were an integral part of both internal commerce and overseas trade.

Only a few examples of stone sculpture have emerged from the Indus sites. A powerful little steatite bust from Mohenjodaro, known as the 'priest-king', depicts a bearded male with full lips, straight nose and half-closed eyes that were once inlaid

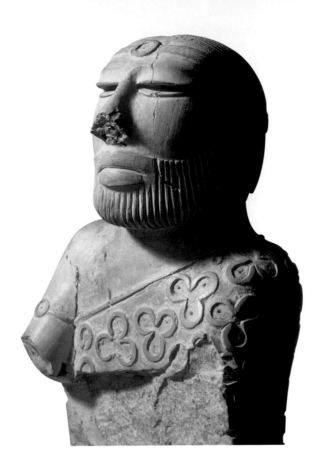

20
Bust of the
'priest-king',
Mohenjodaro,
c.2600–1900
BC.
White steatite;
h.19 cm, 7½ in.
National
Museum,
Karachi

with shell (20). A fillet is tied around his head, and he wears a robe decorated with trefoil designs originally filled with red paste. Holes bored on each side of his neck were probably intended to hold a necklace of precious metal. Who is he? Does the styling of the figure indicate his connections with Sumeria or Mesopotamia? Or perhaps with ancient Bactria? We really do not know.

Two stone torsos from Harappa, both with drilled sockets to attach head and limbs, and both barely 10 cm (4 in) tall, seem to represent a different aesthetic. The first is a nude male torso of red sandstone that is softly and sensuously modelled; the second is a grey stone torso of a dancing male with one leg raised and with shoulders twisting around, displaying a remarkable similarity to later images of dancing Shiva as

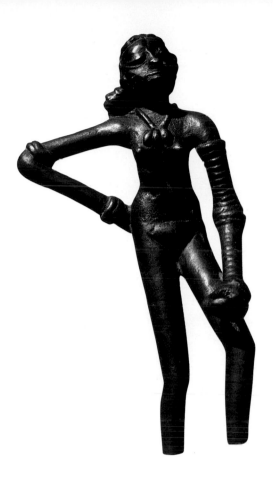

21
Figurine of
'dancing girl',
Mohenjodaro,
c.2600–1900
BC. Bronze;
h.10 cm, 4 in.
National
Museum,
New Delhi

Nataraja. Admittedly, the two images come from slightly
disturbed strata, but there is no cogent reason to assign them to
a later period.

Metal casters created a few small bronze figures, of which the
best known is a remarkably vivacious image from Mohenjodaro
that has been given the conjectural label of 'dancing girl' (21).
Slender and nude, she rests her weight on one leg; a heavily
bangled arm hangs loosely, while the other hand rests on her
hip. Her head is tilted back to display large eyes, a flat nose and
heavy lips, while her hair is braided in an elaborate plait.

Indus craftsmen produced vast quantities of terracotta figures.
Large numbers of female images, wearing a wide girdle, rows of
necklaces and a fan-shaped headdress (22), are generally
named 'mother goddesses'. They are fairly crude in workman-

22
Figurine,
Mohenjodaro,
c.2600–1900
BC. Terracotta;
h. c.18 cm,
c.7 in. National
Museum,
Karachi

ship, with pellets of clay applied to create eyes, breasts and ornaments. It seems likely that these figurines were votive offerings; once the vow that resulted in their creation was fulfilled, they may have been deposited in sacred waters, as seen in an ancient tank dating some 1,500 years later at Shringaverapura near the modern town of Allahabad in northern India. Indus children played with a variety of terracotta toys that included wheeled carts and animals, whistles and tops, birds and dice. The toy animals in both faience and terracotta (23–27) frequently reveal great skill in modelling, as in the instance of a delightful seated monkey carved from faience.

Many aspects of Indus material culture show an overall similarity across a vast geographical area; equally, however, regional variations are evident. Recent studies at Harappa show that

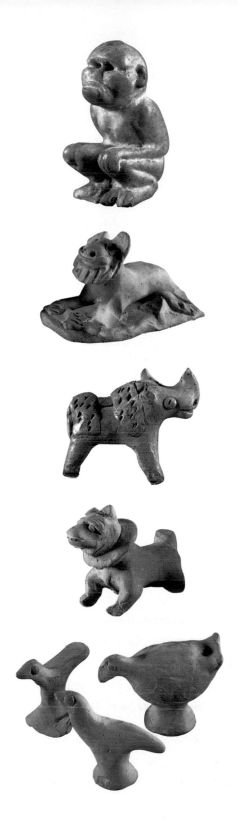

23–27
Toy animals
including a
monkey, rhino,
a dog and
birds,
c.2600–1900
BC. The
monkey is of
faience, the
others
terracotta;
h. c.3 cm,
c.1¼ in.
National
Museum,
Karachi

there were significant stylistic changes over time, whether in seals, terracottas or pottery. Several pivotal questions about the Indus peoples are yet to be answered. How do we explain the sudden emergence of this urban civilization around 2600 BC? Decidedly, its origins lay in the earlier farming communities of the region that date back to the seventh millennium BC. Some dramatic event apparently caused these diverse farming communities to come together within a relatively brief period; the catalyst remains unknown, although it appears that military force played no role. It is intriguing that they built no grand palaces or funerary structures, nor created monumental images of gods, kings or priests. Equally mysterious is the disappearance of the civilization. Recent research has resulted in the dismissal of the earlier theory that invading Aryan peoples were responsible for the destruction of the Indus cities. The most likely explanation seems to be an alteration in the course of the Indus that had a twofold result: towards the east, several settlements were flooded and buried in silt and hence abandoned; elsewhere, dwindling water resources forced the evacuation of settlements. Certainly the shifting of the river system, and the accompanying flooding or drought, had a disastrous result on the agricultural base upon which the civilization depended. A final mystery is the how and why of the elegant Indus script. Why did it vanish so completely that it was over 1,500 years before writing reappeared in India?

At about the time that Indus cities were being abandoned, archaeological and literary records reveal the presence of Indo-European speaking communities in the northwestern part of the subcontinent. Scholars are still trying to work out the process of migration or assimilation that explains their presence. These people, who called themselves Aryas or Noble Ones, spoke an ancient form of the language later known as Sanskrit, one of an Indo-European group of languages. It was in 1786 that Sir William Jones, a British High Court Judge in Colonial Calcutta, discovered the close links that existed between the Greek, Latin, German and Celtic languages on the one hand and

India's ancient Sanskrit on the other. The words for mother and father are illustrative of this link: Latin *mater* and *pater* may be compared with Sanskrit *matru* and *pitru*. However, the earlier theory of wholescale migration of 'Aryas' is today discredited, and linguists and archaeologists are divided in their explanation of the phenomenon. Archaeological records show no major influx of population, and it is preferable to speak in terms of the easy mobility of groups of nomadic peoples. Since it appears that these Arya tribes represent various ethnic groups, many scholars feel that Sanskrit developed in the northwest of the subcontinent.

The Aryas composed a sacred literature known as *Veda*, or Knowledge, which was transmitted orally for at least a millennium; the oral nature of their literature assigns them to proto-history. The first of the four *Veda*s, the *Rigveda*, composed perhaps around 1,300 BC, provides a picture of a nomadic people whose prime occupation was stock-breeding. They lived along the banks of the Indus and its tributaries. The possession of the horse and the spoke-wheeled chariot, both apparently unknown to the Indus peoples, ensured Arya superiority; they also possessed more effective weapons. The Aryas organized themselves into groups that held regular assemblies, and they had distinctive sacred cults centring around sacrifice. Despite an apparent hostility towards the local dark-skinned Dasas who lived in *pura*s or towns, and whom they described contemptuously as 'non-sacrificers', the Aryas adopted the settlement patterns and crafts of the peoples whom they seem to have dominated.

The *Rigveda* consists of ten books of hymns in praise of various deities, among whom Indra, god of war, is prominent (bk 2, hymn 12, v 8–9):

He who is invoked by both of two armies, enemies locked in combat, on this side and that side, he who is invoked separately by each of two men standing on the very same chariot, he, my people, is Indra.

He without whom people do not conquer, he whom they call on for help when they are fighting, who became the image of everything, who shook the unshakeable – he, my people, is Indra.

Religious ritual for the Aryas consisted of simple sacrifices, in which offerings of grain and ghee (clarified butter) were poured into the fire. Agni, god of fire, who carried such offerings up to the gods in the heavens, was a second major deity. Other Aryan gods were largely personifications of various natural elements. Prayers and hymns of praise accompanied sacrifice, and the gods were asked to bestow beneficence on their devotees; cattle were equated with wealth. While occupations were largely hereditary, there was mobility between the four classes of Vedic society – the brahmin priests, the kshatriya warriors, the vaishya merchants, and the shudra manual labourers. In an ironic, worldly poem, one Rigvedic poet writes (bk 9, hymn 112, v 3): 'I am a poet; my Dad's a physician, and Mum a miller with grinding-stones. With diverse thoughts we all strive for wealth, going after it like cattle.' Yet despite the practical streak apparent in their religious ritual, the Rigvedic Aryas also pondered over the enigma of creation (bk 10, hymn 129, v 1–2):

There was neither non-existence nor existence then; there was neither the realm of space nor the sky which is beyond. What stirred? Where? In whose protection? Was there water, bottomlessly deep?

There was neither death nor immortality then. There was no distinguishing sign of night nor of day. That one breathed, windless, by its own impulse. Other than that there was nothing beyond.

The three later *Veda*s, the *Samaveda*, *Yajurveda* and *Atharvaveda*, indicate the movement of the Aryas into the plains of the Ganges River which became their heartland. Agriculture took over from stock-breeding as the means of livelihood, and goddess earth rose to prominence. Archaeology reveals that a second urban phenomenon took place around 800 BC in the Ganges valley. Brick, used in the construction of Vedic sacrificial altars and known as *ishtaka* (from *ishta* or sacrificial

offering), was used to build towns and cities. The artifacts of this culture suggest war and trade as dual methods of expansion: weaponry, fortifications and coins are the evidence.

By the sixth century BC, northern India was divided into a number of small principalities, of which some were monarchies with hereditary kings and others were republics with elected leaders. Agriculture was the established occupation, and trading centres arose that specialized in crafts such as pottery, carpentry and cloth-weaving. Politically and economically the country was thriving. It was, however, a time of spiritual ferment. In previous centuries, Vedic religion had advocated simple sacrifice accompanied by prayers. But now, elaborate sacrificial rites had become obligatory, and their accurate completion required familiarity with a multitude of details, known only to the priestly brahmins. Neither monarchs nor merchants could be expected to be aware of the exact manner in which bricks must be aligned in a sacrificial altar, the number of spoonfuls of ghee to be poured into the sacrificial fire, or the particular *mudra*s or hand gestures to be used. The dominant status thus appropriated by the brahmins, and the accompanying transformation of classes into rigid castes, led to considerable discontent. Sages, philosophers, spiritual leaders and sects of renunciants roamed the Ganges valley, setting up an alternative lifestyle that one might describe as a counter-culture. As many as sixty-six new creeds emerged, though only two survived to become influential faiths. Mahavira, a chieftain of a republic near Vaishali, left home at the age of thirty and upon achieving enlightenment became known as the Jina or 'Victor'. He propagated a path that laid emphasis on austerities and penance. As the faith later known as Jainism developed, it proposed the existence of twenty-three Jinas prior to Mahavira, who was considered the last of a line. Today, Jainism continues to be a significant religion, especially in western India. The other path, introduced by young chieftain Siddhartha, known later as the Buddha, soon dominated early India and spread beyond its boundaries to become influential in China, Korea,

Japan and Southeast Asia. Ironically, it all but died out in the country of its origin, being revived in the twentieth century through the efforts of B R Ambedkar who also championed the cause of indigenous marginalized communities. The traditional dates of 563–483 BC for the Buddha's lifetime have recently been revised and Buddhologists today suggest a date for his death of *c.*400 BC.

The story of Siddhartha, born to chief Suddhodhana and lady Maya of the Shakya republic that bordered Nepal, has been handed down by tradition preserved in Buddhist texts that were committed to writing only in the fifth century AD. Wise men predicted that the new-born infant would become a world conqueror: either he would triumph over the territories of the earth, or he would conquer the minds of men through supreme knowledge won after renouncing the world. In an attempt to prevent the path of renunciation, Suddhodhana surrounded his son with all luxuries, but to no avail. Spurning a life of plea-sure, Siddhartha tried the rigorous path of asceticism and penance, but abandoned it after six years as a futile pursuit. Instead, he sat in profound meditation beneath a pipal tree until he achieved realization. Thenceforth, his followers called him the Buddha or 'Enlightened One', and the pipal became known as the *bodhi* tree, or tree of enlightenment. Buddhism is often described as the Middle Path because it shuns extreme penance as well as sensual indulgence. Later texts narrate how the Buddha explained his approach to a new disciple, Sona (*Vinaya-pitaka* I, v 181–2):

Formerly, when you were a householder, were you skilled at playing the lute?
Yes Lord.
When the strings of the lute were too taut, was it tuneful and fit for playing?
Certainly not Lord.
And when they were slack, was the lute tuneful and fit for playing?
No Lord.

But when the strings were neither too taut nor too slack but were keyed to an even pitch, was your lute tuneful and fit for playing?

Yes Lord.

Even so, Sona, is the *dhamma* that I propose.

Using the popular Prakrit tongue in place of Sanskrit, the language of the Vedas, the Buddha propounded an eightfold path of moral and ethical living that included right views, right conduct, right livelihood and right effort. It involved no priestly intervention, no rites and rituals, and required only faith in the Buddha, his doctrine (*dhamma*) and the monastic community (*samgha*). It rejected the caste system and had widespread appeal among monarchs, merchants and peasants alike, as also among women, particularly widows and courtesans. While it is true that masses of the under-privileged shudra caste converted to Buddhism, several monarchs were also among the Buddha's close followers and their subjects also adopted the faith.

On his deathbed, the Buddha is said to have instructed his disciples to cremate his body and to build a memorial mound, or stupa, over his remains at a crossroads where people congregated. When he passed away in Kushinagara, the local Malla chieftains laid claim to his remains, but were forced to yield to the outraged demands of neighbouring kings and chieftains. The cremated relics – ash, bones and teeth – were divided into eight portions and enshrined within eight stupas in eastern India.

Early Buddhism was a missionary religion. The Buddha exhorted his monks (*bhikkus*) whom he had instituted into the *samgha*, to wander the length and breadth of the country to promote the new faith (*Mahavagga* I, ch 11, v 1):

Go forth, oh *bhikkus*, on your wanderings for the good of the many, for the happiness of the many, out of compassion for this world. Let not two of you go the same way. Oh *bhikkus*, proclaim that *dhamma* that is auspicious at the beginning, auspicious at the middle, and auspicious at the end.

Thus, during the fourth century BC, the cult of wandering monks was established in the Buddhist tradition. They travelled along trade routes, converting merchants, traders and others, and the followers of Buddhism soon reached significant numbers. The monks were permitted a settled existence only during the three months of torrential monsoon rain when rivers swell, streams become unfordable and the countryside is flooded. These temporary shelters, originally intended as rain retreats, ultimately grew into permanent monasteries.

During this period of republics and monarchies, sometimes spoken of as the sixteen *mahajanapada*s or 'great states', India had been drawn into the circuit of the powerful Achaemenid empire of Persia. According to an inscription of king Darius (r.522–486 BC), teak for the palace at Susa was supplied by the northwestern province of Gandhara, today in Pakistan; the records of king Xerxes (r.486–464 BC) indicate that Indian contingents fought in Greece as part of the Persian army. The Persian capital of Persepolis was sacked and burnt by Alexander the Great who, having successfully marched across vast stretches of Asia, arrived on the threshold of India in 326 BC. After capturing the frontier provinces, he reached the Indus where his army mutinied and refused to march further. Forced to abandon his plans to conquer India, a disappointed Alexander returned home by sea. He died soon thereafter in Babylon and within five years Alexander's Indian provinces were recaptured by Chandragupta, the founder of the newly emerging Maurya empire. When the Greek general Seleucus inherited the eastern parts of Alexander's empire, he attempted unsuccessfully to reconquer India, but instead was forced to surrender Afghanistan. The early Mauryan rulers succeeded in uniting immense areas of the country so that when its third and most prominent ruler, Ashoka Maurya, came to power, he controlled a vast empire that extended from Afghanistan to all but the very deep south of India. It was with emperor Ashoka (r.272–231 BC) that large-scale art in stone first appeared, and it was with Ashoka that India entered the age of written history.

Ashoka became a champion of non-violence after a military campaign in Orissa during which he witnessed massacre on an unprecedented scale, and the art which he sponsored was directly connected with his Buddhist persuasion. Ashoka set forth a code for righteous living that incorporated his faith in the Buddhist path, creating edicts which were inscribed on rocks and pillars across the length and breadth of his empire. In Kandahar, on the borders of Afghanistan, his scribes used the Greek and Aramaic scripts; in the rest of India they used the Brahmi script from which all later Indian writing is derived. The exact origins of Brahmi, which arose some 1,500 years after the disappearance of the Indus writing, remain a mystery; recent research indicates connections with Aramaic.

While Ashoka engraved edicts on pillars already standing and presumably established by his predecessors, he also commissioned several new columns. These finely polished pillars were carved of tan-coloured sandstone from a single quarry at Chunar near the Mauryan capital of Pataliputra (modern Patna) in eastern India, where a centralized royal workshop appears to have existed. Smooth, monolithic shafts, some 9 m (30 ft) high,

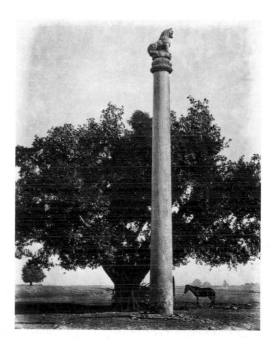

28
Ashokan pillar,
Lauriya
Nandangarh,
246 BC

tapered gently (28). The composite capitals, consisting of an inverted bell, an abacus and a crowning animal, were also carved from single pieces of stone. A large copper bolt connected shaft and capital. The most celebrated of Ashokan capitals crowned a column erected in the deer park at Sarnath where the Buddha preached his first sermon, at which he is said to have 'turned the wheel of the law'. Four highly stylized addorsed lions sit upon an abacus carved with four animals – lion, elephant, bull, horse – that move around in clockwise fashion, punctuated by four small wheels (29). Is it possible that the lions were intended as a reference to descriptions of the Buddha as 'lion of the Shakya clan'? The lions at one time-supported a large wheel upon their heads, which in the Buddhist context symbolizes the doctrine or *dhamma* that must be continually turned to keep the faith alive. It is this Ashokan capital that independent India adopted as its official emblem, regarding it as symbolic of India's first unification under centralized rule.

Is Persian inspiration evident in this first monumental art in stone? This is a complex question. It would appear that the idea of setting up independent columns – that may make reference to the *axis mundi*, rooted in cosmic waters and reaching up to the sun – is indigenous and owes nothing to Persia. Certainly, a comparison of the Ashokan and Persian columns reveals more differences than similarities. Ashokan columns were smooth, rose straight out of the ground and invariably stood by them-selves; Persian columns were fluted, always had a base and were invariably part of an architectural structure. Yet the idea of adopting stone to replace pre-Mauryan wooden columns may indeed have been derived from Persia; in this context, one may take note of the similarity between the introduction of Achaemenid inscriptions, 'Thus spake Darius,' and Ashokan edicts, 'Thus spake *devanampiye piyadasi*,' meaning 'beloved of the gods, beloved slave', a title adopted by Ashoka. Certainly the mask-like character of the heads of the adorsed lions on the Sarnath capital, their incized muzzles and the triangular

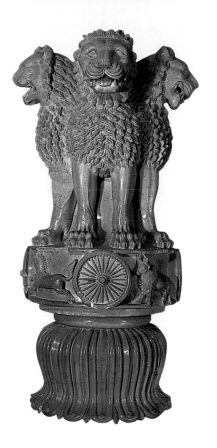

29
Lion capital,
c.250 BC.
Sandstone;
h.215 cm, 84 in.
Archaeological
Museum,
Sarnath

formation of the eyes, are strongly reminiscent of Persian precedents. However, the animals that crown other Ashokan columns, such as the Rampurva bull, are quite non-Persianate; the bull is simply and naturalistically carved, with its body partially engaged in the block of stone (30). If imported Persian craftsmen worked in India, one would expect to see more evidence of their work. It seems more probable that portable objects, like gold or silver lion rhytons or drinking cups, served as inspiration to local craftsmen. Yet, the masterly end product, with no surviving trial attempts, remains perplexing.

What about motifs familiar in the Mediterranean world, such as palmettes and rosettes, that are seen on Ashokan columns as also in later Indian art? Once the Mauryan rulers had reclaimed the Indian provinces captured by Alexander, they maintained friendly relations with the West and regularly exchanged envoys. Megasthenes, a Greek ambassador from Seleucus, lived

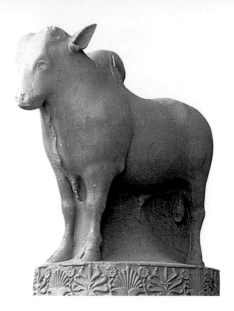

30
Bull capital,
from
Rampurva,
c.250 BC.
Sandstone;
h.203 cm, 80 in.
Rashtrapati
Bhavan,
New Delhi

for several years at the Mauryan capital and travelled exten-
sively in India. His book *Indika*, known only from excerpts
quoted by later authors, contained cordial accounts of his life at
court, as well as his insights into early Indian cultural life and
Mauryan administration. Indian artists probably encountered
motifs such as rosettes, palmettes and winged animals on
portable objects imported into this cosmopolitan milieu. These
they incorporated into their repertoire, either adopting them
wholesale or adapting them to suit their project.

With the exception of imperial stone columns, Mauryan archi-
tecture appears to have continued to rely largely on wood,
brick, terracotta and stucco. Excavations at the capital of
Pataliputra reveal that it was surrounded by a massive wooden
fortification consisting of gigantic teak beams held together
with iron dowels. In the palace area, huge wooden platforms
preceded a pillared hall built of wood in three storeys; however,
a stone Corinthian-type capital from the site suggests that stone
pillars supported the lowest level. Only a few free-standing
stone sculptures, including some life-sized male figures holding
*chauri*s or fly-whisks, have been assigned to the Mauryan
period. A stunning female figure known as the Didarganj *chauri*

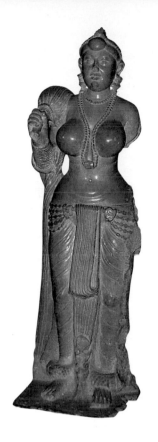

31
Didarganj
chauri-bearer,
1st–2nd
century AD.
Polished
sandstone;
h.162·5 cm,
64 in. Patna
Museum

bearer has been celebrated in the past as a Mauryan master-piece (31), but recent research indicates that this voluptuous female is best relocated to the second century AD where she fits in more comfortably with several other pieces of similar mood and quality. Her placement in the Mauryan era was largely decided by the fine polish seen also on Ashokan pillars; however, it now appears that this polish may be a localized phenomenon characteristic of the Patna region where it survived for several centuries. The problem with dynastic periodization (often used for convenience) is that it does not make allowance for styles to continue after dynasties end. In addition such periodization suggests that all art was commis-sioned by royalty; this was often far removed from the truth.

Recent discoveries in eastern India of several small terracotta figures that are miniature counterparts of the life-sized Didarganj image have opened a new chapter in India's artistic

history. One such image, seemingly of semi-divine status, is a sensuous, yet disturbing figure with snakes wrapped around her body (32).

While Ashoka's rock and pillar edicts highlighted the cause of Buddhism, their erection was not the emperor's most important act in the dissemination of the faith. More significant was his decision to open the original eight stupas containing the Buddha's relics in order to redistribute them among a vast number of simple brick-faced stupas (84,000 according to tradition) which he erected across his far-flung empire. His intention was to bring the Buddha's presence into the midst of his citizenry. One of his simple stupas was built at Sanchi in Central India, a site that rose to artistic prominence in post-Ashokan days.

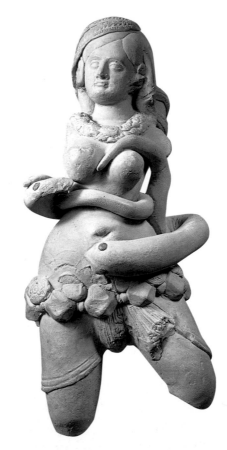

32
Yakshi
encircled by
serpents,
eastern India,
1st–2nd
century AD.
Grey
terracotta;
h.27·5 cm, 11 in.
Private
collection

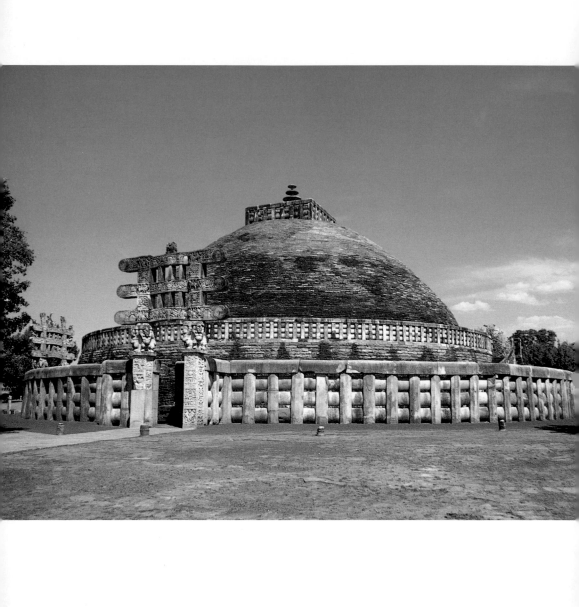

Storytelling is an activity of universal occurrence and timeless appeal; across the world in villages and towns people have gathered to hear the telling and staging of myths and epics. Exploiting the power of narrative, Buddhists in early India used visual storytelling as a way of popularizing their faith. Vibrant narrative reliefs, filled with details from everyday life, introduced visitors to the Buddha's life story and thereby established easy access to a new faith. The major events in his legendary life – birth, departure, enlightenment, first sermon, death – were given a historical dimension through these visual biographies that became the 'text' of images which appear everywhere, though presented in different ways.

33
Great Stupa, Sanchi. Original brick stupa *c*.250 BC; enlarged and renovated *c*.50–25 BC

These stories were used to adorn the stupa, the solid earthen mound that enshrined a portion of the relics of the Buddha and was the focal point of Buddhist monasteries across India (33). A parasol, indicative of rank and status, crowns the stupa and marks the spot where the relic casket rests at the heart of the mound. It honours and shelters the relics just as does a parasol held over a living monarch or carved above the image of a deity or king. There is no interior to a stupa; in sharp contrast with the Christian world, the Buddha's relics are not intended for viewing. Buddhists flock to a stupa to experience proximity to the Buddha by way of his relics that are believed to contain his living essence. The relics are thought to retain and be infused with the quality that animated and defined the living Buddha. A stupa is thus approached by Buddhist pilgrims with the same veneration and love accorded to the Buddha himself.

The Great Stupa in the monastery atop Sanchi hill in Central India is the best preserved of early stone stupas. On one of its ornamental gateways is an ingenious and lively version of the

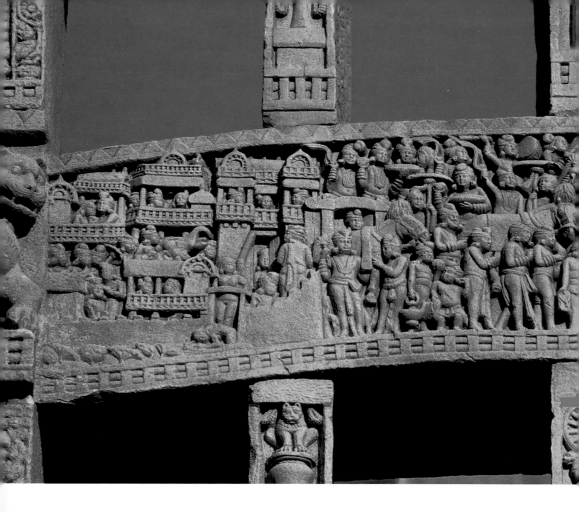

story of the Great Departure, when young chieftain Siddhartha abandoned his palace and rode off in search of truth (34). Sculptors of the first century BC chiselled into smooth sandstone to bring to life a bustling, surging world. To the far left of a lightly curved architrave is a palace from which the Buddha-to-be emerges on his horse, Kanthaka. The horse's legs are held up by the gods to muffle the sound of its hooves and to allow Siddhartha to depart undetected; the length of the carving, 2·5 m (or some 8 ft), invites us to witness the ride from the palace. We see the horse moving further and further away – it is repeated three times – until we reach the far end. The Buddha on horseback? But where is he? In this early art, the Buddha was not shown in human form; his presence on horseback is

34
The Great
Departure,
east gateway,
Great Stupa,
c.50–25 BC

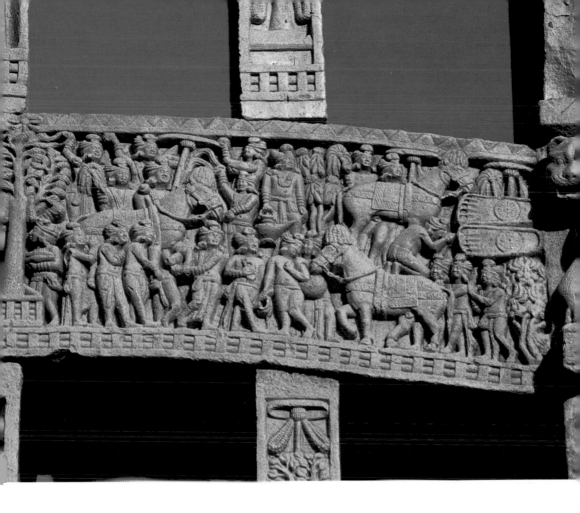

indicated by empty space sheltered by a regal parasol. Having
ridden far from home, Siddhartha dismounts to continue his
journey on foot; his presence is now indicated at the extreme
right by a pair of footprints above which the parasol hovers. His
loyal groom Chandaka kneels at Siddhartha's feet – in effect
before his footprints – to bid farewell. Finally, the riderless
horse, placed contrary to the movement thus far, returns to the
palace led by the groom; the parasol that earlier hovered above
the horse now stays with the footprints. The five horses are in
fact repetitions of the same horse, intended to indicate its
movement in space and time. The method of continuous narra-
tion dispenses with frames to distinguish individual scenes;
instead, the story flows continuously across the available

space. Once attuned to this technique of storytelling, viewers will read the story with ease and admire its vivid formulation.

The reasons for the avoidance of the anthropomorphic image of the Buddha in a narrative art centred on his biography were never articulated in any ancient text. Apart from the difficulty of conveying the transforming effulgence of the Buddha, sculptors and monastic authorities appear to have faced the critical issue of whether it was at all correct to depict him in human bodily form. In accordance with the theories of karma and rebirth, by which individuals are born several times on earth with the opportunity progressively to perfect themselves, the Buddha too had many births. After 550 lives he had finally achieved the highest stage of pure enlightenment; through his death, he had freed himself from the confines of a bodily form. Never more would he be born on earth; he had escaped the cycle of rebirth. The Sanchi monastics certainly wished to depict his inspiring life story upon the gateways. But they appear to have felt it improper to depict him circumscribed by the body that he had finally managed to shed.

It would seem that artists, probably conferring with monastic authorities, came up with the novel solution just encountered in the Great Departure. They would present the Buddha's life story, but would indicate his appearance by traces that stood for his presence. And so, a unique visual system of symbols or emblems was created. Footprints indicate soil on which he trod; a parasol indicates space he occupied; an empty seat signifies his seated presence; an elongated pathway indicates his walking presence.

This narrative sculpture, radically different in mood and style from the Ashokan stone columns, began to be created some 130 years after emperor Ashoka's death when the Mauryan empire had broken up into a series of kingdoms of varying size, mostly ruled by Hindu monarchs. Geographical boundaries fluctuated due to constant warfare. The waging of war was deemed to be a king's royal duty and and every monarch felt impelled to

embark on a 'victory over the four directions', known as a *digvi-jaya*. Thus, battles were fought on a regular basis, not only to expand a kingdom's territorial reach and to acquire wealth in the process, but also to impress subjects and retain their sense of loyal commitment. Such a political scenario continued in India for the next millennium or so until the rise of major empires, both Hindu and Muslim.

The Sanchi area of Central India was under the control of the Sungas, and later the Kanvas, both Hindu dynasties. These monarchs maintained cordial relations with the Hindu Satavahana kingdom of the western coastal region that controlled access to the ports where overseas traders called. The Satavahanas later extended their territory all the way across peninsular India to control ports on the east coast as well. Trade, both internal and overseas, contributed to the stability of the various kingdoms and was also closely linked with the patronage of Buddhist monasteries. Buddhists and Hindus had a shared concept of the importance of *dana* or giving, and their generosity was directed towards the *samgha* which the Buddha had upheld as a deserving entity, as a *punya-kshetra* or field of spiritual merit. Thus, people across the social spectrum gave to the monasteries, their inscribed gifts being described at Sanchi as *danam*, and in the cave monasteries as *deya dhamma* or pious gift. While Hindu royalty was not directly involved in the construction or embellishment of Buddhist establishments, they were quite happy to give the monasteries post-foundation support in the form of land and the money accruing from that land. The thriving condition of the numerous Buddhist monasteries across India indicates that Hindu monarchs viewed monastic centres as points of stability, deserving of at least indirect patronage.

The narrative grandeur of Sanchi's Great Stupa was a creation of the first century BC, when stone, rather than perishable wood and brick, began to be used on an extensive scale for Buddhist sacred structures. The simple brick-faced stupa that

Ashoka had built on Sanchi hill was one of many targeted for enlargement and embellishment. Monastic authorities expanded the stupa to twice its size, and faced it with slabs of sandstone cut from the hill itself. Next, an encircling stone railing was built to mark the stupa enclosure as sacred space and demarcate a path for *pradakshina*, or ritual circling of the stupa, which was a significant mode of homage to the relics. The massive, undecorated railing, modelled upon earlier wooden rails and comprised of pillars connected by crossbars and topped with lengths of coping, rises to twice the height of the approaching devotee. An upper path for *pradakshina* was created 4·5 m (14 ft 9 in) from the ground, with stairway access at the southern entrance. Creamy sandstone of a finer quality, from the adjoining Nagouri hill, was used for the various railings, as well as the crowning post and parasols. Finally, the Sanchi monastic authorities decided to erect four stone gateways at the cardinal points and carve on them stories that narrated the life of Siddhartha who became the Buddha, as well as his many previous lives. The gateways imitated simple wooden structures; two substantial square pillars were extended upwards and connected by three lightly curved architraves. Every part of these gateways was then covered with

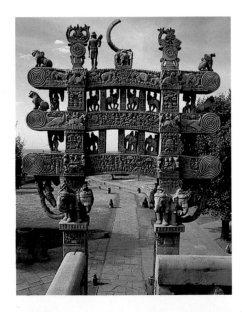

35
North gateway
carvings, Great
Stupa, Sanchi,
c.50–25 BC

narrative sculpture (35). For this detailed carving, sculptors demanded stone of an even finer quality; exploration yielded a whitish sandstone from the Udayagiri hills, some 6·5 km (4 miles) away.

The early architects displayed remarkable adaptability in transferring their skill from the softer materials of wood and brick to hard stone. However, the vitality of the earlier wooden tradition remains evident in the railing and top-heavy gateways where the method of construction, and specifically the jointing, is logical for wood but irrational for stone. Sculptors too were accustomed to working in a softer medium; an inscription on a richly carved gateway pillar speaks of it as the work of a guild of ivory carvers (36).

The earliest stupa to receive such stone embellishment was a small mound halfway up the Sanchi hill that enshrined relics of ten dignitaries of the Buddhist order who had been key players in the time of emperor Ashoka. Here, around 100 BC, the lotus medallion dominated the decoration of the railing. Soon thereafter, at the site of Bharhut some 320 km (200 miles) to the northeast, the art of storytelling emerged more confidently. Created according to a gateway inscription during the reign of

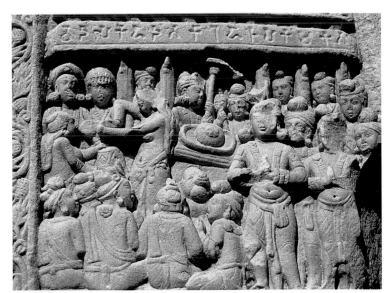

36
Heavenly celebration of the Buddha's turban with a donative inscription from a guild of ivory carvers, south gateway pillar, Great Stupa, Sanchi, c.50–25 BC

the Sungas (rule ended *c*.80 BC), every unit of the Bharhut railing, be it pillar, crossbar or coping, tells a story. Around 50 BC, at the Great Stupa atop Sanchi hill that enshrined relics of the Buddha, and the adjoining stupa with relics of two of the Buddha's disciples, the art of storytelling in stone has achieved assurance. The dates assigned to these early stupas are the result of my own research; those who disagree with the concept of accelerated development may, for instance, wish to advance my suggested dates for the decoration of the Great Stupa.

An outstanding feature of the narratives of the Great Stupa is its expression of joyful participation in all of life's activities. Sculptors did not present viewers with sermons in stone but with the vibrant everyday world of the first century BC to which they could relate with ease, and which would give a sense of immediacy to their viewing of otherwise distant events. We see processions watched by people on balconies, joyous scenes of music and dance, villages where women pound grain and fetch water, and forests where elephants bathe in lotus ponds while monkeys and geese frolic on the banks. In the midst of all these apparently everyday surroundings, the Buddha is present. Processions and dances are in honour of his relics; the village is where he performed one of his miracles; the forest is the setting for a tale of his previous life. In unfolding the story of the Buddha, or the truths of Buddhism, artists invariably framed them in the world of the familiar. Captured by the charm and verve of the presentation, viewers slipped into a mood in which they absorbed the Buddhist creed effortlessly. The Buddhist message was certainly of consequence, but the religious or philosophical aspect was rarely allowed to overshadow creativity. This artistic ingenuity, and the integration of legendary with everyday events, makes an encounter with the Sanchi gateways an unforgettable visual experience.

One architrave that presents the story of the Buddha's enlightenment employs a central focus to create an effect very different from the continuous narrative of the Great Departure. At its

37
The Enlightenment, west gateway, Great Stupa, Sanchi, *c*.50–25 BC

midpoint is the Buddha, whose presence is indicated by a shrine surrounding the seat beneath the pipal tree where he attained enlightenment (37); the distinct heart-like shape of the pipal leaves makes it instantly recognizable. Artists found nothing incongruous in including the shrine that was in place by the first century BC, but certainly not there when the events occurred; this was one way of giving relevance and immediacy to the enlightenment. To the right and left of the symbols that

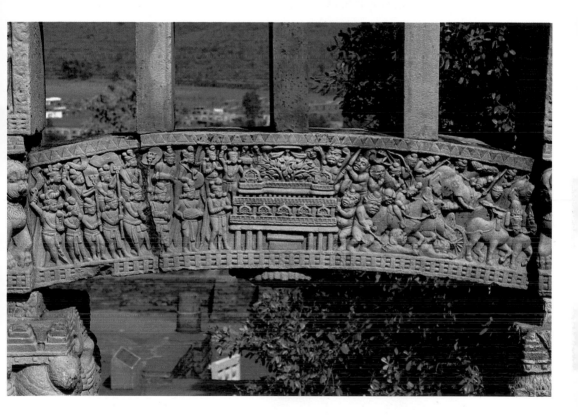

indicate the Buddha's presence are the events immediately preceding and succeeding the enlightenment. The demon armies of Mara, the evil one of Buddhism, assailed Siddhartha with every conceivable weapon; finding themselves unable to distract him from his meditation, they fled in fear and trepidation. Then the rejoicing gods appeared to applaud the momentous event of Siddhartha's enlightenment, which won him the title of the Buddha, or the 'Enlightened One'. The right half of

the architrave portrays Mara's demons fleeing in disarray, trampling one another in their haste; their rotund bodies and flaccid, thick-lipped faces are most expressive in their exaggerated grotesqueness. Their panic-stricken departure continues on the extension of the architrave. The left half presents the arrival of the gods who, by contrast, are a serene and orderly group offering salutations to the Buddha; their arrival too is continued on the architrave's extension. Gazing at the striking difference between the halves of the architrave, one cannot help but wonder whether they were carved by different sculptors, one being far more creative and fanciful in his treatment than the other. On the other hand, a single artist may have intended to contrast the chaotic world of evil with the ordered world of good.

Other modes of telling a story are contained within small rectangular gateway panels, and one such series portrays the legends surrounding the Buddha's conversion of the influential but disbelieving Kasyapa brothers. A panel on the inner face of an east gateway pillar depicts the presence of the Buddha in the tranquil village of Uruvela, where women engage in household activities like grinding spices and winnowing grain while buffaloes laze beside lotus-filled waters. In their midst is the

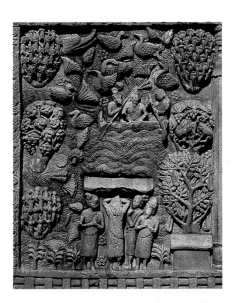

38
The Miracle of
Walking on the
Waters, east
gateway pillar,
Great Stupa,
Sanchi,
c.50–25 BC

empty parasol-sheltered seat that marks the presence of the Buddha. He performed several miracles, and with each miracle the Kasyapas were increasingly impressed. Their final conversion was effected by the miracle depicted on the front face of the same pillar, at a conveniently readable eye-level (38). When the Kasyapa brothers heard that the Buddha had embarked on a river journey, just before a flash flood on the Nairanjana River, they grew concerned about his safety. Setting out in a boat to rescue him, they found him serenely walking on the waters, his presence indicated in the panel by a floating slab of stone. The Kasyapas are depicted a second time, on firm ground, conceding the supremacy of the Buddha who is now represented by a seat beneath a garlanded tree; thereafter masses of their followers converted to the Buddhist faith.

Converts to the new Buddhist faith were equally attracted to the stories of the Buddha's previous lives, known as *jatakas*. Several *jataka*s were widely prevalent fables adapted for Buddhist purposes simply by suggesting that the hero, often an animal or bird, was the Buddha in a previous life. The visual presentation of partly familiar stories on the railings and gateways of the early stupas was an added attraction of the new faith.

The Great Monkey *jataka*, which narrates the Buddha's birth as a monkey-king and his heroic disregard of danger to his own life when it came to saving his subjects, is told in five episodes within a rectangular panel on a gateway pillar (39). No indication is given about where the story begins or how the sequence unravels. The uninitiated viewer might be confused by this irregular pattern of staging; however, it would undoubtedly create interest for those already familiar with the story, with the search for continuity adding enjoyment to their viewing. The story begins in the lower left-hand side. Preceded by a group of soldiers and musicians, the king of Benares arrives on horseback, intent on tracking down the tree that produced the wondrous mango brought to him by a fisherman. Upon seeing

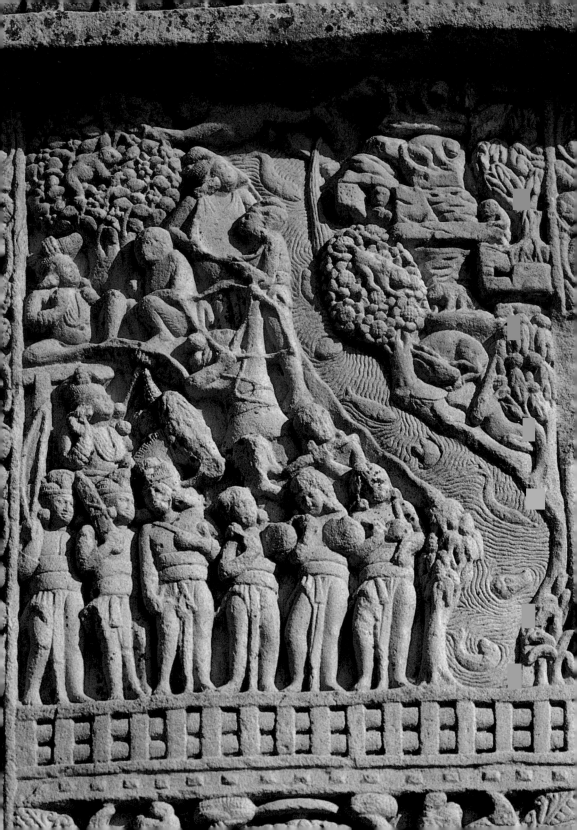

monkeys devouring the fruit he sought, the king ordered them destroyed. Roughly at the centre of the panel, a half-hidden figure of an archer bends backwards as he aims his arrow directly upwards. Following the upward movement of his bow, we see a monkey who has stretched himself out to form a bridge across the river below, and we surmise that his monkey friends are escaping from the archer to the safety of a tree on the opposite right bank where deer laze in a quiet forest environment. Below the monkey, two soldiers hold a stretcher. Viewers will need to recall that the monkey-king's arch enemy, a fellow monkey, jumped so heavily upon his back while escaping across the river that the monkey-king was mortally wounded. They will need to supply the human monarch's admiration of the scene he has witnessed, and understand that the stretcher was to rescue the injured monkey-king. To the upper left are the seated figures of the monkey and the monarch; this last episode portrays the monkey-king preaching on the moral greatness of making every sacrifice to save his subjects. It is self-sacrifice, one of ten Buddhist virtues, that the story exemplifies. In this appealing manner were Buddhist virtues conveyed to both monarch and peasant.

The many modes of visual storytelling evident at Sanchi speak of the sophistication of the early sculptors who made deliberate use of a range of sculptural conventions. With the aim of legibly conveying details of a story, artists portrayed objects in the 'background' of a relief as large and clear as those in the 'foreground'. Viewers understood that the lower part of a panel represented space closer to them, and that objects in the upper portion were further away. Perspective was a non-issue; clarity of visual comprehension was the objective. Had early Indian artists been shown pictures with Western single-point perspective, they may well have regretted the ill fortune of artists who were unable clearly to depict figures in the background! This concern with legibility also led sculptors to present objects by their most easily recognizable aspect so that, within a single narrative, they made use of multiple perspective. In the miracle

39
Great Monkey
jataka, west
gateway pillar,
Great Stupa,
Sanchi,
c.50–25 BC

of walking on the waters (38), certain objects are presented as if seen at eye-level (trees, geese, half-open lotuses, a crocodile, a boat, the Kasyapas); others are viewed from above (the Buddha's walking path, the surface of his seat, full-blown lotuses); yet others are seen from below (lotuses with their calyx depicted). The emphasis on readability also resulted in trees with enlarged leaves and fruit, so that they were easy to identify. Yet another sculptural convention was the absence of facial emotion; gesture and context alone reveal whether a procession is joyous or sorrowful. These deliberate and considered visual conventions continue in use for several centuries, in both Buddhist and Hindu art.

In addition to capitalizing on the lure of storytelling in the propagation of their faith, a second successful Buddhist strategy was to incorporate visually, and hence acknowledge, the widespread pre-Buddhist veneration of fertility. Each of the Great Stupa's four gateways is ornamented with striking female figures, carved in the round and poised as decorative brackets between its pillars and the lowest architrave. One such provocative figure, sensuous and curvaceous, stands beneath a mango tree; wrapping one arm around its trunk, she reaches up with the other to grasp a fruit-laden branch (40).

One may have expected a Buddhist monastery to carry only sacred themes, since women were viewed as a distraction to a monk intent on the path to salvation. The Buddhist text *Mahaparinibbana Sutta* narrates the Buddha's response to his favourite disciple Ananda when queried on the conduct of monks towards women (ch 5, v 23):

Lord, how should we conduct ourselves with women?
Not see them, Ananda.
But if it is necessary to see them, Lord?
Not speak with them.
But what if it is necessary to speak with them, Lord?
Then, Ananda, keep your thoughts tightly controlled.

40
Bracket of a
woman and a
mango tree,
east gateway,
Great Stupa,
Sanchi,
*c.*50–25 BC

On the Sanchi gateways, however, artists, patrons and monas-
tic authorities display their faith in the widely held pan-Indian
belief that the figure of woman is auspicious. Woman was asso-
ciated with fertility and thus, in turn, with growth, abundance
and prosperity. What might seem a paradox to modern minds
was not so to the ancient Indians. After all, in the Buddhist and
Hindu context, woman was not associated with sin; there was
no Eve responsible for the fall of humanity.

Beyond auspiciousness, however, the woman-and-tree motif carried an added dimension of meaning due to a widely prevalent ancient belief that by her very touch, woman could cause a tree to blossom or bear fruit. Ancient writers including the famed Kalidasa (*c*.400 AD) alluded to this belief in their Sanskrit dramas and poems. Later texts codified the theme, specifying the exact actions needed to evoke response from different species of trees. The *ashoka* tree responded to the touch of woman's foot; the *piyala* to the sound of her singing; the *kesara* to wine from her mouth. The mango tree, beneath which the Sanchi figure stands, was believed to blossom at the sound of woman's laughter. The Sanchi figures are generally described as *yakshi*s, or semi-divine nature spirits; however, they could equally be human.

A closer look at the four Sanchi gateways reveals six such figures of woman on each – two large ones poised between the pillar and lowest architrave, and four smaller figures between the upper architraves (35), totalling twenty-four females on the Great Stupa. The significance assigned to these auspicious figures is accentuated by this emphatic repetition. The Buddhist art of India, in its accommodation of popular and widely held beliefs, should be termed, more accurately, an Indian art in the service of the Buddhist religion. Some of Sanchi's sculptors may have been Buddhist, but the greater number was probably Hindu who would also have worked on constructing mansions for the wealthy and decorating Hindu brick shrines. In its articulation and visual presentation, Indian Buddhism is very different from its ancient counterpart in China, Japan and Korea, and also from the contemporary Buddhist expressions of Southeast Asian countries like Myanmar (Burma), Thailand or Vietnam. The austere façade of Buddhism evidenced in such areas is a world apart from the sensuous Buddhist artistic expression of India.

Considering the expense and numbers of artists and artisans involved at Sanchi, it might be reasonable to assume that this

ambitious new project, initiating the use of stone on an unprecedented scale, was funded by royalty or the aristocracy. But quite to the contrary, we find that funding came exclusively from the local populace. Sanchi brings us into contact with the everyday world of the housewife and householder, the fisherman and gardener, the merchant and banker, who left as many as 631 records of donations inscribed in stone. We encounter the simple devotion of Buddhist followers who contributed collectively towards the stone enlargement and narrative embellishment of the stupa on Sanchi hill. The Sanchi monks evidently toured the villages and towns of the vicinity soliciting donations. Men and women, as well as family groups and village associations, gave money for paving slabs, railing units, and gateway narratives and sculptures. The monks probably assured donors that their gifts would bring them spiritual merit that would serve them well in this life and, even more importantly, would ensure them a fortunate birth in the next incarnation. Nuns and lay-women were also significant donors with just under half the donations. It mattered little whether the donors were Hindu or Buddhist since faith in the concept of karma was common to both religions. The monks may have promised donors that on their next visit to Sanchi they would be able to see their name, occupation and hometown inscribed on the piece created with their money (36). With such assurances, donations seemed to have poured in liberally.

The level of overall prosperity that enabled large numbers of the populace to fund Buddhist establishments was the result of flourishing mercantile enterprise. The success of Sanchi, situated on a hilltop a few miles from the capital city of Vidisha, lay partly in its strategic geographic location at the confluence of the rivers Betwa and Bes, where it was easily approached by river traffic. It was also at the crossroads of important land routes, being positioned on the transcontinental highway that linked eastern India to the ports of the west coast, at the point where it was joined by the route from northern India. The monastery was thus easy of access to the many merchants and

traders who regularly crossed the country in their caravans. Buddhist monasteries were invariably located on these trade routes, enabling monks to be in constant contact with this mercantile community and tap it for funds. The west coast of India was an entrepôt for Arab traders who brought in luxury goods from the Mediterranean and exchanged them for fine Indian cloth, and prized spices and aromatics. Indian merchants made substantial profits from the trade and thus had the wherewithal to support the monasteries by donating funds. This early trade will be more fully explored in Chapter 5.

Numerous gifts to the Sanchi stupa also came from monks and nuns. How was it possible for wandering homeless monks, who sought alms even to feed themselves, to contribute towards the enhancement of the Sanchi stupa? Clearly, men and women did not renounce their right to family heritage upon joining the Buddhist order; they seem to have retained a degree of access to it which gave them the means to fund work on sacred monuments. Sanchi's monastic authorities do not seem to have formulated any systematic Buddhist theological programme for the site of a type parallel to that seen in the mural decoration of Christian churches. Our expectations of the Buddha's life unfolding in orderly fashion, either on individual gateways or from one gateway to the next, are confounded. Apparently individual donors requested that their favourite stories be carved on the piece for which they paid, which would explain why the gateways present viewers with a random repetition of stories – even after making allowances for a few architraves that were erroneously replaced back to front during Sir John Marshall's restoration conducted between 1912 and 1919. On the gateways the Buddha's enlightenment is portrayed four times; the Great Departure occurs twice; and the Kasyapa story and the Great Monkey legend are featured only once.

Buddhist establishments, decorated with stories in stone that narrated the legend of the Buddha, were built across the length and breadth of the country during this early period and

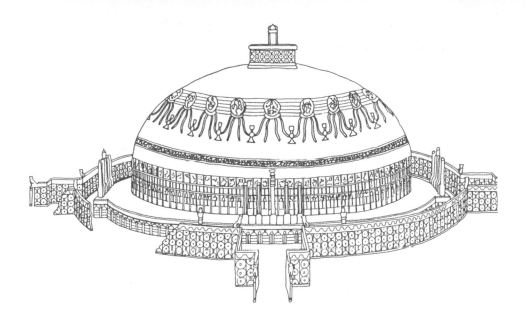

41
Reconstruction
of the
Amaravati
stupa,
c.100–200 AD

included sites in Rajasthan, at Mathura, Gaya and Nagpur. The Andhra region of southeastern India, some 800 km (500 miles) south of Sanchi, was the site of intense activity between the first century BC and the third century AD. Some thirty sizable establishments, and as many smaller monasteries, arose along the banks of the Krishna River, a major artery leading to the ports along the east coast. Excavated caches yielding Roman gold coins confirm a prosperous overseas trade that, as at Sanchi, acted as a stimulus to finance the decoration of Buddhist monasteries.

The site of Amaravati lay in the territory of the Satavahana monarchs. One of the wonders of the Buddhist world in the second century AD was Amaravati's magnificent stupa where visual narrative reached an unparalleled elegance. Today, all that remains is a desolate grass-covered mound, the site having been reduced to ruins in the eighteenth and nineteenth centuries by the haphazard digging of local landowners, trea-sure seekers and amateur archaeologists. Only half of its sculp-tured decoration survives, distributed between museums in London, Madras and Amaravati itself.

Local white-green limestone was richly sculpted and used not only for a splendid railing, but also to cover the Amaravati stupa's drum and the lower part of its dome (41). There is scholarly consensus that work at the site extended over a century or so, and during this period, as Chapter 4 will elucidate, the human image of the Buddha was introduced in northern India. The concept of embodying the Buddha, and its artistic solution, may, in fact, have arisen independently at a number of locations; certainly the Amaravati images are quite distinct from those that appear in the north. Amaravati's narratives carry an added fascination in enabling us to view the actual transition in the portrayal of the Buddha from emblematic traces of his presence to the anthropomorphic image. At Amaravati, however, the Buddha image never entirely replaced the earlier depictions of his presence, which continued to retain their validity.

The sumptuous and exuberant decoration of every portion of the Amaravati rail is quite stunning. Its tall pillars, with three fluted facets, were decorated with a central full-blown lotus and a half lotus at top and bottom. The lotus flower, which grew so abundantly in the Indian landscape and emerged fresh and pure from the hidden depths of muddy waters, was a pan-Indian symbol of purity. Buddhists adopted the symbolism of the lotus and equated its emergence from the murky depths to the manner in which the Buddha, born in this corrupt world, rose above it in his crystalline purity. The outer face of the pillars carried only lotus decoration, with sensuous layers of soft, sinuous petals. On the inner face, all available space around and within the lotuses is crowded with figures that narrate Buddhist legends. At Sanchi the sculpted forms were strong, crisp and lively. At Amaravati, between c.100 and 200 AD, the forms displayed an attenuation and sensuous languor that is perhaps unexpected in a Buddhist monastic context.

Artists presenting stories on Sanchi gateway pillars chose to divide each pillar into four or five rectangular panels, thus

arriving at a circumscribed space for their presentation. By contrast, Amaravati sculptors dedicated each railing pillar (3 m or some 10 ft in height) to a single story, arranging its various episodes between and around the lotus decoration. They derived varying solutions to this challenge in narrative presentation, sometimes starting at the top and working down, or vice versa; at other times beginning at the centre and moving both up and down; or concluding at the centre having commenced at either top or bottom. Each pillar thus requires the viewer to engage with it actively to unravel even a familiar legend.

One rail pillar portraying the events that transpired between the Buddha abandoning his austerities and his final achievement of enlightenment uses traces to suggest the Buddha's presence (42). It commences at the top and moves through the central medallion to the lower segment. The upper central flute depicts the Buddha's bath and his crossing of the Neranjara, his first act after six years of penance. The start and end of the crossing are indicated by two pairs of footprints, while two single prints on the water indicate his actual movement. Next, in the central medallion, the Buddha receives rice pudding as his first meal after abandoning austerities. While Buddhist texts speak of a single girl, the artist has visualized the entire female population of the village attending upon the Buddha whose presence is indicated by a seat and a cushion beneath a sheltering tree. The narrative concludes in the lower central flute that refers to the enlightenment and focuses upon a pair of footprints on a seat beneath a pipal tree.

A pillar that commences with the central medallion, and portrays the events between the great departure and the first sermon, gives us a glimpse into the transition from emblem to human imagery for the Buddha (43). The central medallion focuses upon the youthful form of a haloed and turbaned Siddhartha riding his horse, Kanthaka. In the lower central flute, Siddhartha takes leave of horse and groom. Having moved through the upper, now-damaged, sections of the pillar,

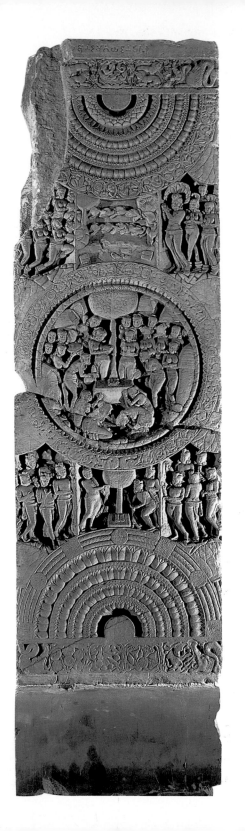
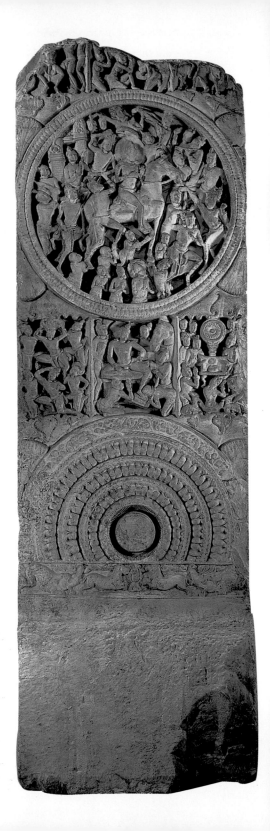

the narrative concludes in the lower-right flute with the first sermon; here, however, the artist abandons the human form, indicating the Buddha's presence by a cushioned throne surmounted by a wheel-crowned pillar.

Crossbars that connected the Amaravati pillars are decorated with medallions which continue the narrative intent of the site, and coping lengths do likewise. The story of the Buddha's previous life as king Mandhata is told in the single scene of the king sharing the throne of god Indra in the heavens (44). Once lured by the exuberance of the carving, viewers will be active participants in the progress of the narrative. They will have to recall the series of events that preceded Indra's invitation to the virtuous king to share his throne, as well as the completion of the story when Mandhata's devouring greed led to his eventual fall from the heavens. The artist was a master of the attenuated sculptural style typical of Amaravati, and the languorous forms of the heavenly nymphs are barely contained within the medallion, spilling over onto its floral edging.

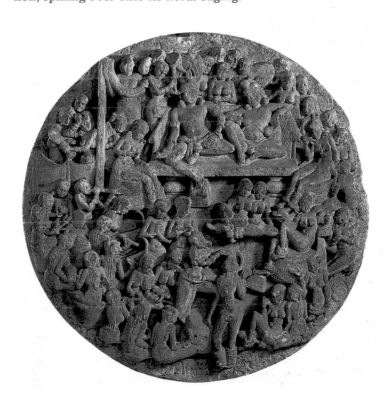

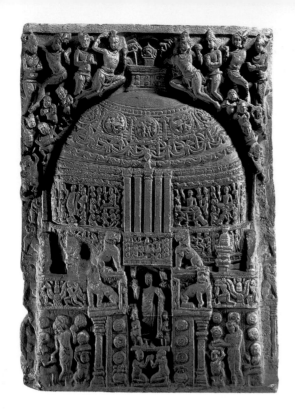

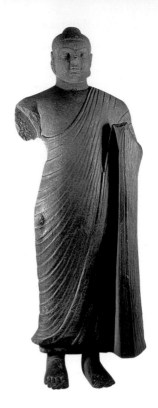

Viewers entering Amaravati's sacred enclosure to participate in ritual *pradakshina* of the stupa would have found themselves surrounded by a rich array of carvings. To their left would be the intricately carved inner face of the rail: to their right, the heavily sculpted slabs (1·8 m or nearly 6 ft high) that covered the drum and its four projections, as well as the lower portion of the dome (45). An indication of increasing monastic control over the stupa's programme comes from drum slabs carved on both sides. When work first commenced, a random array of themes was carved on the drum slabs; such slabs were later reversed, recut to depict the stupa itself and replaced. Dome slabs, rising 3·5 m (11 ft 6 in) above the drum, were carved in three registers, apparently to recall the three jewels of Buddhism – the Buddha, the *dhamma* or doctrine, and the *samgha* or community of monks.

The sculptors who produced narratives of exceptional sophistication and confidence also created a few free-standing images

of the Buddha (46). Robust of body and solemn in expression, with small soft curls covering the head, these figures are swathed in a monastic robe that leaves the right shoulder bare and carries a characteristic swag at its lower hem. These images are quite distinct from the northern images generally assumed to be the source of all embodied forms of the Buddha. The exact position of the images in Amaravati's overall decorative scheme remains uncertain.

The patterns of patronage at Amaravati, as gleaned from inscriptions that record donations, run parallel to those at Sanchi. Two-thirds of the gifts came from lay worshippers, of whom a large proportion were women who clearly had a degree of economic independence. The remaining one-third came from Amaravati's monastic community, with more contributions from nuns than monks. Several nuns held titles that indicate their high status within the ecclesiastic community; nun Roha, for instance, had 'passed beyond the eight worldly conditions'.

Records of gifts to the Amaravati project were generally inscribed on the piece donated with epigraphs occasionally recording multiple gifts. The plethora of donations was not a random, individual activity as at Sanchi, but seems to have been regulated by *navakarmika*s, or monastic supervisors of new works, who are mentioned in three inscriptions. While devotees could choose to donate the type of carving that appealed to them, the supervisors would ensure that all drum slabs were carved to depict a stupa, and that dome slabs carried a single Buddhist message. One supervisor was in special charge of the construction and decoration of the railing; it is indeed unfortunate that the total spoliation of the site precludes retrieval of his original programme.

The many richly adorned Buddhist monasteries that flourished between 100 BC and 200 AD were made possible by public interest and funded by multiple private individuals. Lavish stories in stone depict the Buddha in the midst of common, everyday life familiar to its viewers and donors. We are far

from the glittering world of monarchs and aristocrats, perhaps partly because most of these early kingdoms were ruled by Hindu monarchs. At Sanchi, local Sunga royalty finds no mention at all; the neighbouring Satavahana kingdom features in inscriptions only because its chief artist gifted a carved architrave. At Amaravati too, there was no direct royal involvement in the stupa project. Three inscriptions mention names of Satavahana royalty, but two do so only to establish the year in which gifts were made by householders, while a third was a gift of the officer in charge of the kingdom's water supplies. The early Buddhist period was indeed the age of community patronage, and its charismatic narrative art was sponsored by the people. These early monasteries continued to be thriving centres of Buddhism; Sanchi, for instance, witnessed the addition of simple votive stupas, pillars, images and temples right into the twelfth century, when Buddhism faded across India.

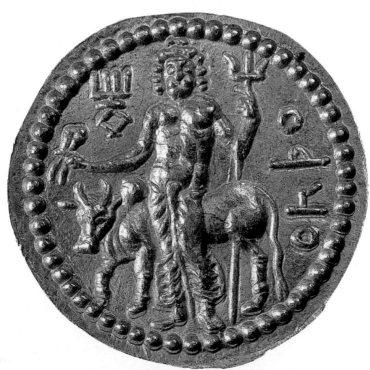

In the first century of the Christian era, northern India was governed by monarchs of the Kushan dynasty, an astute people with a cosmopolitan outlook. Their vast empire extended from Varanasi on the Ganges, through Pakistan, Afghanistan, Baluchistan and Bactria, up to the River Oxus. The Kushans displayed a keen awareness of the conflicting forces and pressures that could arise in an empire straddling so wide a range of ethnic and cultural boundaries. Their diplomacy is strikingly evident in the two distinct types of coinage they issued for circulation in the western and eastern parts of their empire. From their summer capital at Begram in the hills of Afghanistan, they issued coins featuring Iranian deities, Greek goddesses and the Buddha (47). Here, their coin legends used the local Kharoshti script derived from Aramaic, and occasionally incorporated Greek lettering. On these coins, emperor Kanishka chose to call himself 'Shah of Shahs, Kanishka of the Kushans'. Coins issued from their winter capital at Mathura, in the plains of northern India, used the local Indian Brahmi script, and featured a series of Hindu gods (48) as well as the Buddha. Here the emperor generally used Sanskrit, and adopted the Indian title 'Raja of Maharajas, Son of the Gods, Kanishka', which was also inscribed on his portrait statues (67). The Kushan rulers could indeed be all things to all people.

Under Kushan patronage, the anthropomorphic image of the Buddha became popular in art; the earlier preference for a symbolic representation of the Buddha's presence was now abandoned in favour of embodiment. Part of the reason lay in changes within the Buddhist religion itself, which no longer visualized the Buddha as an inspired mortal who had found a path to salvation. He had now been deified, and his followers required a personal focus upon which to pin their devotion.

47–48
Kushan coins.
Gold;
w c 2 cm, ¾ in
British
Museum,
London
Above
Depicting the
Buddha,
1st–2nd
century AD
Below
Depicting the
Hindu god
Shiva with his
bull, 2nd
century AD

With their far-sighted awareness of cultural differences, the Kushans sponsored the production of two distinct types of Buddha image, one created in the western part of their empire, the other in the plains of India.

In the northern regions of the subcontinent, a unique Buddha image was fashioned in local grey schist, using a Greco-Roman Apollo type as the model. Artists portrayed the Buddha with youthful features and wavy hair, clad in a monastic robe draped in heavy classical folds reminiscent of a Roman toga (49). Buddhist texts had formulated a set of thirty-two signs for the Buddha's superhuman perfection, and artists drew on this visual lexicon when creating their images. They invariably gave the Buddha the *ushnisha*, generally interpreted as a wisdom bump on the crown of the head, as well as the *urna*, a curl of hair resting between his eyebrows. Aesthetic sensibilities dictated that sculptors disguise these signs. They transformed

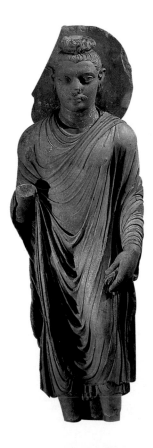

the *ushnisha* into a curly top knot and depicted the *urna* as a dot between the eyebrows. Occasionally they further deferred to Buddhist sacred texts by portraying the Buddha with a webbed hand, and often engraved a wheel on the soles of his feet and the palms of his hands. Most of the other thirty-two attributes, such as the Buddha's lion-like torso, are metaphorical; in fact, such language is also used to describe the *chakravartin* or universal king of Hindu ideology. Additionally, artists gave the Buddha a halo, an accepted sign of divinity and kingship in India and Central Asia. The changeover to the image was certainly facilitated by the Greco-Roman tradition that had always been intensely anthropomorphic. The Greeks had modelled their gods as examples of the perfect male physique for several hundred years before Indian sculptors began to give human form to their gods. While dated images are rare, Kanishka's coinage confirms the creation of the Buddha image during his reign, generally placed between 78 and 101 AD.

49 Far left
Standing
Buddha,
Takht-i-Bahi,
Gandhara,
Kushan period
Schist;
h.91 1 cm,
35⁷⁸ in. British
Museum,
London

50 Left
Reliquary
showing a
Buddha flanked
by two
bodhisattvas,
Bimaran,
c.60 AD. Gold
with garnets;
h.7 cm, 2³⁴ in.
British
Museum,
London

51 Right
Atlas,
Gandhara,
2nd century AD.
Schist. British
Museum,
London

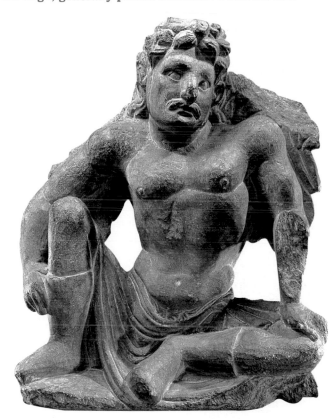

The prevalence of the Hellenized model, which takes its name
from the province of Gandhara in Pakistan where it was first
identified, has been somewhat overstated. A wide range of styl-
istic variation exists, and some Buddha figures seem to derive
from the rigid, almost stern, frontal imagery seen at Syrian
sites like Hatra and Palmyra. Recent excavations in the
Gandharan region increasingly suggest that individual monas-
teries sponsored different groups of artists. The final story of
Gandharan art is likely to emerge only through concentrating
on developments at individual sites.

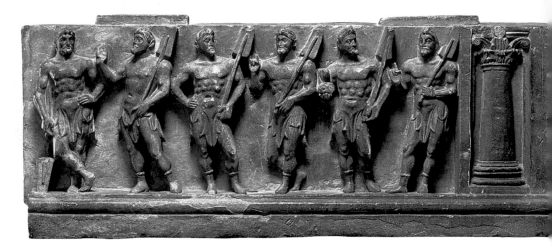

Narrative reliefs that tell the legend of the Buddha incorporated
numerous features of Western origin, such as Greek and Persian
clothing and drapery, figures of cupids and atlantes, and deco-
rative features like swags and cornucopias. Rarely does one
mistake this art for anything but an Asian product; however,
certain images like Atlas figures (51), or rows of marine deities
(52), when isolated from their Buddhist context, could well be
placed anywhere in the Hellenized East.

To understand the origins of this eclectic art, we must return to
the legacy of Alexander the Great and to the Seleucid empire
which embraced the eastern provinces of Alexander's empire.
Bactria was an important Seleucid province until around 250
BC when it broke away to establish itself as an independent

kingdom under its Greek governor Diodotus. Excavations at such Bactrian cities as Ai Khanum and Surkh Kotal reveal Greek colonnades, Corinthian capitals, sculptures and inscriptions. Although situated on the very fringes of the Hellenistic world, it is clear that Bactria continued to nurture Greek cultural ideals.

The story of Gandharan art now moves to the Kushans, originally a nomadic tribe known as Yueh-chi from the southern Chinese province of Kansu, who in the course of their wanderings across Central Asia captured Bactria around 130 BC. With no monumental artistic heritage of their own, this tribal group

52 Left
Marine deities, Gandhara, 2nd–3rd century. Steatite; 16·5 × 43·2 cm, 6½ × 17 in. British Museum, London

53 Above
Corinthian capital featuring seated Buddha, Gandhara, 2nd–3rd century. Schist; 10·8 × 42 cm, 4¼ × 16½ in. British Museum, London

adopted the lingering Greek traditions of Bactria and sponsored their continuance. As their power and territorial ambitions expanded, they adopted the name Kushan and marched into northwestern India as conquerors. Upon encountering Buddhism, the Kushans adopted it and began to build monasteries and stupas. There being no established artistic legacy in the northwest frontier regions that could provide them with a model, the Kushans turned to the Bactrian Greek tradition they had promoted. Capitals with an Asian version of Corinthian columns appeared in structures built under their patronage (53). Called upon to produce an image of the Buddha, Bactrian craftsmen drew upon their own resources and came up with a recognizably Hellenized, beautiful image of the Enlightened One. But Bactrian craftsmen alone cannot account for the vibrancy of Gandharan art or its continued vitality over some

three centuries. We must infer that occasionally the Kushan emperors (and the Sassanid rulers after them) imported craftsmen from the eastern provinces of the Hellenistic empire, and possibly also from Persia. In some such complex manner did this extraordinary school of art come into being and flourish in the cosmopolitan atmosphere fostered by the Kushan emperors.

These emperors indeed had an eye for the beautiful, and were connoisseurs of art. They took advantage of their location at the crossroads of Asia and acquired *objets d'art* traded along the Central Asian silk route. Excavations at their palace in Begram have unearthed treasures that appear to have been hurriedly buried in anticipation of the assault of Sassanian monarch Shapur I around 242 AD. These include Roman painted glass goblets (55), a bronze mask of Silenus and a weight shaped as

54–56
Objects from the Begram Hoard, buried *c.*241. Musée Guimet, Paris
Left
Weight as a bust of Athena. 1st century. Bronze; h.11 cm, 4 ³⁄₈ in
Right
Roman goblet featuring the Rape of Europa. Painted glass; h.15 cm, 6 in
Far right
Indian plaque. Ivory; h.19·6 cm, 7 ³⁄₄ in

Athena from the Mediterranean (54), items of Chinese lacquer, and ivories of Indian manufacture (56).

Emperor Kanishka entered Buddhist legend as an exemplary Buddhist devotee, second only to Ashoka. He built a towering stupa that was one of the wonders of the Buddhist world. Reports of Chinese Buddhist pilgrims indicate that it rose over 90 m (295 ft; some reports speak of 210 m or 690 ft), that its numerous storeys were built of wood, and that it had a gilded copper mast and a set of thirteen copper umbrellas. Only its massive cruciform foundations, some 87 m (286 ft) across, remain today at Shahji-ki-Dheri, but miniature stone models of the Kanishka stupa, created as souvenirs for visiting pilgrims, convey an idea of its erstwhile splendour.

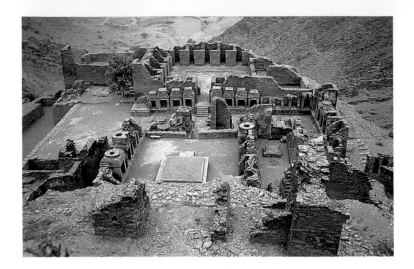

Gandharan architects moved away from the stupa of large
circumference, surrounded by a railing, such as those seen at
Sanchi and Amaravati; their emphasis instead was on vertical-
ity. Stupas consisted of a series of tall, square bases upon which
rested a small circular dome. Railings were eliminated and the
stupa was situated within a rectangular courtyard enclosed by
a row of shrines (57) containing Buddha images, mostly clad in
monastic robes (49), but also portrayed as a prince before
departure from the palace. Such images of the Buddha-to-be
were known as bodhisattva (literally 'essence of enlighten-
ment'). The bodhisattva was visualized as a handsome figure
sporting a twirled moustache, clad in an elaborate turban, rich
jewellery and elegant clothes (58). The multiple image shrines
seem indicative of the lessening dominance of relics and the
increasing attraction of the human image of the Buddha.

Yet, the bodily relics of the Buddha, placed within a relic
casket, were indeed the *raison d'être* for the creation of the
stupa. The Bimaran gold reliquary, cylindrical in shape and
inset with garnets, was contained within a globular stone
casket inscribed with the donor's name and specifying that the
relics were those of the Master himself. Using a single sheet of
gold and working with the repoussé technique, the artist
portrayed two standing images of the Buddha, flanked by

57
Monastery at
Takht-i-bahi,
Gandhara,
2nd–4th
century

58
Prince
Siddhartha as
bodhisattva,
Gandhara,
1st–2nd
century. Schist.
Musée Guimet,
Paris

divine worshippers, and separated by two devotees (50). The date of the gold reliquary is much disputed but it seems likely to have been produced *c*.60 AD.

Narrative relief panels relating the legend of the Buddha were placed along the base of the main stupa of a monastery, and occasionally around votive stupas erected within the monastic compound. With the introduction of the human image, sculptors began to portray events previously ignored when emblems alone indicated the Buddha's presence. Legends surrounding the youth of Siddhartha were introduced. Events depicted by earlier schools now acquired added impact; graphic portrayals of the birth and passing away of the Buddha became possible.

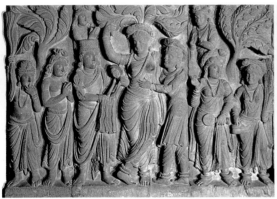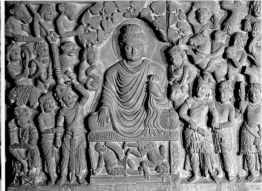

A clear narrative programme seems to have been laid down by monastic authorities. The entire life story of the Buddha was abbreviated or expanded according to the size of its stupa. The essential sequence concerned the four main events in the Buddha's life that are often referred to as the Four Great Miracles (59–62). In the miracle of the birth, Gandharan artists portrayed the infant Buddha, complete with halo, emerging from the right hip of his mother Maya as she stood beneath a tree. The gods, headed by Indra, receive him with swaddling clothes. Hellenic or Greco-Roman features include the wreaths around the heads of the women, their long-sleeved blouses and gown-like garments, and the cornucopia that they frequently

hold. It is intriguing to find that to create their images of queen Maya, artists seem to have drawn on the established repertoire of women and *yakshi*s standing beneath trees. In the miracle of the enlightenment, the Buddha sits beneath a pipal tree in meditation. Mara, the evil one, stands in the foreground about to draw his sword, as his fearsome demon armies attack the Buddha from all sides with a variety of weapons. But the Buddha remains unhurt, serene and unperturbed. Mara is often portrayed a second time, seated in the left foreground in a pose of obvious resignation. The miracle of the first sermon shows the Buddha preaching to monks and lay people, with deer depicted against his seat to identify the location. The compositional similarity to the yogi seals of the Indus civilization (19)

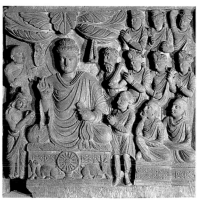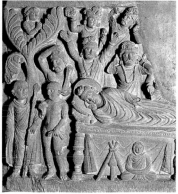

59–62
The Four
Great Miracles,
Gandhara, 2nd
century. Schist;
67 × 290 cm,
26³⁄₈ × 114¹⁄₈ in
Freer Gallery
of Art,
Washington,
DC

gives pause for thought. In the final miracle of the passing away of the Buddha, the local Malla chieftains are unrestrained in their display of grief, while the monks are calm and reconciled. In Buddhist terminology, this event is invariably referred to as the *mahaparinirvana*, or Great Passing Away, nirvana being the term used for the hereafter where there is no future birth.

To create an extended sequence of the life story to adorn a stone stupa at a monastery at Sikri, artists added a further thirteen stories to the four miracles. The first was the legend of Dipankara Buddha, who had appeared on earth in the distant past and in whose time Siddhartha was a brahmin named

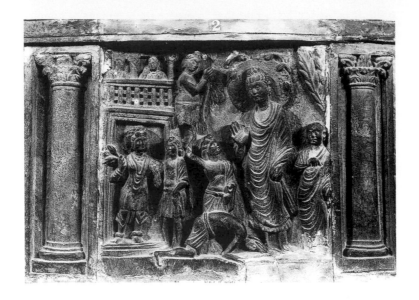

Sumedha who was blessed to achieve future Buddhahood (63). The right half of the panel portrays the enlarged figure of Dipankara, before whom young Sumedha is presented four times. Sumedha buys lotuses from a woman and throws them in adoration at the Buddha (they remain suspended around his halo); he kneels to spread out his long hair across a muddy patch that Dipankara had to cross and rises up into the air upon receiving Dipankara's blessing. All four images of Sumedha refer to the single image of Dipankara. Rejecting the mode of continuous narration, in which Dipankara too would have been portrayed four times, the artist made use of 'conflated' narrative. Besides being economical of space, this manner of presentation emphasized the importance of the figure to whom reference is repeatedly made. Conflation was also seen in the enlightenment panel where two images of Mara referred to the single figure of the meditating Buddha.

As the Buddha image gained in popularity, narrative reliefs increasingly gave way to epiphanic presentation in which the figure of the Buddha is enlarged beyond all proportion to the other players in the story. In the legend of god Indra visiting the Buddha in his cave in a hillside with rocks and mountain goats,

63
Sumedha and
Dipankara
Buddha,
2nd–3rd
century. Schist;
33 × 38 cm,
13 × 15 in.
Lahore
Museum

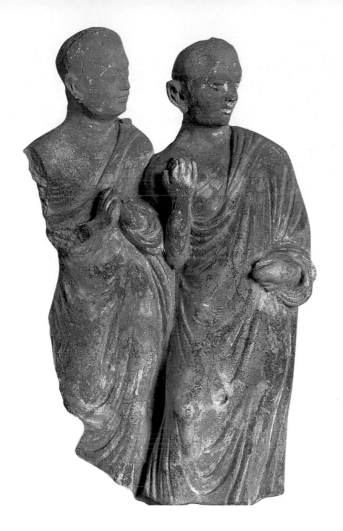

64
Monks,
Hadda,
3rd–4th
century.
Stucco;
h.25.5 cm,
10 in.
Musée Guimet,
Paris

Indra is reduced to about one-sixth of the size of the Buddha. Occasionally, the enlarged free-standing Buddha image takes over totally from the narrative. It is only by focusing upon the knee-high ascetics that we identify the legend of the Kasyapa brothers narrated earlier, in loving detail, on two faces of a Sanchi pillar.

Artists working in Afghanistan and beyond seem to have preferred the use of stucco whose pliability allowed great freedom in modelling. To create large stucco figures, artists used a sandstone substratum or an armature of wood, rope and plaited straw over which they laid the stucco. Moulds were used for faces. Expressive figures of monks and attendants surrounding

monumental images of the Buddha indicate the fluent articulation of stucco modelling (64).

The dating of Gandharan art is a vexed problem. Dated images are few, and scholars have variously applied those dates to the Old Saka era (122 BC) and the eras of Kanishka I (78 AD) and Kanishka II (177 AD). In addition, there is the theory of 'the dropped 100s', similar to the current usage of '97' to indicate the year 1997. However, it may be said with certainty that Hellenistic imagery became prominent during the first century AD, and that some of the finest Gandharan images belong to the second and third centuries. It is evident too that the art continued to be created after the end of Kushan rule in the mid-third century, when the Sassanids took over the western portions of the Kushan domains, often reissuing late Kushan coins counterstruck with their own devices. The production of Gandharan art came to an abrupt end with the catastrophic invasions of the Ephtalite or White Huns around the turn of the fifth century.

Meanwhile, in the Kushan winter capital of Mathura, sculptors responded differently to the challenge of producing a human image of the Buddha (65). Using local red sandstone, sculptors produced an image with a smiling face, eyes that look directly at the viewer and an *ushnisha* barely disguised by the long hair wound around it. The monastic robe leaves one shoulder bare and its translucency reveals a full, robust body beneath – possibly modelled on the earlier, perhaps Mauryan, sturdy images of *chauri* bearers, sometimes called *yaksha*s or male fertility spirits. That Mathura-style Buddha images were in place by 80 AD is confirmed by a full-bodied, over life-sized image dedicated in the second year of Kanishka's reign for worship in a monastery at Kausambi.

When European pioneers in the study of Indian art first discovered the art of Gandhara, they admiringly described its Buddhas as the finest images ever produced by Indian craftsmen. With the rise of nationalistic feeling, the pendulum swung to the other extreme. Acclaiming the power of Mathura

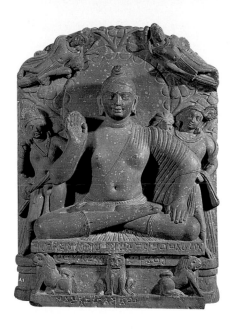

65
Buddha,
Mathura, 2nd
century. Red
sandstone;
h.69 cm,
27 ¹⁄₈ in.
Mathura
Museum

Buddhas, scholars labelled Gandharan Buddhas as imitations of an imitation, and condemned Gandharan reliefs as hybrids. Neither judgement is fair. Owing to the prolific creation of sculpture in Gandhara, quality lost out to quantity. The finest Gandharan sculptures are some of the best images ever produced; its poorer creations are indeed stiff and ill-crafted. Accompanying these arguments was a heated debate regarding primacy in the origin of the Buddha image. European scholars like Alfred Foucher claimed that it was first created by artists trained in the Hellenistic tradition; not unexpectedly, scholars from the subcontinent such as Ananda Coomaraswamy rejected the authority of Gandharan imagery and claimed primacy for the Mathura Buddha. It seems more historically accurate that artists in the two areas, as well as others, responding to the needs of Buddhist worship, came up with dissimilar solutions. Gandhara and Mathura appear to have evolved the Buddha image independently and simultaneously; their styles are so different that it is impossible to derive the one from the other.

The monasteries of Mathura retained the earlier tradition of stupas surrounded by railings, seen at Sanchi and Amaravati.

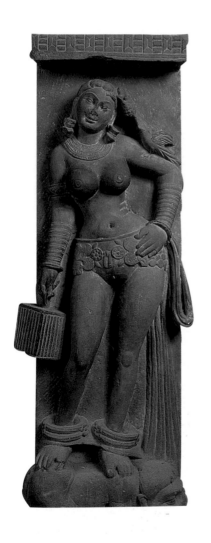
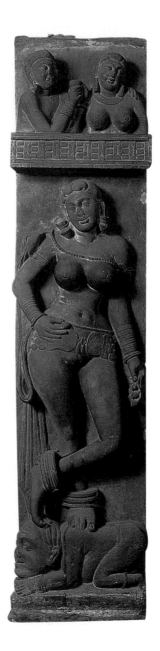

66 Left
Pillars from a
Buddhist stupa
railing, Kankali
Tila, Mathura,
2nd–3rd
century. Red
sandstone;
each h.127 cm,
50 in
India Museum,
Calcutta

67 Right
Portrait statue
of emperor
Kanishka,
Mathura, 2nd
century. Red
sandstone;
h.163 cm,
64¹⁄₈ in.
Mathura
Museum

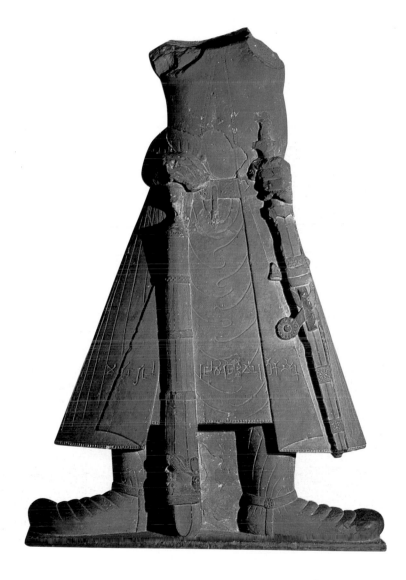

None of the Kushan Mathura stupas survives intact, but excavations have yielded substantial segments of stone railings in which pillars are carved with sensuous female images of great vivacity and vigour (66). Despite the introduction of free-standing sculpted images of the Buddha, it would appear that Mathura continued to give pride of place to the relic stupa; it also acknowledged the auspicious character of female imagery.

The Kushan rulers set up royal galleries to display their portrait statues both in the plains of Mathura and at Surkh Kotal in the Bactrian highlands. Never before, and never after, did any ruling dynasty of India commemorate itself in quite this manner. Presumably, these Kushan portrait shrines were prompted by a desire to legitimize their ancestry and validate their right to royal command. The impressive red sandstone image of Kanishka from Mathura (67) stands erect in stiff, woollen mantle and padded boots, a dress typical of the original northern homeland of the Kushans but totally unsuited to the heat of Mathura. An impression of authority and power is conveyed by the hieratic rigidity of the form and its eccentric silhouette. While the head is missing, the resemblance to the coin portraits of Kanishka is so close that one can easily imagine the addition of the bearded head with its pointed cap (68).

68
Kushan coin portraying emperor Kanishka, minted c.78–101 AD. Gold; w. 2cm, ³⁄₄ in. British Museum, London

Once the Buddha image had been introduced under Kushan patronage, there was no looking back. Its dominance was emphatically confirmed during the Gupta period (c.320–647). This was a time when Sanskrit poetry and drama reached unparalleled heights; the poet Kalidasa wrote his famous plays and lyrical poems, and Bana wrote sophisticated prose. The Hindu religious literature of the *Purana*s, the basis for modern Hinduism, was compiled. Mathematics and astronomy reached a level of pre-eminence. Indians had a clear concept of abstraction and invented the zero. 'Arabic' numerals were initially developed in India and were then taken up widely due to Arab dissemination. Arabs themselves labelled mathematics *hindisat* or 'the Indian (art)'. By 499 the astronomer Aryabhata had

calculated the length of the solar year at 365·3586805 days. Although Gupta India was not ready to accept his ideas, he had posited that the earth was a sphere that rotated on its own axis, and that the lunar eclipse was caused by the shadow of the earth falling on the moon. This was also the period of maritime expansion into Southeast Asia. Sailing out in search of fortune, Indian traders discovered towns and islands, which they named 'Market of Cardomom', 'Island of Camphor' and 'Island of Gold', where they settled, marrying into the families of local chieftains and establishing themselves as the élite class. Sanskrit inscriptions of this period, found in ancient Champa (South Vietnam), Funan (Cambodia), Borneo (Indonesia), Thailand and Malaysia, testify to the status that the Indians achieved in the countries of their adoption.

Under Gupta patronage, artists selected and combined elements from the Gandharan and Mathuran images of the Kushan period to create a quintessential Buddha image. From Gandhara, they adopted the monastic robe that covers both shoulders of the Buddha; from Kushan Mathura they borrowed the full-bodied form of the Buddha. The face of the Gupta Buddha is unique and inspiring; downward-looking eyes create an effect of spiritual preoccupation, and snail-shell curls cover the entire head including the *ushnisha*. Two major workshops of Buddhist art existed in the Gupta empire. At Mathura, which had been active during Kushan rule, sculptors continued to work in the local red sandstone, and one of their earliest surviving Buddhas was dedicated in 432. Here the classical heavy folds of the Gandharan monastic robe were reduced to a looped network of strings beneath which the sensuous body of the Buddha was visible (69). At Sarnath, further to the east, sculptors worked with tan sandstone from the same Chunar quarry that had supplied emperor Ashoka Maurya's columns. Here the strings were eliminated to create a totally smooth robe. A masterpiece of the Sarnath workshop is a high relief image of the Buddha preaching the first sermon (70). Seated in the yogic posture of meditation, the Buddha makes the two-

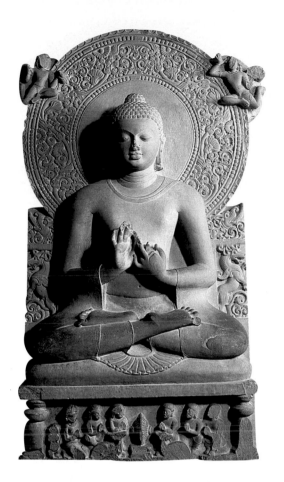

69 Left
Gupta Buddha,
Mathura,
440–55. Red
sandstone;
h.216 cm, 85 in.
National
Museum,
New Delhi

70 Right
Buddha
Preaching the
First Sermon,
Sarnath,
c.465–85. Tan
sandstone;
h.160 cm, 63 in.
Archaeological
Museum,
Sarnath

handed preaching gesture. The sermon's setting in the deer park is indicated by the deer against the pedestal. The awesome dignity and stability of the form are combined with a fluency and sophistication of modelling. With the dominance of the Buddha image firmly established, the stupa receded in prominence and the focus of Buddhist devotions became a temple that enshrined a statue of the Buddha.

The final flourish of Buddhist art on the subcontinent is seen in the many monasteries created in eastern India under the Pala and Sena kings (eighth to twelfth centuries), where early stone images reveal their clear debt to the Gupta model. Here, as part of the transfiguring radiance of a divine being, images of a crowned Buddha (71) were created, thereby returning to the

Buddha the crown he had renounced as prince Siddhartha. Monks and pilgrims from Nepal, Tibet, Southeast Asia and China visited the eastern monastic universities and admired their images. Ultimately, with Muslim destruction of monasteries and temples – the University of Nalanda, for instance, was burnt in 1199 – Buddhists fled to neighbouring countries, and the faith all but died out in India. In Nepal and Tibet, the Gupta image, and its Pala successor, inspired images of exquisite and sensuous workmanship. One such, belonging to fourteenth-century Tibet, is a gilded copper image of seated Maitreya, the Buddha of the Future, with his attribute, the water vessel, atop the lotus attached to his left arm (72).

The Gupta Buddha was a source of inspiration for the Buddhist world. Chinese pilgrims to India, such as the famed Xuanzang (travels 603–64), carried back to their homeland portable Gupta Buddhas of bronze. More importantly, the Gupta Buddha served as the prototype for Buddhist images in Sri Lanka, Burma, Thailand, Cambodia, Vietnam and Java. Each region took the Gupta ideal and developed it along its own lines. It is this ideal that we shall encounter in the cave monasteries of India.

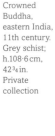

71
Crowned
Buddha,
eastern India,
11th century.
Grey schist;
h.108·6 cm,
42³⁄₄ in.
Private
collection

72
Maitreya or the
Buddha of the
Future, Tibet,
13th–14th
century.
Gilt copper;
h.24 cm, 9¹⁄₂ in.
Brooklyn
Museum,
New York

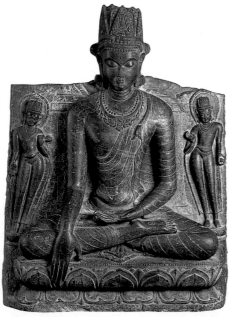

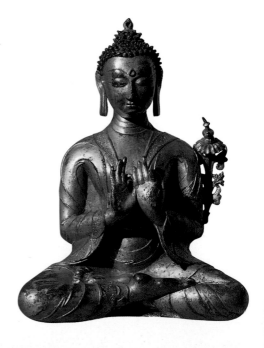

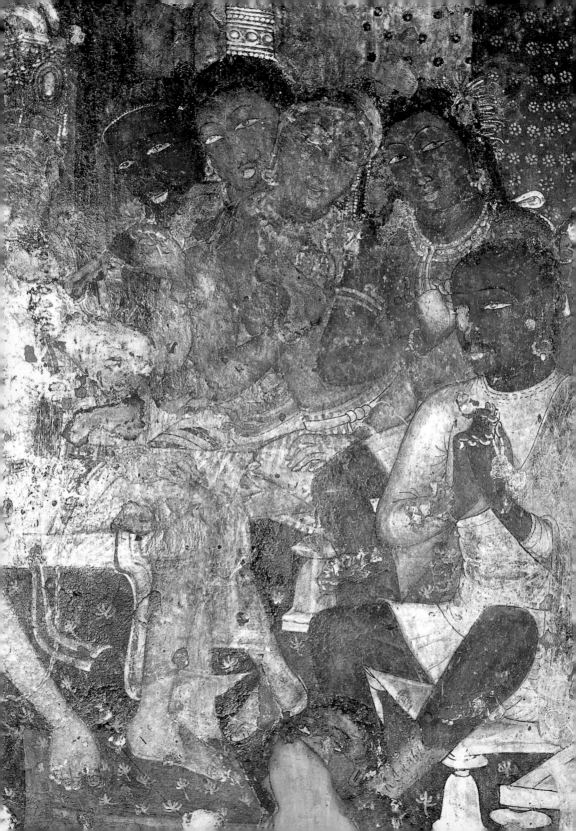

The word cave evokes a picture of a natural mountain recess of no particular artistic significance. But when we speak of the cave monasteries of India, or its cave temples, we refer to artificial monuments of considerable grandeur created by hewing into the mountainside. Decorated with sculptures and adorned with paintings, these remarkable caves were intended as religious centres. Rock-cutting started on a modest scale around 260 BC. It seems to have been taken up enthusiastically by the Buddhists by 100 BC, to be followed about 600 years later by the Hindus. For a millennium, rock-cutting continued to be a favoured mode of artistic expression.

73
A scene from one of the Buddha's previous lives, as told in the *Hamsa Jataka*, Cave 17, Ajanta, c.462–500

The answer to 'Why caves?' is not easy to find. Perhaps the fact that ascetics in India have always retreated to caves, and that the Buddha himself meditated in one after his noonday meal, may have been sufficient to induce renunciants to seek the cave as an ideal place in which to practise their austerities and meditation. The climatic advantages are considerable; a cave remains cool in the hot summer months and dry during the torrential monsoon rains. In addition, there is the durability of a shelter that is part of an entire mountainside. A donor of a Buddhist monastic cave addresses this issue when he speaks of having created a structure that will last a *kalpa*, or a cosmic era. A combination of these factors perhaps led to the enormous popularity of cave monasteries and temples in India. Buddhist caves were also constructed in China and Central Asia. Elsewhere in the world, excavating into a mountainside had lesser impact; while the rock-cut city of Petra in Jordan is indeed striking, it was a single experiment not repeated.

The first caves were cut into the granite hills of Barabar in eastern India, in the vicinity of the Mauryan capital of Pataliputra,

and their interiors display the fine polish observed on Ashokan columns. Each of two *chaitya*s or chapels consists of dual units – an inner circular chamber to accommodate a stupa and an outer rectangular hall in which a few devotees could assemble (74). These caves were cut parallel to the rock face and their makers carried over many techniques from wooden buildings. The decorated entrance of the Lomasa Rishi cave provides several clues pointing to its imitation in granite of a wood and thatched hut (77). Doorjambs display an inward slope that is meaningless in stone, but would have contributed to the stability of a wooden structure. The carved stone arch and its finial seem to imitate bent bamboo arches that would have been tied together and covered with a pottery finial. The large wooden

74–76
Plans of early *chaitya* halls
Far left
Lomasa Rishi cave, Barabar hills, *c*.260 BC
Centre left
Kondivte cave, Bombay, *c*.150 BC
Left
Bhaja cave, Western Ghats, *c*.100 BC

77 Right
Façade of the Lomasa Rishi cave, Barabar Hills, *c*.260 BC

78 Far right
Entrance to the *chaitya* hall, Bhaja, *c*.100 BC

screws used to join arch and doorjamb in a wooden structure are duplicated in granite, with the screw thread clearly carved. Raffia matting used to fill in the archway was also copied in stone. In the interior, the roof of the circular chamber projects beyond its walls just as may be seen to this day in the thatched-roof huts of the region; and the circular stone walls in the adjoining Sudama *chaitya* reveal vertical striations suggestive of the appearance of wooden planking.

As missionary zeal impelled the Buddhist monks to travel along the transcontinental highway, the centre of activity shifted to the hilly ranges that run along the coast of western India. Early

experimental caves cut into rock known as Deccan trap indicate that rock cutters were soon excavating their caves perpendicular to the rock face (75). The visitor entering the cave would then face the inner circular chamber, and light would enter to illuminate the solid rock-cut stupa enshrined within. Soon

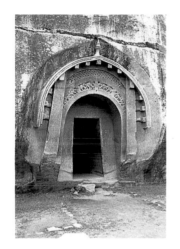

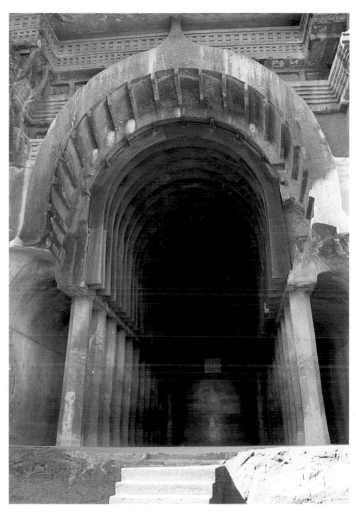

thereafter, rock cutters decided that the walls of the circular chamber were superfluous; they retained its shape but removed its walls to create an apsidal plan (76). Finally, columns were added to demarcate a path for the ritual *pradakshina* walk around the stupa. The resulting interior consisted of a broad, central nave housing a rock-cut stupa in its apse, and two

narrow aisles. The visitor entering the cave has visual access to the stupa; on taking the *pradakshina* path, the view of the stupa is deferred only to be revealed again later. This archetypal Buddhist plan remained the pattern for the next millennium.

The first example of such a Buddhist *chaitya* in Deccan trap was achieved around 100 BC at the cave monastery of Bhaja, 170 km (105 miles) south of Bombay (78). The apsidal cave extends 18 m (60 ft) into the mountainside, and its set of plain octagonal columns slope 12 cm (5 in) inwards in imitation of a wooden original. Its barrel-vaulted ceiling rises some 9 m (29 ft) from the ground and retains most of the original wooden ribs added by the rock cutters over 2,000 years ago. High above the arched entrance doorway, rock cutters created a larger arch to serve as a 'window'. The inner surface of this second arch carries a stone representation of beams that would have supported the ceiling in a wooden structure, while the arch itself was originally filled in with a wooden screen to filter the strong Indian sunlight. The present open frontage of the cave is deceptive; originally, it was enclosed by a substantial wooden façade as indicated by a regular series of pinholes in the front of the window arch. These wooden additions are a reminder of the continuing tradition of building in perishable media, which we can assess only through examples translated into stone. The façade on either side of the Bhaja *chaitya*, which is carved in imitation of a many-storeyed building with balconies and windows, including sculpted men and women who survey the scene below, gives an indication of the appearance of ancient Indian mansions.

79
Plans of early
*vihara*s
Right Bhaja
Far right
Nasik, Vihara 3

Flanking the *chaitya* hall is a group of *vihara*s or residential halls for the monks. A standard *vihara* has a small pillared veranda leading into a hall from which doorways open into a set of simple cells to house individual monks (79). Each cell contains a raised rock-cut bed with a rock-cut pillow, while a niche in the wall serves to house an oil lamp. *Vihara*s housed anywhere from six to twenty-four monks who probably used the central hall for discussions and debates.

The *chaitya* hall at the Karle monastery, cut 150 years after Bhaja and belonging to *c.*50–75 AD, reveals an enlargement of the apsidal plan, with a magnificently embellished veranda cut in the Deccan trap that opens into an expansive courtyard (80). Life-sized stone elephants occupy the side walls of the veranda and effortlessly support the multi-storeyed façade that rises above them. Six sets of over life-sized images of loving couples, known as *mithuna*s, adorn the front wall of the veranda, while

80
Veranda of the
chaitya hall,
Karle,
*c.*50–75 AD

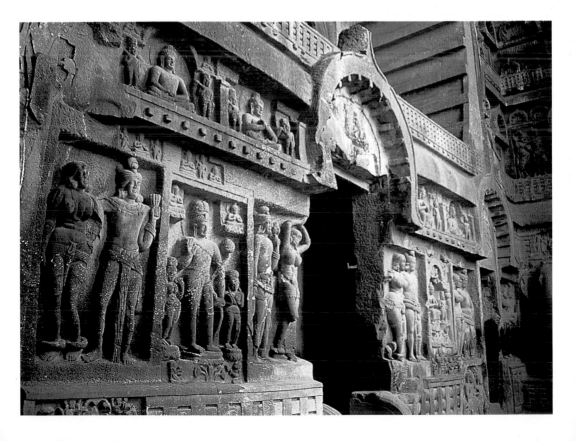

two more occupy its facing wall. Men stand relaxed, with one arm around the shoulder of their partners who are carved with high, rounded breasts, narrow waist and broad hips. The markedly sensuous nature of the carving is somewhat surprising in a Buddhist monastic setting. It represents an acknowledgement of the widespread veneration of fertility that was already in evidence in the sculpted bracket figures adorning the gateways of the Sanchi stupa (40). Here again we have an adaptation of early artistic precedents to serve Buddhist objectives, resulting in a markedly idiosyncratic Indian 'Buddhist' art when compared with the austere Buddhist art seen in, for example, Thailand or China. (The Buddha images between the couples are intrusions, added c.400 years later when such images became the norm.) The interior of the Karle *chaitya* extends deep into the mountainside, and a row of pillars with capitals portraying animated rider couples seated on animals leads the eye towards a rock-cut stupa looming at the far end. As at Bhaja, the barrel-vaulted roof contains remnants of original wooden ribs, and the original wooden parasol still stands above the stupa.

These extraordinary cave monasteries are usually described as rock-cut architecture; however, they are more akin to sculpture on a gigantic scale. No architectural principles are at work in the interior of a Buddhist *chaitya*. The rock cutter did not have to calculate the load that the columns would bear and thereby decide on their size and placement. Faced with the sheer cliff of a mountainside, the rock cutters had to remove vast amounts of rock to empty out a targeted area and thereby produce space. The rock cutter planning a *chaitya* doubtless executed an outline on the rock face to enable his workers to start burrowing wherever doors and windows were located. Detailed plans would have alerted the workers to the number of blocks to be left intact for conversion into columns, while the accurate height and alignment of the columns indicate the existence of an efficient system of measurement. As the far end was approached, a massive block of stone had to be left intact for

conversion into a stupa. With the exception of its wooden additions, all of the rock-cut cave, including the sculpted images, is cut from and attached to the mountain itself.

Unfinished caves provide clues to the process of rock-cutting, which started at the level of the ceiling and moved down, thus eliminating the need for scaffolding in the initial stages. The various categories of workers involved in these enterprises included rock cutters who did the preliminary splitting and removal of the rock, masons who executed the more precise cutting, and sculptors and polishers who performed the finer finishing. Several caves with fully sculpted façades, but with interiors abandoned upon discovery of a faulty strata of rock, indicate that all the workers functioned concurrently and in unison. The initial splitting of the rock was probably accomplished by inserting wooden pegs at close intervals along the intended split; when soaked with water the pegs expanded and the rock fractured along the required line. With a system of grids, in which wooden pegs were inserted into the corners of a square, entire blocks could be dislodged. While no ancient tools have been found at these cave sites, we may assume that iron chisels and hammers were used for the finer work.

The many cave monasteries of western India, numbering some twenty major and numerous minor sites, were undoubtedly an expensive undertaking. Inscriptions tell us that these early Buddhist caves, cut between 100 BC and 200 AD, were the result of multiple individual and collective donations from wealthy traders, merchant financiers and guilds, as well as from the less wealthy such as gardeners, fishermen, housewives, monks and nuns. As at Sanchi and Amaravati, a powerful motive that impelled so varied a group of people into such gifting was the desire to collect religious merit, which added to good karma and ensured a felicitous future birth on earth.

The prosperity of India during this period, which enabled merchants and traders to gift freely toward the construction and embellishment of Buddhist monastic establishments, is

explained by the fact that the early centuries BC and AD were the age of mercantile enterprise. It was a time of expanding trade networks to satisfy both internal needs and the increasing demands of Mediterranean markets. Invaluable information on India's sea and land trade comes from a fascinating log book, *The Periplus of the Erythraean Sea*, written by an unknown Greek sailor who voyaged to India in the first century AD. The prime entrepôt of this period was Bharuch on the west coast, where ships from the Mediterranean were met by pilot vessels and steered into individual berths. Bharuch was the destination of caravans that crossed the country along the transcontinental highway, as also along routes from southern India and from northern Bactria via Gandhara. To enable them to sail with the monsoon winds, foreign merchants generally halted at the port for no more than a month and they loaded their ships with a variety of goods brought to the port by Indian traders. There were bulky items like ebony, teak, sandalwood, bamboo and ivory tusks; consumer items like wheat, rice, sesame oil and honey; dyes like indigo and lac; semi-precious stones like agate, jasper, carnelian and onyx; pepper, aromatics and items of medicinal value; and the much-fancied, fine Indian muslin. Prized imports for Indian traders included wine, dates, glass, tin, copper, tortoiseshell and coral. Bharuch clearly had facilities for handling, sorting and storing the various traded goods, and presumably an efficient banking system must have been available at port. A coin economy was well in place at this time with the Satavahana issue of silver and copper versions. The wealth of early India is confirmed by the lament of Roman historian Pliny the Elder in *Historia Naturalis* (*Natural History*), completed in 77 AD, that all of Rome's coffers were being emptied into India to satisfy Roman demand for translucent Indian muslins.

This bustling trade scenario had close connections with the Buddhist cave monasteries. The monks wisely located every one of their monasteries at strategic points along trade routes. Some were at the heads of passes through the mountains;

others were in valleys where caravans could make a convenient halt. All were easy of access to merchants and traders who could be persuaded to visit the monastery and to make donations. Interestingly, inscriptions record that *yavana*s, the Indian term for Greek merchants, though later used loosely for all foreigners, were among those who contributed towards the embellishment of Buddhist cave monasteries. At Karle, for instance, inscriptions record that seven of the interior pillars were gifted by *yavana*s. In turn, Indian *objets d'art* made their way to the Roman world. Among the excavated finds at Pompeii is a small, sensuous ivory figurine of a richly adorned woman, created much in the style of the Karle and Sanchi figures, and

81
Indian figurine buried in the Vesuvius eruption of 79 AD. Ivory; h.25 cm, 9⅞ in. Archaeological Museum, Naples

possibly serving as a mirror handle (81).

The Satavahana rulers gave substantial post-foundation support to these cave monasteries. It mattered little that the monarchs themselves were Hindus, that their inscriptions flaunt their excellence in having fed hundreds of thousands of brahmins or that they prided themselves on preventing the mixing of the castes. Donations to a religious establishment always brought merit regardless of the religious or sectarian affiliation of individual donors. Satavahana support of the Buddhist monasteries, however, was motivated also by their concern for the fortunes of their empire. Regarding the Buddhist monasteries as stable centres that would encourage and promote the flourishing of local agricultural settlements, the Satavahana monarchs provided them with grants of land, endowments of money in perpetuity and even entire villages. Undoubtedly monasteries appointed administrative officials to oversee their many assets. The Buddhist monasteries held a respected and prominent position in Indian society; however, they never played as influential a social role as did the monasteries of medieval England.

Several of the cave monasteries of this early phase continued to be centres of Buddhism in the centuries that followed, consolidating their position and maintaining their support base. But in the middle of the fifth century, for reasons that are not clear, the milieu of patronage underwent a change; royalty took over from the commoners who, for the previous five centuries, had been the main sponsors of Buddhist establishments, both rock-cut and structural. The result of this royal patronage was renewed artistic activity, seen at its grandest at Ajanta where a small monastery was already in existence. The elaborate new monastery was sponsored by ministers, princes and influential officials at the court of the Hindu Vakataka king Harishena (r.c.462–81 AD). These aristocrats, like the earlier Satavahana rulers, saw nothing strange in proclaiming their descent from the Hindu gods in the very same inscription that recorded their

82
Rock cut *chaitya* halls and *vihara*s around the gorge at Ajanta, *c.*462–500

donation of a Buddhist cave. One donor described his *vihara* as rivalling the splendour of god Indra's crown; another proclaimed that the money he spent on the creation of his cave was too great for most people even to imagine; a third spoke of his cave as providing all comforts in all seasons. It seems that we have come a long way from the mendicant monks of earlier

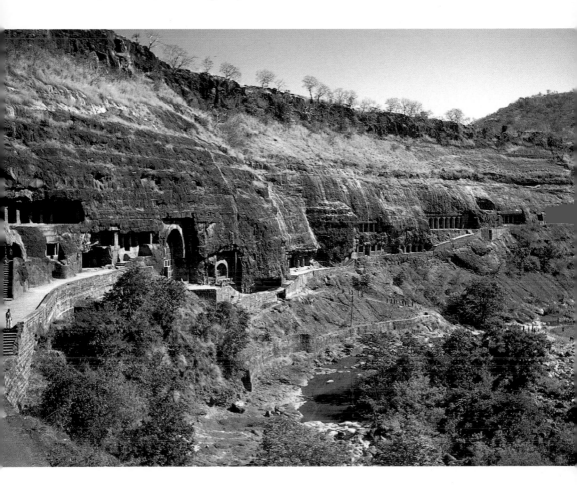

days who were forbidden to handle money; one text records monks now handling money using a piece of cloth as insulation.

A horseshoe-shaped mountain scarp, enclosing a narrow gorge occupied by the Waghora River, was transformed into the elaborate rock-cut monastery of Ajanta, with *chaitya*s and residential caves on both sides of the existing early nucleus (82). *Vihara*s, which had been exclusively residential, now incorpo-

rated a shrine to house an image of the Buddha, which, as we have seen, had by this time become an important part of Buddhist art and ideology (83). The resident monks of each of these large *viharas* thus had their own shrine, located in the rear wall, before which they could practise their daily worship and meditation. Buddhist *chaityas* continued to enshrine the stupa, whose shape had come to be valued in itself for ritual purposes, within the established apsidal, pillared plan; to accommodate current trends, however, artists now gave pride of place to a seated or standing Buddha image against the front of the stupa (84). Ajanta also gave importance to the new group of divine beings known as bodhisattvas who had been added to the evolving Buddhist faith. Such celestial bodhisattvas differed from the earlier use of the term to describe Siddhartha prior to his enlightenment; these were compassionate beings who, though on the threshold of Buddhahood, chose to remain in this world to help others towards salvation.

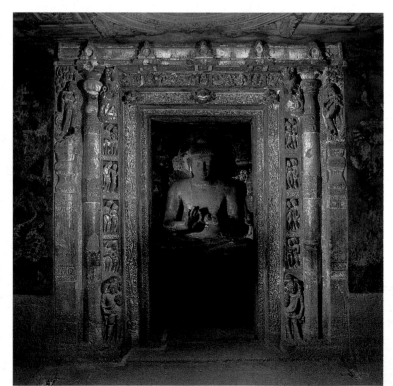

83
The Buddha shrine with decorated walls and ceilings, Cave 2, Ajanta, *c.*462–500

84
Interior of Cave 19, Ajanta, *c.*462–500

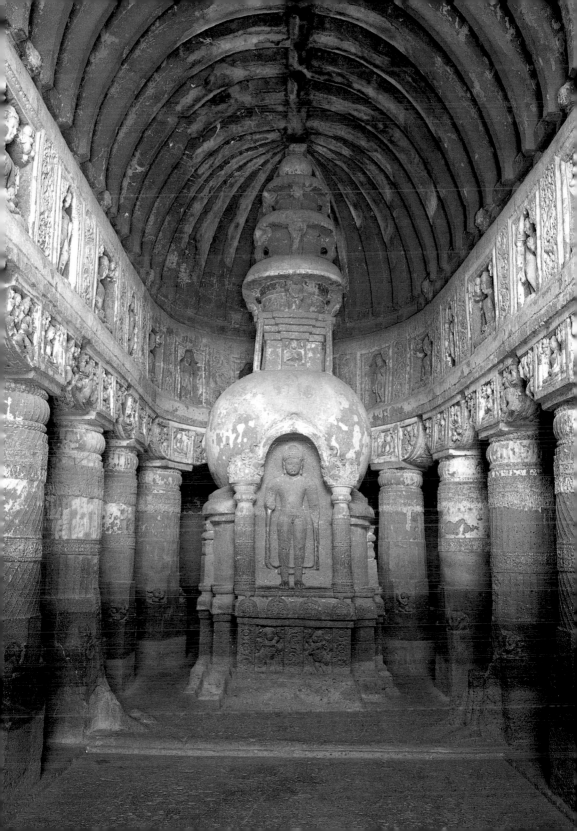

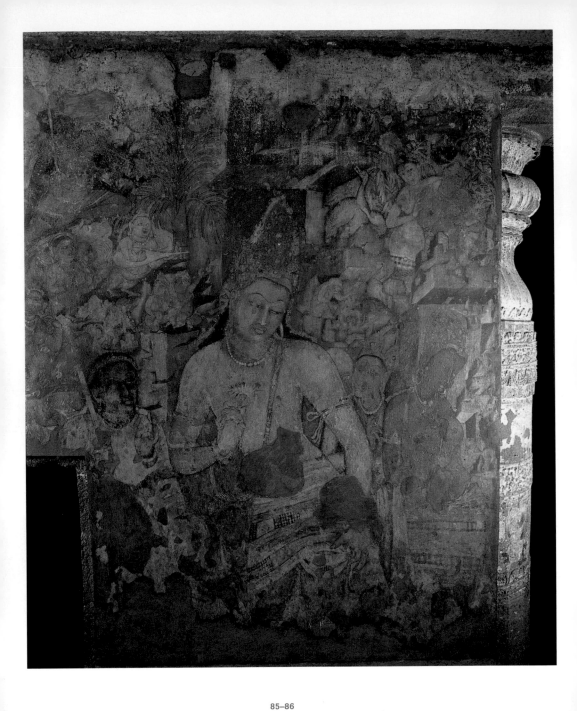

85–86
Bodhisattvas
flanking the
vestibule to the
shrine, Cave 1,
Ajanta,
*c.*462–500

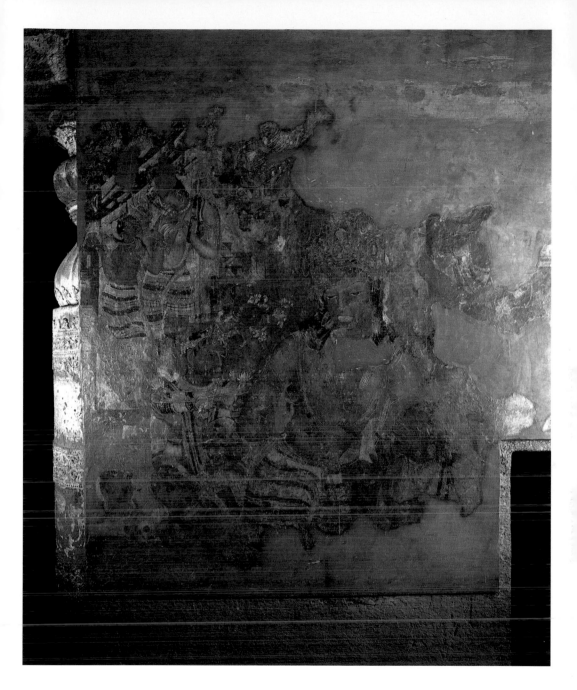

Every wall and ceiling at the Ajanta monastery was covered with lavish painted decoration, made possible by the largesse of the wealthy and influential patrons of the monastery who employed several workshops of painters. Stone walls were left unpolished to provide a suitable base for two layers of mud plaster, which was then overlaid by lime wash. Colours were not added while the lime was still wet, which would have given it the durability of fresco; instead, painters waited for the wash to dry before executing their work, using red paint for outline sketches. Colours were mostly from local minerals: red and yellow ochres, lampblack, white lime and kaolin, and mineral green; only lapis lazuli for blue was imported, coming from Afghanistan. The paintings have suffered considerable water damage since the mural technique, akin to tempera, is water soluble; in addition, insects have attacked the rice husk and other organic matter contained in the mud plaster. Ancient literature contains many references to galleries of paintings and the decoration of palace walls; the murals at Ajanta are the only comprehensive early group of paintings to have survived.

Artists continued the use of multiple perspective that was evident 500 years earlier in the Sanchi narrative reliefs, although there is a growing tendency for foreground figures partially to overlap figures in the background. An increasing use of perspective is evident too in the manner in which build-ings are depicted (88). The picture plane continues to be tilted and viewers must understand that scenes along the top of a wall are, most likely, events occurring in the background. Occasionally, artists made use of hierarchic scaling to empha-size the importance of the Buddha or of bodhisattvas as with the two exquisitely delineated bodhisattvas flanking the vestibule to the shrine in Cave 1 (85, 86) who are painted significantly larger than the many adoring figures of princes, princesses and commoners surrounding them. Shading and highlighting are also evident, but these techniques are used largely to give a sense of three-dimensionality, and do not reflect an actual source of light. Thus, the noses of the

bodhisattvas in Cave 1 are highlighted with white although the scene is not lit from the front.

Murals in Cave 17, a grand *vihara* gifted by a feudatory prince, offer an idea of the nature of the narrative paintings. The entire 14-m (46-ft) span of the cave's left wall, 4·5 m (15 ft) from floor to ceiling, carries the story of prince Vessantara, the last life of the Buddha immediately before his birth as prince Siddhartha. The story of Vessantara, whose charity became a byword in the Buddhist world, was widely known. The narrative moves from left to right and, despite the inconsistent placement of a few episodes, would be readily recognized by viewers. They could applaud Vessantara's gift of the auspicious state elephant, regret his ensuing banishment and departure, and admire his donation of all remaining possessions – horses, chariot, his children and even his wife. Gazing at the far upper right of the wall, they could rejoice in the happy reunion of the family upon god Indra's intervention.

The opposite wall of Cave 17 carries the story of merchant Simhala, who escapes from a witches' island, is crowned king when his monarch is killed by the pursuing witches and whose army finally triumphs over the witches (87). It follows a scheme quite different from the continuous Vessantara narrative and involves a complex networking in time and space. The Simhala legend commences at lower right, moves upwards, then crosses the upper wall to the extreme left where it meanders down to conclude in the central space. It begins to make sense only to viewers aware of the fact that time is not given prime importance; instead, the mural is organized in terms of geographical space. The right segment represents the island of the witches where Simhala was shipwrecked; the left segment depicts the palace of the king in Simhala's hometown; and the central segment carries all important events that centre around Simhala, wherever they occurred. Several other narratives in the Ajanta caves are also organized by geographic space.

As many as thirty Buddhist stories are painted along the walls

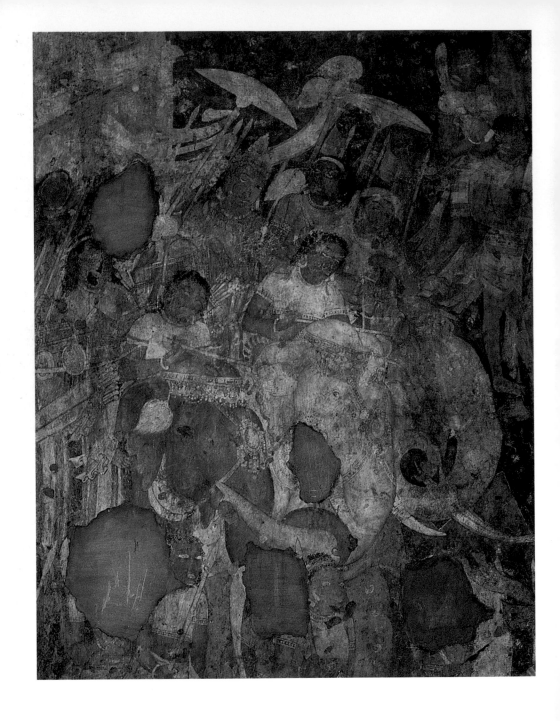

87
A scene from
the *Simhala
Avadana*,
Cave 17, Ajanta,
*c.*462–500

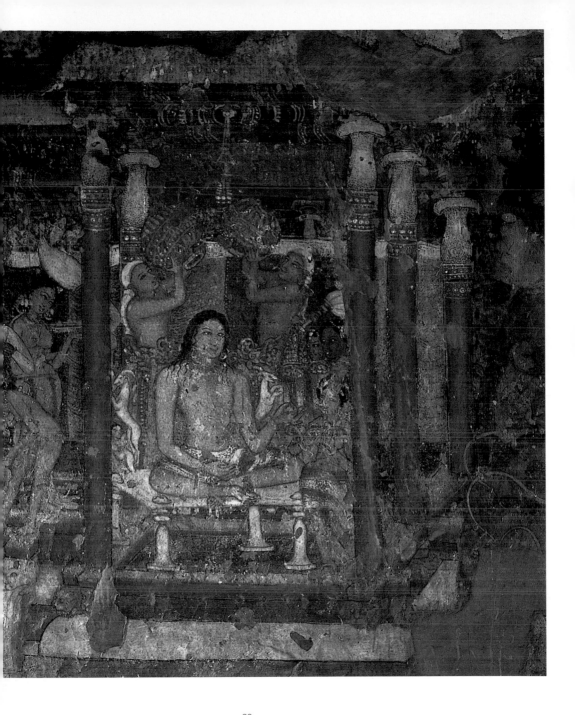

88
Prince
Mahajanaka
bathing, a scene
from the
*Mahajanaka
Jataka*, Cave 1,
Ajanta, *c.*462–500

of Cave 17. Several were compressed into relatively small spaces and told in a more direct fashion. The Buddha's previous life as Syama is narrated in a set of scenes placed directly above each other. His birth as a great fish is presented by a single scene extracted from the middle of the tale; it requires the active participation of viewers, who must supply not only the beginning of the tale but also its completion.

Ajanta's painted murals were presumably intended for a varied audience, which included its patrons, visitors to the site and the resident monks themselves. With the oil lamps then used, it would have been difficult to see more than just one segment of

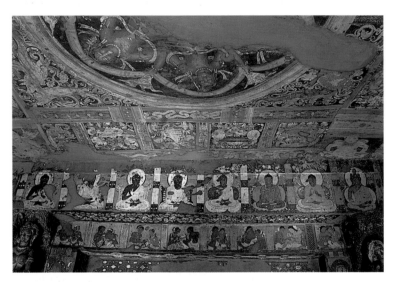

89
Entrance to Cave 17, Ajanta, c.462–500. The differing styles of the two artists who painted the lintel are evident in the floral bands beneath the figures, and in the sizes and colours of the figures themselves

a painting at a time, and visitors would have required the help of a monk to guide them through their visual experience. One wonders whether the paintings were intended for such viewing; perhaps they were created for the monastic residents to focus their meditation upon the Buddhist virtues. Certainly the *Mulasarvastivadin Vinaya*, a text of monastic discipline, while giving instructions for the decoration of monasteries, speaks of paintings for the meditative practices of the monks. In addition, in several contexts it would appear that images were created to enhance or complete the sacred programme of a site; their

viewing may have been of secondary importance.

What do we know about the painters and workshops involved in decorating the twenty-five caves created during this fifth-century phase of patronage? Even within individual caves, more than one workshop seems to have been involved in producing the murals. The workshop that painted the Vessantara story portrayed large figures, concentrating on the main characters of the tale and delighting in using sweeping curves. By contrast, artists of the Simhala story on the opposite wall preferred small figures, filling the space with dozens of subsidiary forms so that viewers have to search even to locate Simhala. The depiction of scarves, fluttering drapery, banners and flags, all ending in a swallowtail shape, is a stylistic idiosyncrasy of this particular workshop. When large murals covering an entire wall were painted, several artists from a workshop appear to have divided the wall among themselves. A strange disregard for conformity is frequently evident in such collaborative work. The painter of the left half of the Vessantara story gave the prince a dhoti with horizontal blue stripes, while the artist of the right half painted Vessantara's garment with red vertical stripes. A similar disregard is apparent in the decoration of Cave 17's entrance doorway. The halves were painted by two artists whose work met at the centre of the lintel. For instance, though each artist knew the type of floral and geometric bands to be painted, the precise size and proportions of individual units of design had not been agreed upon, so that the work of the two artists is quite distinct (89).

Speculation continues about how long it took to cut, carve, plaster and paint the Ajanta monastery. All scholars agree that work began in 462 AD when the Vakataka monarch Harishena came to the throne; early scholars proposed that work continued sporadically over 150 years. However, the research of Walter Spink, who has spent decades studying the site, convincingly indicates that the caves were completed in a brief spurt of intense activity, although his increasingly narrow bracket, with

its reliance on eight-hour days and seven-day weeks, may be difficult to sustain. The murals in particular present even greater problems since apparently the detailed work could not have been executed with oil lamps alone. One would assume that reflectors, perhaps lengths of white cloth, would have been required – but such work would have been impossible during the three months of monsoon rain; even otherwise, the placement of the caves would have permitted the effective use of reflectors for only a couple of hours each day. Unfinished work in several caves, and the pristine condition of murals showing little sign of usage, suggests an abrupt cessation to work at Ajanta that has been connected with the end of the dynastic line upon Harishena's death. However, it may be necessary to extend the working time to a more realistic span of about forty years. Be that as it may, the site appears today as it was left by rock cutters, sculptors and painters, perhaps soon after 500 AD.

Around the time that work ended at Buddhist Ajanta, the Hindus picked up the technique of rock-cut architecture and began to create monuments dedicated to their gods. As opposed to Buddhist sites, Hindu rock-cut sites do not include any residential caves, and we must assume that their priests and ascetics continued to live in brick and wood structures. In Chapter 2, we left the Hindu Vedic faith in a period of spiritual ferment that led the Jina and the Buddha to found new paths. At around the same time, the Hindu faith realized the need for reform and reassessment. A number of profound philosophic systems developed within the Hindu fold including Yoga, a graded path leading through bodily control, to meditation and final salvation. Equally important was the emergence of a path of deep personal devotion to a chosen deity. Two male gods, Shiva and Vishnu, and the great goddess known simply as Devi (meaning goddess), rose to prominence.

The most outstanding of early Hindu caves is located on the small island of Elephanta, an hour's journey by motorized launch from Bombay. The scale and magnificence of the main

cave suggests that it was a royal or aristocratic commission – possibly by Krishnaraja I of the Kalachuri dynasty (r.c.550–75), an ardent Shiva worshipper who had recently captured the region and whose coins have been found on the island. An important finale to any new Hindu imperial conquest was the monarch's construction of a shrine of unparalleled grandeur.

Three great, colonnaded portals permit light to flood into the interior of Elephanta's Cave 1, dedicated to Hindu god Shiva. The pillared cruciform cave, roughly 40 m (131 ft) across, has dual shrines, and its plan (90) reveals a dual focus. Placed off-centre towards the west entrance is a square chamber that enshrines an aniconic *linga*, the emblem of Shiva. Extending from the floor to a 5-m (16-ft) ceiling and with four doorways, each flanked by guardians, the *linga* shrine has been displaced from its central position to enable visitors entering from the north portal to get an undisturbed view of the monumental triple form of Shiva that occupies the end wall. Three giant

90
Plan of Cave 1,
Elephanta,
c.550–75

N

heads of Shiva, emerging from a recess 3·5 m (11 ft) deep and rising 5·5 m (18 ft) above a moulded base itself 1 m (3 ft) high, create a theatrical effect (see 1). Guardian figures, 4 m (13 ft) tall, flank this 'stage', emphasizing its position as a second shrine. Finally, grouped around the cave are eight monumental sculpted tableaux that expand on the legend of Shiva. In a clockwise direction from the north portal we see Shiva seated in yogic posture as the great teacher Lakulisha; trapping demon-king Ravana beneath mount Kailasa; playing dice with his consort Parvati; in his astounding manifestation as Ardhanari or Half-Woman (91); facilitating the descent to earth of the heavenly Ganges (92); celebrating his marriage to the lovely Parvati; in the enraged activity of destroying the demon Andhaka; and dancing a joyous, triumphant dance.

There has been considerable discussion, and conflicting interpretations, regarding the imagery seen in this cave. The evidence strongly indicates a sophisticated Shaiva ideology in which the transcendent gradually moves towards manifestation. The *linga* within the shrine represents the Unmanifest and formless Shiva. The triple-headed figure depicts the Unmanifest-Manifest, known as Sadashiva, in which the formless begins to assume form. Finally, the eight sculpted tableaux portray the Manifest forms that bring the faithful to Shiva.

The triple bust of Unmanifest-Manifest Shiva seems intended to signify his five aspects that are frequently represented as faces against the *linga*; a fourth face at the rear and a fifth at the zenith are implied but not carved. The central impassive face of the monumental icon portrays the essential, serene, inscrutable aspect of the god; this aspect as Sadyojata reflects the fullness of absolute knowledge. Shiva, after all, is the great yogi who sat in meditation for aeons in his Himalayan mountain home known as Kailasa. The left profile, with twisted moustache and angry brow, presents the god in his ferocious aspect known as Aghora; snakes wind themselves in his matted hair that is decorated with skulls, and a snake forms his ear ornament. Shiva is

91–92
Sculpted tableaux, Cave 1, Elephanta, c.550–75. h.c.550 cm, 216½ in.
Right
Ardhanari or Shiva as half female
Far right
The descent of the Ganges

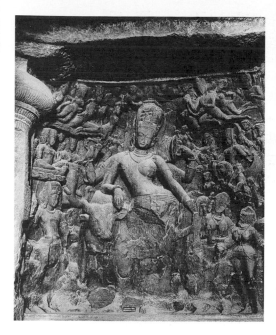
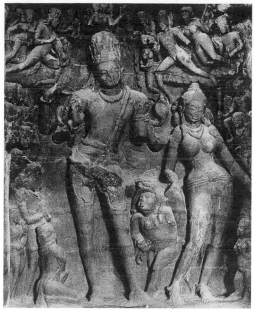

famed for his destructive powers; in enraged wrath, he fights
time (*kala*), death (*yama*), blindness (*andhaka*) and various
other delusive powers of darkness. The right profile, with its
soft curls and full lips, is known as Vamadeva and presents the
dreamy blissful face of goddess Parvati, Shiva's beautiful,
loving spouse from whom he is rarely separated. The sculptor
was a master able to combine the three heads into a homoge-
neous bust to create a unique effigy. While the broad shoulders
seem to belong to the central face, they also meld convincingly
with the other two heads in profile. The two damaged hands
that rest upon the base belong to the central head; two other
hands, one holding a snake and the other a lotus, belong to the
lateral heads.

Does the choice of the various manifest forms of Shiva, and
their placement around the cave, merely reflect Krishnaraja's
personal preference, or is there some deeper underlying
scheme? Quite appropriately, studies of Indian temples are
increasingly seeking out iconographic programmes. Yet the
recent proposal that Elephanta's panels are to be read counter-
clockwise, and that they relate to the esoteric Shaiva sect of the

Pasupatas, is not wholly convincing. It would be best if supporting textual evidence came from a single, in this case Pasupata, source, rather than being culled from a range of texts of different dates.

The panels flanking the triple head serve as good examples of the sculptural conventions and the technique of Elephanta's artists. Occupying the central axis of the left panel is Shiva's manifestation as Ardhanari in which, according to one legend, Shiva and Parvati merge into one to allow worshippers to adore them in their unity as a single form (91). The right half depicts Parvati holding a mirror, and her breast, curvaceous hips and indented waist contrast with the strong, firm contours of the other half in which Shiva rests one of his two arms upon his bull Nandi. The face of the image, framed by an oval nimbus, likewise mirrors the difference. Parvati's jawline is soft compared with the square contours given to Shiva, and her hair is arranged in delicate curls while Shiva's matted locks are piled high on his head. The gods in the heavens, riding their respective vehicles, appear to applaud this amazing manifestation: Brahma, Indra, Vishnu are each sculpted roughly one-quarter the size of Ardhanari. Elephanta's artists made consistent use of this principle of hierarchic scaling, which enabled them to emphasize the supremacy of one deity, here Shiva. The lower portion of this relief, as of most others in the cave, is badly damaged as a result of the artillery practice conducted by the Portuguese military garrison stationed on the island during the sixteenth century.

To the right of the triple head is an iconic representation of the legend of the descent of the Ganges, in which Shiva and Parvati are placed on either side of the panel's central axis (92). According to Hindu mythology the Ganges, originally a heavenly river, agreed to descend to earth as a sequel to the propitiating austerities of Bhagiratha, to ensure the well-being of his ancestors' souls by immersing their cremated ashes in its waters. The panel shows Bhagiratha kneeling at Shiva's feet,

beseeching him to bear the impact of the descent of the Ganges so that the earth should not suffer. Since the Ganges is formed by the merger of three streams, she is shown descending upon Shiva's matted locks as a triple-headed female. As if to affirm the legend that the Ganges was Shiva's second love, the sculptor has positioned Parvati moving away from her lord to express her displeasure. Here too, the use of hierarchic sealing results in the celestials witnessing the event being depicted one-quarter the size of the main figures.

Perhaps the greatest wonder of the rock-cut world is the Kailasa Shiva temple (93) cut some two centuries later into a range of low Deccan trap hills at Ellora, which was also the site of Buddhist and Jain caves. The very nature of caves precludes the possibility of magnificent exteriors; they must restrict themselves to the sculpted and painted decoration of the interior. But the rock cutters of the Kailasa temple found an exceptional strategy to sidestep what one might have considered an inescapable mandate. Excavating into the hillside, they first created a huge trench, 90 × 53 m (295 × 173ft), which they then

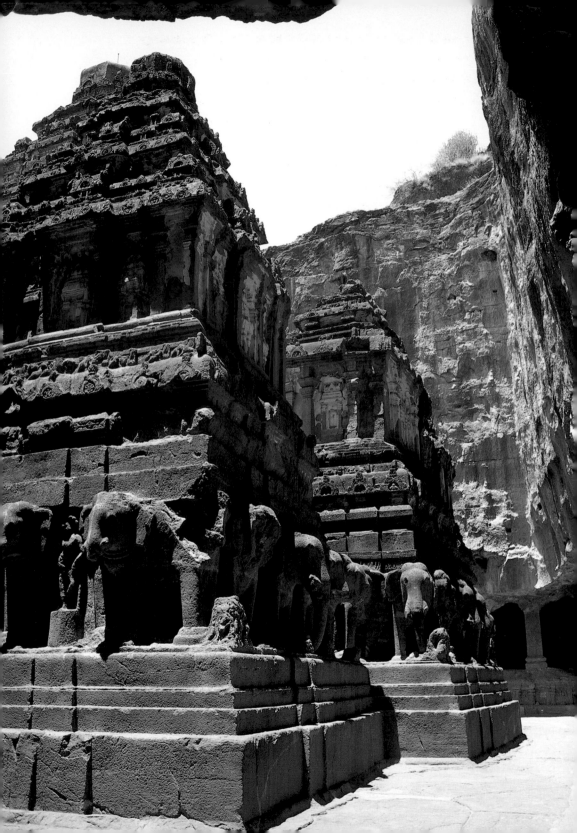

cut down vertically to the base of the low hill. This strategy left standing an isolated 'island' of rock, 60 m long, 30 m wide and 30 m deep (196 × 98 × 98 ft). Commencing work at the top, this mass of rock was transformed into an expansive temple unit intricately adorned on both exterior and interior, while the floor of the courtyard carries free-standing, life-sized rock-cut elephants and two monumental rock-cut columns. The magnitude of the undertaking is perhaps conveyed by the fact that its ground plan is equal to that of the Parthenon in Athens (fifth century BC), while its height is half again that of the Greek masterpiece.

The Kailasa temple was the creation of Krishna I (757–83) of the Rashtrakuta dynasty, who controlled much of the Deccan plateau of south-central India from his capital of Paithan, not far from Ellora. The temple may have been started by his father, but it was Krishna who carried it to its conclusion, believing, like other Hindu rulers, that such an act would constitute the final facet in establishing his overlordship of the earth and his right to use the title of *chakravartin*, or Universal Emperor. The decision to name the temple Kailasa, after god Shiva's mountain home in the Himalayas, is also a revealing gesture. By this act, Krishna I symbolically relocated Mount Kailasa within his domain. The temple was a dramatic statement to the effect that Rashtrakuta territory, in the southern Deccan, was the centre of the earth. The sacred northern rivers, Ganges and Yamuna, carved in stone on the temple walls, guarded the temple and blessed it with their life-giving powers.

The Kailasa consists of three separate units – a gatehouse; a pavilion to house Shiva's vehicle, the bull Nandi; and a cruciform Dravida or southern-style temple comprising a pillared hall opening onto a shrine containing a *linga*. Such a plan was inspired by the Hindu temple that had already come into being and which we shall explore later. The Kailasa gatehouse and Nandi pavilion are flat-roofed structures, 15 m (49 ft) high. The temple proper comprises a flat-roofed hall and a shrine with a

94
Kailasa temple, Ellora, c.757–83

pyramidal *shikhara* crowned by a rounded unit that rises 29 m (95 ft) above the courtyard floor; it is surrounded by five mini-shrines that echo its shape. Each of the three units of the Kailasa has steps leading to an upper level of what looks like a double-storeyed structure. However, the lower 7·5 m (25 ft) is solid rock so that the interior floor of the temple is the same height above ground. It is possible to move from the gatehouse to the bull pavilion and on to the main temple on the ground level of the courtyard, walking past the rock elephants and the free-standing columns, and ascending each unit independently. Alternately, a rock-cut bridge links the gatehouse to the bull pavilion, and a second bridge connects to the hall of the main temple. The Kailasa is indeed a daring undertaking that speaks eloquently both of the creative genius of the architect and the driving enthusiasm of Krishna I.

The exterior walls of the Kailasa carry niches flanked by pilasters to enclose statues of deities and exuberant mytho-logical scenes. The gatehouse niches display a range of lesser gods especially the guardian deities of the various directions. Tales from the legend of Shiva abound in the interior, but images of other significant deities, including the goddesses Lakshmi and Durga, are also in evidence. The sculptural opulence and the dazzling profusion of mythological themes at the Kailasa leave the visitor spell-bound.

The theatrical effect evident 200 years earlier at Elephanta reaches a climactic conclusion in the Kailasa where the image of Ravana in one relief panel is actually detached from its back-ground so that the action takes place on a deeply shadowed stone stage. The 240 km (149 miles) separating the two sites makes it probable that the Elephanta cave was known to Rashtrakuta artists. The legend of Ravana, already encountered at Elephanta, tells the story of the ten-headed, twenty-armed demon king and his attempt to uproot mount Kailasa and use it as a magic dynamo of energy in his great battle against Rama, hero of the epic *Ramayana* (95). The arms of kneeling Ravana,

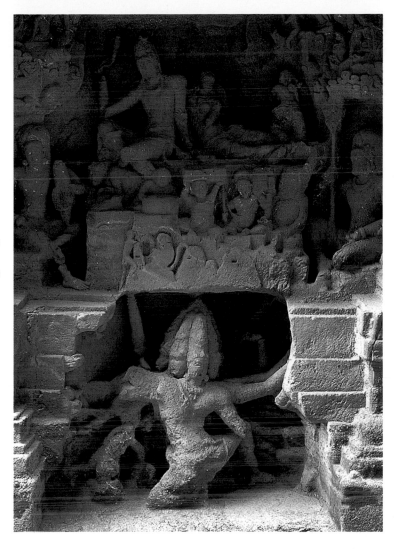

arranged like the spokes of a wheel, convey the enormous pres-
sure he exerts on the mountain around and above him. As the
mountain quakes, Parvati clutches Shiva in alarm, while her
attendant turns and flees. But Shiva, seated in a stance of
effortless command, merely presses down his big toe and
imprisons Ravana under the mountain. Sculptors connected the
figure of Ravana to the mother rock at the level of his knees and
his many arms, but they completely detached his body from the
background and carved it in the round, creating a deeply shad-
owed zone of darkness toward the rear.

Originally, both exterior and interior of this rock-cut temple carried painted adornment over a thin layer of plaster. In certain areas, three layers of paint are discernible, indicating the continual refurbishment of the mural decoration. Further confirmation of such renewal of the murals comes from sixteenth-century Muslim accounts which speak of the Kailasa as Rang Mahal, or Coloured Mansion. Today, mere fragments of the paintings remain, largely within the main temple unit.

No records exist on the building of this spectacular temple, but an estimate of twenty-five years would ensure that it was completed while Krishna I was in power. In its own day, the temple was considered a challenging achievement. A contemporary copper-plate inscription proclaims that when it was complete, its architect (who remains nameless) stood before it in amazement and asked, 'Was it indeed I who built this?' The record goes on to describe the temple as 'an astounding edifice' and states that the gods who rode over it in their celestial vehicles could not believe that it was the work of mortals.

Perhaps every climax has to be followed by an anticlimax; at any rate, rock cutting which continued in a perfunctory fashion at Ellora saw the creation of an imitation known popularly as *Chota* or Little Kailasa. By the ninth century, the rock-cut tradition was engulfed by the relatively prosaic mode of building by piling stone upon stone. One is left to ponder over the reasons for the abrupt abandonment of the inspired technique of the rock-cutting tradition which endured in India for over a millennium.

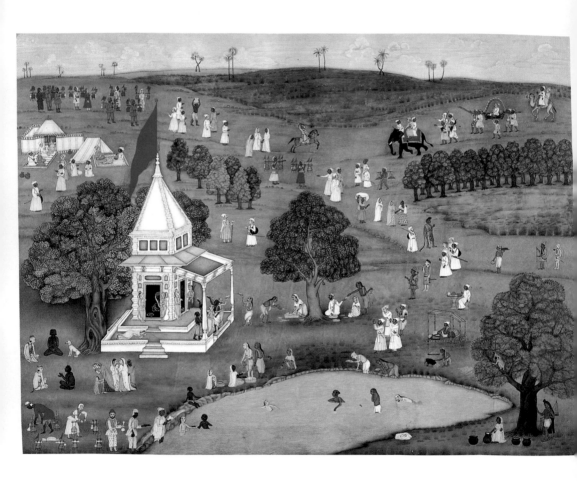

Hindus visit a temple for *darshan*, or 'seeing' the image of the enshrined deity. Such seeing does not literally mean merely using one's eyes, but is a dynamic act of awareness. This type of 'seeing' lies behind the choice of 'seer' to designate a holy prophet or sage. The deity, in presenting itself for *darshan*, bestows blessings upon worshippers who, by their act of seeing, have made themselves receptive to this transfer of grace. The concept of *darshan* lies at the heart of the creation of images of the divine and of temples to enshrine them.

The multiple religious traditions of India resulted in an exuberant exploration of the possibilities of divine imagery. To comprehend and appreciate such a scenario, it is essential to set aside the deep-rooted Judeo-Christian distrust of icons traceable to the Biblical admonition against 'graven images', as well as the pejorative connotations of the words idol and idolatry. The *Vishnu Samhita*, an ancient Hindu ritual text, persuasively endorses the use of imagery (ch 29, v 55–7):

Without a form, how can God be meditated upon?
Where will the mind fix itself?
When there is nothing for the mind to attach itself to, it will slip away from meditation or will glide into a state of slumber.
Therefore the wise will meditate on some form

Many are perplexed by the multifarious profusion of Hindu temple images. Despite historical acceptance of multiple deities, the Hindu focus at any particular ritual is always upon one single deity invested with all the attributes of divinity. For the duration of the worship, none other exists. Hindus accept many gods because they accept many perspectives. To them, monotheism is but one avenue. In seeking to explain their outlook, Hindus today may suggest that the Infinite is like a

90
A scene at
a shrine,
Murshidabad,
c.1760.
Gouache with
gold on paper;
25·3 × 33·3 cm,
10 × 13 In.
British Library,
London

diamond of innumerable sparkling facets, one facet appealing
to an individual more forcefully than another. By adoring that
facet as the god Shiva, the individual does not negate the valid-
ity of other facets such as Vishnu, Krishna or Ganesha. Or, in
more historically grounded terms, they may describe the
Infinite as the 'One in the many'. Bricks, plates and vases have
different forms but all are made from clay. So indeed it is with
the different gods of India. Hinduism, which declares the
oneness of Reality, also accepts the seeming multiplicity of
name and form.

This profound belief is embodied in sacred Hindu texts of a
philosophical nature known as *Upanishad*s which began to be
composed around the fourth century BC. In part, they embody
responses to the criticisms of the Buddha and others regarding
the elaborate sacrificial ritual of late Vedic religion. In an oft-
quoted dialogue, a seeker after truth persistently questions the
venerated sage Yajnavalkya on the number of gods in existence,
refusing to accept his initial statement that the Vedic hymns
speak of 300. Yajnavalkya ultimately speaks of just one god,
and explains the truth about the 'One in the many'.

By the start of the Christian era, Vedic religion had evolved into
what we call Hinduism, and texts known as the *Purana*s
(ancient writings) were being written. Three major deities had
come to dominate the religious scene – the two male gods
Vishnu and Shiva, and the great goddess Devi or Shakti
(literally 'power'). Today Hindus refer to themselves as
Vaishnavites, Shaivites or Shaktas depending on which of the
three is the focus of their worship. Earlier Western formulations
that spoke of three gods – Brahma as creator, Vishnu as
preserver and Shiva as destroyer – and likened them to a trinity
were modelling the Hindu world on a Judeo-Christian para-
digm. Worshippers of Vishnu, Shiva or Devi visualize the deity
as containing all three functions within one form or concept.

A theory of ten incarnations, with one to occur in the future,
arose around Vishnu who, in different aeons, repeatedly

descended to earth when evil seemed to overpower the forces of good. Most popular among the incarnations are the seventh avatar as Rama, prince of Ayodhya, hero of the great epic *Ramayana*, and the eighth as Krishna, the divine lover, who is the driving force behind the *Bhagavad Gita*. In the latter (bk 4, v 7–8) Krishna explains the theory of avatar thus:

Whenever sacred duty decays
and chaos prevails,
then, I create myself, Arjuna.

To protect men of virtue
and destroy men who do evil,
to set the standard of sacred duty,
I appear in age after age.

Hinduism's historical tendency to draw varying threads into a seamless weave is evident in the fact that the Buddha was drawn into the Vaishnava system as the ninth avatar, although Buddhists of course do not accept such a formulation. Shiva, by contrast, was not linked to any codified incarnation theory, but manifested himself on earth as and when required. Both gods have consorts – Vishnu's wife is Lakshmi, goddess of wealth and fortune, while Shiva is accompanied by his wife Parvati and two sons, elephant-headed Ganesha and warrior youth Skanda. As the popular god who removes all obstacles and who is worshipped before all undertakings, Ganesha is an appropriate figure to appear on the cover of this book. Devi, the great goddess, worshipped in her own right, is also identified with Parvati, wife of Shiva, and known by a myriad of other names.

While the religious traditions of India present an overall picture of the coexistence of a multiplicity of views, intersectarian strife could be bitter and protracted. Within each persuasion, too, internal strife erupted; thus orthodox Shaivas protested against the practices of radical Shaiva sects like the Kaulas of central India. In addition, southern India witnessed bitter disputes between the Hindus on the one hand and the Jains and

Buddhists on the other. By and large, however, the recognition of pluralism overshadows the phases of prejudice and discrimination that were of limited and often local impact.

The gods and goddesses were frequently portrayed with multiple arms, which prompted early European travellers to speak of them as 'monstrosities'. In India, multiple arms were regarded as a simple and effective way of portraying the immense power of the deity who could achieve many tasks simultaneously. Deities portrayed in a beneficent mode are given two, or at most four, arms. But if the god is in an active, warlike mode, destroying demons for the well-being of the world, multiple arms are added. When goddess Durga destroys the menacing buffalo-demon, she is frequently given eighteen arms, each holding a different weapon.

Occasionally, deities are portrayed with more than one head. While frequently used to stress the ability of the deity to be all-seeing, such a tactic also portrayed the various aspects of a god's personality, as in the triple-headed Shiva at Elephanta (see 1). Hindu deities are also portrayed with vehicles upon which they ride. Shiva rides the bull; Vishnu flies on the divine eagle Garuda; goddess Devi mounts the lion. Occasionally, gods are depicted as composite images in which two very different aspects merge. At Elephanta we saw the merger of Shiva and Parvati into a single androgynous form that emphasizes the dual aspect of the godhead (91). Another composite image unites Shiva and Vishnu, stressing the essential oneness of the godhead. Most deities are worshipped in human form, Shiva alone being enshrined within the sanctum as an aniconic shaft known as a *linga*. The prime meaning of *linga* is sign; but it came to be understood as a phallic symbol associated with the great ascetic and yogic power of Shiva. Images of gods, as well as temples to enshrine them, were a relatively late introduction, none being known in Vedic times. It is ironic that a religion renowned today for its proliferation of deities began to require images only around the start of the Christian era.

97
Brick temple,
Bhitargaon,
mid-5th century

The Hindu temple rose to prominence during the Gupta period (*c*.320–647) examined earlier as the epoch of great Buddhist art. The temple is regarded as the home of the deity when he or she descends from an abstract state of transcendence. It consists of a sanctum to enshrine the image, and a porch or compact hall as a shelter for devotees. Since Hinduism is not a congregational religion, its temples do not require expansive interiors. Devotions are performed daily in a home shrine. There is no sacred day; Hindus visit a temple individually or as a family unit on days of personal importance such as a birthday, or on days significant in the mythology of the enshrined deity.

Early temples were built of brick and an inscription from one such at the Andhra site of Nagarjunakonda speaks of the installation, in 278 AD, of a wooden image of Vishnu upon a stone pedestal. Several brick temples, adorned with carved bricks and terracotta plaques, were built during the Gupta period. A lone, spectacular survivor in the north is the mid-fifth century temple at Bhitargaon (97), with a *shikhara* that reaches up to 15 m (49 ft). The porch is no longer standing. Each of three exterior walls of the shrine carry three rectangular terracotta panels of equal size, apparently reflecting a phase prior to the

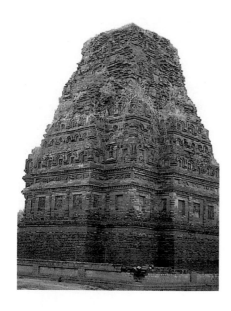

standardization of temple decoration when a single, large panel adorned each face. The much-damaged plaques seem to feature Shaiva themes on the south face, Vaishnava on the west and Shakta myths on the north, making its original dedication somewhat uncertain. Brick held a position of great prestige in Vedic times, representing the quality of Mother Earth; but it gradually lost its status and from the sixth century was held to be inferior to stone.

One of the earliest Hindu stone temples to survive was built *c*.500 AD at Deogarh in Central India (98). Dedicated to Vishnu, it consists of a much-damaged tower above a sandstone sanctum, some 5 m (16 ft) square, which today is bereft of its shrine image. Confirmation of the temple's affiliation comes from the seated image of Vishnu on his coiled serpent seat that adorns the lintel of the richly carved doorway. A single niche on each of the three exterior walls of the shrine contains sculpted panels portraying the myths connected with Vishnu (*eg* 99). This early organizational scheme remained the accepted formula for the decoration of Hindu temples all over India, even when they later became exceedingly ornate and expansive.

More than one scholar to study the programme of the Deogarh temple has arrived at a theory linking its images with the Pancharatra school of Vaisnava thought. Put simply, the Pancharatra believes in an emanation concept from the supreme Vishnu known as Vasudeva, through his forms as Aniruddha (the creative aspect), Pradyumna (the force of preservation) and Samkarshana (his destructive form). If we move around the Deogarh temple clockwise from the lintel image of Vishnu, we first encounter the god arriving upon his divine eagle in answer to the cries of an elephant devotee whose life was threatened by serpent-like aquatic creatures. Vishnu, poised to throw his discus of destruction, represents the destructive aspect of the god. The panel at the rear of the shrine depicts two sages, Nara and Narayana, who represent the meditative power of preservation. The third panel relates to

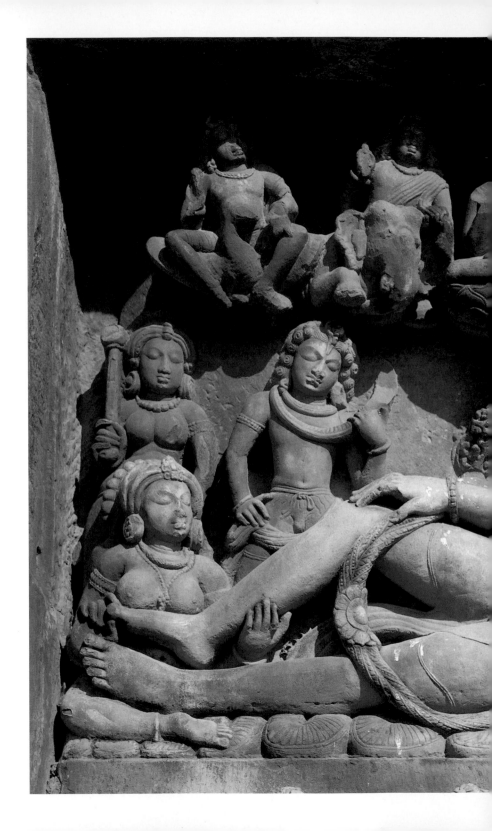

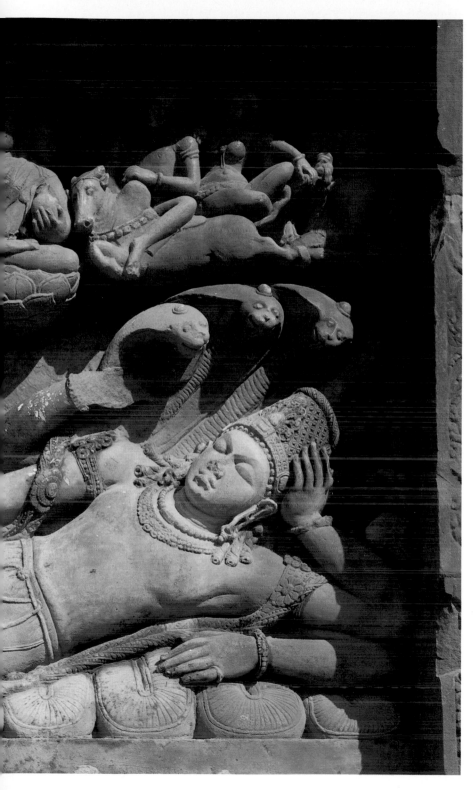

99
Vishnu
reclining on
his serpent.
Sculpted panel
from the south
façade of the
Vishnu temple,
Deogarh,
*c.*500 AD

the creative aspect of Vishnu in portraying the Hindu cosmic myth in which he reclines at ease upon his serpent whose many-headed hood shelters him like a parasol (99). God Brahma, who will create the world, sits on a lotus that emerges from Vishnu's navel, while below the god two demons are kept in check by his attendants who are actually personifications of his attributes. Upon their heads are the telling symbols that identify them, from right to left, as the mace (female), discus, shield and sword.

Much remains to be explained about the deceptively simple Deogarh temple that reveals, in fact, a highly sophisticated ideology. Logically, one might expect the sculpted panels to commence with creation and conclude with destruction; the reason for their counter-clockwise arrangement is yet to be resolved. The temple stands on an expansive platform and it would appear, from beams still in place and from pillars found at the site, that an awning was erected on all four sides of the shrine. It would appear too that the temple platform had wide steps on all four sides as well as small shrines at its corners. Finally there is the question of decoration of the platform itself; while its original programme may never be recovered, we know from existing fragments that it featured scenes from the stories of Rama and Krishna.

The Hindu temple, which started out as a relatively modest structure, soon acquired impressive proportions. Temple *shikhara*s often rose 24–30 m (79–98 ft), while some reached over 60 m (196 ft). The exteriors of temples in both the north and south are made up of projecting components, or aedicules; these are not mere surface decoration but are conceived three-dimensionally, being embedded in and emerging from the body of the temple (100). The rich appearance of later temples is created by the aedicules being staggered, split and progressively multiplied to create multi-aedicular structures to which rich pictorial representation was added. The construction of a temple was a collaborative process. Priests sanctified a

100
Aedicular components of a temple. The aedicules emerge from the central sanctum core. More elaborate temples have successive layers of components
Above
(A) The Nagara or northern temple. The sanctum core or *latina prasada* is elaborated with (1) *kutastambha*s at the corners, (2) aedicules repeating the form of the sanctum on each side, and (3) *gavaksha* aedicules as wall shrines
Below
(B) The Dravida or southern temple. The sanctum core or *alpha vimana* (1) is elaborated with (2) corner aedicules of *kuta* form, (3) side aedicules of *shala* form, and (4) *panjara* aedicules as wall shrines

A 1 2 3

B 1 2 3 4

carefully selected site and architects, following the instructions of architectural texts, laid out the plan of the temple based on a mandala or geometric map of the cosmos.

Building techniques were simple. Temples were built by the rudimentary method of placing finely dressed blocks of stone one upon the other without the use of any mortar. Sockets and dowels were cut into many of the stone blocks, while crucial portions of the roof and *shikhara* utilized iron beams. The simple post-and-lintel method of construction demanded that interior spaces be divided by pillars which supported the roof beams. Most interior halls were no more than 7·5 m (25 ft) square, a comparatively small space to cover with a roof. However, in the absence of the true arch, which was used with regularity only in Islamic India, dome-like temple ceilings had to be created by laying beams so that each projected fraction-ally beyond the beam below until a dome-like appearance was created. As temples rose in height, mud ramps were built to facilitate the raising of stone. An alternative method was to surround a temple with circular mud ramps as it rose in height; a twentieth-century restoration at Khiching in Orissa success-fully used this method to re-erect an ancient fallen temple.

Once the temple was complete as an architectural unit its walls were carved with decorative and figural themes. Temple archi-tects and sculptors experimented with the decorative treatment of wall surfaces until they achieved a satisfying sculptural idiom. They planned their compositions so that the joints between blocks did not cut across the face of a figure, but were disguised by, say, the girdle at the waist. Divine images to be placed in the niches on the exterior walls of the shrine were generally not carved from the stone blocks of the temple wall. Instead, an image created separately from a single, large stone slab was inserted into an aedicular shrine-niche. Carved frag-ments found at quarries indicate that, on occasion, decorated pillars and ceiling units were produced there and transported to the temple site.

The sanctum sanctorum of a temple is known as the *garbha-griha* or womb-house. It is hidden, secret and dark as no natural light enters except that filtering through the single, small doorway. Its plain, cave-like interior is in sharp contrast with the richly sculpted exterior of the temple. The sanctum image, like all other sacred imagery on a Hindu temple, was created according to rules laid down in the texts on art and religion; it was then installed and consecrated by priests. The final act of consecration was to open the eyes of the image, which would have been covered, thus far, usually by sandal paste. Symbolically, priests often used a paint brush, or a silver chisel, to complete this ceremony – after which the image could give, and the devotee could receive, *darshan*.

A Hindu deity is accorded both honour and affection. Ritual worship, known as *puja*, is comparable with the hospitality one would offer a highly esteemed guest. It includes offerings of a fresh flower garland, new clothes, food, cool water, lamps, incense and music (101). Hindu worship is anything but a withdrawal of the senses; rather, ritual sharpens the senses and directs them solely towards the object of worship. *Puja* involves seeing the deity, smelling incense, hearing the chants of worship and the chiming of bells, touching the feet of the image, and tasting food sanctified by the deity.

Creating a stone temple to enshrine a divine image was an expensive proposition, and temple-building was largely undertaken by royalty, nobility and highly placed ecclesiasts. In several instances, the construction of a great temple seems to have been motivated as much by the desire to assert personal power and majesty as to venerate a deity. King Rajaraja of the Chola dynasty built his monumental Tanjavur temple not only to glorify Shiva but also to establish his overlordship of South India. Succeeding Chola monarchs each built a new temple bearing their name in a new town exclusively associated with them, despite the fact that the temples and towns of each of their predecessors were still standing in magnificence.

When a monarch consolidated his empire and achieved territorial control, he invariably built a grand temple at his capital, using it as a statement of his overlordship. Likewise several monarchs in the southern regions of India built temples to Shiva, naming them Kailasa after the Himalayan mountain peak which is the home of the god – such as the rock-cut temple at Ellora built by Krishna I of the Rashtrakuta dynasty (93, 94). Monarchs who sponsored such Kailasa temples were implying that they had relocated the sacred peak, together with its potent powers, within their own realms.

In certain circumstances building a temple could be a challenge to any neighbouring kings who might come forward in confrontation. Capturing the sacred image of a powerful rival and installing it in one's own capital was an act of defiance. To proclaim the independence of the Chandella chieftains, Yashovarman Chandella seized an image of Vishnu from his erstwhile Pratihara overlord and built a temple to enshrine it at Khajuraho (see Chapter 7). Lesser rulers with plebeian, often tribal, backgrounds frequently used temple-building as a means to legitimize their position.

Powerful emperors too appropriated sacred images and built temples to enshrine them within their own kingdom, with the aim of signalling their power and glory. The sixteenth-century South Indian emperor Krishnadevaraya captured an image of the child god Krishna after crushing the kingdom along his eastern border. At his capital of Vijayanagara, or City of Victory, he built a grand temple to honour Krishna. A second temple (185), built by the emperor and dedicated to Vishnu in the form of Vitthala, housed a figure that held significance in the western coastal regions from where it may have been transported. Such reconsecrated images were believed to transmit their potency to the site of the newly established temple; admired by vassal monarchs and visiting dignitaries, these shrines reconfirmed the king's status and prestige.

101
Puja being performed at a small temple in Madya Pradesh

Like Buddhist monasteries before them, temples operated as economic and banking institutions, lending money, for instance, to individuals and guilds. The temple also functioned as an economic resource, bringing in income from pilgrims. It is not often that one finds impressive temples wholly built by the effort of the common people: one such fifth-century brick temple at Mandasor in northern India was constructed through contributions from a guild of silk weavers who also left investments for its continued upkeep; unfortunately, the stone inscription alone survives. Most instances of temples built by commoners are in the nature of small unostentatious village shrines, generally devoid of sculpture. Every Indian village, however small, has at least one shrine of great local sanctity.

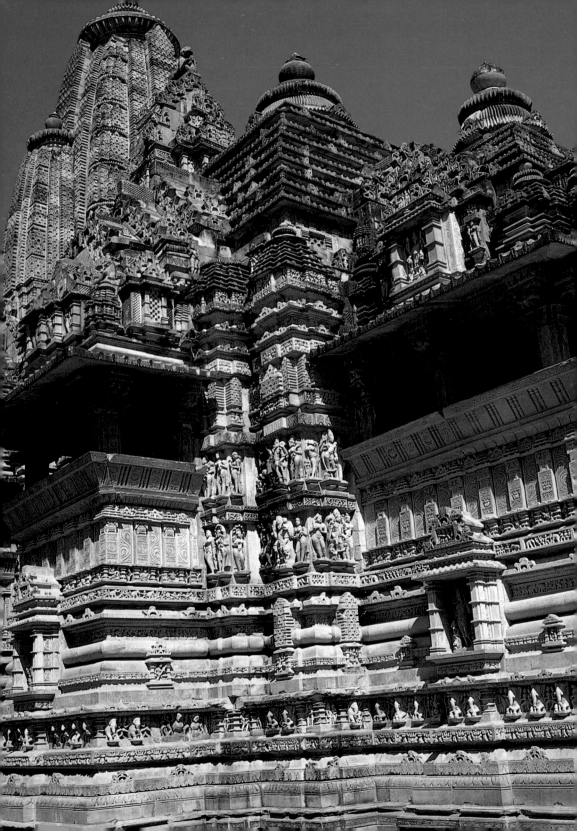

The many temples built across the landscape of northern India share a common architectural style distinct from that of the South. This difference was recognized by ancient Indians who spoke in their texts of the Nagara style of temple, which prevailed in the North, as against the Dravida, or southern style (100). Although regional idioms are discernible, the distinctive, curved *shikhara* of the Nagara temple is seen everywhere within northern India. It is crowned by a fluted, cushion-like device, or *amalaka*, which derives its shape from the lobed *amala* or myrobalan fruit believed to have purifying medicinal powers. Mini *amalaka*s are placed at the corners of the various levels of the *shikhara*. The pyramidal roofs of the various halls in front of the sanctum are also typical of the northern style; in the interior these lend themselves to the creation of decorative 'domed' ceilings. In architectural terms, it is primarily the *shikhara* and roof structure of the hall that distinguishes the northern from the southern style of temple.

Equally, a sharp contrast in sculptural subject matter exists between north and south. The walls of northern Indian temples repeatedly display provocative female imagery, often juxtaposed with embracing couples, while southern temples tend to restrict their figural sculpture to images of gods and goddesses. A group of sites in the Deccan plateau of southern India carries both styles of temple, each maintaining its architectural identity together with its sculptural predilections; the area seems to represent the meeting ground of the two styles. A third type of temple mentioned in the texts as Vesara is difficult to define precisely; the term seems to refer to the mixed architectural style evident at some Deccan sites.

102
Lakshmana
temple,
Khajuraho,
completed 954

When the Gupta empire disintegrated, northern India divided into a series of regional kingdoms of varying size in which local loyalties, rather than a central authority, played a major role. These regional dynastic houses operated on the Indian feudal system in which kings granted land to vassals in return for a portion of the revenue from that land. Feudatories permitted to rule their mini-kingdoms had also to provide military support whenever their overlord went to war. Other duties of vassals and feudatories included attendance at court on a variety of ceremonial occasions such as the king's birthday. Any temples they built, or inscriptions they issued, had to name the king and extol his glory.

In the early tenth century, local Chandella chieftains ruled a small area as feudatories of the powerful Pratihara dynasty whose kingdom lay to their north and east. In a bold move, Yashovarman Chandella (r.925–50) appropriated from his Pratihara overlord an important statue of Vishnu as three-headed Vaikuntha, and built a sandstone temple to enshrine it at his capital of Khajuraho (102, 103). This Vaikuntha temple, known today as the Lakshmana, and completed by his son Dhanga in 954, was Yashovarman's defiant gesture to establish the sovereignty of his new dynasty. It was also an act of legiti-mation of somewhat lowly chieftains who had connections with local tribal groups including the Gonds; as such, Yashovarman's first inscription was devoted largely to constructing a royal genealogy for the Chandellas.

During the early part of his reign, Dhanga was preoccupied with large-scale military activity, which led to the consolidation of the new Chandella kingdom. His own temple, completed in 999, was dedicated to Shiva and enshrined both a stone and an emerald *linga*. Traditionally, the emerald is used in images of worship to signify the fulfilment of desires. In this instance, it may have been Dhanga's thanksgiving both for his military accomplishments and for having been granted a lifespan close to a century. One of the most important Chandella rulers was

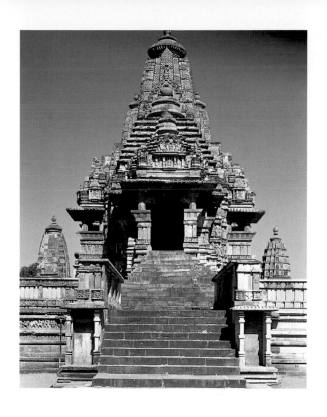

Vidyadhara (r.1004–35) during whose reign the Chandellas were recognized as the dominant power in northern India. Vidyadhara twice organized successful resistance against the early Muslim invaders. It is probable that he was the builder of the sandstone Kandariya Mahadeo temple (7, 104–108, 110, 111) that marks the climax of building activity at Khajuraho, and which is the focus here.

Though the Chandellas undertook numerous public works such as irrigation tanks and dams, the flamboyantly decorated temples and artificial lakes which adorn their capital are their best-known monuments. The temples occupy a site measuring 2·6 sq. km (1 sq. mile), and are dedicated variously to the deities Shiva, Vishnu, the solar god Surya and the goddess. When first built, they appear to have been arranged asymmetrically around the borders of an ornamental shallow pool of water, today completely dry. Standing apart from this royal grouping are Jain temples sponsored by the mercantile commu-

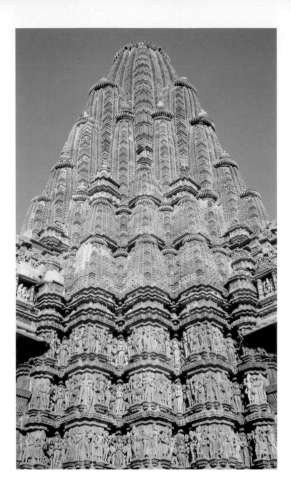

104–105
Kandariya
temple,
Khajuraho,
*c.*1004–35
Left
General view
of tower
Right
Plan

nity. About twenty-five Khajuraho temples are relatively intact,
while the remains of another twenty-five may still be traced,
lending some credence to the tradition that speaks of eighty-
five temples at the site. Inscriptional evidence suggests that the
majority was erected between *c.*954 and 1035, after which a
branch of Chedi rulers temporarily overran the area. Standing
amidst fields and jungle, the temples have been deserted for
centuries – although recently a landscaped garden was laid out
around the central group. Congregating a number of temples on
one site is not uncommon in India, but an assembly on the
scale seen at Khajuraho, and built within a restricted period, is
suggestive of a special goal. In addition to being a declaration
of the power of successive Chandella rulers, the temples may
also have been the outcome of a dynastic desire to create a

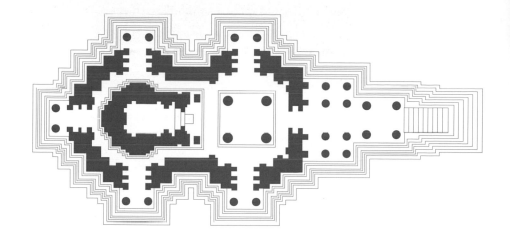

N

central seat of religious learning.

Khajuraho's temples are among the most polished and sophisti-
cated examples of the northern style of architecture. Each
temple stands on a high, solid masonry terrace and consists of
a sanctum fronted by one or more halls. None is of any great
size, the largest being the Shiva temple of Kandariya which
rises to 30 m (98 ft). They rely for effect on their balanced
proportions, elegant contours and rich surface treatment. In
plan, each is the shape of a Latin cross, with its long axis from
west to east where a single entrance is located. The Kandariya
temple resolves itself into an entrance portico, an assembly
hall, a vestibule to the shrine and a sanctum surrounded by a
processional passage with transepts. The four units comprising
the temple are not treated as additive structures, but are inte-
grated to create a unified architectural whole (105).

In elevation, the temples consist of three horizontal zones. A
high, solid basement decorated with a series of intricate mould-
ings raises the interior floor level of the Kandariya to 4 m (13 ft)
above its terrace, and requires a steep flight of steps to enter
the temple. The next zone comprises walls and openings of the
interior compartments where architects introduced a series of
balconied openings that add greatly to the delicate appearance
of the structure. They transformed solid sections of walls into a

series of projections and recesses that allowed space for the maximum number of sculpted images, while still retaining order and continuity. At the Kandariya, the superior workmanship of the artists is evidenced in three horizontal sculpted bands that present a continuous procession of shapely mortals and divine beings – about 650 such figures in total – carved in high relief and at about half life-size (106).

The temple elevation culminates in a dramatic grouping of roofs. Each of the interior units of the temple has its own pyra-

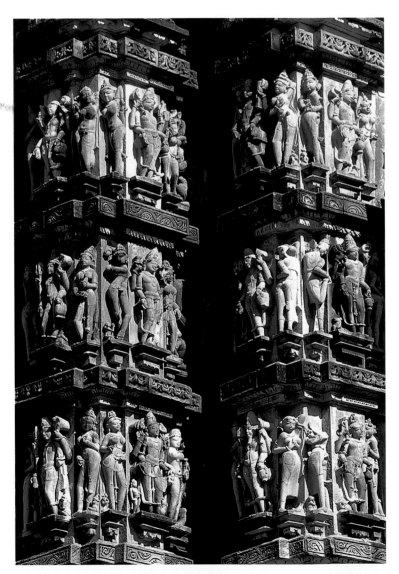

106
Exterior walls of the Kandariya temple, Khajuraho, c.1004–35

midal roof, the smallest and lowest being that of the portico. Each succeeding unit has a larger and loftier roof until the profile sweeps upwards to the tall *shikhara* above the shrine. The external appearance of the Khajuraho temples owes much of its grace to the grouping of these roofs that are reminiscent of the rising peaks of a mountain range. While following the basic curvilinear format of the northern style, the Khajuraho *shikhara*s have a distinctive form, created by using miniature replicas of the *shikhara* itself as its main decorative motif. In its simplest form, builders attached a fairly large, flattened, half spire against all four sides of the tower. In the more developed examples, these turrets were duplicated and triplicated in miniature, so that the tower acquires a rounded profile. Dated temples reveal that no evolutionary scheme may be built up from simple to complex *shikhara*s.

To enter the temple, visitors climb the steep steps and walk beneath a fine stone tracery archway reminiscent of ivory carving. The ceilings and their supporting pillars are connected by decorative brackets, created as female figures, carved from separate slabs of stone and fitted into prepared sockets, so that devotees gazing upwards would be confronted by a group of sensuous celestial dancers and musicians. Decorated ceilings are a speciality of the North Indian temple style, and Khajuraho artists displayed great ingenuity and skill in their design and execution. No ceiling design is repeated exactly from one temple to the next, and each of the Kandariya's three ceilings – of portico, hall and vestibule – is different. Patterns are geometric and consist of an arrangement of intersecting circles, with an elaborate lotus bud pendant suspended from the centre of each (108). The entire surface is transformed into a swirling pattern of circles and semi-circles, created in three or four courses, with each course supporting the one above. Before raising carved stones onto the roof to lower them into place, they must have been assembled on the ground to make sure that the entire composition interlocked accurately. Artists expended much expertise on ceilings that remain partly

shrouded in the muted light of the interior.

While the elegant architectural effect of the Khajuraho temples is sufficient to grant them pride of place in the story of Indian art, their sculptures raise them to the status of masterpieces. Before we turn to the sensuous and erotic imagery that has made these temples famous, it is appropriate to discuss the sacred iconographic programme which, of course, is the *raison d'être* for their creation. Recent investigation suggests that the philosophy and ideology of the system known as Shaiva Siddhanta, seen already in the Elephanta cave, underlies the programme of the Kandariya temple. It may be viewed as an attempt to demonstrate the principle of emanation from the Unmanifest *linga* enshrined in the sanctum, through the Unmanifest-Manifest form of six-headed Sadashiva within the temple, to Shiva's many Manifest forms of dance, destruction and the like seen on the outer walls of the temple. Research likewise indicates that the Vaishnava Pancharatra system, encountered earlier on the Gupta temple at Deogarh, is the guiding principle behind the programme of the Lakshmana temple. In both temples, the images contained in the niches along the base moulding – a group of mother goddesses known as Matrikas in the case of the Kandariya, and of *graha*s or planetary deities in the Lakshmana – are intended to form a protective mandala around the temple.

107
Detail of bands of sculpture on the exterior of the Kandariya temple, Khajuraho
c.1004–35

A closer look at the three sculpted bands that follow the multi-faceted indentations of the exterior of the Kandariya's walls reveals that each projection displays an image of a four-armed deity, while the partially recessed flanking portions carry figures of women (107). The importance of the deity is suggested by its placement both towards the viewer and by its centralized position flanked by a woman on each side, whose figures are the same size as the deity's and carved with equal attention to detail. Khajuraho's walls thus tend to exhibit more figures of women than of gods. The women are tall and slim, with elongated eyes, curved eyebrows, shapely breasts and

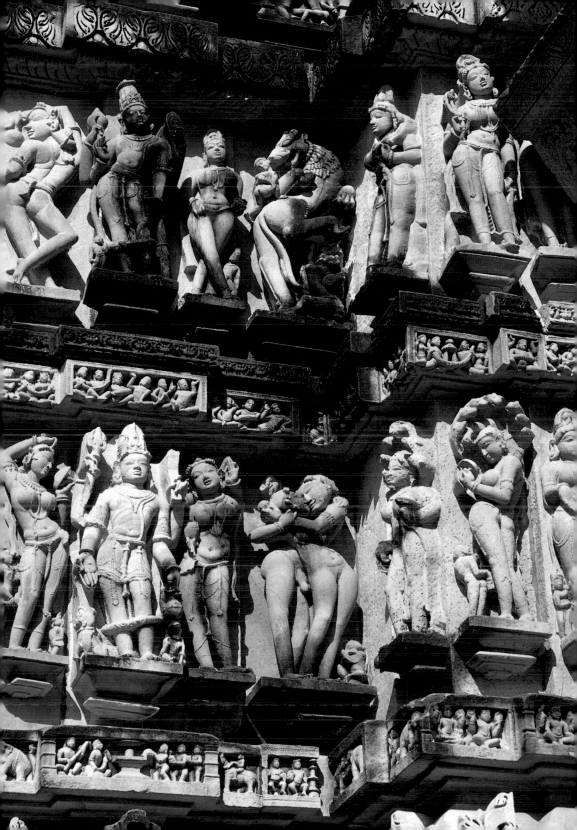

broad hips. They wear opulent jewellery and display a wide range of hair styles and headdresses, including diadems, crowns, ribbons, flowers, pins, jewels, buns, locks and long tresses. With long, shapely limbs poised in vivid postures, they exude warmth and vitality. Often, however, their poses seem exaggerated, since artists rarely positioned them to look out directly at the viewer as was the standard mode with the images of gods. Instead, in displaying themselves to spectators, the women seem to twist and turn in space. It has become fashionable to describe these positions as impossible 'corkscrew' twists; they are, in fact, variations upon the twist poses advocated by yoga, with which Indian artists would have been familiar.

Earlier in our exploration of India's art, we saw that woman's association with fertility and abundance led to her being trans-formed into an emblem of the auspicious. By 1000 AD, when the Khajuraho temples were being built, the texts for temple archi-tects and sculptors had codified these ideas, specifying that images of women were a necessity. The Orissan text of the *Shilpa Prakasha*, or Light on Art, phrases it emphatically (bk 1, v 391–2):

As a house without a wife, as frolic without a woman,
So, without the figure of woman the monument will be

108
Kandariya
temple,
Khajuraho,
c.1004–35.
Ceiling

of inferior quality
and will bear no fruit.

It then proceeds to list sixteen types of women whose images
should grace the walls of a temple. Being a text for practising
sculptors, it describes how to create an elongated rectangle,
divide it into segments, and then place the head, hips,
outstretched arm or leg of these sixteen female forms at appro-
priate points within these segments. Among the forms is the
woman who looks into a mirror, peeps from behind a door,
smells a blossom, plays with a parrot, the dancer, the drummer,
the bashful young girl, the haughty offended woman, and the
mother with child. Every one of the sixteen varieties mentioned
in the text, and indeed others like the girl playing with a ball, is
seen on the walls of the Khajuraho temples – where the woman
looking into a mirror was one of the sculptors' favourites and
appears with great frequency.

Khajuraho's temple walls also present images of couples gazing
into each other's eyes as their bodies entwine (109). Men are
handsome, sturdy and broad-shouldered; they wear rich
jewellery including earrings and necklaces, and invariably have
long hair arranged in a variety of fashions. Some have a pointed

109
Fragment of a
loving couple,
10th–11th
century.
Archaeological
Museum,
Kajuraho

beard, but most are clean-shaven. The couples are carved with remarkable mastery over the flexibility of the human figure.

No simple answer, nor indeed a single answer, can explain Khajuraho's erotic imagery, and we must invoke a combination of factors to understand the display of such images on temple walls. The loving couple is a theme encountered earlier in the Buddhist monastic chapel of Karle (80) belonging to the first century AD, although at that early date, love was not displayed in such an explicit manner. Like the woman on her own, the togetherness of a couple represented fertility, abundance and prosperity, and was considered an emblem of auspiciousness. Since *kama* or love was accepted as one of the goals of life, the display of images pertaining to love was also considered valid.

In part, erotic imagery may also be construed as a reference to the mystic union of the human soul with the divine. The philosophy of the *Upanishad*s explains that the human soul emanates from the Infinite and is not a distinct entity; the soul lives its life on earth, and then returns to merge and become one with that Infinite. This doctrine is termed monism and stresses the essential unity of an apparent duality. The ancient writers realised that no means more graphic than sexual symbolism could be found to convey their philosophy, and certainly none more capable of universal comprehension (*Brihadaranyaka Upanishad*, bk 4, ch 3, v 21):

In the embrace of his beloved, a man forgets the whole world – everything both within and without; in the very same way, he who embraces the Self knows neither within nor without.

Erotic temple imagery may, in part, be interpreted as a visual reiteration of this philosophical principle.

This explanation, however, cannot be extended to a category of erotic scenes depicting groups of figures. On the Kandariya temple, as on the two earlier temples of kings Yashovarman and Dhanga, such scenes are displayed on the wall that connects the sanctum and hall (110, 111). Texts describe the

110–111
Imagery on the 'joining wall', Kandariya temple, Khajuraho, c.1004–35
Above
General view
Below
Detail of erotic imagery

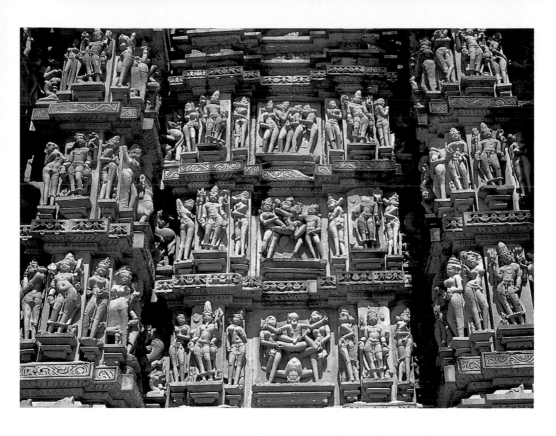

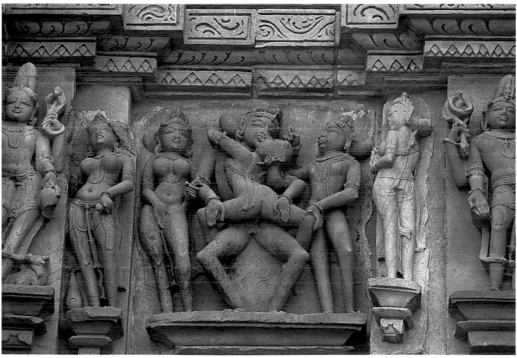

shrine and the hall as bridegroom and bride, with the 'joining wall' being their place of union. In what may be read as a visual pun, the central panel of all three levels of the joining wall carries images of 'joining' couples.

In the tenth century when the Khajuraho temples began to be built, the esoteric sect of the Kaulas, a tantric offshoot of Shiva worship, was at its most prevalent. Kaula teachers advocated secret practices known as the *panchamakaras*, or five items starting with 'M' in Sanskrit – *matsya* (fish), *mamsa* (meat), *mudra* (parched grain), *mada* (wine) and *maithuna* (sexual intercourse). Kula, the ultimate goal of the Kaulas, was defined as 'the state in which the mind and sight are united, the sense organs lose their individuality ... and the sight merges into the object to be visualized'. Though the enunciated goal was legitimate, we learn from eleventh-century writers that the unorthodox Kaula practices degenerated into a corrupt form of ritual. If, indeed, the erotic imagery on the joining walls depicts the rites of this sect, it would suggest that the Chandella rulers who built the temples either directly or indirectly patronized the Kaulas. But here we run into problems. King Dhanga's inscription on his Shiva temple, which contains such imagery, speaks of his support of the brahmins, of the caste system and of the Vedic order. By contrast, the Kaulas are anti-brahmin, anti-caste and anti-Vedas.

Another theory proposes, in the context of the Lakshmana temple, that the imagery makes specific reference to an allegorical play staged at the Chandella court. Central to the theme of the *Prabhodacandrodaya* or Moonrise of Awakening is the conflict between on the one hand king Mahamoha (delusion) and his love Mithyadhrishti (false perception), and on the other king Viveka (power of discrimination) and his wife Upanishad. The conflict is between the unorthodox path that includes tantra and the orthodox Brahamanical path. However, the play was written at least a century after the temple was built, so it becomes necessary to postulate an earlier counterpart. More

problematic is the fact that while it may be possible to read characters from a play onto the sculpted images on the Lakshmana walls, the theory cannot be extended to the other temples with such imagery, including the Kandariya. Whatever the explanation is for this perplexing erotic imagery, the sculptures on the walls of Khajuraho's temples are a testimony to the artistic achievements of its sculptors.

No such imagery is to be found on the six surviving Jain temples grouped together at the southeast end of the site. Chapter 2 briefly mentioned Mahavira, propagator of Jainism in the fifth century BC. An early schism within the monastic order resulted in the formation of two sects, the Shvetambara or white-clad monks and the Digambara or sky-clad and hence naked monks. Emphasis on avoiding harm to any living creature was exceedingly strong, so that Jains avoided professions that might result in even inadvertent harm to the smallest organism. Farming, for instance, was not favoured, as the process of tilling the soil could harm insect life. The outcome was that Jains frequently took up trading, establishing themselves as a successful merchant community. The earliest Jain temple at Khajuraho was dedicated in 955 by a Jain merchant who claimed, in his dedicatory inscription, to have won favour with king Dhanga; other Jain temples and images were likewise sponsored by merchants. The architectural character of Khajuraho's Jain temples differs little from its Hindu counterparts, except that the graceful balconied openings into the interior compartments were eliminated. Their sculptural character varies somewhat; while sensuous women are found here, too, there are no entwined couples. This makes it difficult to sustain the suggestion that some of the erotic imagery on the Hindu temples should be read as naked Jain ascetics of the Digambara sect.

Apart from the stone temples, no other art form of the Chandellas has survived. None of the rich ornaments depicted on the stone figures has come down to us. Then, as now, gold

was the material of choice, and gold jewellery was routinely melted down and refashioned from one generation to the next. Metal vessels of ritual and functional use were similarly recycled, while pottery and textiles have long since turned to dust. Although we know of plays performed at the royal courts, no Chandella painted manuscripts survive. And, having been built of perishable brick and wood, no Chandella palaces survive either.

The Jain shrines at Mount Abu in western India are an interesting contrast with their counterparts at Khajuraho. While the Khajuraho Jain temples rise in conspicuous grandeur, the Mount Abu shrines are enclosed within tall courtyard walls which afford no glimpse of the structure within (112). The interior of the walled enclosure consists of a series of fifty-two small shrines, each with a portico. Within the courtyard stands the temple structure consisting of the sanctum with a modest *shikhara* of the northern type, an attached hall and an additional two open halls. The starkly simple, almost forbidding, character of the exterior leaves the visitor quite unprepared for the overwhelming pristine white marble of the interior (113). An abundance of the sculptural decoration covers pillar and ceiling, wall and doorstep.

What is the explanation for these extraordinary temples? In the

112–113
Vimala temple, Mount Abu, completed 1032, repaired *c.*1300
Left
Exterior view
Right
Interior

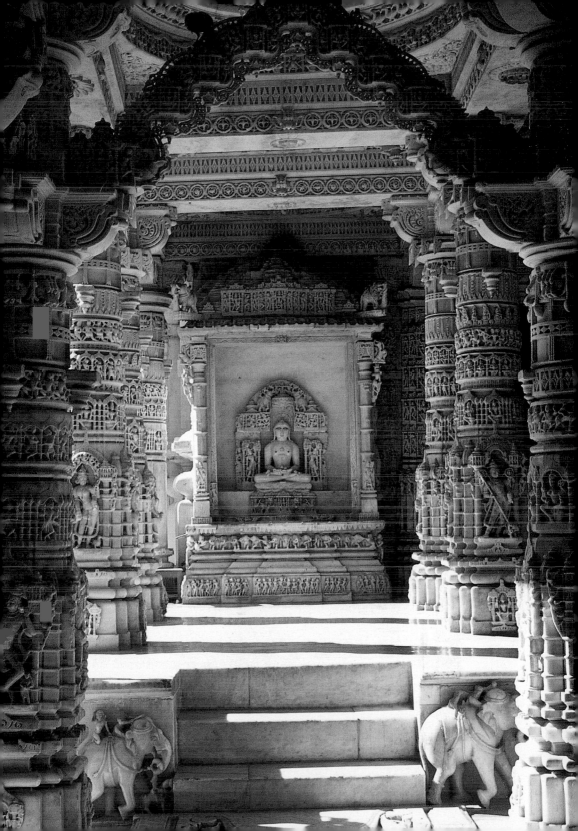

eleventh century, western India was ruled by Hindu Solanki kings whose capital was the town of Patan in the plains of Gujarat. The western coastal region was a stronghold of the Jains, the majority of whom were merchants and traders who acquired considerable wealth from overseas trade conducted through the ports of Gujarat, and several of whom rose to trusted positions of responsibility. One such was Vimala, minister to Solanki king Bhima I (r.1022–63). The monarch himself constructed a sandstone temple to the Hindu solar god Surya at Modhera near his capital, while his queen Udayamati constructed at the capital the grand stone step-well to glorify god Vishnu encountered in Chapter 1 (see 9, 10). Minister Vimala seemingly surpassed both by constructing this floridly decorated temple on the hills of Mount Abu to honour Adinatha, the first Jina. Legend reports that to acquire the land on which the temple stands, Vimala had to cover it with gold coins; he then spent 153 million, in the Indian currency of the eleventh century, to construct the temple which was built of expensive marble carried up the hill from the plains.

114
Carved white marble ceiling, Vimala temple, Mount Abu, completed 1032, repaired c.1300

The renown of Vimala's temple, completed in 1032, rests largely on the phenomenal variety of its ceiling decoration (114, 115) and the intricate lavishness of its sculptured decoration. Khajuraho's major temples each carried three distinctive ceilings; Vimala's temple presents us with fifty-five. Three belong to the main temple unit, while others cover the porches of the courtyard's fifty-two small shrines. Each ceiling, known as *vitana* or canopy of the heavens, is unique and dazzling, and different from every other ceiling within the temple complex. Some are created as elaborate floral or geometric patterns. Others have sculpted figures superimposed upon a patterned background, while yet others focus upon a set of deities, or a single deity such the Jain goddess of knowledge. Art texts of the time speak of three categories of ceilings – those carved on a single level, those with flat surfaces on several levels and those created in vaulted fashion – each of which is here displayed in a bewildering variety.

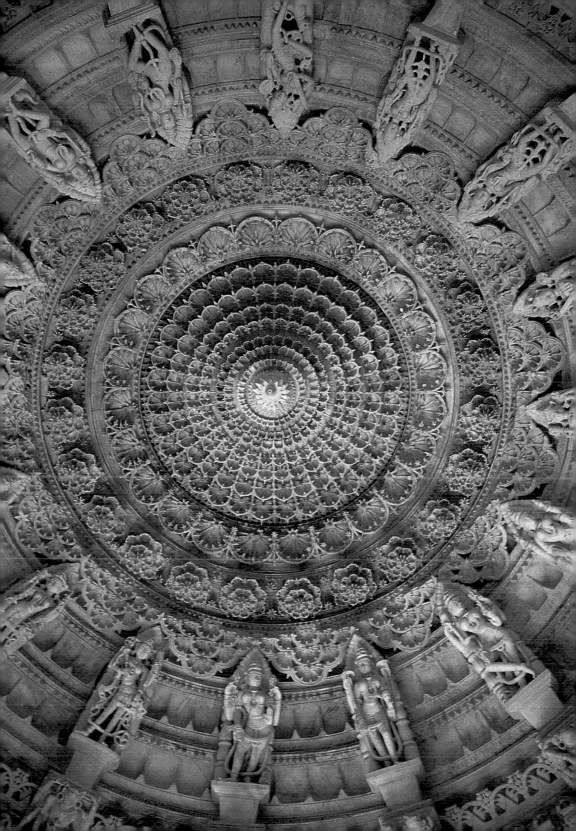

In front of the cruciform temple building is a dance hall with an exceptionally large ceiling termed a *karotaka* or 'vision of the cosmos'. A series of concentric ceiling rings is carved as friezes of animals and people in movement; placed across these, and contained within elaborate aureoles, are sixteen bracket figures of *Vidyadevi*s or goddesses of esoteric knowledge. At the apex of the dome, 9 m (30 ft) above the ground, is an astoundingly detailed lotus pendant surrounded by a cluster of smaller buds. The central octagonal hall below is supported by eight pillars ornamented with bracket figures of dancers and female musicians with their elongated and angular limbs poised in lively fashion (116).

 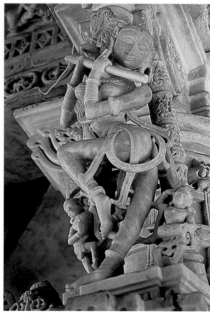

115–116
Vimala temple, Mount Abu, completed 1032, repaired *c*.1300
Far left
Ceiling of a courtyard shrine
Left
Bracket figure

In front of his temple, Vimala constructed an open hall within which was placed an entire series of marble elephants with riders. Pride of place was given to a portrait statue of Vimala upon an elephant; he was indeed the first among devotees. Around 1300, two devout Jains sponsored the temple's repair after it had been badly damaged by the armies of Ala al-Din Khalji, the Muslim sultan of Delhi, and it was restructured to be

a close copy of the original. The constant threat of Muslim invasion may have contributed to the decision to enclose the Abu Jain temples within forbiddingly high and plain walls.

Jainism is a religion of devotional practices with a stress on asceticism and restraint of the senses. Yet, as we look around the temple, bracket figures of musicians and dancers twirl and twist, while pillars too are carved with an abundance of figures moving in glad abandon. There seems little doubt that the Jains joined the Hindus and Buddhists in their acceptance of the auspicious nature of female imagery. A mid-twelfth-century poem, *Kumarapalavihara Shataka*, written by a Jain monk, describes the atmosphere and activities within a Jain temple erected by the monarch Kumarapala:

In that temple made of stone, lovely women smiled upon seeing the female bracket figures, felt fear at the sight of the lions adorning the thrones of the main images; they were wearied by the crush of worshippers and felt a tingle of pleasure as they brushed against the bodies of their husbands; they danced to the sound of drums and all in all were a delight to the young gallants who watched them …

In that temple people were always present; faithful Jains came simply as a pious act; … artists came to admire the skill and workmanship; … some who loved music came to hear the singing …

In that temple, people experienced a strange desire to renounce further pleasures of the senses; … all they could smell was the fragrant water that was being used to bathe the main image.

It appears that temple worship was not restricted by solemnity, but was an informal occasion for genuine devotion. The poem reveals that temples, whether Jain or Hindu, were also places where people gathered to witness music and dance, and to admire temple art.

Few people could afford to build an entire temple. Jain merchant devotees frequently commissioned small bronze altars, some 30 cm (12 in) high, in which a central image of the

Jina of their choice was surrounded by the remaining twenty-three Jinas in miniature. These 'altars' were used for individual home worship, or gifted to temples where marble Jinas may be seen surrounded by numerous small bronzes.

Individual Jains also commissioned vast numbers of illustrated manuscripts that they gifted to temple libraries in the hope of acquiring spiritual merit. A frequently commissioned text was the *Kalpasutra* that narrates the lives of the Jinas. Jains produced an iconic mode of narration, vastly different from the intricate visual narratives of the Buddhists. To depict each legend, the iconic mode featured a single scene, repeated with little variation from one manuscript to the next. Artists portrayed highly stylized figures in profile, with the same huge eyes and sharp, thin noses apparent in marble temple figures (117). An amazing mannerism is the portrayal of the further eye so that it protrudes onto the page beyond the contours of the face. Poses are pert, lively and angular, as in temple sculptures, and the figures are clothed in the brilliantly patterned textiles that, to this day, are a specialty of the region; unfortunately, no ancient textiles, jewels or other objects of material culture have survived. As merchant wealth escalated, manuscripts made increasingly lavish use of gold, red and imported blue from Persian aquamarine; in fact, several rich manuscripts are written entirely in gold ink. Jain painted manuscripts are forerunners of Rajput painting in the Mewar region of western India, which will be discussed in Chapter 14.

117
Jain manuscript page, *c.*1475. Watercolour on paper; 11·4 × 25·4 cm, 4½ × 10 in. Bharat Kala Bhavan, Varanasi

The state of Orissa in eastern India provides a picture of continuous temple development, from post-Gupta shrines of the seventh century to the climactic thirteenth-century Chariot of the Sun at Konarak. One of the earliest, the Parasurameshvar temple to Shiva at Bhubaneshvar (118), continues the established Gupta scheme for the decoration of its shrine, with its three exterior niches housing images of Parvati, Ganesha and Skanda. But it reveals considerable uncertainty about the treatment of the walls of its rectangular, flat-roofed hall. The experi-

mental placement of doors and windows, and the tentative, unplanned nature of its sculpted compositions, suggest that this was among the first temples to have an added hall. By 950, with the exquisitely carved, gem-like Mukteshvar temple (119), architects had arrived at a scheme. A pyramidal roof was added to the hall, and a single doorway and two windows occupied the position assumed by the three sculpture niches of the sanctum walls. The tiny Mukteshvar, reaching a height of only 10·5 m (34 ft), was followed a hundred years later by the great Lingaraj temple whose *shikhara* reaches 48 m (157 ft). This, in turn, was soon followed by an almost identical temple, with a

shikhara 60 m (197 ft) tall, built on the coast at Puri, dedicated to Vishnu in his significant local visualization as Jagannatha. The deity draws great crowds to Puri, especially during the annual celebration of his chariot festival.

All these temples were superseded in scale by the grand temple at Konarak built by Narasimhadeva of the Ganga dynasty (r.1238–64) that stands today in ruins along the sands of the Bay of Bengal (120, 121). In Hindu mythology, the Sun god Surya rides across the sky each day in a chariot drawn by seven

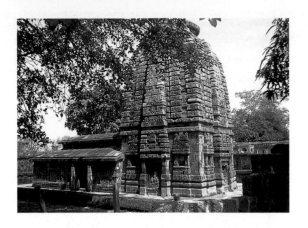

118
Parasuramesh-
var temple,
Bhubaneshvar,
c.650–80

119
Mukteshvar
temple
surrounded by
a wall and
entrance
gateway,
Bhubaneshvar,
c.950–75

horses; his charioteer is Aruna, the dawn. The sanctum and hall
at Konarak, standing upon a high plinth, were transformed into
a monumental stone horse-drawn chariot; its twenty-four
wheels, twelve to a side, presumably make reference to the
twelve months of the year and to the lunar calendar's waxing
and waning halves of the month. The entire temple is conceived
on a monumental scale; the wheels, for instance, are nearly 3 m
(10 ft) high and the pyramidal roof of the hall reaches a height
of 30 m (98 ft). It is estimated that its now ruined *shikhara* may
have reached 68 m (223 ft), making it the tallest temple in India
in the thirteenth century.

The image that once graced the sanctum has disappeared; only
its 2-m (6-ft) high pedestal, carved with images of king
Narasimhadeva and his court paying homage to Surya, remains
in place. Some idea of the original may be obtained from the
three forms of Surya in the niches around the exterior of the
sanctum. Created from finely polished chlorite, one depicts the
god standing in his chariot, holding lotuses in both hands, and
clad in boots and a long robe (122); Aruna sits between his feet
and the seven horses are carved against the pedestal. According
to ancient Puranic texts, Surya donned boots and a garment
that covered him fully to shield his devotees from his blinding
brightness. In front of the temple stands a dance hall, which
today lacks its pyramidal roof. Its walls are covered with

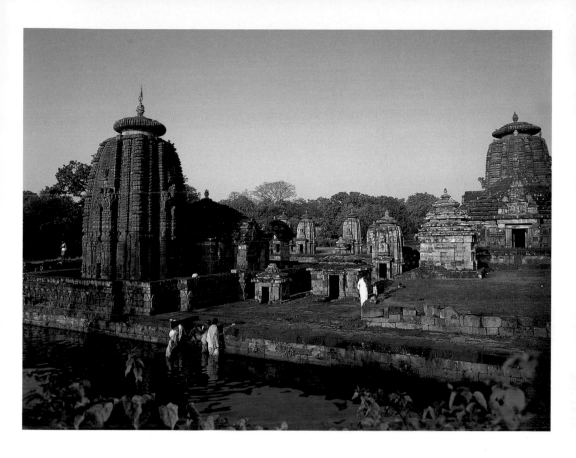

musicians and dancers, and the twentieth-century revival of Odissi dance drew for its initial inspiration on these numerous sculpted images. The entire complex stands within a spacious walled enclosure.

Women, loving couples and erotic groups cover the 6-m (20-ft) high plinth of the main temple, as well as the walls of the hall. The exquisitely carved erotic images poised prominently along the upper levels of the hall are life-sized to be clearly visible from below; the musicians standing on the platform that separates two levels of the pyramidal roof are 2·5 m (8 ft) high. To the various issues discussed in relation to the erotic imagery at Khajuraho, one additional factor may be added. The temple at Konarak honours the sun, source of all life; perhaps here, more than elsewhere, images suggestive of growth, abundance and fertility are especially appropriate.

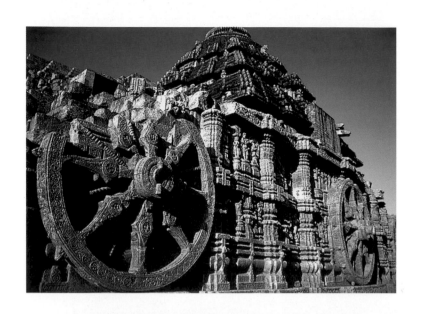

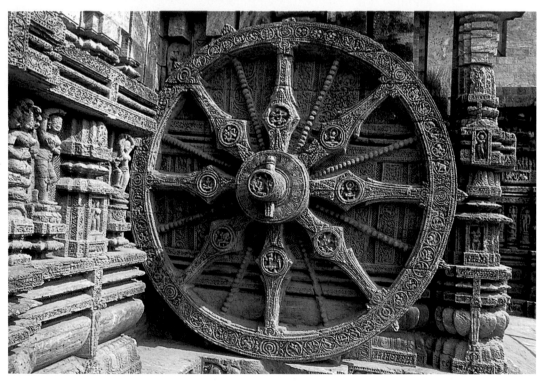

120–122
Sun Temple,
Konarak,
*c.*1238–58
Above
General view
Below
Detail of a
wheel
Right
Image of Surya

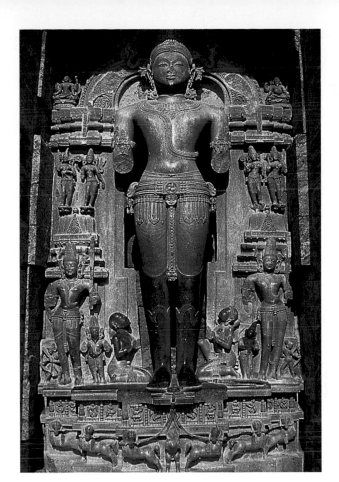

A recently discovered manuscript, the *Baya Cakadu*, purports to
be a record of the payments made to the hundreds of craftsmen
who worked on the monument, which apparently took six years
in the planning and a further twelve years in construction. It
portrays an anxious architect attempting to meet the wishes of
his monarch who insisted that the temple be ready for dedica-
tion in 1258 when the Sun's birthday fell on a Sun-day.
Astronomical records reveal that there was increased sun-spot
activity during this period, a phenomena which may have
resulted in the desire to honour and appease the Sun. While the
manuscript contains much fascinating information, it is wise to
treat it with caution. At least one section may have been
tampered with since it records the placement of twenty-four
vertical ribs just below the crowning unit on the roof of the hall;

these beams are not portrayed in any of the British nineteenth-century drawings and seem to have been added when the British restored and stabilized the monument in the twentieth century.

The temple certainly stood in all its glory during the sixteenth century when Mughal emperor Akbar's chronicler, Abul Fazl, reported that even those whose judgement was highly critical must stand amazed at the sight of it. Sometime thereafter the *shikhara* collapsed, so that nineteenth-century British drawings reveal only a small portion still standing. We can only speculate on what caused its collapse. Perhaps, as suggested by the manuscript, shortcuts were taken in its construction; perhaps the copper *kalasha* (water vessel) crowning the *shikhara* was hit by lightning in the course of the cyclonic storms that batter the coast of Orissa year after year. Certainly the khondalite stone, transported from some 170 km (106 miles) away, was an unfortunate choice. No doubt the garnet, quartz and marble it incorporated sparkled when freshly quarried and attracted the builders. But the semi-precious stones have disintegrated so that the stone has crumbled and large portions have detached themselves from the main fabric. Why the temple should have been abandoned remains a mystery. Perhaps it was too closely associated with Narasimhadeva, with whose death funds for its maintenance may have been curtailed. Certainly we know that later rulers turned their attention to the temple of Vishnu as Jagannatha at nearby Puri, where Narasimhadeva too had worshipped. At some stage, the pillar that stood in front of the Konarak temple was also shifted to Puri so that Aruna, the charioteer of Surya, now pays homage to lord Jagannatha.

Konarak is the last of the great Hindu temples of northern India. After the thirteenth century, the Islamic dome and minaret replaced the temple *shikhara* as characteristic features of the sky line of the North.

A Riddle in Stone Pallava Mamallapuram

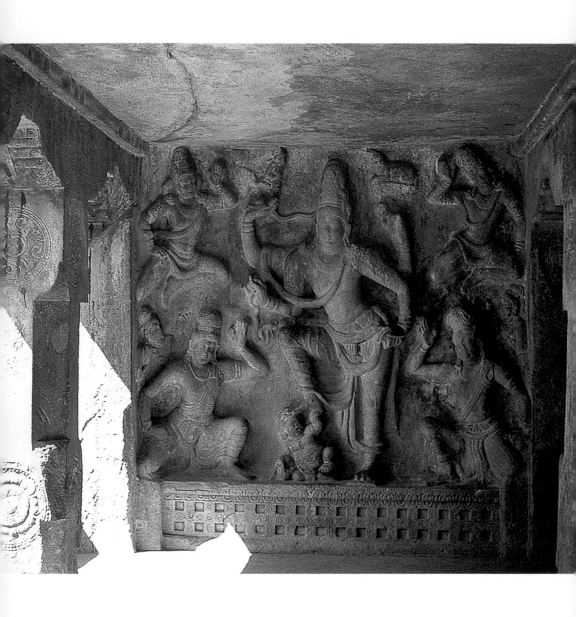

Cut into an isolated outcrop of granite in the Tamil country of
South India and overlooking a large irrigation tank is a small,
shallow cave containing three empty shrines in its rear wall.
What makes this simple cave at Mandagapattu worthy of atten-
tion is its inscription, which proudly proclaims that Pallava
king Mahendra (r. *c*.600–30) had created a home for Brahma,
Vishnu and Shiva 'without the use of bricks, timber, metals and
mortar'. We have seen that rock-cutting was a long-established
technique in western India, but clearly it was a rarity in the far
South. One reason why stone was adopted so much later there
may be because the South had first to disassociate it from the
funerary connotations acquired in an area where ancient mega-
lithic tomb cultures had once prevailed. Mahendra seems to
have been enthralled by the technique of rock-cutting; having
cut this first cave, he went on to create several more, most
overlooking a reservoir, thus confirming the importance of irri-
gation works to the prosperity of his kingdom.

123
Shiva receiving
the Ganges
in his locks,
cave shrine,
Tiruchirapalli,
c.600–30

One of Mahendra's last caves is cut half-way up a granite hill at
the centre of the town of Tiruchirapalli (Trichinopoly), over-
looking the Kaveri, the sacred river of the South. A shrine for
a *linga* is cut into one side wall, while opposite is a superb
sculpted panel portraying Shiva holding out a strand of his hair
to receive the heavenly Ganges in his locks (123). Mahendra's
poetic inscription states that he created this cave high on the
rock because Shiva had notified the king that he would not be
able to admire the beauty of the Kaveri from the ground.

Mahendra was the third ruler of the line of the imperial
Pallavas founded by Simhavarman around 550. He was a
remarkable man – a poet, the author of at least two plays, an
accomplished musician and a connoisseur of the arts. He

expanded the small kingdom he inherited in the Madras region, with its capital at Kanchipuram, to Tiruchirapalli and the Kaveri. It appears that the site of Mamalai or 'great hill', located along the coast some 65 km (40 miles) from the capital, was first developed by his successor, Narasimha (*c.*630–68), titled Mamalla or 'great warrior', who saw its potential as a port town for the Pallavas. He widened and deepened its inlet to accommodate large military and trading vessels, then marginally altered its name to Mamallapuram, to reflect his own title. From this new port he sent two naval expeditions to Sri Lanka to help reinstate the Sinhala prince Manavarma. Ships also sailed to southeast Asia; a Tamil inscription found in Thailand, at the site of Takua Pa, testifies to southeast Asian commerce with the Pallava region. A poem written by the eighth-century Vaishnava saint, Tirumangai, speaks of the port where 'ships rode at anchor, bent to the point of breaking, laden as they were with wealth, with big-trunked elephants, and with mountains of gems of nine varieties'. Mamalla fought numerous battles against the Chalukyas of Badami; yet, he apparently had sufficient leisure to devote time to Mamallapuram, commencing the process that has left it a veritable riddle in stone.

Today Mamallapuram is a deserted site except for its stone cutters and local traders who sell a variety of wares to tourists; there are empty stretches of sandy beachfront with just a few fishermen plying their trade. Inland, cut into a great outcrop of hard, grey granite, and dotted here and there amid the windswept sands, is a series of granite monuments of four distinct types – entire cliff faces transformed into sculpted tableaux; rock-cut monolithic shrines created out of single boulders of granite; rock-cut caves with pillared façades; and structural temples built by piling stone upon stone. In addition, there are rock-cut throne seats with rock-cut bolster cushions, rock-cut cisterns, a charming monkey family cut in the round (124) and several rock-cut animals with hollowed-out shrine niches. Added to the staggering variety of monuments is the curious fact that over half are unfinished.

124
Monkey family,
Mamallapuram,
7th century

Among the many questions posed by Mamallapuram is the
specific purpose of the monuments; several features seem to
contradict a religious reading of the site. Yet another issue
concerns the authorship of the monuments. While several
inscriptions exist at the site, most are in the nature of titles or
birudas. Titles on one monument include *Narasimha* (not only
the name of two Pallava rulers, but also the Man-lion incarna-
tion of Vishnu), *Kamalalita* (playful with love), *Nayanamanohara*
(pleasing to the eyes), *Ranajaya* (victorious in battle), *Niruttara*
(without superior) and several others, all of which could be
assigned to various kings. Only the last monarch, Rajasimha
(r. *c*.700–28), has left actual foundation records.

There are two divergent theories regarding the dating of the
monuments. The first maintains they are all the creation of a
single monarch – Mahendra is suggested by some, Rajasimha
by others. The second theory, of steady development, argues
that the monuments were created gradually between *c*.630 and
728. Variations in the sculptural style at Mamallapuram make
the latter more likely. In addition, granite, the hardest of
stones, is extremely time-consuming to carve. When questioned
about the time it might have taken to carve the great cliff,
contemporary stone carvers working in the village point out

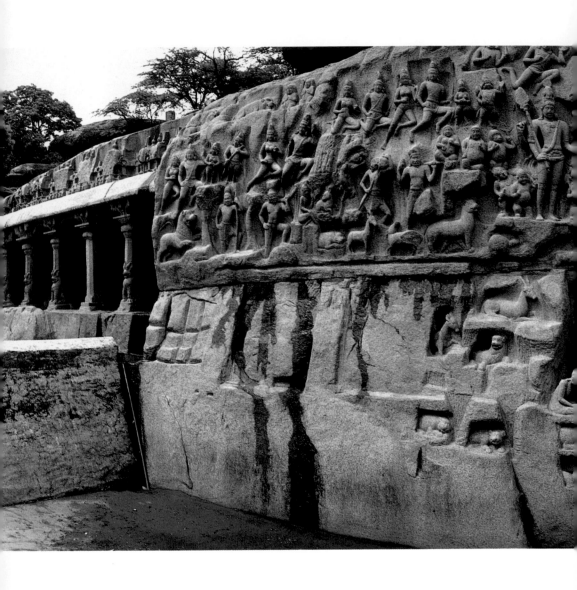

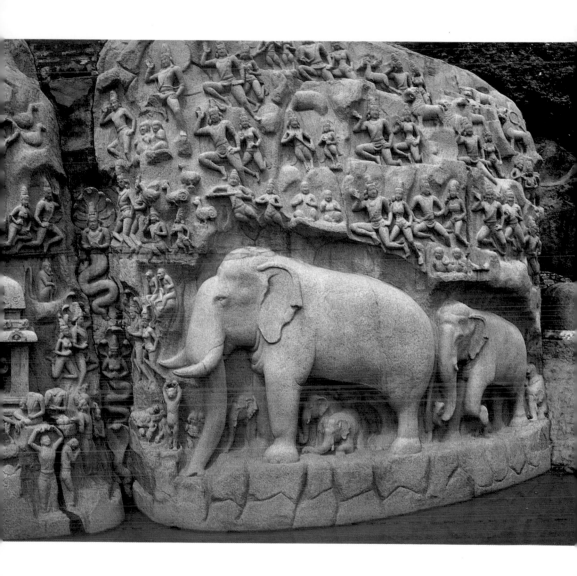

125
Sculpted cliff,
Mamallapuram,
*c.*630–68

that they normally squat upon stone to cut it. The cliff would require a totally different manner of working; they suggest twenty men working over ten years. In the exploration of the site that follows, I have presented one probable scenario of development and dating.

The great sculpted cliff, 30 m (98 ft) across by 15 m (49 ft) high, stands at the centre of the site of Mamallapuram facing the ocean (125, 126). It is a dramatic creation likely to have been one of the first monuments seen by the overseas merchants and traders who berthed their vessels in the port there. To reinforce the fact that the central cleft is the Ganges, artists have filled it with *naga*s and *nagini*s, snake beings associated with water. To the upper left, god Shiva appears to grant a boon to an ascetic who stands on one leg and performs penance. Immediately below, as if to declare that sectarianism had no place here, is a shrine to god Vishnu before which sits an aged sage and three disciples; beside them four more ascetics perform various rites of penance and *puja*. On the opposite bank is a herd of life-sized elephants, with their frolicking young. And just beside the feet of the first elephant is a charming detail – a penance-performing cat who has cunningly deluded the mice with his asceticism. The *Mahabharata* epic tells of the sad fate that overtook these trusting mice, one of whom has his paws joined together in admiring adoration. If we move diagonally up from the cat, we arrive at the genuine penance-performing ascetic.

126
Detail of relief at Mamallapuram, *c*.630–68

There are two schools of thought about the identity of the legend told by this tableau – either it is Arjuna's penance for Shiva's potent weapon for use in the great *Mahabharata* war, or Bhagiratha imploring Shiva to bear the force of the Ganges's descent to earth. Perhaps it was intentionally ambiguous, in the same way that contemporary literature of the seventh and eighth centuries often was. Playwright Dandin, who seems to have lived at the Pallava court of Mahendra, wrote a Sanskrit work that could be read as either the *Ramayana* or the

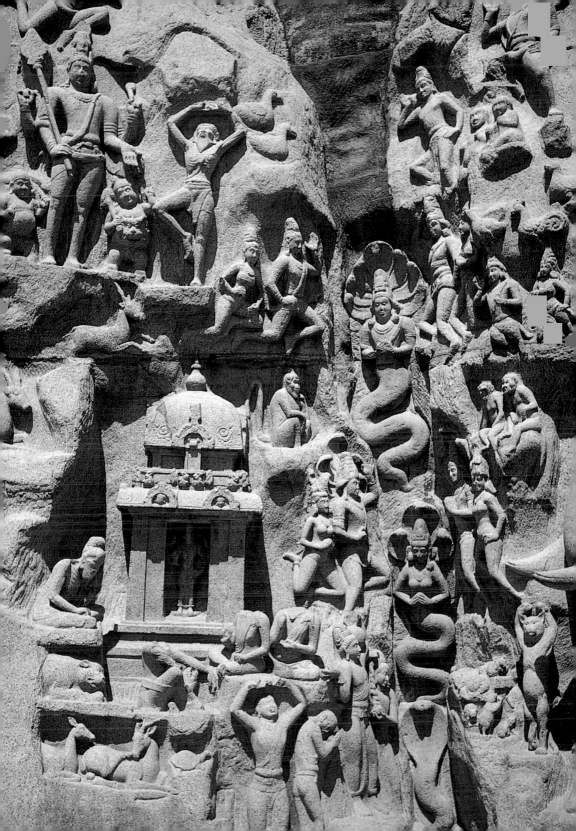

Mahabharata depending on how you split and interpreted the words. This literary genre, called *dvi-samdhi-kavya* or 'double-meaning poem', remained in favour for centuries, even though such poems were highly contrived. What was being done by a literary artist could surely be replicated by a visual artist.

But we may possibly move one step further and suggest that the tableau was intended to have a multivalent significance. A great sculpted relief, located at a port visited by foreign traders unfamiliar with sacred legend, may have been intended for viewing in the more universal terms of evolving karma by portraying a hierarchy of beings – from the lower level of elephants, monkeys and other animals, through a level of human experience to an upper level occupied by celestial beings. Also evident from the provision of a pool at its base and a storage tank above is the original dramatic intention of the showpiece: on celebratory occasions water could be let out of the tank to cascade down the cleft, recreating a flowing river. Perhaps such an effect was recreated every time the monarch visited the port, or whenever a foreign ship berthed at its docks; it was the *son et lumière* of its time. Quite puzzling though is that almost one-quarter of the cliff – its entire lower left – has not been finished. Adding to the mystery surrounding the tableau is a lesser, quite unfinished relief located close by

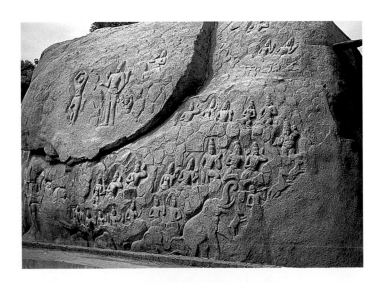

127
Incomplete sculpted cliff at Mamallapuram, *c.*630–68

that seems to replicate the same theme (127). Was it a trial attempt abandoned because there were two clefts in the rock? Is it possible that the site represents a vast outdoor workshop?

At the southern end of Mamallapuram is an isolated group of rock-cut monoliths known as the five *ratha*s or chariots, named after the heroes of the *Mahabharata* epic; the term *ratha* and the names given to each are later appellations. The *ratha*s present several intriguing issues, not the least being that four of the five represent differing architectural types (128–130). The first, a stone rendition of a wooden hut with a thatched roof, is dedicated to goddess Durga whose image is carved on the rear wall while her female attendants flank the entrance. Her mount, the lion, is carved from rock that stands in front of the shrine; instead of facing Durga, the lion gazes off into the distance. If these monoliths were actually shrines intended for worship, one would expect the lion to have been detached from the mother rock and placed in its correct orientation.

The adjoining Arjuna *ratha* is the first example of a sizeable Dravida or South Indian temple, of the type encountered earlier in the discussion on the rock-cut Kailasa temple at Ellora. Its *shikhara* is crowned by a rounded unit known as a *stupi*, miniature versions of which are repeated at the corners of its lower level. Between the *stupi*s are small barrel-vaulted units known as *shala*s. The Arjuna *ratha* is empty, and the suggestion that it was a Shiva shrine rests largely on a magnificent rock-cut bull located close behind it. But he has not been detached and placed in the correct ritual position as we would expect in a sacred centre. Is this because the five *ratha*s are more in the nature of a workshop than a site of worship?

The Bhima *ratha* is a barrel-vaulted structure incomplete in its lower level; the partially cut stone in the interior was probably intended to be an image of reclining Vishnu. The fourth shrine of the series, the Dharmaraja *ratha*, is a taller, more impressive version of the southern temple than the Arjuna *ratha*. It reveals much about the manner in which rock cutters worked upon a

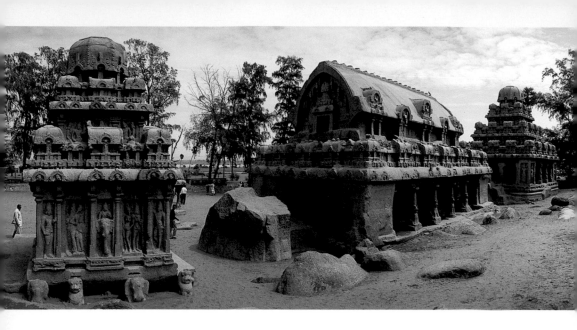

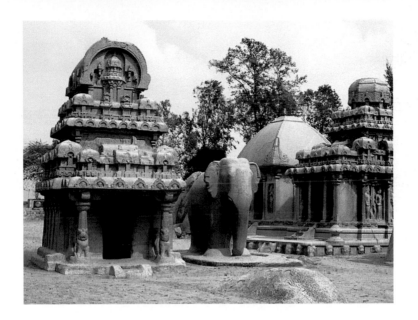

128–130
The five *ratha*s,
Mamallapuram,
c.630–68
Above left
From left the
Arjuna,
Bhima and
Dharmaraja
*ratha*s
Above right
From left the
Nakula
Sahadeva
ratha, elephant,
Durga shrine
and Arjuna
ratha
Left
Plan showing:
(A) Durga
shrine
(B) Lion
(C) Arjuna
ratha
(D) Bull
(E) Bhima *ratha*
(F) Dharmaraja
ratha
(G) Nakula
Sahadeva *ratha*
(H) Elephant
(I) Rocks

giant boulder to convert it to a shrine, commencing at the top and working down. The two upper levels of this structure have a shrine chamber in each, the topmost featuring a relief image known as Somaskanda, of Shiva, Parvati and their infant son Skanda (*sa* [with] Uma [Parvati] and Skanda). The lowest level is solid, incompletely cut rock. Carved stone steps lead from the third to the second level, but the stone-cutters had not got around to creating steps from the second to the first level. The Dharmaraja is the only one of the *ratha*s to contain inscriptions; unfortunately, they may be assigned to one of several rulers. However, the title Mamalla is engraved prominently along the stairway balustrade and may indicate that these *ratha*s were commissioned by Narasimha Mamalla.

The fifth, an apsidal *ratha* known as the Nakula Sahadeva, is juxtaposed in an intriguing manner with the elephant carved beside it. The shrine may have been dedicated to either Indra or Aiyanar, both of whom ride an elephant, although the animal is incorrectly placed for a sacred context. In Sanskrit, an apsidal shrine is referred to as *gaja-prishtha* or elephant-backed. Perhaps apprentices in a outdoor workshop were asked to carve the elephant and then beside it an elephant-backed shrine.

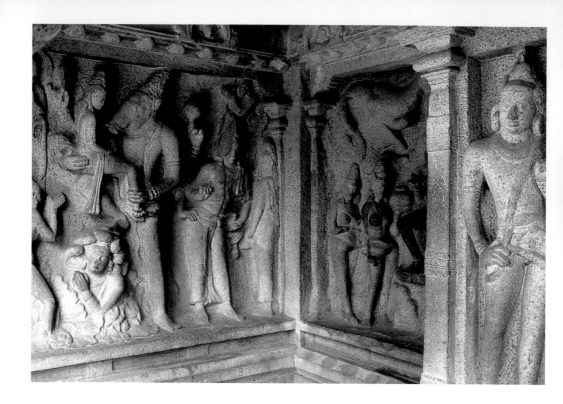

Cave architecture, begun by Mahendra, continued to be popular
at Mamallapuram. A small but strikingly sculpted Varaha cave,
which lies directly behind the great cliff, was probably a
Mamalla creation. A tank cut into the rock floor in front of it
again stresses the significance of water. The sculptures within
are imposing. One wall depicts Vishnu in his third incarnation
as the gigantic boar Varaha, upholding personified goddess
Earth whom he has rescued from the depths of the cosmic
ocean (131). Opposite is the gigantic form of Trivikrama
assumed by Vishnu as part of the fifth incarnation, after coming
to earth as a dwarf and being granted three strides of land from
the powerful king Bali: one stride covered the earth, the second
the heavens and with the third stride he placed his foot on
Bali's head. The rear walls of the cave are devoted to goddess
Lakshmi lustrated by elephants, and Durga as the heroic
warrior goddess. The main shrine today is empty; the cave is
the only one at Mamallapuram which has a ceiling carved with
floral designs that still show traces of paint.

131
Vishnu as
Varaha,
Varaha cave,
Mamallapuram,
*c.*630–68

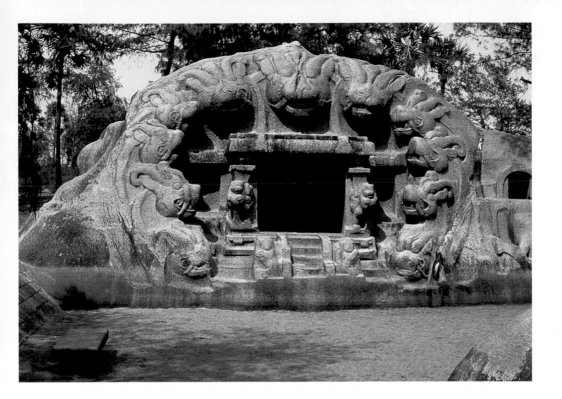

132
Yali cave,
Mamallapuram,
c.700

During his reign, Parameshvara (r. *c.*670–700) fought several battles against the Chalukyas and the neighbouring southern kingdoms. But he too continued patronage at Mamallapuram and may have commissioned the Shaiva cave known as the Mahishamardini (slayer of the buffalo-demon); his name Parameshvara or 'Great Lord' is an epithet of Shiva. While dedicated to Shiva (the rear wall of the shrine contains a Somaskanda panel), its left wall features Vishnu reclining in slumber upon the milky ocean prior to the creation of the world, while its right wall presents the great battle between the goddess Durga and the buffalo-demon that gives the cave its name (133).

An extraordinary creation, the Yali (or Tiger) cave is located some 4 km (2½ miles) to the north of the site (132). A great boulder has been converted into a fanciful structure with enlarged heads of *yali*s or mythical lion-like creatures framing a shallow niche in the rock face. The niche is flanked by rearing

133 Overleaf
Durga fighting
the buffalo-
demon,
Mahisha-
mardini cave,
Mamallapuram,
c.670–700

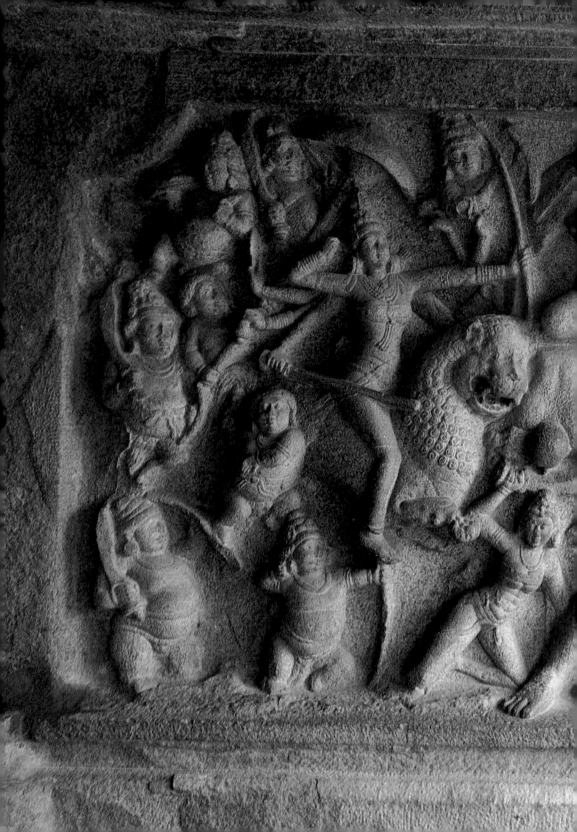

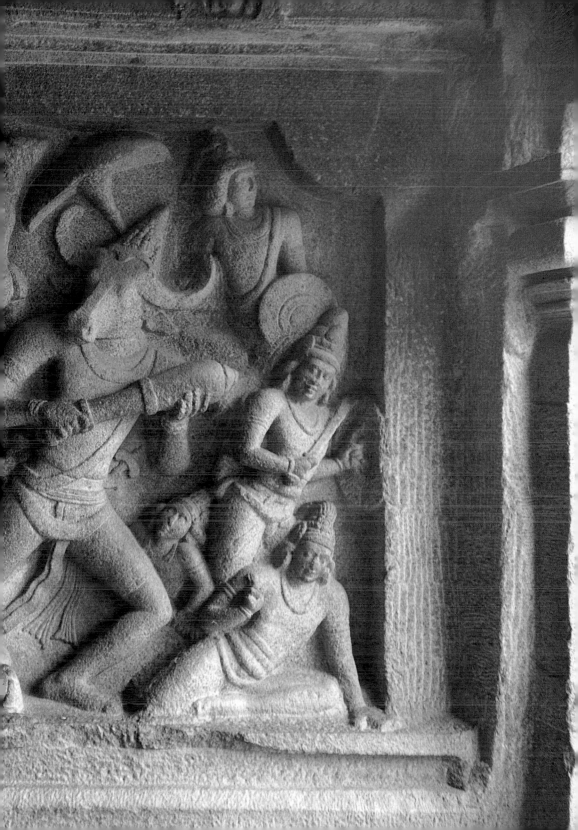

lion pilasters. The rest of the boulder has been carved to present frontal views of two elephants with *howdah*s on their backs carrying images of deities. As in several other structures at Mamallapuram, it would seem that water was meant to collect in the hollow space in front of the cave. What purpose did it serve? Perhaps a sacred image was brought in procession along the beach to be placed in the shallow niche to witness a festival, and then taken back to its home site.

The reign of the last great monarch of the imperial Pallavas, Narasimhavarman II, known as Rajasimha, seems to have been relatively free of warfare, and he was able to devote his time to temple-building. The quintessential monument of his reign is his personal chapel of Kailasanatha, named after Shiva's mountain home, at his capital of Kanchipuram, 72 km (45 miles) from Mamallapuram. Oriented east–west, the Kailasanatha complex consists of a sandstone shrine with a detached hall, enclosed within a rectangular courtyard wall (134, 135). The impressive pyramidal *shikhara*, a clear progression from the Dharmaraja *ratha*, represents the southern temple in its fully fledged form. The main shrine houses a Shiva *linga*, 2·5 m (8 ft) high, and against its back wall is a sculpted Somaskanda family group. Seven sub-shrines, attached to the exterior of the main shrine, contain monumental images of Shiva some 3 m (10 ft) high, including Shiva dancing, as the enchanting mendicant, destroying demons and receiving the Ganges. We see the unmanifest in the *linga*, and the manifest in the anthropomorphic images both in the sub-shrines and in the many aedicules along the temple walls. The hall in front (the connection between is a sixteenth-century addition) carries sculpted images of four forms of the goddess. Ancient religious texts, the *agama*s, describe the hall as the embodiment of the feminine force, Shakti, and the shrine as the male energy or Purusha.

Rajasimha's engraved foundation inscription encircles the sanctum and informs us that he 'erected this extensive and wonderful house of Shiva, whose grandeur resembles the fame and the

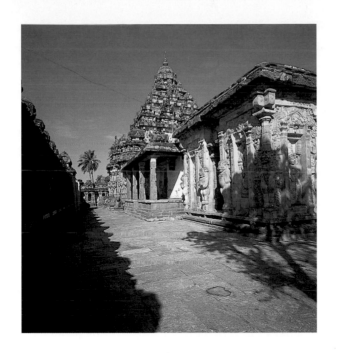

134–135
Kailasanatha
temple,
Kanchipuram,
*c.*700–28
Above
View within
the courtyard
enclosure
Below
Corner rear
view of the
shrine

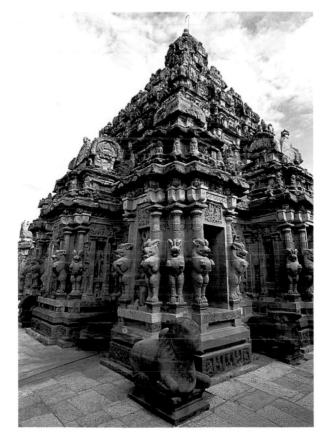

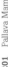

laughter of Shiva'. The temple seems to have been something of a family undertaking. Immediately inside the entrance is a compact, barrel-vaulted, rectangular shrine built by Rajasimha's son Mahendra, while beyond the modest entrance gateway stand eight miniature shrines apparently built by Rajasimha's queens. A considerable distance in front of the temple is a pavilion with Shiva's bull seated within it, facing the lord.

The enclosing courtyard wall consists of a series of mini-shrines. The shrines of the east and west walls carry sculpted Somaskanda images; those along the north and south walls contain, in addition to interior images, a shallow niche on their façades to accommodate further images. These interiors feature either the family group of Shiva, or Uma on her own; some are sculpted while others are purely painted forms revealed recently after the layer of lime plaster was removed. A specific programme is evident in the placement of images; for instance, the destructive aspects of Shiva are all located along the south wall, while his benign aspects are portrayed along the north. Within the courtyard of this Shaivite shrine, Vishnu appears in a range of forms that include Narasimha and Trivikrama.

A unique feature of the Kailasanatha temple is the recording of the over 250 titles or *biruda*s of Rajasimha along the base of these courtyard shrines. The titles are inscribed four times, on four different levels, in varying styles of script – northern, southern and florid versions. The *biruda*s celebrate Rajasimha's exploits and accomplishments. He is Ocean of Arts or *Kala-samudra*; Storehouse of Arts or *Kala-nidhi*; Sole Hero or *Eka-vira*; Victor in Battle or *Rana-jaya*; Unconquered or *Aparajita*; Devastating in Battle or *Atiranachanda*; He who Showers Gifts or *Dana-varsha*; One of Unlimited Fancies or *Atyantakama*. The titles reveal much about the personality of an ideal ruler: his beauty, temperament, valour, care for his subjects, mastery of politics, upright conduct, personal accomplishments, love of the arts and, in Rajasimha's case, his adoration of Shiva. The titles

also demonstrate the enormous difficulty of ascribing monuments, such as the Dharmaraja *ratha*, to any ruler solely on the basis of inscribed *birudas*.

At Mamallapuram itself, Rajasimha built the Shore Temple (136, 137) with its twin granite towers glorifying Shiva twice over. It bears a clear dedicatory inscription. The larger shrine faces the ocean, the smaller one inland; both carry Somaskanda reliefs on their rear walls. According to a tale narrated by poet Dandin, an image of reclining Vishnu, carved into a rocky outcrop, once occupied pride of place upon the seashore. When Rajasimha decided to proclaim the glory of Shiva at that very spot, he left the reclining image in place and even built a little pavilion around it; but then he sandwiched it between two shrines to Shiva, literally putting Vishnu in the shade. Until recently, the ocean waves beat onto and into the Shore Temple, but today a reclamation project protects it. Recent excavations have yielded evidence of a Pallava retaining wall towards the land side of the temple, making one wonder if the promontory was once an island.

There is much at Mamallapuram that remains enigmatic. After Rajasimha, there was a dynastic revolution, and a collateral

136
Shore Temple,
Mamallapuram,
*c.*700–28

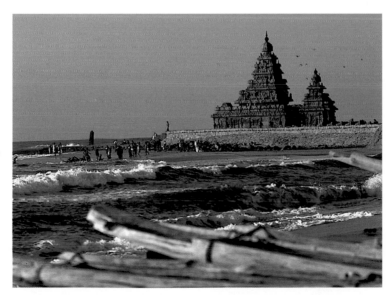

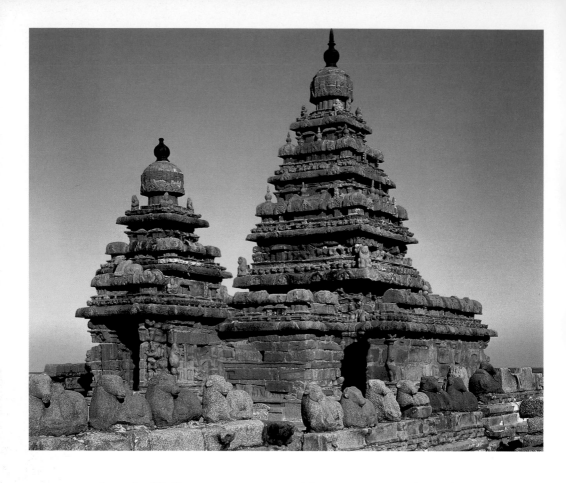

137
Shore Temple,
Mamallapuram,
*c.*700–28

branch of Pallavas came to power. They too were passionately interested in art and religion, and built important temples at Kanchipuram. However, it seems they did not build at Mamallapuram. Perhaps the site was too strongly associated with the Simhavishnu-to-Rajasimha branch of the Pallavas. The reason why Mamallapuram was never completed remains a mystery. Perhaps the answer is to be found in the obscure history of the later Pallava rulers.

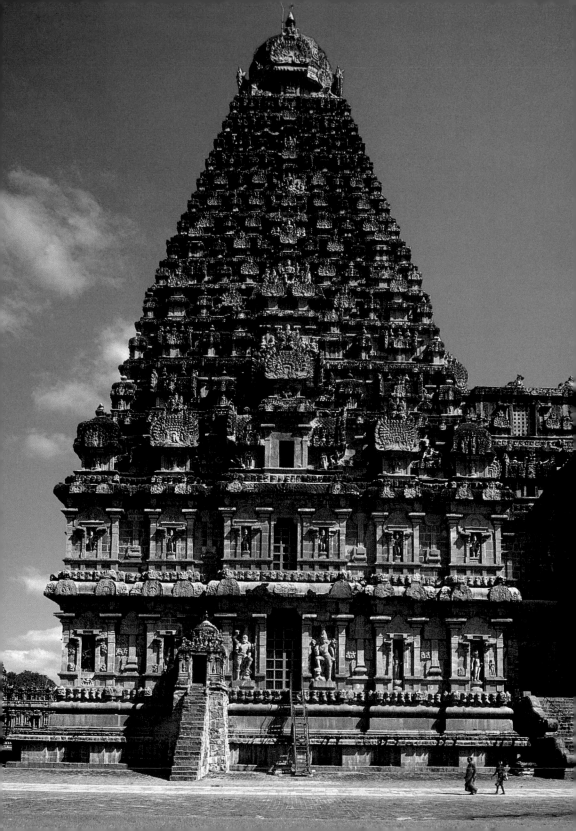

In the year 1010, southern India was resounding with news of
the imposing granite temple just completed by emperor Rajaraja
Chola (138). Five times the size of the shrines constructed by his
ancestors, this temple was enclosed by a set of high walls, with
access through two impressive gateways. Its *shikhara*, the sky-
scraper of its time, was crowned by a great *stupi*, or crowning
element, topped by a magnificent copper *kalasha*, or water
vessel, that reached 66 m (216 ft). It surpassed all other temples
in India in height and space and in the grandeur of its bronze
images of the gods. It was indeed a fitting adornment for the
Chola capital city of Tanjavur (Tanjore) situated on the banks of
the sacred Kaveri River. Known as the Rajarajeshvara or Lord of

138
Rajarajeshvara
temple,
Tanjavur,
completed
1010

Rajaraja, and dedicated to god Shiva, the temple was a superb
example of the Dravida or southern style.

While the curvilinear *shikhara* of the northern Nagara temple is
emphatically vertical, all but obscuring the ascending levels,
the *shikhara* of the Dravida temple permits us to distinguish its
various horizontal levels. Dravida temples further differ from
the Nagara in having flat-roofed halls with plain ceilings. While
the Dravida temple interior relies on the same post-and-lintel
mode of construction, its pillars are undecorated and have none
of the bracket figures seen so repeatedly in the north. Neither
do the exterior walls feature any female figures, couples or
erotic groups, which apparently were not considered especially
auspicious in South India. Images of deities alone tend to grace
the walls of Dravida temples, with occasional additions of
kings, saints and legendary devotees. Aedicular niches enshrin-
ing deities are frequently flanked by vignettes portraying
mythological stories associated with them.

The Cholas first appeared as a ruling family during the Sangam period in the first two centuries AD. They re-emerged around 850 when a chieftain named Vijayalaya, possibly a feudatory of the Pallavas, captured Tanjavur and established the Vijayalaya line of Cholas. The distinctive and elegant Chola temple is a product of the architectural and sculptural features which coalesced during the reigns of Vijayalaya's successors, Aditya I (r. *c*.871–907) and Parantaka (r. *c*.907–47).

Perhaps the most intriguing and idiosyncratic of these temples is the Nageshvara at Kumbakonam, completed in 886. The central aedicular niches on the three side walls of the shrine, as

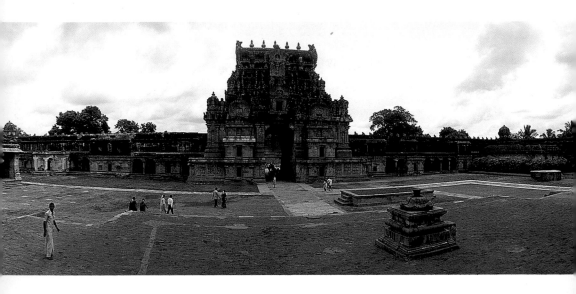

well as the two on the walls of the hall in front, are here flanked by further niches with elegant male and female figures, that appear as if about to step forwards. They perhaps represent members of the royal household, together with their gurus and preceptors – or possibly they are the various characters of the *Ramayana* epic. The aedicular niche on the rear wall of the shrine contains a sinuous, elegant stone image of Shiva in his androgynous form as Ardhanari; the two flanking figures of

aristocratic males have been identified as Rama, hero of the epic, and his brother Lakshmana. Around the corner from Rama, in a flanking niche on the side wall, is a sensuous princess, perhaps Rama's wife Sita (140). In this small, exquisitely sculpted shrine, the master stone sculptor has imbued every image with vitality, beauty and élan.

One of the most important patrons of the tenth century was queen Sembiyan Mahadevi whose inscriptions reveal she was involved in temple-building and its associated arts for over sixty years. Sembiyan appears to have had a sense of the historical;

139 Left
Courtyard and entrance gateways, Rajarajeshvara temple, Tanjavur, c.1004–10

140 Right
Princess, perhaps Rama's wife Sita, rear wall of the Nageshvara temple, Kumbakonam, completed 886

141 Far right
Shiva Nataraja, Shiva temple, Sembiyan Mahadevi, c.980

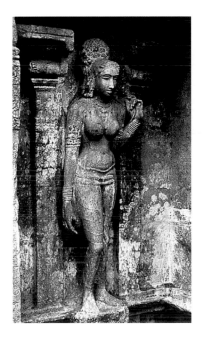
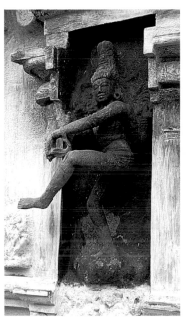

when she rebuilt in stone a number of earlier brick temples, she reinscribed the prior donative inscriptions before adding her own. It was during her reign too that the characteristic image of Shiva Nataraja became established in both stone and bronze (2, 141). The beauty of this form of Shiva, in the posture known as the dance of bliss or *ananda tandava*, was such that saint Appar described it as one for which even rebirth on earth was desirable (*Tevaram*, bk 4, hymn 81, v 4):

If one may see his arched eyebrows

the gentle smile upon his lips of kovai red

his matted locks of reddish hue

the milk white ash upon his coral form

if one may but see the beauty of

his lifted foot of golden glow –

then indeed one would wish

for human birth upon this earth.

Sembiyan's grandson Rajaraja, born as Arulmoli or Essence of Grace, ascended the throne in 985, inheriting a small kingdom centred around the delta of the Kaveri, the lifeline of the South. He amassed an army of thirty-one regiments that included elephant troops, cavalry and foot soldiers, and embarked on transforming his kingdom into a vast empire. Defeating the monarchs of the neighbouring Chera and Pandya kingdoms as well as the Chalukya rulers to his north, he then captured the Maldive Islands and the Buddhist island kingdom of Sri Lanka. The Tiruvalankadu copper-plate inscription boastfully celebrates the defeat of Lanka:

Rama built with the aid of monkeys, a causeway across the sea, and then with great difficulty, defeated the King of Lanka by means of sharp edged arrows. But Rama was excelled by this King whose powerful army crossed the ocean by ships and burnt up the King of Lanka.

Having achieved his political and territorial ambitions in the first eighteen years of his reign, Arulmoli Chola assumed the title of Rajaraja or King of Kings. Now it was time to celebrate his victories and declare his overlordship by building a temple that would not only glorify Shiva, but also would stand as a testament to Rajaraja's power.

Two stylized portraits of Rajaraja are found in his temple, one in stone, the other in paint (142); a third commission in bronze, of the emperor with his queen, no longer exists. In the sculpted and painted portraits, Rajaraja is portrayed with matted locks piled high upon his head, in imitation of Shiva, as he stands or

142
Portrait of king
Rajaraja with
his spiritual
guru,
Rajarajeshvara
temple,
Tanjavur,
c.1010. Paint
on plastered
granite

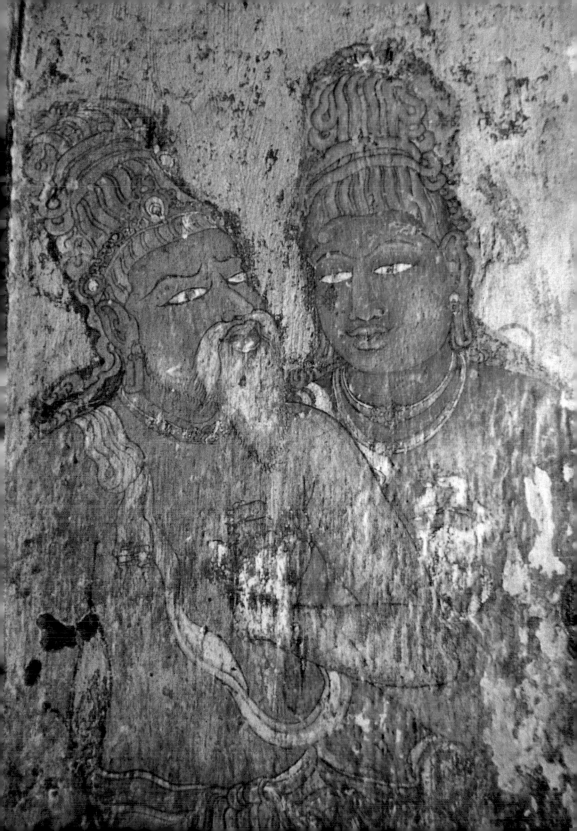

sits humbly behind his spiritual guru, the venerated, bearded Karuvur Devar. As is traditional in India, the stylized portraits give little indication of the personality of the monarch.

The small, exquisitely decorated temples constructed by Rajaraja's predecessors had walls approximately 4·5 m (15 ft) high, while the tallest *shikhara* rose to 10·5 m (35 ft). The base on which Rajaraja's Tanjavur temple stands is itself 4·5 m (15 ft). Its square sanctum, enshrining a monumental stone *linga*, is surrounded by circumambulatory paths at two levels. A flat roof covers the sanctum at a height of 10·5 m (35 ft), above which the *shikhara* commences its graceful inward slope, as a hollow pyramid in thirteen horizontal stages. A recently discovered inscription seems to indicate that gold plate may have been applied to parts of the *shikhara*. A square platform caps the tower, repeating precisely the size of the sanctum that lies directly below. Upon this capstone was placed an immense *stupi* originally plated with gold, and crowning it was a copper *kalasha* presented by the emperor in 1010 to signify the completion of the temple project.

The temple complex is precisely laid out. If the large enclosing courtyard (241 × 121 m, 791 × 397 ft) is divided into two equal squares, the temple sanctum occupies the centre of the rear square, and the open pavilion housing Shiva's bull, the centre of the square in front. Recent studies reveal that the height of the temple, without its *stupi* and *kalasha*, is the unit of measurement for the courtyard, which is twice that unit in width and four times in length. Enclosing the temple is a two-storeyed pillared cloister, built by the emperor's trusted general. It is entered by a three-tiered *gopuram*, or pyramidal gatehouse (139), with impressive sculpted guardian figures, while beyond this stands a larger and taller five-tiered *gopuram*.

Situated on a piece of high ground and surrounded by a wide moat (143), the complex once consisted of the stone temple plus Rajaraja's brick royal palace, which was linked directly to the temple through a gateway in its northern wall. The building

143
Rajarajeshvara
temple,
Tanjavur,
completed
1010. General
view with the
moat

of this royal complex was considered such a magnificent
achievement that it seems to have been the subject of a play
entitled 'Rajarajesvara natakam'. An inscription of one of
Rajaraja's successors details the wages paid to a troupe of
actors, and speaks of special provisions made for the enactment
of the play during a great festival held at the temple. If ever the
manuscript were discovered, it might indeed yield valuable
data regarding Rajaraja's ambitious venture.

Of the miscellaneous shrines within the compound, only the
Chandesa shrine is part of the original Chola programme (145),
the remainder being later additions. According to legend, every
day young cowherd Chandesa built a mud Shiva *linga* and
lustrated it with milk; he would then sit engrossed in contem-
plation of Shiva. Investigating complaints about Chandesa's
misuse of milk, his enraged father kicked the *linga* whereupon
Chandesa blindly lashed out at the intruder's foot with his staff;
transformed into the axe of Shiva, the staff felled his father to
the ground. Chandesa was blessed by Shiva who promised to be

a father to him, and he won a place among the sixty-three 'canonized' saints of Shiva. The Cholas projected him into the role of temple guardian; who better to guard a temple than one who had tended a mere mud *linga* with such single-hearted devotion?

The monumental walls of the Tanjavur temple are divided horizontally into two sculptural levels, each comprised of a series of niches (146). On the three outer walls of the temple, door-sized 'windows', visual counterparts of the door giving access

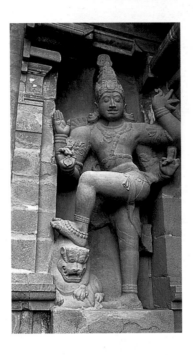

144–146
Rajarajeshvara
temple,
Tanjavur,
*c.*1004–10
Left
Dvarapala or
guardian figure
Above
Chandesa
shrine
Below
View of the
rear wall

to the sanctum, allow in light and air. In the niches of the lower level is a range of manifestations of Shiva that include Nataraja, Lord of Dance; Bhikshatana, the naked mendicant whose beauty and charm won the hearts of the women who came to give him alms (147); androgynous Ardhanari; and Lingodbhava, in which he materializes within a column of fire to demonstrate his superiority over gods Vishnu and Brahma. In contrast with the profusion of imagery on the lower level, each of the thirty upper-level niches carries an identical image of Shiva as Tripurantaka, following his triumphant destruction of the forts

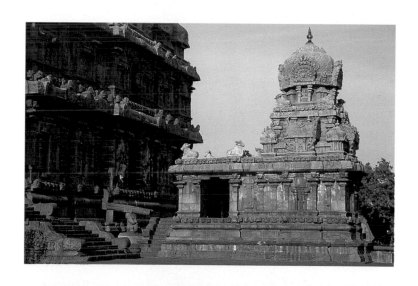

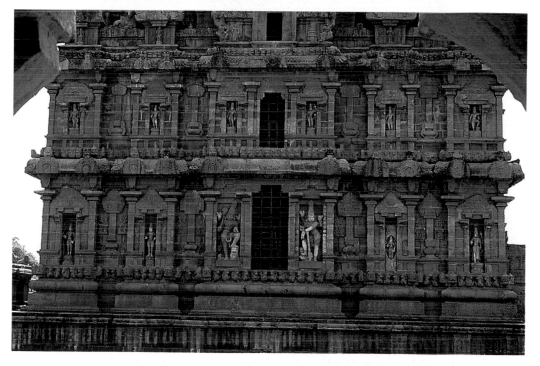

147
Shiva as
enchanting
mendicant,
Rajarajeshvara
temple,
Tanjavur,
c.1004–10

of three demons with a single arrow. The emphatic repetition of
this form suggests that it held a specific meaning for Rajaraja,
himself a proud conqueror, who early in his reign needed a
divine archetype whose blessings would ensure him victory.

The carving of the stone images on the temple walls lacks the
fluency of modelling and the inspired idiom that we might
expect from artists capable of constructing so powerful a build-
ing. Compared with early Chola imagery (140), figures are
broad shouldered, broad bodied and somewhat flaccid, and the
face is frequently heavy and lacks expression. While icono-
graphic concepts are clearly expressed in stone, Shiva as
Bhikshatana lacks the sensitivity of treatment and appeal that
the bronze caster was able to capture (153). The disappointing
impact of these sculptures may be due to the artists' unfamil-
iarity with carving such large images (roughly 3 m or 10 ft high)
to suit the size of the Tanjavur temple.

Painted murals decorate the lower path around the sanctum,
which is divided into fifteen bays, each devoted to a single
mythological theme. The major figures, scaled to occupy the
entire height of the lofty passage, seem taut and rigid, but the
smaller figures display a remarkable rhythm and a flexibility of

148
Celestial
dancer, lower
ambulatory,
Rajarajeshvara
temple,
Tanjavur,
c.1004–10

movement (148). Painted legends of Shiva include a giant
portrayal of his dancing form, his feat as Tripurantaka, and his
role as friend and confidant of the saint Sundarar. Painters
created durable murals, using fresco where colours are applied
to a layer of wet limewash which absorbs the pigments. Fresco
painters had to work with great speed to complete each section
before the limewash dried. Except for blue obtained from
imported lapis lazuli, all other colours were locally available.
White was from lime, black from lampblack, yellow and red

from ochres, green from terre-verte, while other shades were obtained by mixing pigments. The colours are subdued, and the outlines were redrawn to yield firm, sinewy lines. Later rulers of the sixteenth century superimposed a new layer of paintings upon these Chola murals; it was only when these were partly destroyed by water that the earlier work of Rajaraja's artists surfaced.

The painted murals in the lower *pradakshina* passage, which is both narrow and dark, are impossible to see without ladders and powerful lights. Their primary aim seems to have been to complete the iconographic programme of the temple and thereby increase its sacred potency. The upper *pradakshina* path has a low enclosing ledge which is adorned with relief carvings that present the 108 traditional poses of classical Indian dance listed in the ancient dance texts; the unfinished state of the last twenty-seven images suggests a hurried completion of the temple.

The custom of creating sizeable portable bronzes of deities to participate in a range of rites became widely prevalent during Chola rule. The images were ceremonially bathed, clothed, decorated with flower garlands and venerated. Inscriptions inform us that Rajaraja's temple possessed sixty-six bronze images of gods and saints, as also of the monarch himself. The majority was donated by Rajaraja and his queens, while a few were gifted by the temple manager, the chief priest and other dignitaries.

Bronzes were created by the lost-wax process whereby the image is initially created – in every last detail – from hard beeswax combined with a local resin. It was then encased in two layers of clay. This clay-enclosed wax image was fired in a kiln so that the melted wax ran out of tubular outlets, leaving a hollow clay mould. Molten metal was then poured carefully into this mould. Once cool, the mould was broken to release the solid bronze image. Every detail originally contained on the wax image is evident in the bronze and each is a unique piece

since the clay mould is broken and cannot be re-used. Separate hollow castings produced a lotus base for each image and a rectangular pedestal.

Chola bronze casters produced some magnificent images for Rajaraja. The Tanjavur inscriptions speak of a group comprising Shiva, his bull and goddess Parvati, known as Vrishabha-vahana (with the bull as mount), standing on a common base and framed by a single aureole. While this particular group is missing, we get some idea of its appearance and quality by examining a Rajaraja commission for a nearby temple at Tiruvenkadu (149). This majestic image, in which Shiva is poised to rest his hand upon his now missing bull, was produced in 1011. Shiva's matted hair is wrapped in a turban of snakes; his eyes have a distant look of contemplation. The restrained elegance of the piece makes it one of the most exquisite of Chola bronzes. The image of his consort Parvati was commissioned a year later. The fluent outline of her slim body and the gentle curve of her breasts in profile is characteristic of the style of Rajaraja's workshop.

From the same workshop comes a theatrical group depicting the marriage of Shiva and Parvati (150), and referred to as Kalyanasundara. The stately bridegroom, with matted locks piled high on his head to resemble a crown, takes Parvati's hand. Beside the demure bride stands her companion, goddess Lakshmi, who gently pushes her towards the groom. On the other side of Shiva stands god Vishnu who, in certain versions of the story, was the officiating priest at this divine wedding. Inscriptions specify that the Tanjavur temple's marriage group omitted the bride's companion but included god Brahma as officiating priest in addition to Vishnu.

Once the bronze images had been created, royalty, nobility, landowners and merchants gave generous gifts of jewellery for their decoration. Inscriptions speak of a dazzling array of girdles, necklaces, crowns, diadems, anklets, bracelets, ear ornaments, and toe and finger rings, all made of gold and set

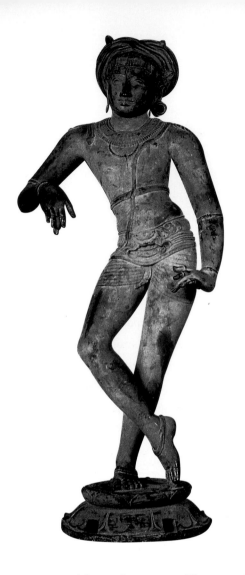

with precious gems. The records specify the exact weight of gold contained in each item down to the gold screws used to attach beads. They speak of pearls, diamonds and corals, specifying the number of perfect quality, those with minor flaws and those of lesser value. An entire treatise on Chola jewellery could be culled from the detailed records inscribed along the base mouldings of the temple, which list sixty-five distinct varieties of ornaments. All booty acquired in war went to the temple coffers, and an enormous amount of gold ritual vessels and lamps was also gifted to the temple, whose gold reserves must have been considerable.

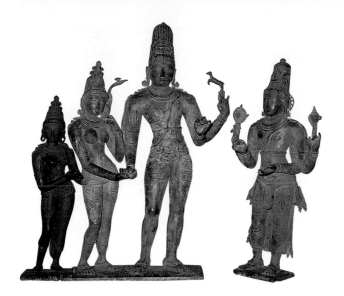

149
Shiva and
Parvati,
Tiruvenkadu
temple, 1011
and 1012.
Bronze, Shiva,
h.106·5 cm,
42 in;
Parvati,
h.93 cm,
36⅝ in.
Tanjavur Art
Gallery

150
Marriage
group of Shiva
and Parvati,
Tiruvenkadu
temple, c.1012.
Bronze; Shiva,
h.95 cm,
37½ in.
Tanjavur Art
Gallery

Rajaraja's royal temple required a large staff to attend to its
regular ritual needs and to ensure its maintenance. Of the 850
temple employees listed in inscriptions, 400 were dancing girls
and sixty-seven musicians. The dancers, brought to Tanjavur
from the many smaller temples of Rajaraja's empire, lived in
their own houses in two streets adjoining the temple. Each was
given the entire yield of rice from one *veli* (roughly five acres) of
land, a quantity sufficient to ensure her a comfortable living.
Inscriptions imply that the profession was hereditary. Temple
dancers were highly accomplished in the arts of poetry, music,
dance, drama and painting, and were called upon at various
times of the day to dance in the main hall in front of the sanc-
tum, in honour of Shiva. From records of twentieth-century
interviews with the last of these dancers, we learn of the status
and respect accorded to them; without their dance, the worship
of the Lord was considered incomplete and lacking in *rasa*.

The vast number of functionaries needed to support this great
religious complex – 174 priests, 143 watchmen, treasurers,
accountants, astrologers, lamp bearers, water sprinklers,
potters, tailors, carpenters, goldsmiths and appraisors of jewels
– was coordinated by the temple manager, chief Adittan
Suryan. Rajaraja made a variety of arrangements to ensure

adequate financing. He designated entire villages as gifts to the deity, which then had to supply all the foodstuffs needed for the ritual food offering. The types of food specified as temple offerings include rice-and-curds and are identical to those eaten to this day in the south. Village herders were given a certain number of animals; from the milk yielded, they had to provide a daily supply of butter and ghee for use in the 158 butter lamps that illuminated the temple in the evenings. Inscriptions speak also of money set aside to ensure that fragrant cardamom seeds and the aromatic khus root were available each day for the ritual bath of the deity.

Rajaraja set aside certain tracts of lands as *devadana*s or gifts to the deity, ensuring that their revenue went directly to the temple. He seems to have instituted a highly efficient system of revenue survey and settlement, carried out by an officer entitled Ulagalandan or One who Measured the Earth. Records speak of the confiscation and sale of lands belonging to those who had not paid their dues for three years.

Defeated feudatories and vassals too had to support Rajaraja's great temple by contributing a portion of their revenues, both in cash and in kind. Thus, villages from the captured island province of Sri Lanka were required to send to the temple a portion of their revenue as well as a designated amount of rice. Yet despite this single-hearted devotion to Shiva, Rajaraja was quite happy to permit a feudatory prince to grant a village to support a Buddhist monastery in his kingdom.

The Tanjavur temple was the sacred centre of the town, and the finest architects, sculptors, painters, bronze casters and jewellers gave of their expertise to produce an impressive religious nucleus. But it was also the town's civic centre, and the focus for the music and dance, that played a significant role in temple ritual. The sixty-seven temple 'musicians' of Rajaraja's temple include six dance masters, four drama directors, five singers of Vedic hymns, four singers who specialized in the hymns of the Tamil saints and five other vocalists. Rajaraja's

inscriptions indicate that the temple was an educational centre too – an important aspect of the temple until recently, as all schools for Vedic studies were attached to temples, and were administered and staffed by temple priests. Additionally, the temple was the main banking institution and lent money at 12·5 per cent interest, projecting saint Chandesa into the position of divine financial agent who dispensed and collected temple money. Several hundred temple inscriptions, like this one, record such transactions: 'We have received from Chandesa, who is the first servant of the divine lord, 500 coins out of the money deposited '

Literary genius in the Tamil language reached new heights and Chola courts began the system of appointing poet laureates known as *kavi chakravartin*s or poet-kings. The great poet Kamban, who wrote the Tamil version of the original Sanskrit *Ramayana*, lived during the Chola period. The lively *Periya Purana*, or Great Ancient Text, which narrates the lives of the Tamil saints in fluent Tamil prose, was produced during the reign of the Chola monarchs, and commentaries were written on the influential philosophical system of Shaiva Siddhanta.

Two years after completing his Tanjavur temple, Rajaraja decided to crown his son Rajendra as emperor, and both father and son ruled jointly for four years. In Rajendra's reign, the Chola empire reached the peak of its power. Rajendra led campaigns into the northern Indian states of Bihar and Orissa. He then marched to the banks of the sacred Ganges and returned with pots of water carried, according to the words of his arrogant inscription, 'on the heads of vanquished rulers'. His successful naval expeditions to the Malay peninsula, Sumatra and Java extended a degree of Chola control, though not direct rule, into Southeast Asia. Rajendra occupied the Andaman and Nicobar islands, and maintained diplomatic relations with China and Burma.

Early in his reign, Rajendra decided to build a new temple and a new capital city some 65 km (40 miles) north of Tanjavur.

Considering the grandeur of the barely completed Tanjavur temple, he must have believed this necessary, as a new sovereign, to establish his personal supremacy. At the site of his capital, he created an artificial lake, 25 km (16 miles) long and 5 km (3 miles) wide, connected to the nearby Kolladam River by weirs and input channels. Into this he symbolically emptied his pots of Ganges water, naming his capital Gangai-konda-chola-puram, or 'City of the Chola who captured the Ganges'.

Only Rajendra's granite temple (151) today stands intact at Gangaikondacholapuram. The adjoining palace area appears to have been built of brick with wooden columns that rested on circular granite bases. The elemental nature of this excavated material makes it difficult to conjure up the glory of the palace suggested by Rajendra's poet laureate (*Rajarajacholan Ula*, v 79–81):

Palace entrance, mansions, avenues,
temples, pavilions, balconies,
windows, verandas, upper storeys,
dancing halls and platforms
were filled with palace women
with crowds of people
so that the very landscape around
was made invisible to the eye.

Rajendra's temple closely resembled the masterpiece just completed at Tanjavur. In fact, there is little doubt that architects and craftsmen were transferred from Tanjavur to the new capital to work on Rajendra's commission. Here too the temple shrine has an outside measurement of 30 m (100 ft) on each side; however, it only reaches up to a height of 50 m (164 ft), being proportioned somewhat differently. The sculpted imagery within its many niches is more imaginative in treatment than at Tanjavur where images were placed frontally. In Rajendra's temple, sculptors often carved figures in three-quarters view, to turn and look out sideways, suggesting their increasing famil-

iarity with creating over life-sized images (152). The temple appears to have been completed by 1035.

Bronze workshops that had created images for Rajaraja continued to work on commissions for Rajendra's temple, and the image of Shiva Bhikshatana is one of their masterpieces (153). Inscriptions recording gifts of jewels to this bronze, in 1048, confirm its production early in Rajendra's reign. Clad in sandals, with the snake as his only garment, and followed by his pet antelope, Shiva wandered the earth seeking alms. Wherever he went, the women who came to give alms fell in love with the inexpressible radiance of his form. In the words of saint Sundarar (*Tevaram*, bk 7, hymn 36, v 7), these women, enamoured of his form, yet keenly aware of the incongruous nature of his beauty, addressed him thus:

Wild golden cassia
adorns your hair,
your ornaments
are graveyard bones,
the dark dense forest
is your home,
and the bowl
in your hand
is a skull –

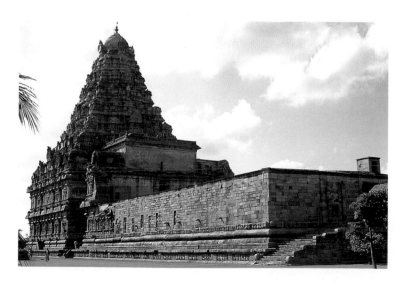

151
Gangaikonda-
cholapuram
temple, *c.*1035

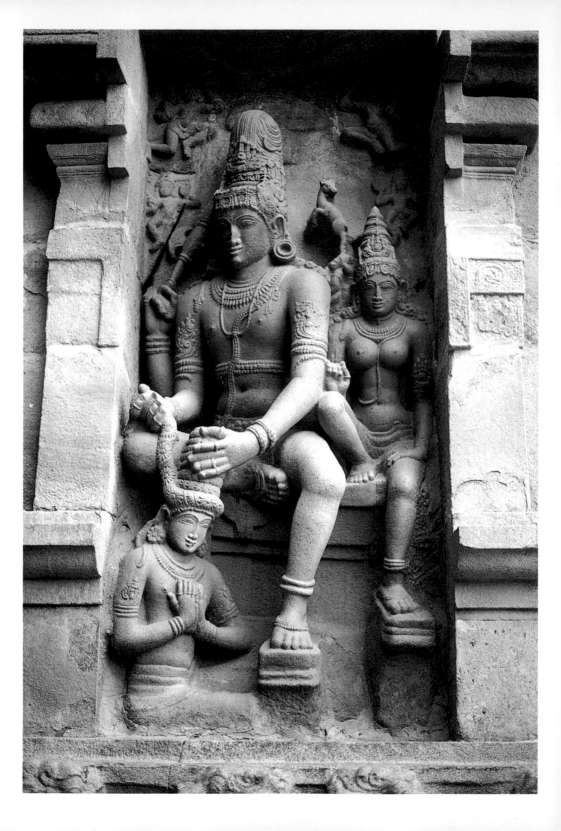

We women in love

what can we hope

to gain from you?

A captivating bronze of Shiva Ardhanari, similarly dated by inscription, distinguishes precisely the masculine and feminine aspects of the deity, and yet fuses them into a harmonious composite form. Facial features too reflect the difference; Parvati has a gently curved jawline while Shiva has a straight, firm profile. The feminine aspect of the image cannot be better visualized than by the child saint Sambandar who sang in its praise (*Tevaram*, bk 3, hymn 260, v 3):

Smooth and curved

her stomach

like a snake's

dancing hood.

Her flawless gait

mocks the peacock's grace.

With feet soft

as cotton down

and waist

a slender creeper,

Uma devi is one half of Shiva

lord of sacred Pundurai

152
Shiva and
Parvati blessing
saint Chandesa,
Gangaikonda-
cholapuram
temple, *c.*1035

The finesse displayed by the bronze casters in the creation of these images is as direct and alluring as the beautiful verses composed by the southern saints. In India, the relationships between the devotee and deity were many – slave and lord, child and parent, lover and beloved. Saint Sambandar felt it appropriate to describe the bodily form of the goddess, just as the artist in bronze felt no dichotomy in creating sacred images which may be classified as 'sensuous'.

Under the aegis of the Chola monarchs, the Tamil country not only widened its boundaries but also acquired fame and renown as the centre of a rich and varied culture. Succeeding

Chola rulers retained Gangaikondacholapuram as their capital, but each built his own grand temple in a town associated solely with him. Rajaraja II built his temple at the town of Darasuram, while Kulottunga III built a towering temple at Tribhuvanam. In the declining days of Chola rule, temples in which the shrine with its towering *shikhara* was the focal point were constructed less frequently. Instead, as we shall see in Chapter 10, temples grew horizontally in spatial terms to resemble mini-townships, and their massive *gopuram* gateways became the dominating feature of the southern landscape.

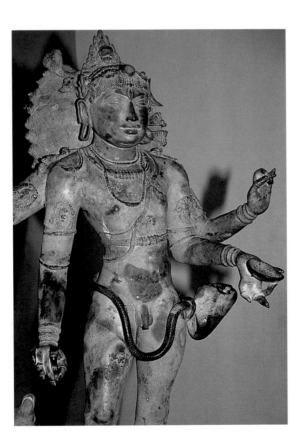

153
Shiva as
enchanting
mendicant,
Tiruvenkadu
temple,
consecrated
before 1048.
Bronze;
h.89 cm, 35 in.
Tanjavur Art
Gallery

God in Their Midst The Temple City and Festival Bronzes

10

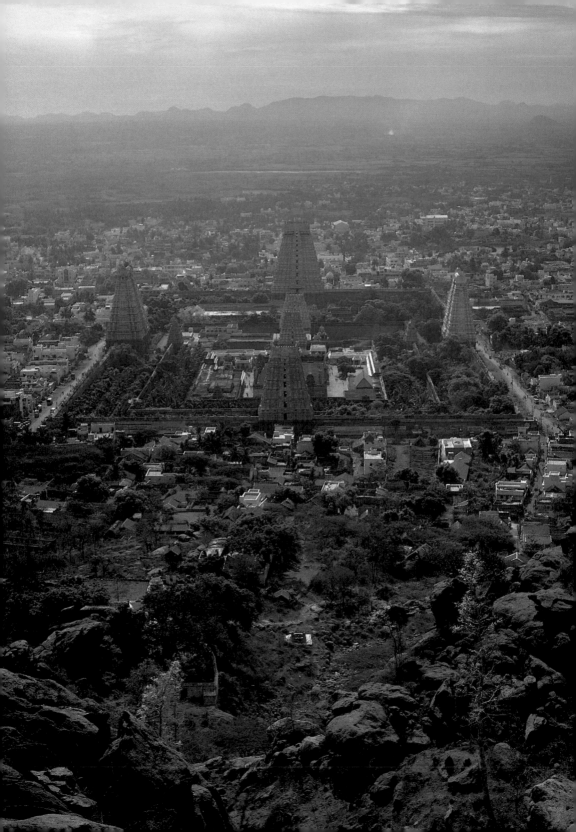

A persistent feature of the skyline of the densely populated
Tamil country is the pyramidal *gopuram* gateway, whose height
is anything between 20 and 60 m (66–197 ft). While earlier
forms of the *gopuram* were known at the Shore Temple at
Mamallapuram and the Tanjavur temple, these later *gopuram*s
overshadow the *shikhara* of the sanctum and give access to
expansive walled temple complexes (154), usually comprising
four concentric enclosures. The outermost enclosure, open to
the sky and entered through *gopuram*s on each of its four sides,
contains halls and shrines, as well as a large, step-lined water
tank. The next, more compact, walled enclosure, entered
through smaller *gopuram*s, is also open to the sky, with a simi-
lar array of halls and shrines. The third enclosure, generally
covered with a roof, has one or two compact *gopuram*s. Finally
a single, small *gopuram*, sometimes two, leads to the innermost
roofed area which houses the sanctum. This intricate, almost
maze-like layout, often with asymmetrically placed *gopuram*s,
is confusing to the visitor who is likely to need directions to
find an easy route to the main sanctum.

154
Arunachalesh-
vara temple,
Tiruvannamalai,
1030–1600, with
19th-century
additions

One of the earliest temples of this style arose between the
twelfth and sixteenth centuries at Chidambaram, whose danc-
ing lord, Shiva Nataraja, had long been patron deity of the
Chola monarchs. The modest eleventh-century Chidambaram
temple now grew sixfold in size to occupy 16 hectares
(40 acres). The impetus for this expansion came from
Kulottunga I and Vikrama Chola, the first two rulers
(r. 1070–1135) of the new Chalukya–Chola line, and a major
force behind it was Naralokaviran, who served both monarchs
as general and minister.

The first walled enclosure of the Chidambaram complex,

entered by two *gopuram*s, was built during the reign of Kulottunga. The second wall and its two *gopuram*s were added during Vikrama Chola's reign, along with the great Shiva Ganga temple tank, subsidized by tributes collected from his feudatories in 1122. Minister Naralokaviran added several important structures in what became the third enclosure: the Hall of a Hundred Pillars, an extensive walled shrine for the goddess, a shrine for child saint Sambandar and a hall for the recitation of the *Tevaram* hymns of the Shaiva saints. The third wall with a double-storeyed pillared cloister was added by Kulottunga III (r.1178–1218), who also built two 'chariot' halls with wheels along their bases, one to serve as a shrine for Shiva's second son, Skanda, the other to serve as a dance hall. Four great *gopuram*s that gave access to the third enclosure seem to have been constructed between 1150 and 1300. Each is built of stone along its lower vertical section with aedicular niches housing deities; above this rise seven diminishing storeys of brick and plaster. Crowning the *gopuram* is a barrel-vaulted structure topped with thirteen *kalasha* finials. The base of these gate-houses, accommodating rooms for storage and guards, measures roughly 30 m wide x 9 m deep x 43 m high (98 x 29 x 141 ft). The northern *gopuram* was originally completed only up to its stone cornice level; its brick portions were added in the sixteenth century under the Vijayanagara emperors. No two of these outer *gopuram*s are directly opposite each other, while only the southern is even approximately at the centre of its wall. The fourth and outermost wall of the complex, enclosing the temple gardens, was also added during the last phase of activity in the sixteenth century.

The immediate motivation for this enormous expansion was the desire to transform an exceedingly sacred but small and architecturally insignificant shrine into a structure of majestic proportions. Custom ordained that it was improper either to demolish the shrine and build a more impressive one in its place or to change its appearance by adding a tall *shikhara* above the sanctum. One solution was to exalt its environment

by surrounding it with high walls and to provide access through impressive *gopurams*.

But the altered architectural and spatial emphasis was also due to changes in the concepts surrounding the enshrined god. Previously, the deity of a temple was visualized as resting solely within the darkened mystery of the sanctum, receiving homage and conferring benediction. From the eleventh century, the temple deity was increasingly allotted multiple roles similar to those of an earthly monarch, which included giving audience to devotees, inspecting the temple premises, celebrating birthday and marriage anniversaries, and taking an active part in special festivities. The stone image of the god remained within the sanctum to bless the devout who assembled at the shrine, but bronze images, generally 60–90 cm (2–3 ft) in height, were created to be carried in procession as festival images. We know, for instance, that during the twelfth century a bronze image of Nataraja was taken from Chidambaram to Killai, on the sea, to enjoy the fresh sea air; Naralokaviran, who constructed the road to the oceanfront, also erected a seaside pavilion to house the deity, and constructed a fresh-water tank to serve the needs of the devotees who assembled at the beach.

A temple would commission up to seventy such festival bronzes, depending on the wealth and size of its congregation. Annual activities at southern temples involved the celebration of special festivals each month, some of which lasted up to ten days. The creation of vast numbers of bronze images was governed by the fact that appropriate forms of the god and goddess were required for different occasions. A bronze Kalyanasundara group of Shiva taking the hand of Parvati in marriage, for example, such as the group created for Chola king Rajaraja (150), was appropriate only for the wedding anniversary celebration. Any temple of consequence thus needed to possess a range of festival bronzes, most of which were used just once a year and then returned to their place of rest in an area adjoining the sanctum.

A medium-sized temple hall was no longer adequate for the number of people who now assembled to witness temple festivities. In addition, each festival needed a suitable hall for its celebration. Thus, Naralokaviran's Hall of a Hundred Pillars at Chidambaram was erected solely as a marriage hall for Shiva and Parvati; devotees assembled there once a year to witness the festivities and to partake in the marriage feast cooked in the temple kitchens. As temple rituals and celebrations increased in number, a variety of impressive halls and pavilions was added randomly to existing premises – with the exception of a large tank, where devotees wash their feet before proceeding, which is usually located in the outermost enclosure. While their pillared halls and tall *gopuram*s are imposing structures, the expanded temples rarely hold together as unified architectural entities.

Most of the expanded temples of the Tamil region belong to a period slightly later than Chidambaram, having been built largely under the aegis of the Rayas of Vijayanagar (1336–1565) and the Nayaks of Madurai (1529–1736), erstwhile governors of the Vijayanagar emperors. These temples grew gradually from the centre outwards over several centuries. One of the most renowned is the Minakshi temple at Madurai along the Vaigai River (155–161), whose festivities provide an insight into the unique nature of the rituals of worship in which we see devotees recreating the gods in their own images. The Madurai temple is dedicated to Shiva, known locally as Sundareshvara or Handsome One, together with his consort Minakshi or Fish-eyed One. The dual shrines dedicated to god and goddess add to the complexity of the Madurai temple layout; while known today as the Minakshi temple, its floor plan reveals that the Shiva shrine is at the very centre of the complex, suggesting that the ritual dominance of the goddess was a later development. The two small shrines with modest *shikhara*s crowned with gold-plated *stupi*s, are located side by side and enclosed within their own roofed and walled enclosures, each entered by a small gateway, with a connecting gate in their common

155
West gateway of the Minakshi temple, Madurai, mainly 1336–1736, gateways repainted regularly

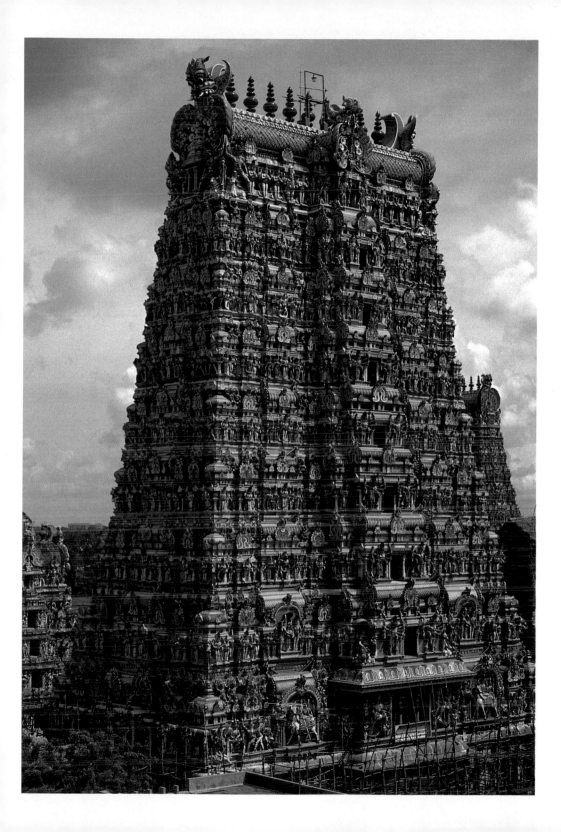

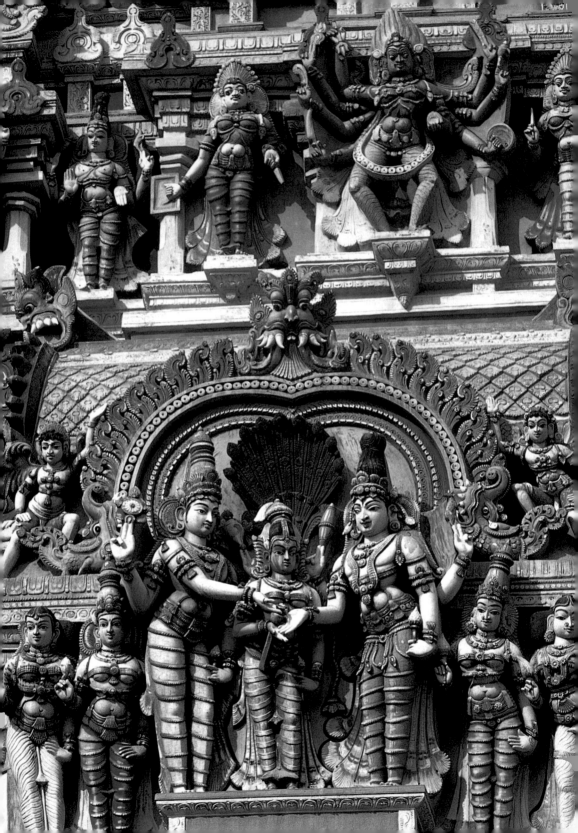

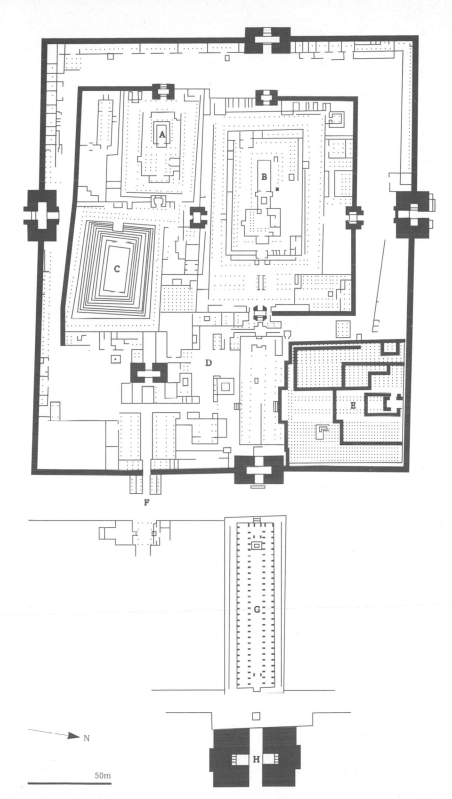

156–157
Minakshi
temple,
Madurai,
mainly
1336–1736
Left
Marriage of
Shiva and
Parvati, 1877.
Detail of
gateway
Right
Plan
(A) Minakshi
shrine
(B) Sundar-
eshvara shrine
(C) Golden Lily
tank
(D) Marriage
Hall
(E) Hall of a
Thousand
Pillars
(F) Porch of
the Eight
Goddesses
(now the main
entrance)
(G) New Hall
(H) Unfinished
gopuram

N

50m

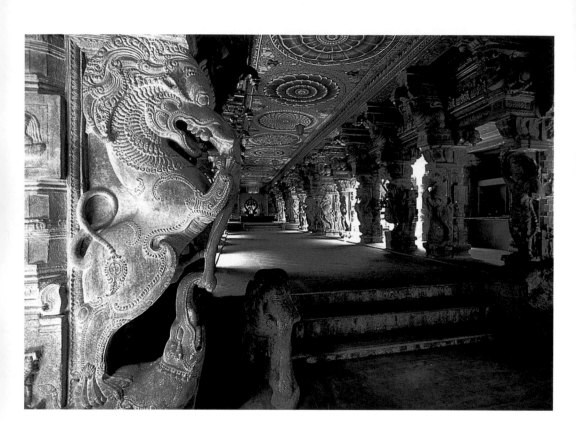

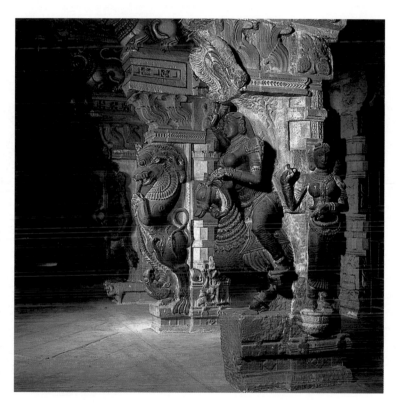

158–159
Hall of a
Thousand
Pillars,
Mīnakshī
temple,
Madurai, 1569
Left
General view
with a rampant
Yalı in the fore-
ground
Right
Rati on her
swan

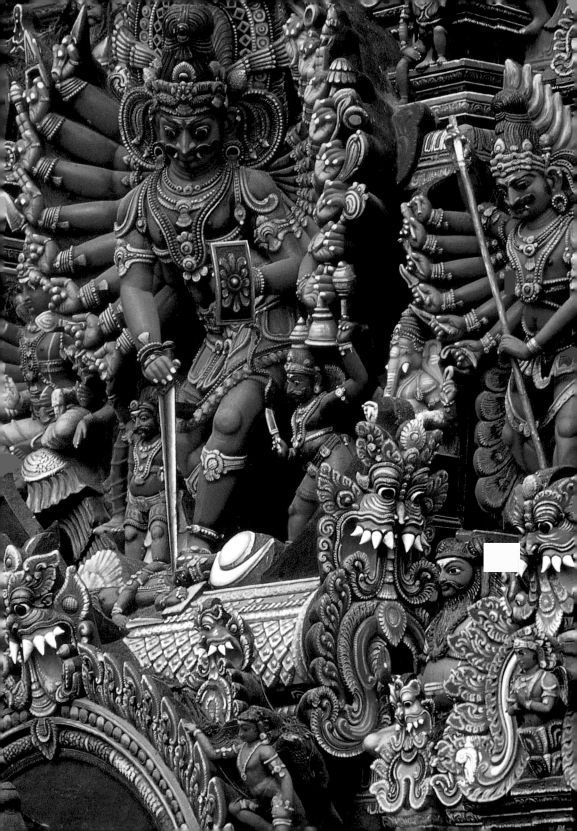

160–161
Minakshi
temple, Madurai
Left
Detail of figures,
south gateway,
1569
Right
Painted portrait
statue of
Tirumala Nayak
and his queens,
New Hall,
1628–35

side wall. Thereafter, no clear pattern can be traced in the
expansion of the temple; even the Golden Lily tank is relocated
from its standard location in the outermost enclosure to the
second enclosure outside the goddess's shrine (see 157).

Additions were made at Madurai according to the individual
predilections of its patrons. Its spectacular sixteenth-century
Hall of a Thousand Pillars (158) was sponsored by the minister
of a Nayak ruler. One pillar portrays an exquisite image of
Rati, consort of Kama, god of love, seated on her swan (159);
a second depicts the elephant-headed god Ganesha with his
consort on his knee; a third portrays youthful Skanda riding a
peacock; a fourth depicts Sarasvati, goddess of music and
learning, holding the string instrument known as a *vina*. Local
love legends revolving around gypsies are also featured; one
pillar depicts a handsome gypsy carrying away a lovely young
princess. Carved from single pieces of granite, each pillar is a
monumental work of art.

Clay-modelled figural sculptures decorate the brick superstructures of the Madurai temple's twelve gateways. Its south gateway, built in 1599 by a wealthy landowner, rises to 60 m (197 ft) in a soaring concave curve of nine storeys, and is covered with over 1,500 plaster figures of gods and demons painted in variegated colours (160). Flanking the window openings on each level are guardian figures, often with arms and legs akimbo to emphasize their immense strength. Every twelve years, as the temple prepares for a ritual reconsecration to maintain its sacred potency, craftsmen undertake repairs and renovation. Stucco figures are restored, even replaced, and repainted in bright colours to suit the taste of local townspeople. Figures are occasionally replaced at the whim of the stucco carvers; a temple at Tiruvannamalai carries the figure of an American cowboy!

After the Madurai temple was 'complete', the seventeenth-century Nayak ruler, Tirumala, decided to build an immense pillared pavilion known as the New Hall directly opposite the east entrance and across what is today a busy thoroughfare. He commissioned life-sized images of Nayak royalty to be carved against its enormous granite columns, commencing with the first Nayak monarch and ending with himself accompanied by two queens (161). Traces of the original paint may still be seen. Tirumala erected portrait statues in all the temples in which he had a hand; his figure, depicted with a noticeable stomach roll, speaks of a degree of realism in portraiture. An immense pedestal towards the western end of the New Hall was intended to receive bronze images of Shiva and Minakshi; they had supposedly promised the ruler that each year, in the hot month of May, they would spend ten days in his hall, which was cooled by scented water that filled a sunken course surrounding it. Tirumala Nayak was unable to complete the monumental gateway and wall intended to enclose his pavilion. Another of his projects was an immense tank, the Teppakulam, that was connected to the Vaigai River through channels, and where a Float Festival for Shiva and Minakshi was held. Each January,

after dusk, images of god and goddess are placed in the tank on a float illuminated with myriads of oil lamps; thousands of citizens and pilgrim visitors assemble to enjoy the spectacle. Tirumala also built a grandiose palace whose main hall presents a vista of large circular piers that support broad arches with cusped profiles; an enormous 'Islamic' dome covers the throne area.

While Shiva is the centre of the Madurai temple in spatial and topographical terms, it is the enshrined image of the goddess which attracts the devotees who flock to the town. Through the centuries Minakshi has been gifted fabulous jewellery including a diamond headdress, pearls from the Pandyan rulers and vast quantities of gold ornaments studded with gems. Even the British collector of Madurai was in awe of Minakshi and, in 1812, he presented her with gem-studded gold stirrups for occasions when she might ride on horseback. Each day of the week, Minakshi is decked in one of her sumptuous sets of jewels. Devotees know that if they wish to see her in her diamonds, they must visit the temple on Mondays. Through a substantial donation, wealthier devotees may arrange for Minakshi to be decked in a specific manner on the day of their visit. Friday is the evening of the swing ceremony: bronze images of god and goddess are placed in the swing pavilion which overlooks the temple tank and, as temple attendants push the swing, musicians and singers provide entertainment with sacred songs. Crowds seated along the steps of the tank are cooled by the breeze that wafts off the waters. South Indian vocal music, or *kirtanam*, has a sacred content; it was in temple premises that music was nurtured. One *kirtanam* by Muthuswami Dikshitar begins:

O Goddess Minakshi
whose lovely body has a deep blue sheen
with long eyes shaped like a carp
Goddess who provides release from the fetters of life
who resides in the forest of kadamba trees

Esteemed one
who conquered Shiva
Grant me bliss.

Each evening after the eighth and last *puja* of the day, a bronze image of the goddess is placed upon a golden bed in the jewelled bedroom (*palli arai*) located in the innermost enclosure around the sanctum. Then a pair of golden feet (to represent the god) is transported from Shiva's shrine to the bedroom. Morning rituals commence at five o'clock when priests and singers congregate before the bedroom and sing to awaken the lord and his consort. At the song's end, priests open the doors, carry the images back to their respective shrines and begin the day's rituals with a dawn *puja*.

The annual celebration (April–May) of the marriage of Minakshi and Sundareshvara draws throngs of worshippers to the temple. In recent years the festivities have had to be televized so that the thousands who cannot be accommodated in the temple may witness them on screen. Viewers place garlands and sacred offerings around the television sets which provide them with the opportunity for such *darshan*. An important

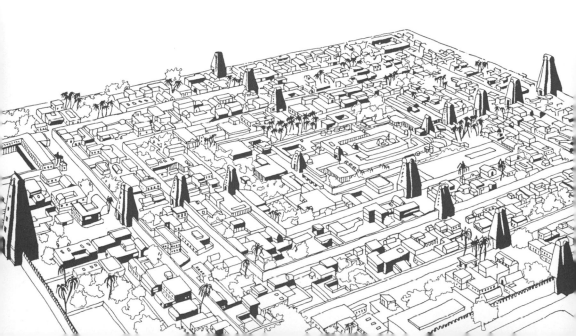

component of this and other temple festivals is the procession in which bronze images of the deities are taken through the town, halting along the way at platforms and pavilions. At each, the deity rests for a while, allowing those unable to make the trip to the temple, or those disallowed entry, to approach and worship. This aspect of the temple festivities was an additional reason for the immense popularity of the rites revolving around bronze images, and for their continued significance.

While most temples were complete with the fourth enclosure, the great Vishnu temple on the island of Srirangam (162) has seven walled enclosures (the outermost is 878 x 754 m or 2,880 x 2,474 ft) and twenty-one gateways. It grew over four centuries, commencing with its 1371 reconstruction after occupation by the armies of the Sultans of Delhi (see Chapter 11), and reaching its final shape after 1670 when the adjoining town of Tiruchirapalli became the second capital of the Nayaks. Its four outermost gateways were left incomplete; in 1987, the southern *gopuram* was completed by a wealthy land-owning family and today it stands 72 m (236 ft) tall. The three outer enclosures share the character of the surrounding town; they contain houses for temple employees, hostels for overnight pilgrims, eating places, stalls selling temple offerings, and shops selling sacred books and souvenirs. The sacred precincts commence only at the fourth enclosure where visitors leave their footwear to enter holy space. Here are spacious pillared halls with immense monolithic granite columns that are converted, in one hall, to magnificent leaping horses with riders carved almost in the round. The third enclosure contains two tanks, one rectangular the other semi-circular, as well as five huge, octagonal brick structures that may have served as granaries. As one moves inwards, each succeeding gateway is lower; at the very centre is the small barrel-vaulted sanctum tower distinguishable only because it is plated with gold.

The rectangular sanctum of Srirangam encloses an image of Vishnu as Ranganatha reclining on his serpent-couch. The daily

162
Vishnu temple, Srirangam, mainly 14th–17th centuries. Drawing showing enclosure walls and gateways

rituals of Vishnu are numerous and varied, and commence with this dawn wake-up chant composed by a Vaishnava saint who lived more than 1,000 years ago (*Divya Prabandham*, 'Tirupalli-ezhichi' of Tondaradippodi Alvar):

O lord of Srirangam
it's time to awake
the sun looks over
the crest of
the eastern hill
night has departed
giving way to dawn
the morning buds open
dripping with honey …
O lord of Srirangam
will you not awaken
from your slumber?

The vast number of festivals at Srirangam celebrating Vishnu mythology includes those connected with Vishnu's two popular avatars as Rama and Krishna. A ten-day flower-and-chariot festival in April–May draws immense crowds. Other festivities of major significance include an eight-day swing festival in October–November, a twenty-day recital of the *Divya Prabandham* hymns of the Vaishnava saints in December–January, and a Float Festival in February–March.

It is perhaps because the divine is visualized and celebrated as participating in activities familiar to devotees that the expanded southern temples have retained so strong a hold on the lives of people. To this day, residents of Madurai congregate at the temple tank in the evenings where the atmosphere is enlivened with oil and electric lamps, the fragrance of flowers and incense, and the songs and chants of temple musicians. After *puja*, it is at the temple tank that the local residents socialize and relax. The expanded temples of South India continue to play a meaningful role in the lives of the people.

When followers of Islam entered India, they encountered a land of Buddhist, Hindu and Jain shrines, all with elegant, sensuous and richly decorated images of deities in human form. To appreciate the culture shock this presented to the Muslims, we must turn to the origins of Islam and understand its suspicion of portraiture in the context of religion and its aversion to the worship of the divine represented in anthropomorphic form.

Islam was established in the seventh century. It grants validity to Judaism and Christianity; regards Moses, David and Jesus as prophets; and accepts their revealed books, the Torah, the Psalms and the Gospels. It asserts, however, that Muhammad is the last and greatest of prophets and that God's message to him completes and supersedes all previous revelations. The call came to Prophet Muhammad one night in 619 AD as he slept in solitude on Mount Hira in Mecca. The angel Gabriel appeared to him and said 'Recite'; what Muhammad recited is known as the Koran, Arabic for recitation. The Koran is not a narrative, it is revelation. Islam articulates a single, universal vision of Truth and declares that there is only one way to reach it; a pluralistic vision such as that of Hindu India was not accepted.

The holiest sanctuary of Islam, rebuilt many times, is the Kaaba in Mecca, today a hollow cube of stone draped with black cloth. Its existence dates back to at least 600, prior to the emergence of Islam. Muhammad cleansed the Kaaba by removing all idols. The Kaaba is the centre of the Islamic world, which is visualized as a wheel with spokes radiating from the Kaaba.

Propagating a simple religion that, unlike Christianity, Judaism and earlier Sassanian religions, did not need any intermediaries, Muhammad soon collected an immense following. Of the Five Pillars of Islam, the first and foremost is the profession of

163
Reused
doubled temple
pillars, Quwwat
al-Islam
Mosque, Delhi,
1192 6

faith (*Shahada*), which says there is no god but God and that Muhammad is his messenger. Another important pillar was prayer, a physical act involving kneeling, bowing and prostrating in the direction of Mecca. Mosque, or *masjid*, means a place for prostration. The other three pillars of Islam are fasting in the ninth month of Ramadan, monetary contribution to the Islamic community and a pilgrimage to Mecca. The new faith spread rapidly, and by the tenth century the Islamic world extended from Spain to India.

From its beginnings, Islam exhibited a deep distrust of the depiction of the human form. The Koran itself does not forbid such representation; but the next most holy text, the *Hadith* or Utterances of the Prophet, contains words that have been understood to be against the creation of form. It is believed that on the Day of Judgement, Allah will order the man who has created a replica of the human form to breathe life into it – when he is unable to do so, he will be cast into the deepest of hells. To comprehend the depth of this conviction, we must appreciate that the word for artist, *musawwir* or fashioner, is the same as the word for the Ultimate. Allah the Creator is the only Artist, the sole *Musawwir*. While the occasional representation of the human form is found in secular court contexts, by and large this was deemed an act akin to blasphemy. For a people nurtured in such a tradition, the exuberant sculptural portrayal of Hindu, Buddhist and Jain deities was an outrage.

The sacred art of most religions appeals to its followers on an emotional level by depicting the pathos of Christ on the cross, the peace of the meditating Buddha, or the majesty of the Hindu dancing god Shiva. These religions harness the power of images, using it to evoke and intensify faith. The arts of Islam, however, opted to engage its viewers on an abstract level. The Koran superseded the unfolding of the sacred life, and the iconographic, symbolic and practical functions of the representations of Christ, the Buddha and the Hindu gods were replaced in Islam by calligraphy, geometry and arabesques.

The historical circumstances of Islamic ingress into India are quite different from earlier contacts with the Arabs who had been coming to the subcontinent for centuries as traders. The campaigns of Mahmud of Ghazni and Muhammad of Ghor introduced India to the armies of the Turks and Afghans. Mahmud of Ghazni raided India seventeen times between 1000 and 1025, acquiring some of the wealth of the Hindu temples; his campaign to Gujarat alone, in which he destroyed the renowned temple of Somnath, yielded as much as 6,000 kg (6½ tons) of gold. A century and a half later, the ambitious Muhammad of Ghor targeted India with territorial aims in mind. In 1192, he defeated a confederacy of Hindu states led by the Chauhan ruler of Delhi, and soon conquered all of northern India. When Muhammad of Ghor died in 1206, his army general, Qutb al-Din Aybak, who had risen from being a slave to holding the viceroyship of Delhi, declared independence, calling himself a Sultan of the 'Slave dynasty'. Qutb al-Din Aybak's son and successor Iltutmish, who was confirmed as Sultan of Delhi by the Caliph ruling from Baghdad, reigned over an empire which extended across northern India and comprised an area as large as the earlier Gupta empire. For the next three hundred years, the Sultanate of Delhi, the term used to describe Turkish rule in India, controlled northern India under five different dynasties, although with fluctuating geographical boundaries.

Turkish armies conquered India with remarkable facility. In their favour was the totally different concepts of war held by the Turks and the Indians. For Hindu India, war was a pastime of the rulers, a sport played according to set rules, with armies laying down their weapons at sunset. To the Afghans and Turks, whose astute generals were schooled in the science of warfare, war was a matter of life and death. Unwieldy Indian elephant battalions could ill compete with the swiftness of Central Asian horses. In addition, the Hindu rulers, practising a war of shifting alliances, were unable to present a truly united front – unlike the solidarity of the Turks.

One of Qutb al-Din Aybak's first acts was to build a mosque in the centre of the citadel of the former Hindu rulers of Delhi, thus appropriating for Islam the heart of the previous Hindu stronghold. This practice of locating new sacred structures in previously sacred places was common cross-culturally; for instance, the Christians built a Gothic cathedral in the middle of a mosque at Córdoba in Spain.

The form of the mosque is modelled on the house of the Prophet Muhammad, in whose courtyard early devotees used to meet for prayer. To protect the faithful from the sun, they had set up a colonnade of palm trunks upon which they laid a shelter of palm fronds. A *muezzin* (announcer) called the faithful to prayer from the roof of Muhammad's house, and the Prophet mounted a pulpit to lead the prayer. Mosques were thus built as courtyards, open to the sky, with protective colonnades on three sides, while the fourth wall, known as the *qibla* (or front) wall, marked the direction of Mecca towards which Muslims face for prayer. The centre of this *qibla* wall contains a shallow niche known as a *mihrab* to distinguish the wall from the other three; the *mihrab* was never intended to contain any object. Later, this wall was transformed into an impressive architectural façade, and a tower or minaret from which the *muezzin* could call the faithful to prayer was added. The minaret soon became the symbol of an Islamic centre.

A mosque in which to conduct communal prayer was an immediate necessity in the legitimizing process of Islamic rulers. While still viceroy of Delhi, Qutb al-Din Aybak made use of pillars and ceilings from twenty-seven Hindu temples to construct the mosque's open courtyard, its pillared galleries and *qibla* wall. Since Hindu temple pillars lacked the height needed for the construction of impressive colonnades, local builders double stacked them (163). Pillars carved with floral motifs were selected, although it seems to have been impossible entirely to avoid figural carvings. According to Persian inscriptions at the site, the mosque, named Quwwat al-Islam or Might

164
Screen of corbelled arches added to the Quwwat al-Islam Mosque, Delhi, 1198. The iron pillar in the centre was taken from a temple dedicated to Vishnu in the 4th century AD and erected as a trophy in the mosque

of Islam, was built between 1192 and 1196. A striking contrast is presented by a Hindu temple and an Islamic mosque. The temple is a directional building that is enclosed, dark, perhaps even mysteriously introvert; the mosque may be entered from any one of three directions, is open to the sky, easy to read, perhaps extroverted in the clarity of its presentation.

Dissatisfied with the mosque's appearance, Qutb al-Din Aybak gave it a new façade in the form of an enormous sandstone screen pierced with five great arches (164). Though designed to resemble Iranian prototypes, its construction was in the hands of local craftsmen who resorted to the use of corbelling in the creation of arches. This technique, commonly used by Indian

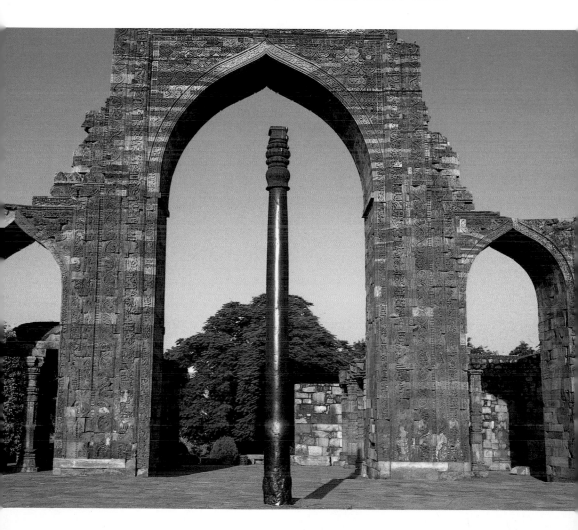

165
Detail of the
calligraphic
bands of the
Quwwat al-
Islam Mosque
screen, 1198

temple builders, consists of laying stone blocks on each level which project marginally beyond the block below. The true arch favoured in Islamic countries, and comprised of a central keystone and a series of wedge-shaped voussoirs, is generally believed to have been unknown to Indian builders; however, an isolated instance of a true arch at Bhitargaon's brick temple, built in the Gupta period, must give pause for thought. Qutb al-Din Aybak's stone screen was embellished with Arabic calligraphy and leafy arabesques (165), both of which are recurrent and important themes in the Islamic tradition.

Arabic lettering that preserves the divine word of the Koran is the accepted heritage of all Islamic societies. Sanctity is believed to be inherent in koranic texts, and holy phrases are duplicated, mirrored and used as ornamentation in Islamic architecture. The enormous importance given to writing in the Islamic world is reflected in the statement of poets that the sky itself had put on spectacles, in the form of the sun and the moon, in order to admire beautiful handwriting. The Koran avers that everything has been written down from all eternity, on the *lauh al-mahfuz* (the Well-Preserved Tablets), by means of the pre-existent Pen which was the first thing God created. Wherever the Muslims went, the engraved letters of the Koran proclaimed the victory of Islam.

The term arabesques is used in Islamic art to describe scrolling or interlacing plant forms. They are characterized by a continuous stem with a series of symmetrically arranged, secondary stems; these may split again or return to be reintegrated into the main stem, resulting in an endless stream that creates an effect of abstraction. However, the exuberance and naturalism of the floral creepers on Aybak's screen, and the manner in which they climb over and around the sacred Arabic calligraphy, is unusual; the floral devices within each coil are reminiscent of the exquisite floral bands along temple doorways. The creative energy apparent in the decoration of the screen suggests a dynamic union of two contrasting artistic traditions.

166
Quwwat al-
Islam Mosque
complex with
the Alai
Darvaza,
completed 1311
(right), Qutb
Minar, 13th
century (centre)
and prayer hall,
12th century
(left)

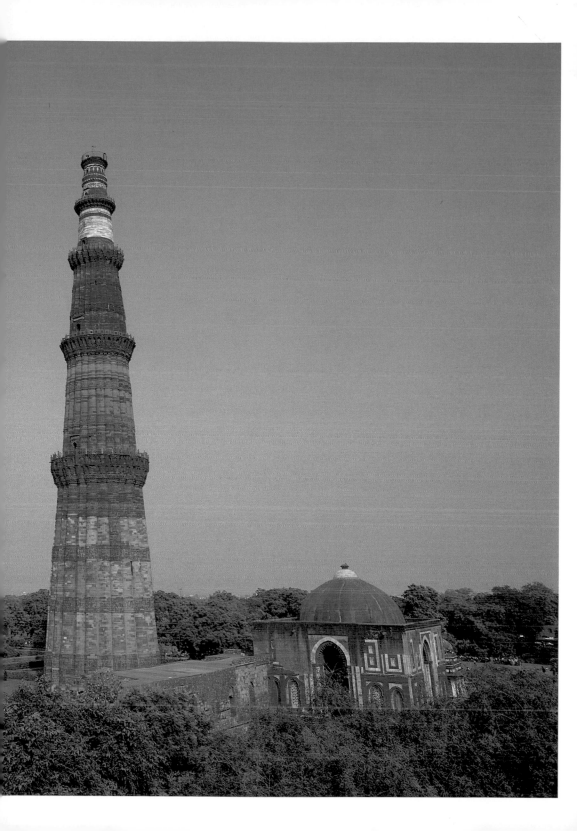

To the south of his mosque, Qutb al-Din Aybak built an enor-
mous sandstone minaret rising 72·5 m (238 ft) and known today
as Qutb Minar (166). Completed by his successor Iltutmish, it is
the tallest extant minaret in the world. Too high and too distant
from the mosque to be regularly used for the call to prayer, it
was created as a declaration in stone of Islamic supremacy in
India. Wide bands of Arabic calligraphy interspersed with
flowers and leaves decorate the minaret. Though much of the
calligraphy comes from the Koran, the added historical inscrip-
tions indicate that these early sultans of India, while deeply
desirous of being viewed as 'rulers of India', considered them-
selves part of the greater Islamic world.

Another totally novel form of architecture introduced into India
was the Islamic tomb. Hindus, Buddhists and Jains cremated
their dead and, with the sole exception of the Buddhist stupa,
no commemorative funerary monument existed in India. Early
Islam believed in simple tombs in which to inter the dead; but
by the tenth century, a series of impressive tombs at Bukhara in
Central Iran indicates that monarchs had reinvented a pre-
Islamic tradition of self-glorification. While still reigning
monarch, Iltutmish built a tomb for himself, thus introducing a
practice followed by most later Islamic rulers. It stands behind
the mosque, a square stone tomb, with plain exterior, covered
with a corbelled dome. Its interior walls, however, are richly
carved with entire chapters from the Koran that speak of
Paradise as the reward for the true believer – and particularly
for those who die while spreading the message of Islam.

Iltutmish was briefly succeeded by his daughter, of whom
contemporary historian Minhajus Siraj wrote (*Tabakat-i Nasiri*,
tabakat XXI):

Sultana Raziyya was a great monarch. She was wise, just, and generous,
a benefactor to her kingdom, a dispenser of justice, the protector of her
subjects, and the leader of her armies. She was endowed with all the
qualities befitting a king, but she was not born of the right sex

Raziyya's murder was followed by a long struggle for power which ended in 1286 when a Turkish noble established the Khalji dynasty. Internal power plays now became common among the Turks who had earlier presented a united front to the Hindus.

Sultan Ala al-Din Khalji (r.1296–1316) completed the final extension to the Qutb mosque complex with an impressive ceremonial gateway (see 166) in 1311; its true arch and true dome indicate that local craftsmen had rapidly mastered new techniques. Another Islamic decorative theme is seen in the façade of this gateway, which is embellished with carved geometric blocks of red sandstone and white marble, a simple prelude to the later elaboration of decorative geometry into a major art form. Its visual principles were those of repetition and symmetry, and the basic design of the circle was developed into squares, triangles, polygons, hexagons, octagons and stars. In later Islamic monuments, one pattern is frequently superimposed upon another in reversed colours and materials, with striking effect. In the context of Islam, these designs have been interpreted as demonstrations of the singleness of God and His presence everywhere, and as expressions of the belief that matter is continuously changed by God.

Ala al-Din Khalji was a man of grandiose schemes, of which several came to nothing. He commenced a second minaret at the site of the Qutb mosque, intending it to be over twice the size of the Qutb Minar, but only the gigantic base levels of the tower remain to testify to his failed efforts. Ala al-Din's dreams included the conquest of the whole of India. He sent several military expeditions to the deep south where his generals entered cities like Madurai and Srirangam, seizing elephants and treasures. Madurai was captured, but its governor severed allegiance to Ala al-Din and established the independent Madurai sultanate of Mabar. Ala al-Din's armies raided the Hindu Yadava capital of Devagiri in the Deccan plateau to the south, the Jain marble temple at Mount Abu, and the Rajput

capital of Chitor in the west. But all this proved unprofitable as by this time his northern territories had begun to slip out of control.

By the fourteenth century, an indigenous Islamic culture was emerging. Poet Amir Khusraw, born in India but of Turkish descent, was hailed even by Persian poets as the 'sweet-tongued parrot of India'. His affinities and sympathies lay with the land of his birth. He boasted that he knew the local tongue of Hindavi better than Arabic, and his poems make bold use of mixed Persian and Hindavi. At this time, the Delhi Sultanate was in the hands of the Tughlak dynasty whose founder built a massive fortified capital city named Tughlakabad, 6 km ($3\frac{1}{2}$ miles) from the Qutb site. Later rulers followed this precedent by each building a new capital city; the environs of modern Delhi are packed with the ruins of these ancient sites.

The next sultan, Muhammad ibn Tughlak, named his city Jahan Panah, meaning World Refuge, of which the Moroccan traveller Ibn Battuta, visiting in 1334, wrote: 'A vast and magnificent city, uniting beauty with strength. It is surrounded by a wall that has no equal in the world, and is the largest city in India, nay rather the largest city in the entire Muslim world.'

Ibn Battuta also wrote admiringly of the efficiency of the Tughlak transport and postal system. Muhammad ibn Tughlak, like Ala al-Din Khalji before him, dreamt of capturing the south, and shifted his capital from Delhi to the Deccan town of Devagiri, renaming it Daulatabad. His insistence that the entire population, not just the courtly circle, move south, backfired and he was forced to relocate to Delhi just three years later. However, his Deccan interlude set the stage for independent Deccan sultanates that were to become influential centres of Islamic culture for over 300 years.

At a time when the Sultanate's power was rapidly diminishing, and its territorial domains encompassed little more than the immediate surroundings of Delhi, Firuz Shah Tughlak initiated

167
Ruins of
Firuzabad
(1351–88) with
relocated
Ashokan
column (c.250
BC), Delhi

an even more massive building programme. He constructed
hunting pavilions, palaces and mosques, as well as public
works such as canals, wells and sluices. He also transported
two of Mauryan emperor Ashoka's columns to Delhi despite
having no idea who had erected them or what the early
Ashokan script meant – but he had little doubt that they were
linked with India's ancient monarchic glory. His chronicles,
with accompanying drawings, record the laborious process of
taking down the pillars that weighed several tons, transporting
them hundreds of kilometres and re-erecting them in Delhi. One
pillar was placed beside his mosque in Firuzabad and became
known as the golden minaret because of its colour (167).

At a site known today as Hauz Khas, Firuz Shah built himself a
sandstone, brick and plaster domed tomb in the grounds of a
madrasa complex, or a school for the teaching of Islam, which

was planted with trees, flowers and shrubs, and interspersed with small kiosks serving as seats for religious discussions (168). The school itself overlooked an expansive water tank. Before Firuz Shah's tomb is a terrace enclosed by a railing, a feature typical of Buddhist construction but unusual in an Islamic context. Perhaps such an addition was intended to resuscitate the memory of ancient Indian splendour.

The Sultanate was divided into provinces, each ruled by a governor responsible for administration and the collection of revenue. A fixed share constituted the governor's salary, while the rest went to the sultan. There was also a tax on non-Muslims that varied according to the whim of the sultan; if a citizen converted to Islam, he ceased paying this tax. Mass conversions may not have been to the sultan's monetary advantage. The bulk of the land belonged to the sultan, who gifted revenue from it (not land itself) to his officers as rewards; such land-grants were not hereditary but depended upon the pleasure of the sultan in a system similar to that which had existed in Hindu northern India prior to the establishment of the Delhi Sultanate. Both governors and land-grant holders were required to supply soldiers for the sultan's army.

In 1398, Timur, known better to the West as Tamerlane, sacked Delhi leaving it desolate and deserted for nearly fifteen years. The mid-fifteenth century saw the emergence of the Lodis, the last dynasty of the Delhi Sultanate. The Lodis built no new cities, mosques or *madrasa*s; instead, they erected numerous tomb structures scattered throughout the landscape of the city known today as New Delhi, giving it the appearance of an Islamic necropolis. Under earlier Indo-Islamic dynasties, only kings and revered saints were buried in such impressive mausoleums. How was it that a dynasty in power for a mere seventy-five years, with only three ruling monarchs, built so large a number? The answer appears to lie in the Lodi concept of kingship, which may be traced to their tribal origins in Afghanistan. The Lodis regarded a king not as an absolute

168
Madrasa complex with the tomb of Firuz Shah Tughlak, Hauz Khas, Delhi, 1351–88

169
Tomb of Muhammad Shah Lodi, Lodi Gardens, Delhi, 1434–44

ruler, but as the first among equals; consequently tomb-building ceased to be a royal prerogative and became more of a status symbol. Sultans built themselves octagonal tombs (169); nobles built square ones. The dynastic burial ground, known today as Lodi Gardens, is entered by an imposing domed gate with a mosque to its west, and contains both octagonal and square tombs. This period also saw the introduction of the Iranian double dome, in which an inner shell related to the spatial requirements of the monument's interior, while a lofty outer dome lent grandeur to its exterior. After three centuries of sovereignty, the Delhi Sultanate ended in 1526 when Babur, founder of the Mughal dynasty, defeated the last Lodi king.

It is relevant to analyse the circumstances in which the Delhi sultans gained a reputation as iconoclasts who burned temples and destroyed idols. One important reason was certainly that creating the human three-dimensional form was considered blasphemous. Iconoclasm was also a means of asserting superiority. However, the Muslims were a minority in a land of people who professed other faiths, and the temple, in particular, was feared as an institution where people of similar ideologies congregated; the sultans were afraid that temples might become homes of revolt and rebellion. Occasional acts of iconoclasm were also a way for the sultans to convince their theologians, the Ulema (the sole authorities empowered to reinterpret the *Sharia* or holy law of Islam), of the strength of their Islamic convictions – thus persuading them to sanction divine kingship, a theory accepted in India but not part of original Islam.

While Islam disdained the artistic representation of the human body in three-dimensional form, Muslim rulers nevertheless patronized painting workshops which produced illustrated histories of the Islamic world glorifying its monarchs, as well as collections of popular tales and fables. These paintings featured humans, animals and birds. This apparent paradox was fiercely debated by theologians who pointed out that since the painted form cast no shadow, painting could not be interpreted as an

attempt to usurp the power of God. Royal workshops flourished under broad-minded monarchs, and were regularly shut down when fundamentalist rulers came to the throne. Firuz Shah Tughlak banned the painted decoration of palaces and public structures; records inform us that he removed from his palace walls every trace of figurative painting. However, this very erasure is a clear indication of the patronage that earlier sultans accorded to painted murals.

Despite its typically Iranian theme, an interesting *Shahnama*, or History of the shahs of Persia, painted *c.*1450, seems to have been the work of an Indian artist (170). The style bears a remarkable kinship to the Jain paintings considered during the discussion of the Jain temples at Mount Abu (117). One particular page of the *Shahnama* depicts the hero and his newly wed wife surrounded by attendants: the women have full breasts, narrow waists and long plaited braids, and wear patterned diaphanous clothing with the lower fold of the garment arranged in a stiff triangle. Nothing could be further removed from the style of the Islamic painting of Iran. The profusion of pearl ornaments, the sitar-like instrument played by an attendant, the parasols, and the vibrant use of colour are also strongly reminiscent of Jain work. This manuscript, written in Persian and illustrating Persia's national epic, is a reminder of the extraordinary fusion of cultures that took place on Indian soil. Among the incidental side effects of India's contact with the Afghans and Turks was the fact that Indian numerals travelled to Europe via Arabia, where they became known as arabic numerals; chess too travelled from India to Europe via Persia.

Pursuing the political fortunes of the sultans leads us to the Deccan plateau of southern India, where a noble of Persian origin, Bahman Shah, was governor of the Deccan possessions of the Delhi sultan Muhammad ibn Tughlak. Declaring his independence in 1347, he founded the line of Bahmani sultans who, at the height of their power around 1500, ruled a sultanate extending across peninsular India from the Arabian Sea to the

Bay of Bengal. Bahman Shah established himself at Gulbarga,
where he built a fortress-capital on a rocky outcrop, with
double walls 16 m (52 ft) thick, and surrounded by a moat 30 m
(98 ft) wide cut into the rock scarp whose irregular outlines
determined the shape of the city. Interrupting the walls at regu-
lar intervals were immense semi-circular bastions with plat-
forms for heavy arsenal. Complete with gateways and
drawbridges, the fortress battlements were comprised of indi-
vidual stones 3 m (10 ft) square. Such fortified capitals became
standard in the Deccan. Just ten years previously, also capital-
izing on the Delhi Sultanate's failure to hold southern India,
Hindu monarchs had established the kingdom of Vijayanagara,

south of Bahmani territory, with the Krishna River as the dividing line. Conflict between the two kingdoms was inevitable since both wanted control over the fertile river area and possession of the profitable diamond mines of Golconda.

The Deccani style of art originated from two different strands. One derived from local craftsmen, including descendants of the Delhi craftsmen who had moved south at the insistence of Muhammad ibn Tughlak (the *dakhni*s, or Deccanis). The second was derived from the foreign Islamic population of the Deccan that included Turks, Persians, Arabs and Africans (the *afaqi*s, or newcomers). Skilled craftsmen, who arrived from the Persian Gulf in Arab ships that docked at the ports along the west coast of India, contributed towards the novel aesthetic sense seen in the arts of the Deccan. One outstanding innovation that seems to have arrived by this circuitous route was the application of brilliantly coloured tiles to the surfaces of buildings – in some cases covering the entire monument like a mantle, an effect characteristic of Persian art.

The resilience of the Persian tradition in India is illustrated by a *madrasa* built by Mahmud Gawan, a scholarly Persian minister of the Bahmani sultan, in 1472 in Bidar. The *madrasa* was decorated with glazed bricks and tiles (171). Complete with lecture halls, library, mosque and accommodation for both students and professors, it is a replica of *madrasa*s erected in Iranian cities, and was probably the creation of an immigrant architect. The main façade of this three-storeyed building has tall

171
Madrasa of
Mahmud
Gawan, Bidar,
1472

minarets at either end. The surface treatment turned it into a blaze of colour, now sadly faded by damp weather, since the façade was completely covered with glazed tiles, chiefly designed as arabesques, but also with calligraphic writing in which each letter is about 90 cm (3 ft) high. A chevron pattern of glazed bricks decorated the minarets.

In 1538, the governors of four important provinces of the Bahmani Sultanate declared independence, resulting in the formation of five smaller Deccani sultanates of Bijapur, Ahmadnagar, Bidar, Berar and Golconda. Frequent conflicts left territorial boundaries in a constant state of flux. The only occa-

sion on which the sultanates united was in 1564 to battle against the Vijayanagar empire and its Hindu rulers.

Some of the most stunning Deccani monuments were produced by the Adil Shahi sultans of Bijapur, who seem to have been of Turkish origin. Ibrahim Adil Shah II (r.1579–1627) built the Rauza, an extraordinary garden complex of tomb and mosque, built of stone, brick and plaster, standing on an oblong terrace with an ornamental tank and fountain (172). Although the two buildings were different in function, they were planned to balance each other as a symmetrical composition. The tomb

consists of a central chamber with an arched veranda around it, while an elaborately bracketed upper storey carries a bulbous dome that rises out of a band of petals. Four slender minarets at the corners of the building are complemented by turrets that rise from its various angles. The interior is filled with carved arabesques and traceried inscriptions; the intricacy of pattern on the walls of the tomb chamber is unrivalled. A phenomenal feature is the hanging ceiling of the tomb chamber which seemingly defies all rules of architectural and structural logic; it has no visible support and apparently rests in place by the extraordinary strength of the mortar alone.

Sultan Ibrahim was a connoisseur of music, poetry and painting, and his court attracted poets, historians, architects, musicians and Sufi mystics. He was himself a musician and writer; his remarkable book, *Kitab-i Nauras* or 'Book of Nine Rasas', commences not with the traditional Islamic *bism Allah*, but with an invocation to Ganesha, Hindu god of beginnings. The work consists of songs and commentaries on musical modes or *raga*s, praise to Sarasvati, the Hindu goddess of learning and music, and to Shiva and Parvati, as well as songs in honour of Hazrat Gesu Daraz, a saint of the Chishti order. It is written not in Persian but in the local vernacular of Dakhni in which loan words from local Telegu and Kannada are added to northern Urdu, itself an amalgam of Persian with old Punjabi. Sultan Ibrahim inspired an efflorescence of painting at Bijapur that is evidenced by a painting of him hawking, riding a hennaed horse through an enchanted landscape with fantastic lilac rocks, swaying trees and flowers (173). Its sweeping calligraphic contours and gold arabesques speak more of the Islamic style, while its delicate sensuousness seems Indian in inspiration. Bijapur painting has aptly been described as 'South Indian visions of Iran'.

Bijapur was the centre of a popular devotional Islamic culture that centred around mystic Sufi saints who wrote folk poetry in Dakhni relating to simple chores performed by women. Two

172
Ibrahim Adil Shah's tomb and mosque complex, or Rauza, Bijapur, c.1615

major collections of such poems revolve around either grinding grain (*Chakki-nama*) or spinning thread (*Charkha-nama*). One *Chakki-nama* poem, attributed to Chishti saint Bandanawaz Gisudaraz who died in 1422, likens the handle of the grindstone to the letter alif, signifying Allah, the axle to Muhammad and the grindstone to the body, and ends thus:

Grind the flour and make stuffed puri;
Put in it heavenly fruits and sugar,
The seven ingredients must be taken in the body
As the seven ingredients fill the puri, oh sister.
Ya bism Allah, hu hu Allah.

Bijapur houses no less than 300 tombs or tombstones of Sufis that are known as *dargah*s. Women, Muslim and non-Muslim, played a prominent role in the devotional *dargah* culture, which reached out to the masses. Lighting candles and offering flowers were ways of participating in the *urs* festival that commemorated the death of a saint, *urs* meaning marriage (with God). Women asked, and still ask, for simple boons – health, the birth of a child. A popular song, *git*, sung in Dakhni at the *dargah* of Bandanawaz goes thus:

Having said 'Allah, Allah', I have climbed the stairs,
One by one.
With my thread and flowers in hand
I am standing here claiming my wishes …
Today, fill my lap with child.

Muhammad Adil Shah (1627–57), one of the greatest of the sultans of Bijapur, realized the impossibility of exceeding the architectural perfection of his predecessor's tomb and mosque complex; he opted to excel it in size. He built himself a tomb of stone, brick and plaster, known as the Gol Gumbaz or Round Dome (174), which stands on a podium 183 m (600 ft) square, and is possibly the largest and most remarkable building in India. Its interior chamber is a hall of majestic proportions that encloses an area even larger than that of the Pantheon in Rome.

173
Adil Shah Hawking,
Bijapur, c.1600.
Watercolour on paper,
28·5 × 16·5 cm,
11¼ × 6⅛ in.
Institute of Oriental Studies,
Russian Academy of Sciences,
St Petersburg

A series of intersecting arches converts the square plan of the building into an octagon to receive the dome. Externally, each corner of the giant cube has an attached tower enclosing winding stairways. A broad gallery at the eighth level, known popularly as the Whispering Gallery, creates extraordinary acoustic effects. Both the interior and exterior of this stone tomb, with its dome built of brick, are severely plain. Its impressiveness derives from its amazing size.

During Muhammad's reign, portraiture became favoured, and the emphasis in painting shifted from idealistic images to realistic forms. The monarch, as well as his African prime minister, Ikhlas Khan, are repeatedly portrayed (175). In 1686, together with the other four Deccani sultanates, Bijapur finally succumbed to the Mughal emperors.

174
Gol Gumbaz, tomb of Muhammad Adil Shah, Bijapur, 1627–57

175
Muhammad Adil Shah and Ikhlas Khan Riding an Elephant, Bijapur, *c.*1645. Watercolour with gold on paper; 32 × 44·5 cm, 12½ × 17½ in. Collection of Howard Hodgkin, London

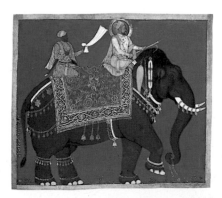

12

Within a dramatic landscape of granite outcrops and boulders stand the ruins of Vijayanagara, or City of Victory, the capital of an empire that took the same name (176). Founded in 1336, this remarkable city was occupied for just over 200 years before it was destroyed by the combined forces of the Deccan sultanates. During that spell it was one of the wealthiest and grandest of cities in Asia, described by the Afghan ambassador Abdul Razzaq as: 'such that the pupil of the eye has never seen a place like it, and the ear of intelligence has never been informed that there existed anything equal to it in the world'.

176
View of
Vijayanagara
with the
Tiruvengala-
natha temple,
1336–1565

From a series of ancient documents, including the accounts of the Italian traveller Niccolo di Conti, the Afghan Razzaq and the Portuguese visitors Domingo Paes, Fernao Nuniz and Duarte Barbosa, it is possible to reconstruct in imagination the milieu of Vijayanagara's palaces and pavilions, its ceremonial platforms and baths, and its numerous temples. The city's monuments are further brought to life by Indian courtly epics written in the local language of Telugu, and by plays and poems in both Telugu and Sanskrit written by the Vijayanagara emperors.

Two distinct strands evident in the architectural and decorative techniques prevalent in this capital city speak of the creativity of its artists and testify to its cosmopolitan character. While the sacred temples are purely Dravida, the mansions, halls, palaces and public domains of royalty are a remarkable combination of Dravida and local Islamic styles. An introduction to this art is provided by a double-storeyed monument, known popularly as the Lotus Mahal (177), the best preserved monument of the Royal Enclave. Built of stone blocks set in heavy mortar, with some brick additions to complete the details of parapet and roofs, it was originally covered with a thick layer of plaster

decoration. The Lotus Mahal is laid out symmetrically as a series of projecting squares, with piers that create thirteen bays, and results in a cross-like plan; an additional bay at one corner accommodates a staircase tower to the upper level. At the lower level the pavilion is open; its large cusped and arched entrances, in two or three receding planes, dominate the exterior. The upper level is enclosed and has a series of multilobed arched windows; the bays are roofed by pyramidal towers in three diminishing and ascending levels, while a central, taller tower adds a vertical effect to the monument. A ribbed finial crowning the towers might be described as a cross between a temple *shikhara* and an Islamic dome. The construction techniques of the Lotus Mahal – arches, domes and vaults – are Islamic; the towers and plaster decoration of birds, mythical lionlike *yali* heads and human riders on rearing animals are Dravida in concept and treatment.

To appreciate the eclectic character of the art of the city of Vijayanagara, we must understand the conditions prevailing in the Deccan plateau between the fourteenth and sixteenth centuries when the city was a major and thriving entrepôt. Though the circumstances surrounding the establishment of the empire of Vijayanagara are somewhat obscure, two brothers, Harihara and Bukka, chieftains of uncertain genealogy, are known to have been instrumental. By luck they received the blessings of Vidyaranya, an influential pontiff of a sacred Shaiva centre at nearby Shringeri, who conferred them with monarchical legitimacy. At its height, the empire comprised much of peninsular India south of the Tungabhadra and Krishna rivers; it was ruled by some sixty monarchs, belonging to three separate dynasties, all of whom titled themselves 'rayas' using the Telugu title in place of the Sanskrit 'raja'.

The Vijayanagara empire had frequent military encounters with the adjoining Muslim territories to the west and north. It even held temporary control of the sultanate's coastal posses- sion of Goa, before losing it to the Portuguese. To the south, Vijayanagara forces captured Madurai from the Mabar sultans who had ruled it for most of the fourteenth century, and battled against various Hindu kingdoms. Conflicts between the Hindu empire and the sultanates revolved around territory rather than religion, and the capital city accommodated an entire settle- ment of Muslims; in addition, the Vijayanagara rulers placed great value on Arab horses and cavalry. The fifteenth-century king Devaraya II (r.1424–46), a sophisticated Hindu monarch who surrounded himself with a brilliant literary circle, recruited several Muslim officers and kept a Koran beside him on which to make them swear allegiance. One of his high- ranking officers, Ahmad Khan, built both a mosque and a tomb for himself. The Islamic domes, vaults and arches, which are recurring features in the courtly architecture of Vijayanagara, testify to the cultural and artistic exchange between neighbours.

The City of Victory, located in a natural basin of the Tungabhadra, was planned to resist military onslaught. City planners took advantage of the wild, craggy landscape, erecting massive walls along the ridged mountain tops by placing immense wedge-shaped blocks to meet at the centre, and packing the spaces with rubble. Impressive stone gateways were built to interrupt the walls so that one had to turn to enter the city. Apart from preventing unwanted visitors from riding straight in, the gateways also served as checkpoints where duties were paid on animals and goods entering the city. Only one of the seven circuit walls mentioned by ambassador Abd al-Razzaq in 1443 exists today. It encloses an area of 26 sq km (10 sq miles), extending 4 km (2½ miles) from end to end. Its numerous gateways, incorporating both Hindu and Islamic building techniques, underline the mixed character of the city's architecture. Bhima's gate, which carries an image of Bhima, a hero of the *Mahabharata*, is built in the simple post-and-lintel method favoured by Hindu builders; another stone and plaster gateway is crowned by an Islamic dome carried on four pointed arches (178).

178
Domed, arched gateway along the city walls, Vijayanagara, *c.*15th century

Ancient Indian architectural texts lay down that cities should be built on the plan of a *mandala* or cosmic diagram, ideally as a square, with broad 'royal ways' crossing the city from north to south and from east to west. The City of Victory, however, follows its own individual plan – comprising two zones, sacred and royal, of relatively equal significance, separated by an irrigated valley – which was probably influenced by the wide, torrential Tungabhadra, as well as by the very nature of the terrain which includes both high outcrops and low-lying valleys. The Sacred Centre of temple structures, totally Dravida in character, stands along the south bank of the river and is built against the rocky granite hills of the valley, unprotected by any fortifications. To its south lies the Royal Enclave and, set apart to its east, its fortified township; together they form an elliptical unit larger than the Sacred Centre. Within the township, the Royal Enclave is further segregated by its own inner set of encircling walls.

While no systematic excavation of the township has been undertaken, the agricultural area is clearly segregated from the residential section which has revealed wells, pottery shards and rubble houses. Workshops for the production of specific types of goods appear grouped together, while the concentrated presence of tombs and tombstones in the northeast indicates that this was the Muslim residential area. Within the Royal Enclave, an enormous variety of forms, plans and façades is evident, and no two structures are alike. Many of its buildings are constructed of stone blocks set in mortar and covered with plaster, with arched doors and windows, and crowning domes and vaults. Quite clearly, the style that today we call Islamic was in those days devoid of ideological or religious implications. In this capital city ruled by Hindu kings, it was apparently deemed aesthetically pleasing.

In addition to the natural advantages offered by the rocky landscape and the proximity of the Tungabhadra, the site for Vijayanagara was carefully selected as one of sacred

significance, being associated with both Shiva and Vishnu. Harihara and Bukka, deferring to Vidyaranya's exhortation to build a temple to Shiva, expanded the already existing hallowed, but architecturally insignificant shrine of Shiva as Virupaksha, praying that his powerful beneficence be specially directed towards their royal household. All later Vijayanagara monarchs accepted Shiva Virupaksha as their overlord, mentioning his protecting grace in their inscriptions and featuring him on their gold and copper coins. Numerous images of *linga*s, the abstract symbol of Shiva, and of his bull mount are found carved into the rocky outcrops along the river. The ancient site was in fact originally associated with goddess Pampa, personification of the Tungabhadra; however, her marriage to the mighty Shiva exalted the goddess and led to the elevation of the shrine in terms of architectural space and splendour. To this day, the annual celebration of the marriage of Pampa and Virupaksha attracts huge crowds of devotees to a normally deserted archaeological site and the little village of Hampi (a variant of Pampa).

Vijayanagara had an even more direct association with Rama, avatar of Vishnu and heroic warrior of the epic *Ramayana*, the ideal monarch who was the paradigm for all Hindu kings. Vijayanagara is sanctified by its identification with the monkey kingdom of Kishkinda where Rama dwelt for some months in the course of his search for his wife Sita, abducted by Ravana. Rama helped Sugriva, king of Kishkinda, to regain the throne usurped by his uncle; in return Sugriva helped Rama to defeat Ravana by putting at Rama's disposal his entire army led by the monkey-general Hanuman. Specific places in the local landscape are identified with Kishkinda events, such as the cave in which were hidden the jewels dropped by Sita as she was carried away by Ravana and the hill where Rama waited while Hanuman travelled to Lanka to find Sita. The monuments at the site are replete with imagery connected with the *Ramayana*, and several boulders carry roughly carved images of the valiant Hanuman. The Vijayanagara rulers often compared themselves

and their capital city with Rama and his capital; an inscription of 1379 declares: 'In Vijayanagara did Harihara dwell, as in former times Rama dwelt in the city of Ayodhya.'

Before we discuss the zones of Vijayanagara and the relevance of the *Ramayana* in planning the city, it would be useful to look at the carefully orchestrated water system which indicates that the planners were aware that agricultural prosperity in the dry Deccan plateau would depend totally on irrigation. The city stands in a natural basin where the Tungabhadra loses height and runs through a rocky gorge. Water was transported through the site by channels cut in the rock. The valley separating the Royal Enclave and Sacred Centre is traversed by such water channels, of which several remain operative to this day feeding banana and sugarcane crops. Raised aqueducts built of plaster-lined granite (179) or brick, earthenware pipes embedded in concrete and gigantic rainwater tanks constructed along the outskirts of the city were part of the intricate water-supply system. This elaborate irrigation scheme, which led to the creation of some of the most fertile cotton-growing areas in India, was responsible, together with imports, for the markets overflowing with produce, of which the Portuguese traveller Paes wrote:

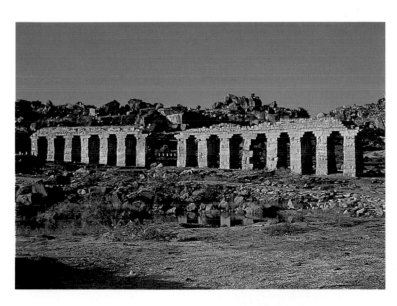

179
Raised
aqueducts,
Vijayanagara,
*c.*15th century

This is the best provided city in the world, and is stocked with provisions such as rice, wheat, grains, Indian-corn, and a certain amount of barley and beans, pulses, horse-gram and many other seeds which grow in this country which are the food of the people … Then you see the many loads of limes that come every day, and also loads of sweet and sour oranges, and wild brinjals, and other garden stuff in such abundance as to stupefy one ….

Vijayanagara was the focal point of several transpeninsular trade routes which brought into its markets gems from various centres, causing Paes to remark on the availability of 'all sorts of rubies, and diamonds, and emeralds and pearls'. The city's sixteenth-century population (estimated at over 100,000 people) must have made it a major entrepôt for consumer goods. Vijayanagara's monarchs recognized the importance of encouraging trade, and in the poem *Amuktamalayada* Krishnadevaraya (r.1509–29) launches on a brief homily on commercial tactics and finesse (bk IV, ch 5, v 245–7):

A king should improve the harbours of his country and so encourage its commerce that horses, elephants, precious gems, sandalwood, pearls and other articles are freely imported … Make the merchants of distant foreign countries who import elephants and good horses be attached to yourself by providing them with daily audience, presents and allowing decent profits.

Vijayanagara's capture of the coastal possession of Goa from the Bahmani sultans was motivated by the desire to have direct access to overseas trade, especially the import of horses which were an important component of its armies. Paes was such a trader and recounts how he escorted trains of horses on the arduous journey from Goa to the city of Vijayanagara.

The basic plan of the city and its circuit of walls took shape when it was founded by Harihara in 1336. Over the years, successive monarchs added individual palaces, water pavilions, temples and other structures. One of the first additions was Deva Raya I's (r.1406–24) temple dedicated to Rama, whose

location at the heart of the Royal Enclave divides the private from the public areas. Known today as the Hazara Rama, the temple, surrounded by a courtyard, consists of a square sanctum with a brick and plaster *shikhara* in the Dravida style, a vestibule, and a spacious square hall with porticoes on three sides. The outer walls of the hall carry *Ramayana* panels arranged in three rows; curiously, however, the narrative does not commence at the entrance, and to follow the story in its correct sequence devotees need to walk around the shrine to the rear of the hall. The high walls surrounding the temple are carved on both faces; the inner face carries another set of *Ramayana* carvings, while the outer face reflects the character of the surrounding Royal Enclave by featuring processions of horses, elephants, warriors, wrestlers, soldiers, musicians and dancers. A system of roads, many paved with stone, radiates from the temple. The significance of the *Ramayana* for the monarchs is demonstrated by the fact that the temple is linked, axially and visually, with the Matanga and Malyavanta hills, associated respectively with monkey-king Sugriva and his general Hanuman; both hills may be sighted from a circle inscribed on the floor of the temple hall.

180 Overleaf
Elephant
stables,
Vijayanagara,
c.15th century

To the west of the Rama temple is the public zone comprising halls where the emperor gave audience, administered justice, made public gifts and conducted military exercizes. The most impressive structure in the Royal Enclave's public zone is the stone and brick elephant stables (180) – despite their unwieldiness in war, elephants in India were accorded a position of honour and dignity. Five spacious square chambers, each with expansive arched openings, are placed on either side of a central tower, which appears to have been used by drummers and musicians on ceremonial occasions. The chambers are roofed with alternating domes and vaults of differing designs. The domes are either plain or fluted, while the vaults, rising in three curved tiers on the exterior, are octagonal or square with curved ribs. The entire structure was once adorned with elaborate plasterwork friezes. The imposing building, 85 m (288 ft) in

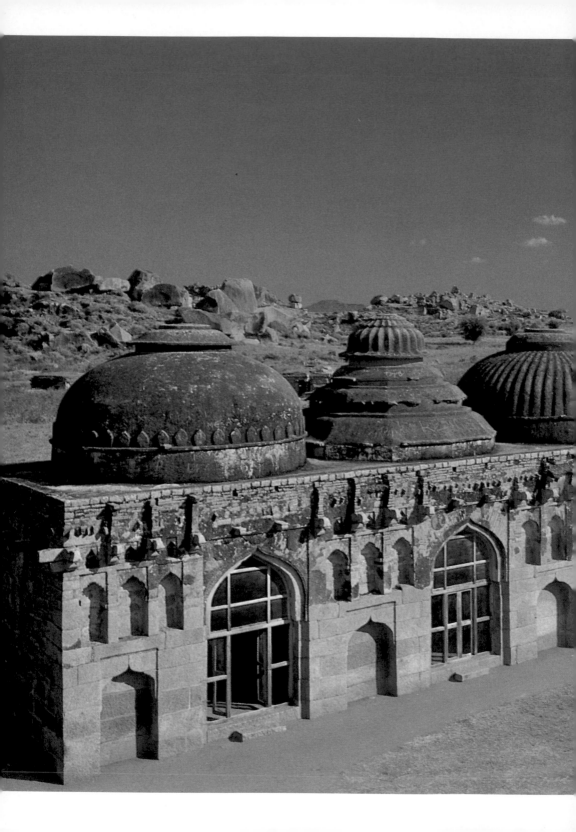

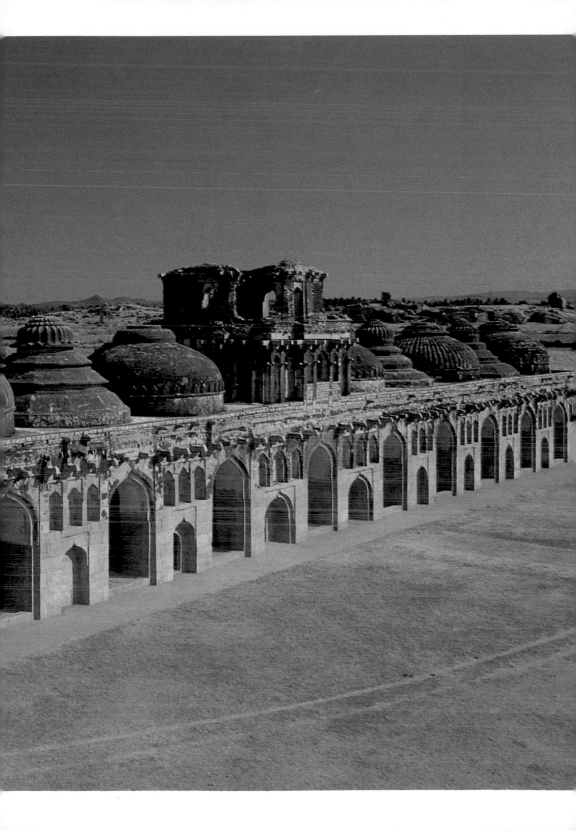

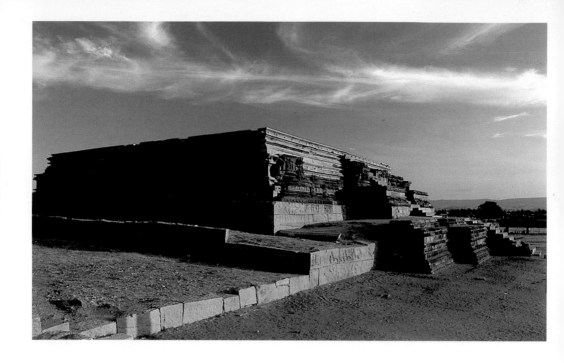

length, looks out over grounds used for military and ceremonial displays. Standing close to the elephant stables is the Lotus Mahal whose location suggests that it might have served as a general's residence.

Located in the Royal Enclave's public zone is a massive granite and chlorite ceremonial platform of significance in the affirmation of the king's divine 'persona' (181). Here the emperor publicly worshipped Durga before leaving the capital on a campaign of war, just as Rama had done before launching into battle against his enemy Ravana. This platform was used to celebrate *Mahanavami* or Nine Nights, a spectacle attended by viceroys, commanders, governors and chiefs. Each of the Nine Nights presented a variety of ceremonial processions and displays of wrestling, music, dance and fireworks. Several foreign visitors confirm that the stepped granite platform, 22 m (72 ft) square and rising 10 m (33 ft) above the ground, once carried a jewelled pavilion. Paes wrote:

As soon as ever the sun is down many torches are lit and some great

flambeaux made of cloth; and these are placed in the arena in such a way that the whole is as light as day, and even along the tops of the walls for on all the battlements are lighted lamps, and the place where the king sits is all full of torches. As soon as these are lit up there are introduced many very graceful plays and contrivances.

The walls of this great platform are covered with bas reliefs depicting rows of elephants, horses, dancers, drummers and jesters, recreating the processions so colourfully described by Paes and other visitors.

The *Mahanavami* festival, held in late September or early October at the end of the rainy season, heralded the beginning of the annual phase of war and travel related activities and the start of a new fiscal year. In the first half of the year, the king and his entourage travelled throughout the realm, visiting pilgrimage sites, participating in local religious festivities, adjudicating disputes and embarking on warfare. In the second half, the king, his court and army resided in the capital. In the vicinity of the *Mahanavami* platform are several large ponds and tanks, one of which, as large as a modern Olympic pool, could have accommodated the large floats used in the *Mahanavami* and other festivals. A second is a stepped tank with precisely cut steps arranged on all four sides in a series of pyramidal formations (182).

To the east of the Hazara Rama temple lay the emperor's private domains consisting of multiple palaces, fountains, baths and pleasure pavilions – of which little more than the foundations now remain. Duarte Barbosa, the Portuguese visitor who arrived in 1518, speaks of 'great and fair palaces ... with many enclosed courts and great houses very well built, and within them are wide open spaces, with water tanks in great number'. Other travellers' reports indicate that gold plate, jewels, silks and colourful murals were part of the embellishment. A local Sanskrit text speaks of palaces 'coloured like gems'. A succession of spaces, passageways, doors and barriers emphasizes both protection and privacy, and confirms foreign accounts

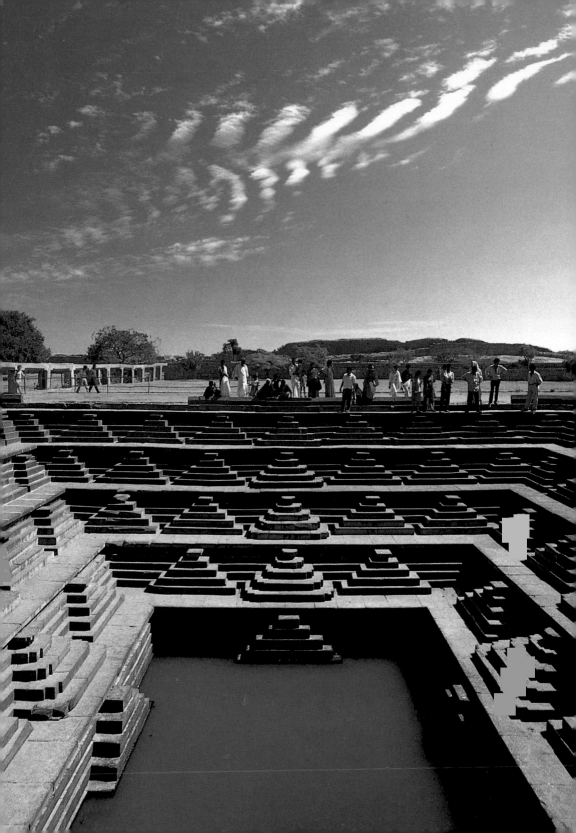

about the inaccessibility of the monarch and his household. Little more than the foundations of these glorious palaces remain; only partly burnt excavated finials of ivory testify to their rich and delicate decorative effects. Chinese porcelain discovered in the remains of one of these palaces testifies to the monarchs' taste for imported luxury goods.

A few eighteenth-century paintings in the Virupaksha temple's outer halls are all that survive of the colourful murals that once decorated the monuments of Vijayanagara, both sacred and secular. To get a feel for these erstwhile murals, we can turn to the Shiva temple at Lepakshi, an important city within the Vijayanagara empire that retains its sixteenth-century painted decoration. One spectacular composition celebrates the divine marriage of Shiva and his consort. The slender, gracefully poised women wear brilliantly patterned textiles and exuberant jewellery, styling their hair either in long braids or in knots pulled to one side of the head (183). The murals provide a glimpse of the luxurious and sensuous lifestyle that once existed within the now stark stone halls.

182
Stepped tank,
Vijayanagara,
c.15th century

A spacious pleasure pavilion at Vijayanagara, known popularly as the Queen's Bath, consists of a large, square pool surrounded by a tall, arcaded corridor of twenty-four bays roofed with domes and vaults in varied designs. Projecting over the water and affording a cool setting for its royal occupants are graceful roofed balconies with high arched windows (184). Only traces remain of the once exquisite plaster decoration of geometric and foliate motifs, parrots and mythical *yalis*, while its fanciful towers seen in nineteenth-century photographs have since crumbled away. Surrounding the entire structure is a broad water channel which provided for the central pool. Since the Royal Enclave is in an elevated, dry part of the site, water for its many tanks and baths had to be circulated through a series of aqueducts that ran through the entire zone, some resting on the ground while others were raised on stone beams. Waste water travelled through drains into sumps. A number of octago-

nal structures in the area includes a bath, a fountain, a double-storeyed pavilion and a tall watchtower, all with arched openings and vaulted ceilings.

The Sacred Centre consists of four major, walled temple complexes set in open spaces and reached via long, straight streets. Several smaller sacred shrines are located in small valleys among the rocky ridges. The Virupaksha temple complex dedicated to god Shiva belongs, like the other temples in the capital, to the Dravida building tradition of the Tamil country. Additions were made to the temple, which remains in worship to this day, throughout the 200-year history of Vijayanagara. Its small, square sanctum containing a Shiva *linga* existed from the tenth century; the shrine of Pampa seems to have been elaborated during the twelfth century. The temple precincts were enlarged in the fourteenth century when the site became a capital city, at which time the inner courtyard wall

183 Left
Wall-paintings,
Shiva temple,
Lepakshi, 16th
century.
Colour on
plastered
stone

184 Right
Queen's Bath,
Vijayanagara,
c.15th century

and two gateways were also built. The temple, including a huge
tank to its north, was completed in the reign of the celebrated
monarch Krishnadevaraya, who constructed the outer walled
enclosure and the impressive eastern gateway, some 50 m (164
ft) high, crowned with the typically southern barrel-vaulted
roof. Krishnadevaraya also added a number of pillared halls,
including a 1,000-pillared pavilion to celebrate the marriage of
Shiva and Pampa. Its pillars consist of solid, square blocks
joined by a series of slender colonnettes clustering around a
slim, central shaft, alternating with columns carved as rearing
lions. During the fifteenth and sixteenth centuries, the
Vijayanagara monarchs, as overlords of the Tamil country,
added similar pillared halls to numerous temples including
Srirangam, discussed in Chapter 10.

Krishnadevaraya built the Vitthala temple complex to enshrine
an image of the Vitthala form of Vishnu, which may have been

185
Garuda shrine
in the form of a
chariot, Vitthala
temple,
Vijayanagara,
1509–29

brought back from a campaign along the west coast. Standing within a walled courtyard entered by three gateways, the temple consists of a sanctum with a southern-style brick tower, an attached enclosed hall and an outer open hall with steps on three sides. Facing the temple is an exquisite little shrine of Vishnu's mount, the divine eagle Garuda, created in the form of a temple chariot, with wheels cut from separate blocks of stone so allowing them to rotate on their axles (185). The Vitthala temple, like other major temples at Vijayanagara, also possessed its own wooden chariot to be used on festive occasions for pulling a bronze image of the deity triumphantly along the ceremonial street stretching a kilometre (over half a mile) in front of the temple. Paes reports:

Outside the city walls on the north are three very beautiful pagodas, one of which they call the Vitella. Whenever the festival of one of these temples occurs they drag along certain triumphal cars which run on wheels, and with it go dancing-girls and other women with music to the temple, conducting the idol along the said street with much pomp.

The final addition to the Vitthala temple was a detached open hall with an extraordinary set of monolithic granite columns, gifted in 1554 by the commander-in-chief of the last Vijayanagara emperor. The outer columns are carved as clusters of colonnettes surrounding a central shaft; the central columns on each of the outer faces of the hall are carved into rearing lion-like *yalis*, while those in the interior are carved with a variety of animal and human figures.

Krishnadevaraya built a third temple to enshrine an image of the child god Krishna, incarnation of Vishnu, that he had captured in the course of a victorious campaign to Orissa. By thus honouring the deity, the emperor ensured that Krishna would transfer his potency and power to the City of Victory. The sparse and simple nature of the carved decoration suggests that the temple was completed hurriedly in response to the king's desire for immediate consecration of the image. Within the temple walls is a great multi-domed granary used to store

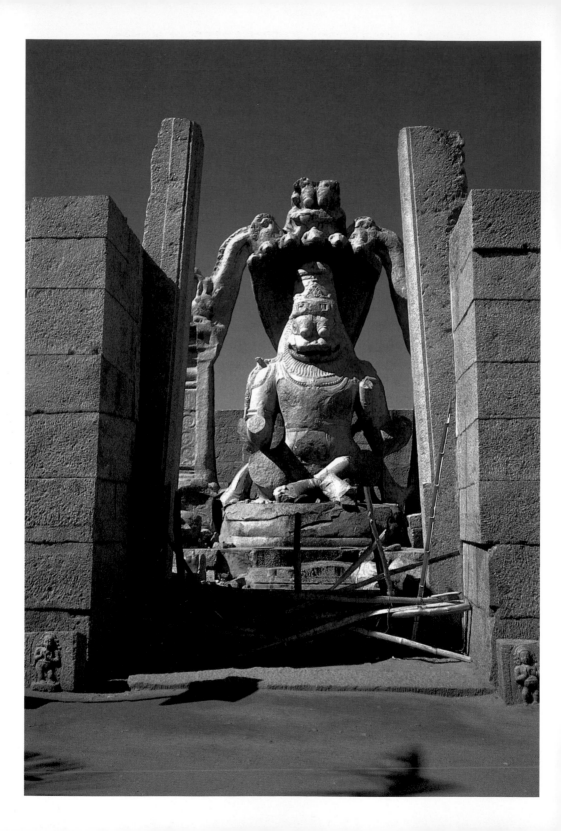

grain for the ritual preparation of food for the festivals held in the temple premises. A gigantic granite monolith portraying Narasimha, the man-lion incarnation of Vishnu, in yogic posture (186), is located south of the Krishna temple. He is backed by a hooded serpent cut from the same single piece of rock and once had a diminutive image of his consort Lakshmi on his lap. The sanctum that would have enshrined the image was never completed.

During the reign of Krishnadevaraya, the City of Victory was a centre of arts and learning. The emperor himself was a writer of poetry, prose and drama; his works, focusing on sacred themes, included the *Amuktamalayada*, a poem in Telugu on the life of Andal, a ninth-century woman saint who composed Tamil poetry on Vishnu, and a Sanskrit drama, *Jambavati Kalyanam*, written to be staged at the Virupaksha temple during the annual spring festival. Literary figures from across India were attracted to his court where they produced epics and poems, dramas and prose works, in Sanskrit and in the southern languages of Telugu, Tamil and Kannada. The words of one of his court poets, Allasani Peddanna (*Manucaritramu*, ch I, v 13–14), suggest that he formed close bonds with those whose learning he respected:

While guards stood nearby,
fearless men with terrifying swords of blinding brightness,
and tributary kings surrounded him …
his heart was moved by the sweetness
of poetry and, from his throne,
he spoke to me with kindness.

Another court poet, Nandi Timmanna, accorded Krishnadevaraya a highly elevated status (*Parijatapaharanamu*, ch I, v 17)·

He is Krishna descended again, who has taken on a form
that receives utmost honour from everyone in the world:
the son of Narasaraya, Krishnaraya, lord of the earth.

In the mid-sixteenth century, with Vijayanagara monarch Sadashiva a mere figurehead, Ramaraya, military commander of the Vijayanagara army and effective ruler of the empire, acted arrogantly towards the Deccan sultans. In retaliation, the sultanates unexpectedly joined forces and in January 1565 defeated Ramaraya in battle. Though the battle site was some distance from Vijayanagara, the city was ransacked and reduced to rubble. Temples and gateways were set on fire, sculptures were smashed or removed and precious materials plundered. The city was never again occupied by its kings who fled to the neighbouring region of Andhra. Vijayanagara, once a showpiece of imperial triumph and magnificence, was abandoned to centuries of sporadic pillaging and neglect. Since the 1970s, an international team of archaeologists has been working to restore something of its former glory, and it aims to reconstruct several of its monuments.

13

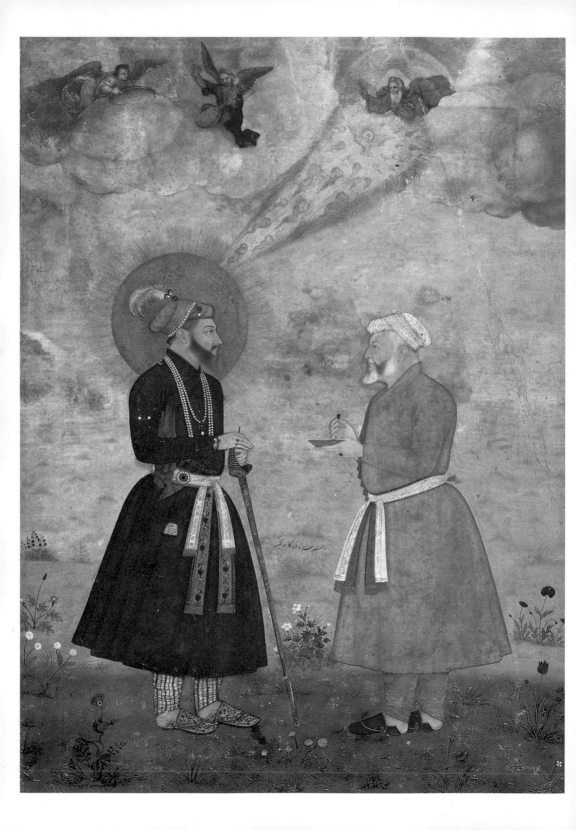

Overlooking an expansive ornamental garden, and rising in marbled splendour on the banks of the River Jamuna, is the world-renowned Taj Mahal (203). Built by Mughal emperor Shah Jahan ('World Ruler') to entomb the remains of his beloved wife Mumtaz Mahal ('Chosen One of the Palace') who died in childbirth, it is frequently celebrated as a symbol of perfect conjugal love. Court poet Kalim wrote:

Since heaven's vault has been standing,

an edifice like this

has never risen to compete against the sky.

187
Emperor Shah Jahan with his Prime Minister, c.1650. Watercolour and gold on paper; 44 × 32·9 cm, 17½ × 12⅞ in. Arthur M Sackler Gallery, Washington, DC

In the twentieth century, the famed Indian poet Rabindranath Tagore evoked it as 'a teardrop on the cheeks of time'. This Islamic monument has become a national symbol of beauty and excellence for all Indians regardless of religious or sectarian affiliation. It also carries a profound and symbolic significance.

Many would judge the Taj Mahal, with its exuberant use of marble, and its charming and tranquil canals and gardens, to represent the perfection of ideas and forms that coalesced under the Mughal dynasty. The English word 'mogul' is derived from these historic Mughals whose milieu of palaces, gardens, gems and rich manuscripts has become synonymous with affluence and luxury. The Mughals were of Turkish–Mongolian heritage; the founder of the dynasty, Babur, was descended on his father's side from Timur or Tamerlane, and on his mother's from Genghis Khan. But these warriors also cultivated an eye for the beautiful. Babur's son Humayun found time for art even as he fled India upon his temporary ouster from the throne. When an exotic bird flew into his tent, he caught it and ordered his artists to paint it.

Babur (r.1526–30), the erstwhile ruler of a small Central Asian principality, turned his attention to India in 1526; defeating the Lodi sultan, he established himself in Delhi as *padshah* or emperor of India, ruling over a loosely knit kingdom that stretched from Afghanistan to the borders of Bengal. His son Humayun temporarily lost his empire to a rival chief of eastern India, and fled the country taking refuge at the court of Shah Tahmasp of Iran. Aided by Iranian forces, Humayun recaptured his territories, but died soon after from a fall. The few architectural remains of these first two monarchs reveal a combination of Iranian Timurid elements with the local inclination for inlaying red sandstone with marble and coloured stones.

It was the third monarch, Akbar (the 'Great'), who not only stabilized and expanded the empire, but also left his indelible imprint on the architecture and painting of India. The first task facing the 14-year-old monarch was the consolidation of the power of the Mughal empire by securing the cooperation of the warring Rajput kingdoms along its western borders. Realizing that distrust between Hindus and Muslims could be detrimental, Akbar took steps to ensure the continuing success of his empire. He prohibited the enslavement of Hindu prisoners of war, abolished the *jizya* tax levied against non-Muslims and in 1562 married a Hindu princess of Amber (near Jaipur), giving her the name Maryam al-Zamani (Mary of the Age). These actions won him the friendship of several Hindu Rajput kings who showed willingness to serve the imperial cause; military successes followed, with most of northern India coming under Akbar's control. Going a step further, Akbar included several Hindus in his trusted group of nobles and court officials. He also permitted his queen and her entourage to celebrate their Hindu rites, rituals and festivals within the palace grounds.

Akbar was a shrewd administrator whose administrative model was later emulated by the British. His empire consisted of twelve, later eighteen, provinces, divided into districts and sub-districts. Each province had two sets of officers, a magistrate in

charge of armed forces and a revenue official; thus one had the armed forces without the cash, while the other had the revenue without the forces. Akbar's imperial service consisted of handsomely paid officers or *mansabdar*s in thirty-three grades, from commanders of ten troops to commanders of 5,000. Each provided the emperor with the number of troops indicated by his command, receiving handsome salaries in return. Salaries were later replaced by the revenue from tracts of land; since positions were not hereditary, land reverted to the emperor.

A man of deep intellectual curiosity, Akbar invited to his court Zoroastrians, Jains, Muslims, Hindus and Jesuits from Goa to discuss and exchange religious ideas. He commissioned illustrated versions of the Hindu epics, the *Ramayana* and the *Mahabharata*, after first having the texts translated from the original Sanskrit into Persian, the court language. The earliest extant illustrated *Ramayana* is one produced by him. He eventually proclaimed a new code, an amalgamation of religious conduct that he called *Din-ilahi*, or Divine Faith. His temerity in announcing this new code (not a new religion), knowing full well that it would outrage the orthodox Ulema, may have had its roots in the Mughal belief that emperors radiated from the Light of Allah and were hence special beings touched with divinity. In Abul Fazl's official history of Akbar's reign, the *Akbarnama*, the Mughals refer to themselves as the 'lamp of the house of Timur'. Royalty is also described in the *Ain-i Akbari* or 'Institutes of Akbar' as:

a light emanating from God, and a ray from the sun, the illuminator of the universe ... Modern language calls this light *farr-i izidi* (the divine light) and the tongue of antiquity called it *kiyan khurra* (the sublime halo). It is communicated by God to kings without the intermediate assistance of anyone

The concept of divine light being communicated from God is depicted graphically in a painting of emperor Shah Jahan with his prime minister (187), while royal portraits customarily depict the emperors with a halo.

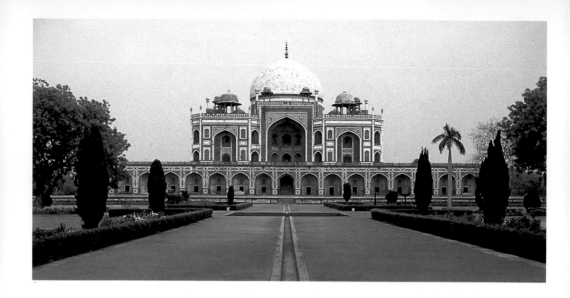

The early years of Akbar's reign were spent in Delhi during which time he built for his father Humayun a magnificent tomb (188), completed in 1571. While tradition assigns a major role in the choice of Iranian architect Mirak Sayyid Ghiyas to Humayun's queen, recent research suggests that Akbar was the main patron. The architect constructed this first grand Mughal garden tomb by placing the red sandstone and marble structure in the middle of a *char-bagh* or four-part garden divided by four water channels. The layout of Mughal garden tombs is embedded in the Islamic visualization of Paradise as a garden through which four streams flow. Today green lawns planted by the British surround the tombs; originally, however, arrayed with flowering plants, indigenous trees and exotic herbs, they must have presented a totally different effect. The mausoleum, built of red sandstone trimmed with white marble, sits on a high plinth. A lofty arched portal dominates the main façade of the large square structure with chamfered sides, and the whole is crowned by an Iranian double dome with an exterior facing of marble. The interior consists of a central octagonal chamber surrounded by eight interconnected chambers. Pierced screens allow light to enter, for light is a symbol of the presence of God. An oft-quoted koranic verse (*sura* 24, lines 35–6) specifies:

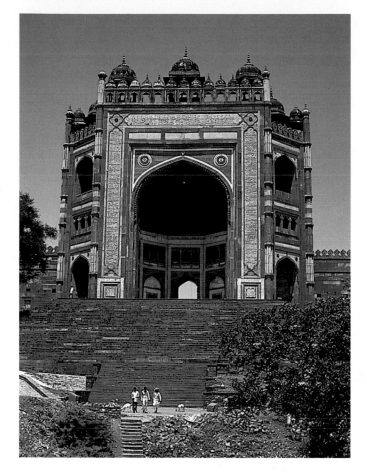

188
Humayun's
tomb, Delhi,
completed in
1571

189
Buland
Darvaza,
Fatehpur Sikri,
1573–4

God is the Light of the Heavens and the Earth …
This Light is found in houses which God allows to be exalted.

Akbar ordered the rebuilding of the old mud-brick Lodi fort at
Agra, but later decided to create a new capital city, some
distance from Agra, located spectacularly on a rocky plateau
overlooking a lake. The choice of the site was dictated by its
being home to shaykh Salim Chishti, a Sufi mystic who had
prophesied that Akbar, yet without a living heir, would be
blessed with three sons. In 1571, Akbar's Hindu wife gave birth
to a son who would become emperor Jahangir; to give honour
and thanks, Akbar named his son Salim, and built the town of
Fatehpur Sikri (Town of Victory-Sikri), the name perhaps
commemorating the inclusion of the Gujarat Sultanate in

Akbar's empire. The town's monuments, built over fifteen years, were constructed largely by western Indian temple carvers who modified pre-existing Sultanate styles.

Upon the rocky plateau of Fatehpur Sikri stands the royal mosque complex with the palace area to its west and the residential town below. The entrance is through a red sandstone grand gateway, the Buland Darvaza (189), reached by a lofty flight of steps. Its crowning parapet, decorated with a row of kiosks, rises 54 m (177 ft). The large central face of the gateway, dominated by an arched, domed recess, is flanked by two lesser chamfered faces. Framing the arched opening is a wide ornamental border laid with continuous calligraphy of koranic verses. This magnificent entrance leads into a mosque with an arched façade crowned with kiosks, within which are three *mihrab*s to mark the direction of Mecca. On either side of the central archway is a calligraphic chronogram that speaks of the grandeur of the mosque, completed in 1571–2, 'which for its elegance deserves as much reverence as the Kaaba'.

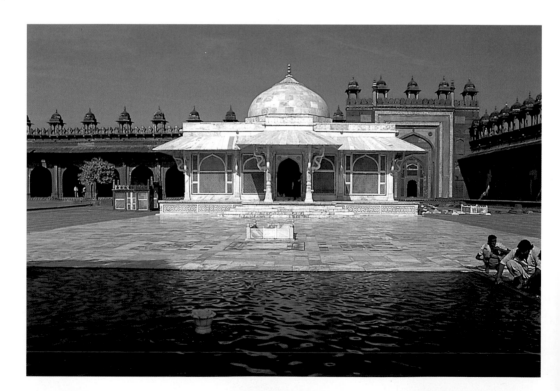

Within the spacious courtyard is an exquisite marble tomb for shaykh Salim Chishti (190, 191). Delicate screens cut into geometric patterns and elegantly inscribed verses from the Koran are artistic evidence of the abstract approach of Islam, while its brackets, in the form of serpentine volutes, speak of the lively repertoire of temple builders. Designs on the marble floor are inlaid with semi-precious stones, and above the tomb rises a remarkable canopy totally covered with thin scales of mother-of-pearl cut into elaborate patterns. The structure seems to have been originally completed in 1580–1 with a veranda and dome of red sandstone. Some of the outer screens may have been the 1606 contribution of Jahangir's foster brother, Khan Koka, while the marble veneer for the dome was added at the behest of the English District Magistrate of Agra in 1866.

The monuments at Fatehpur Sikri carry fanciful nineteenth-century names that have caused confusion regarding the actual usage of buildings. Jodh Bai's palace, for example, supposedly built for the use of Akbar's Rajput wife, is actually a series of

190–191
Tomb of shaykh
Salim Chishti,
Fatehpur Sikri,
mainly
c.1571–80
Left
General view
of tomb
Right
Detail of screen,
c.1606

mansions. Its high, forbiddingly plain exterior wall encloses a series of residential palace structures that face the interior courtyard in the fashion of Gujarat in western India. The decorative treatment of entrances, brackets and relief carvings suggests the craftsmanship of Gujarati woodworkers transferring their art to sandstone. The complex seems to have been the main *haram sara* or harem enclosure that housed the many women of the imperial household, chief among whom was Akbar's mother who held the title of Maryam Makani or Equal to Mary.

Among the more striking monuments in the palace area is the open Panch Mahal (192), or five-storeyed mansion, which seems to have been a *badgir* or wind catcher. Here ladies of the court relaxed in the breeze behind the privacy of delicate latticed screens of which only fragments survive today. The pavilions diminished in size on each succeeding floor, commencing with the lowest containing eighty-four pillars of which no two are alike, and culminating in a single, domed pavilion with just four pillars.

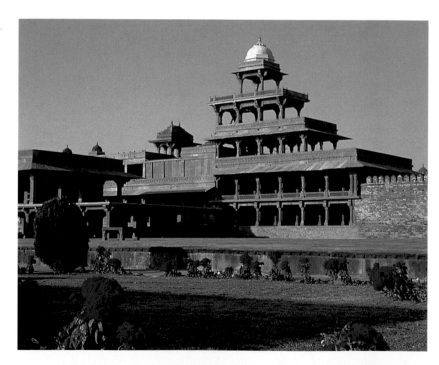

192
Panch Mahal,
Fatehpur Sikri,
c.1571–6

Perhaps the most unusual building is one known as the *Diwan-i-Khas* or Hall of Public Audience (193), although its actual use remains a matter for further research. It gives the outward appearance of being a two-storeyed structure topped by four tall kiosks. Its lofty interior contains a large central pillar topped by one of the most exuberant capitals ever conceived (194); thirty-six closely set brackets, in a circular arrangement in two levels, support a circular stone platform, with bridges connecting it to a gallery that runs around the interior wall. The closest parallels to such brackets, though never in such extravagance, are found in the mosque minarets of the sultans of Gujarat. It was once believed that Akbar, seated upon silken cushions in this central platform, gave audience; the citizenry who came for redress or to submit complaints stood on the ground below, while the nobles sat in the galleries branching out from behind the emperor. Some scholars suggest that Akbar inspected gems and jewels here. All that appears certain is that Akbar sat enthroned on high, proclaiming as it were his position as the *axis mundi*, the central pillar of the Mughal empire.

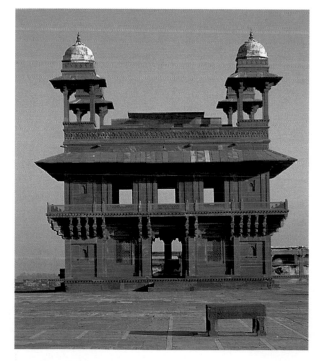

193
'Hall of Public Audience', Fatehpur Sikri, *c.*1571–6

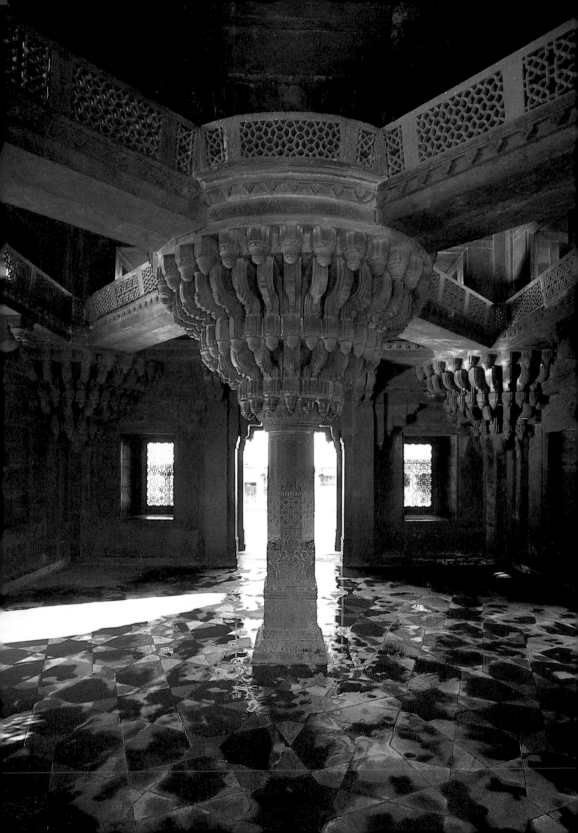

Fatehpur Sikri was abandoned even during Akbar's reign. The common explanation of a shortage of water might seem possible today since its lake is totally dry; in its time, however, located along the 'royal corridor' between Agra and Ajmer, it was a waterfront city of note. In 1585, Akbar left Sikri to move to Lahore to be closer to troubled frontier areas; his courtiers seem to have been surprised when, in 1598, he chose to go to Agra instead of returning. He does not seem to have made any formal decision to abandon Sikri, and his reason for not returning remains an enigma.

Mughal paintings are among the most treasured works of Indian art, and it was Akbar who cultivated and nurtured the artists who created the Mughal style. The paintings are known as 'miniatures', despite generally being page-sized. By the sixteenth century, prevalent Islamic attitudes towards the representation of living creatures were reconsidered by Indian Muslims. Akbar submitted to theologians this defence of painting (*Ain-i Akbari*, bk I, *ain* 34):

It appears to me as if a painter has quite peculiar means of recognizing God; for a painter in sketching anything that has life, and in devising its limbs, one after the other, must come to feel that he cannot bestow individuality upon his work, and is thus forced to think of God, the Giver of Life, and will thus increase in knowledge.

Akbar's contention was that painting, far from being blasphemous, would actually serve to deepen faith and religious fervour.

The visit of Akbar's father Humayun to the Iranian court was as crucial to art history as to empire. Admiring the paintings of Shah Tahmasp's artists, Humayun persuaded two leading Iranian painters, Mir Sayyid Ali and Abd as-Samad, to join him in Delhi. These two senior artists took charge of Akbar's painting workshop and supervised around a hundred local painters. The rapid process that resulted in the emergence of Mughal painting remains unclear. Akbar's painters drew upon existing

194
Central pillar of
'Hall of Public
Audience',
c.1571–6

indigenous painting traditions of the Hindus, Jains (117) and the sultanates (170), assimilating them with established Iranian styles. Representational techniques from Chinese and European sources were also studied and synthesized. The creation of this new, vibrant style may largely be due to Akbar's encouragement of artistic experimentation, though credit must also go to his artists who effected the transformation.

Painters sat on the ground with one knee flexed to support a drawing board upon which they applied watercolours to paper. From childhood they were taught how to make paint brushes from bird quills set with fine hairs plucked from kittens or baby squirrels. They learned how to grind mineral pigments in a mortar, and to prepare the binding medium of glue. Pigments were also made from earths (red and yellow ochres), and from insect and animal matters (crimson from the lac insect, vivid yellow from the urine of cows fed on mango leaves). To make metallic pigments, gold, silver and copper were pounded in foil, which was then ground in a mortar together with salt. When washed with water, the salt dissolved leaving only pure metal powder. Some artists like Basavan were specially skilled in the application of gold, which they pricked with a stylus to make it glitter. Paintings were burnished by laying them painted side down on a hard, smooth surface and stroking them firmly with polished crystal; burnishing provided a protective hardening comparable with varnishing an oil painting.

Akbar's workshop, like its Iranian counterparts, accumulated a stock of sketches and tracings that could be used to produce new paintings. Tracing was an accepted technique: transparent gazelle skin was placed on a drawing whose contours were transferred to the skin by pricking with a pin. The tracing skin was then placed on fresh paper, and black pigment forced through the pinholes to create an outline. Paintings seem to have taken considerable time to complete; one marginal notation speaks of fifty days worth of work. Once paintings had been burnished they were handed to other specialists who

mounted them on decorative borders and bound them into a book or album.

Although technically illiterate, Akbar had a keen intellect and a phenomenal memory; readers read to him, scribes took dictation. He had an extensive library of 24,000 books, most of them acquired by inheritance, purchase or as gifts from the Iranians. Books that Akbar himself commissioned were written in Persian and invariably illustrated, perhaps to emphasize visual enjoyment. The painting workshop was closely attached to the library, nearly all work being illustrations of manuscripts. Work on a painted page was a collaboration between the master artist, responsible for composition, another to add colour, and frequently a specialist in portraiture. The superintendent of the workshop then wrote the names of all the artists along the margins of the page. From the memoirs of Akbar's reign, it seems the emperor inspected finished work every week, and when pleased, handed out rewards to artists who were normally employed on monthly salaries.

The *Akbarnama*'s section on the art of painting, written by 1598, speaks especially of the work at Akbar's court of the two great Persian masters, two local artists – Dasavanth who died prematurely and Basavan whose specialty was portraiture – and then names another thirteen local artists. Recent scholarship has begun to focus increasingly on the works of individual artists in the emergence of the Mughal style, rather than Akbar's dominating role. Court painters were generally humble craftsmen, but the specially talented earned privileged positions close to the throne; one such was Abul Hasan whom Akbar's son, emperor Jahangir, honoured with the title Nadir al-zaman ('Wonder of the Age').

One of the first projects of Akbar's workshop was a series of large paintings on cloth, the size of modern posters, illustrating the *Hamzanama*, the fabulous adventures of Hamza, an uncle of the prophet Muhammad (195). We know that Akbar enjoyed listening to a recitation of these fantastic stories; the large size

of the paintings and their stout backing suggests that they may have been held up to accompany such recitation. Only some 150 of the original 1,400 paintings of this immense project survive. The images seem to burst from their boundaries, men and women are seen in dramatic action, and even rocks are dynamic. Circular movement is emphasized by figures with outstretched arms and legs. Frequently, scenes are scarcely contained within the boundary of the painting, and foreground figures are often cut off by the lower margin. Using the Indian and Iranian convention of multiple perspective, artists depicted exteriors and interiors of forts and palaces within a single view.

195
Sanghari-i Balki and Lulu the Spy Slit the Throats of the Prison Guards and Free Aiidi Farrukh Nizhad, from the *Tales of Hamza*, 1562–77. Watercolour and gold on cloth; 77 × 62 cm, 30¼ × 24½ in. Brooklyn Museum, New York

At Akbar's command, his trusted noble Abul Fazl assumed the task of chronicling the monarch's daily activities. The painting workshop produced an illustrated biography of this *Akbarnama* or 'Tales of Akbar' in which pages of pure text were interspersed with illustrated pages that occasionally carried a line or two of text. Several illustrations were conceived as double-page spreads. This manuscript illustrates the maturity of the Mughal style. The two facing pages depicting Akbar restraining elephant Havai seethe with energy (196). Basavan, who was responsible for the composition, made effective use of the diagonal movement across the two pages. The sweeping action, the billowing waters, the numerous details like the goats at the water's edge, swimmers and oarsmen in the act of rowing are accorded as much attention as the emperor upon his elephant. The horizon is placed high as is usual in Mughal paintings; often it is beyond the upper margin which cuts landscape or architecture in an arbitrary manner. Basavan has created an effect of perspective with boats in the distance painted much smaller than those in the foreground. The palace from which Akbar's minister has emerged to beg Akbar to dismount, as well as other monuments in the pages of the *Akbarnama*, are the painted equivalents of the monuments at Fatehpur Sikri. Abul Fazl's words record the scene depicted by Basavan (*Akbarnama*, ch XXXVII):

Havai was a mighty animal and reckoned among the special elephants … Strong and experienced drivers who had spent a long life in riding similar elephants mounted him with difficulty … That royal cavalier [Akbar] … one day without hesitation mounted this elephant in the very height of its ferocity … After that he pitted him against elephant Ran Bagha … The loyal and experienced who were present were in such a state as had never happened to them before … Great and small raised hands of entreaty … Havai looked neither behind nor before and … went like the wind in pursuit of the fugitive. After running a long way the elephants came to the edge of the River Jamuna and went to the head of the great bridge behind him … Owing to the great weight of these two mountain forms the pontoons were sometimes submerged

197
*Akbar Hunting
in an Enclosure*,
from the
Akbarnama,
*c.*1590.
Watercolour
on paper;
32·1 × 18·8 cm,
12⅝ × 7⅜ in.
Victoria &
Albert
Museum,
London

198
*Krishna
Enthroned in the
Golden City of
Dvarka*, from
the *Harivamsa*
*c.*1585.
Watercolour
on paper;
23·9 × 17·3 cm,
9 × 6¾ in. Freer
Gallery of Art,
Washington,
DC

and sometimes lifted up. The royal servants flung themselves into the water on both sides of the bridge and went on swimming until the elephants had traversed the whole of the bridge and got to the other side.

The naturalism evident in such pages is seen in neither the Iranian tradition with its other-worldly colours and its highly stylized figures, nor the earlier indigenous painting style of, for instance, Jain manuscripts. It may have been Akbar's own interest in realism, together with the European prints arriving at the Mughal court, that encouraged his artists to create this new style using naturalistic colours.

Another magnificent double-page composition depicts an imperial hunting technique known as *qamargah* in which animals were enclosed within a circular stockade while beaters drove

the game towards the emperor. The left-hand page created by Miskin, known for his complex compositions with several centres of interest (197), depicts Akbar, accompanied by trained cheetahs and hunters, galloping through the enclosure firing arrows at trapped beasts. This page was coloured by Mansur who was later to become a specialist in painting flora and fauna. The circular composition highlights the impossibility of containing all the action within a page. It was during one such hunt, at the age of thirty-six, that Akbar had one of two mystic experiences reported in his biography; disgusted by the slaughter, he subsequently banned the qamargah.

From Akbar's extensive translations of Hindu texts there emerges a superb page from the Harivamsa or Genealogy of Vishnu, depicting god Krishna painted in the traditional deep blue, and enthroned in the golden city of Dvarka (198). The artist uses multiple perspective to show us innumerable details of both the interior and exterior of this splendid palace, while the simple cowherds in the foreground tell the tale of village life. The feeling of receding space is conveyed by the large scale of the foreground figures compared with the small enthroned figure of Krishna.

199
The Crucifixion, after a European engraving, *c.*1590. Watercolour on paper; 32 × 20 cm, 12½ × 7⅞ in. British Museum, London

Copies of European paintings of Christ, the Madonna, the Last Supper, St John and a variety of allegorical themes were created for the pleasure of the Mughal emperors. Such images should not be interpreted as evidence of Christian leanings; they were no more than exotic curiosities. The art of copying was highly respected in Mughal India. One of the sources was an eight-volume polyglot Bible with engraved frontispieces presented to Akbar by Father Monserrate, head of the Jesuit mission at Goa. Also known to the artists, and copied closely, were the works of several German and Flemish engravers, including Albrecht Dürer. *The Crucifixion* is an example of the Christian paintings made for Akbar (199); the heavy modelling of the figure of Christ suggests that the artist may also have had a crucifix at hand. Its colouring hints that artists had access to more than black-and-white prints; perhaps imported tapestries gave them a sense of the European use of colour.

Akbar was particularly interested in textiles, and his workshops produced fine-quality velvets, silks and cottons. Carpets too were highly valued, being used to cover the floors of palaces, tombs and tents; an exquisite pictorial carpet woven around 1590 consists of a series of vignettes that includes a hunting scene with a cheetah on a bullock cart, and a phoenix approaching lion-like creatures (200). The art of Akbar's court represents a dynamic phase of Mughal culture in which diverse elements were syncretized; it established the basis for future Mughal artistic development.

The reign of Akbar's son Jahangir ('World Seizer', r.1605–27) witnessed a change in the role of women who had thus far been heavily veiled and secluded from public view. Jahangir's wife Nur Jahan ('Light of the World'), whom he married in 1611, was a charismatic and forceful personality who issued *farman*s or official orders, and even had coins struck in her name. She traded with Europeans in luxury goods, received petitions from nobles and was a superb rifle markswoman. One of her most significant architectural contributions was a small but

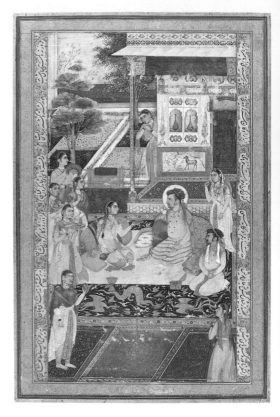

200
Pictorial carpet,
c.1580–90,
Cotton warp
and weft,
woollen pile;
243 × 154 cm,
95⁵⁄₈ × 60⁵⁄₈ in.
Museum of Fine
Arts, Boston

exquisitely bejewelled marble tomb at Agra for her father,
Itimad al-Dawla, constructed at the centre of a *char-bagh*
garden divided by four waterways. In a painting of Nur Jahan
hosting a feast for her husband and prince Khurram (later
emperor Shah Jahan), she is depicted seated on a pictorial
carpet sharing the stage equally with her husband (201). It was
undoubtedly her example that now permitted Mughal artists to
focus on women as the subject matter of their paintings.

The Mughal passion for gardens was developed by Jahangir
and Nur Jahan who explored both the terraced hillside garden
and the riverfront garden. Jahangir was especially enamoured
of the valley of Kashmir with its idyllic town of Srinagar situ-
ated along the Dal Lake, which he planned to use as his official
summer residence. He wrote enthusiastically in his memoirs,
the *Tuzuk-i Jahangiri*):

201
*Nur Jahan
Hosting a
Banquet for
Jahangir and
Prince Khurram.*
Watercolour on
paper;
25·2 × 14·2 cm,
10 × 5½ in. Freer
Gallery of Art,
Washington, DC

Kashmir is a garden of eternal spring … a delightful flower-bed, and a heart-expanding heritage … Its pleasant meads and enchanting cascades are beyond all descriptions. There are running streams and fountains beyond count. Wherever the eye reaches, there are verdure and running water.

Jahangir and his son Shah Jahan planned the perfectly symmetrical Shalimar ('abode of love') Gardens in which a natural spring flows to the lake via a canal that forms the main axis of the garden. A series of terraces was laid out along the gently sloping hillside with ponds, lateral conduits, pavilions and platforms. Shalimar, planned mainly as Jahangir's personal royal garden, is divided into three terraced sections; from the centre of each an architectural feature extends across the channel and overlooks the cascading waters. The lowest level, the area of public audience, has a black marble throne platform that rises above the waters. The second level has the private audience pavilion (of which little remains today), while at the top is a black marble pleasure pavilion, the garden's main architectural feature, built by Shah Jahan. Since the gardens were used as much at night as during the day, recessed niches were carved into the low walls enclosing the water channel to contain lamps that would illuminate the water. Kashmir is renowned for its numerous Mughal terraced gardens, laid out by members of the royal family and nobles. In other parts of his empire Jahangir built riverfront gardens in which the architectural accent was no longer on the central axis, but arranged along a waterfront terrace.

Jahangir's outstanding architectural achievement was a tomb for his father Akbar, built at Sikandra near Agra, in the centre of a *char-bagh* garden. Unlike Humayun's tomb, however, the plan of this red sandstone building in five storeys is more like that of a palace. A central square room housing the sarcophagus has a ceiling that reaches up to the third floor; a gem-inlaid marble cenotaph rests on the topmost level within a courtyard enclosed by screens of white marble but completely open to the

202
Gateway to
Akbar's tomb,
Sikandra,
c.1610

203
Taj Mahal,
Agra, 1631–43

sky. The reason for the curious disregard for damage from the
elements lies perhaps in the verse inscribed on the entrance
gateway: 'May his [Akbar's] soul shine like the rays of the sun
and the moon in the light of God.' The tomb structure with its
many crowning kiosks is reminiscent of the Panch Mahal at
Fatehpur Sikri. Equally striking is the decorative treatment of
the imposing gateway, surmounted by four slender marble
minarets, in which elaborate geometric patterns and large floral
designs created from white marble and multi-coloured stones
are inlaid on the basic fabric of red sandstone (202). The
continuous bands of calligraphy in white marble include refer-
ences to the gardens of paradise:

Hail blessed space happier than the garden of Paradise
Hail lofty buildings higher than the divine throne …
These are the gardens of Eden,
enter them and live forever.

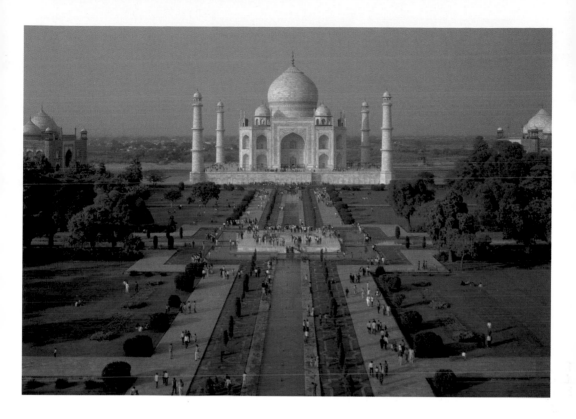

With emperor Shah Jahan, Mughal architecture made use of
marble more extensively than ever before, and like all other
Mughal tombs Shah Jahan's renowned Taj Mahal (203) is
replete with the imagery of paradise. Indeed, the visitor about
to enter through the great red sandstone doorway leading into
the complex is greeted with this verse from the Koran, in black
marble calligraphy inset on the white marble border that runs
around the gateway arch (*sura* 89, lines 27–30):

But O thou soul at peace,
Return thou unto thy Lord, well-pleased, and well-pleasing unto Him,
Enter thou among my servants,
And enter thou My paradise.

The spectacle of the Taj, rising in marble eminence upon its
raised platform at the far end of a formal garden, evokes a
sense of awe and wonder. The simplicity of the proportions
creates its effect of symmetry and harmony: it is exactly as

wide as it is high (55 m or 180 ft), and the height of its dome is
the same as the height of its arched façade. It is flanked by two
identical monuments of red sandstone inlaid with marble, of
which the left one is a mosque, the other being its architectural
replica referred to as a *javab*, or an answer or echo, whose only
purpose is to balance the symmetry.

But this garden tomb differs from its predecessors in that it is
not placed at the centre of the *char-bagh*; rather it is located at
the far end from its entrance gateway, to be approached
through the garden, which is some 305 m (1,000 ft) square. The
central, raised marble tank is visualized as a replica of the
celestial tank of abundance. The original garden conception
included a plan to ensure that each quadrant would have
flowers in bloom at specified times throughout the year. These
included the carnation, iris, tulip, hyacinth, jasmine, lotus,
marigold, narcissus and zinnia. Fruit trees were planted along
the walls where they would not block the view. Flowers that
relate to paradise were duplicated on the Taj in marble carving
as well as inlay (204–206). Thin sections of precisely cut
semi-precious stones and gemstones were inlaid into the
white marble in the technique known as *pietra dura*. Inlaid
stones include jade, lapis, yellow amber, carnelian, jasper,
amethyst, agate, heliotrope and green beryl. Subtle shading
effects were achieved by using stones of varying degrees of

colour: a single flower may contain as many as thirty-seven pieces of inlay.

204–206
Details of the
pietra dura
decoration, Taj
Mahal, Agra,
1631–43

Recent research suggests that the Taj complex may relate not so much to paradise *per se*, but more specifically to paradise on the Day of Judgement, which Islam conceives in terms analogous to that of Christianity. The Taj itself may have been visualized as the Throne of God; possibly the four minarets are supports for the canopy of the throne. The marble platform at the centre of the *char-bagh* may represent the platform where Prophet Muhammad will decide upon the fate of souls. A study of the numerous inscriptions engraved on various portions of the monument reveals that every verse from the Koran that speaks about the Day of Judgement is present, while no other koranic verse is given a place. One such inscribed chapter (*sura* 82) on the west door commences:

When the Sky shall be cleft asunder –
When the Stars shall be scattered –
When the Seas shall be poured forth –
And when the Graves shall be overturned –

Islamic tradition says that such chapters should be recited by those who would like to witness the end of the world enacted before their eyes. It is difficult to believe that they would have been intended solely for a mausoleum for a beloved wife.

The central tomb inside the Taj is of Mumtaz Mahal, with Shah Jahan to one side; both are cenotaphs, and the actual bodies rest in a crypt. In the Islamic tradition the most blessed burial place is beneath the Throne of God. Contrary to popular tradition, it appears that the mausoleum was always conceived as a resting place for Shah Jahan too.

Even more intriguing is the Mehtab Bagh or Moonlight Garden on the opposite bank from the Taj Mahal, which seems to have been part of the original conception. A recent joint project by the Archaeological Survey of India and the Smithsonian Institution, Washington, DC, has uncovered a great octagonal

pool in which the Taj would be reflected by moonlight. Beyond is a garden, the exact width of the Taj garden, with walls and corner towers aligned exactly with those of the Taj. It would appear that the Taj did not have an asymmetrical setting, but that taking into account the Mehtab Bagh, it stood at the very centre of an immense garden, like all other royal Mughal tombs.

The planning of this vast complex and the creation of its symbolic programme was no small challenge to the emperor, his architect Ustad Ahmed Lahori and his calligrapher Amanat Khan. Even hydraulic considerations were necessary. As the Jamuna flows along the northern edge of the Taj terrace, the architect ingeniously incorporated several cylindrical wells into the foundations to withstand the effects of flooding. Water for the garden was collected by an elaborate system of storage tanks and pumps, and brought to the grounds through under-ground pipes, which are still in use; the original pump had to be replaced when it was dismantled by the British to discover how it functioned. The terrace and mausoleum proper, begun in 1631, seem to have taken shape in six years; the rest of the complex, including the garden and the various structures that comprise the gateway, were completed by 1643.

Returning to Delhi from Agra, Shah Jahan built himself a new capital city, choosing virgin soil overlooking the Jamuna. Commenced in 1638 and almost complete ten years later, it was given the name Shahjahanabad, literally Abode of Shah Jahan. The city encompassed 50 hectares (125 acres) and was surrounded by a fortified wall with fourteen major gates, of which only three survive. The two main streets, Chandni Chowk and Faiz Bazaar, were long, straight and broad, flanked by pillared galleries, while an ample water canal ran through the centre of each. Chandni Chowk, or Silver Square, was the scene of much building activity sponsored by the women of the city. Shah Jahan's favourite daughter Jahan Ara constructed a garden; his third wife Fatehpuri Begum built a mosque; several

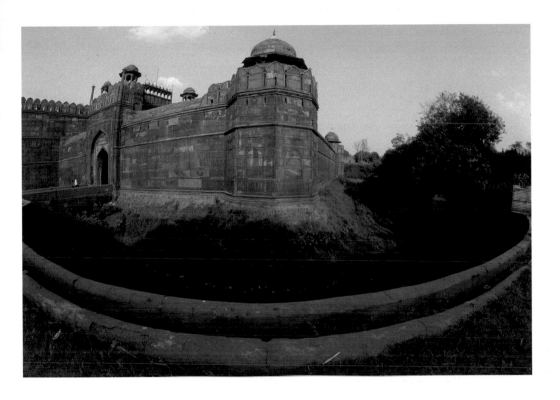

207–208
The Red Fort,
Delhi,
*c.*1638–48
Above
General view,
showing moat
Right
Start of water
channel
running
through the
palace

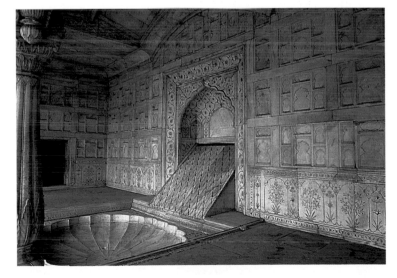

other court ladies did likewise. It is estimated that some 400,000 people – kings, nobles, merchants and servants – lived in the city, whose layout exemplifies Shah Jahan's ideal of bilateral symmetry.

Shah Jahan's palace of red sandstone, known today simply as the Red Fort (207), lies on the eastern edge of the city along the banks of the Jamuna which, today, has shifted its course considerably. The other three sides of the palace are surrounded by a moat once connected to the river. Marble pavilions and halls were laid out along the riverfront, and through them all ran a water channel known as the Canal of Paradise. Water brought in from the river entered this canal by way of a marble ramp (208) that led into a lotus-shaped pool in the northernmost building. From there it filled the royal baths, then ran through the elegant Hall of Private Audience in which is inscribed the oft-quoted verse 'If there be a paradise on earth, this is it, this is it, this is it.' The canal then flowed through the emperor's personal bedroom chambers, beneath a marble trellis screen that carries a carving of the scales of justice. Finally it entered the *zenana* section reserved for the

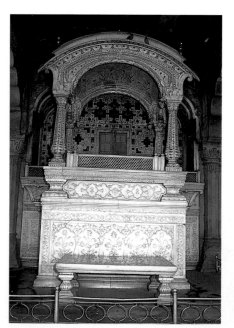

209–210
The Red Fort, Delhi, *c.*1638–48
Far left
Throne in the Hall of Public Audience
Left
Imported plaque of Orpheus playing the lute

211 Right
Jami mosque, Shahjahanabad, *c.*1650–6

royal women where the water was caught in a large, marble lotus-shaped pool.

At right angles to these residential palaces is the public axis along which lies the pillared Hall of Public Audience where Shah Jahan heard petitions. Against the rear wall is the emperor's lofty marble balcony-throne with a marble canopy inset with semi-precious stones (209). Its backdrop consists of indigenous, white marble plaques inlaid with semi-precious stones, interspersed with imported Florentine plaques of inlaid black marble. Placed directly above the emperor's head is an imported marble plaque depicting Orpheus playing the lute while wild animals rest at his feet (210); its use may signify little more than the magnitude of Shah Jahan's reach. Seated upon this balcony-throne, it is reported that the emperor gave audience each day at noon; standing before him, in strict order of rank, was an entire assembly from nobles and rajas, through *mansabdars* to the poor. Facing his subjects thus was perhaps Shah Jahan's way of emphasizing his role as a just ruler, and embodying Mughal concepts of kingship; at the same time, one

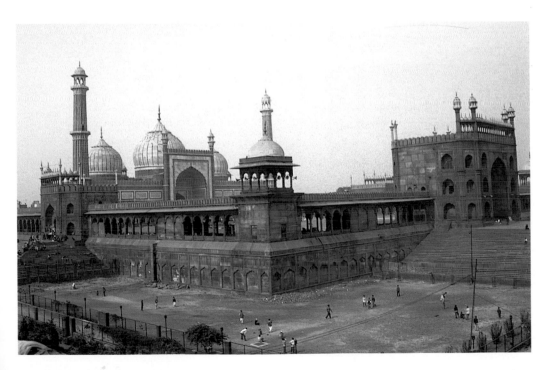

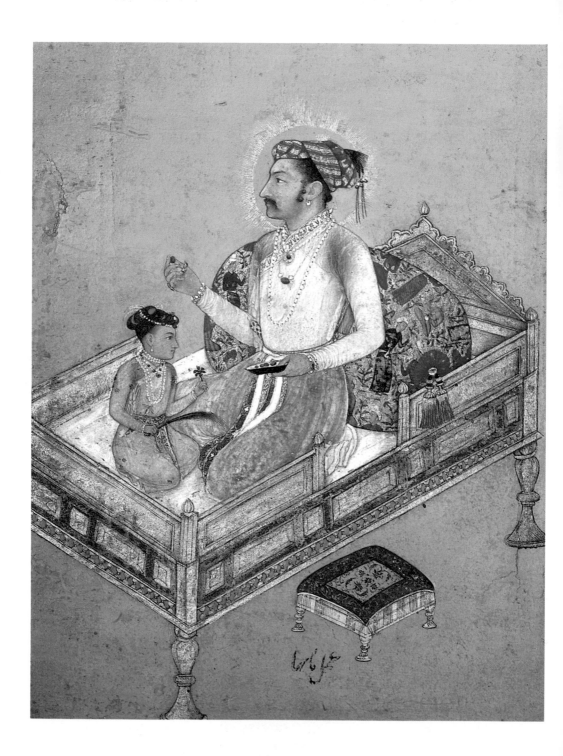

wonders if indigenous ideas of giving *darshan* were assimilated into the 'performance'.

The imposing south gate of the fort led directly to Shah Jahan's Jami mosque (211) built of red sandstone and marble and located at an angle between the city's two main streets, upon a natural rocky outcrop. It is approached by steep stairs and its *qibla* wall is embellished with a tall, arched façade, three bulbous marble domes and two tall minarets. It was begun in 1650, and apparently 5,000 masons worked on it every day for six years.

Shah Jahan was a connoisseur of gems; in most portraits he is holding a gem or jewel, and in one he assesses the quality of

gemstones (212). He wore extravagant jewellery in the form of necklaces, armlets, turban ornaments, pendants and rings (214–215). A unique Colombian emerald, known as the Taj Mahal emerald (213), weighing over 140 carats and carved with a stylized chrysanthemum, lotus and poppy, with leaves arranged asymmetrically, may have been set in a pendant worn by Shah Jahan himself. Jade was another favourite stone. An exquisite lobed wine cup in white jade, shaped like a halved fruit with a goat's head handle (216), carries Shah Jahan's monogram and the date 1657. Since jade was believed to be effective in counteracting poison, it was specially favoured for cups; it was also believed to bring victory, and was widely used, frequently encrusted with gems, for Mughal dagger handles, scabbards and other weaponry fittings. Ivory too was popular and the occasional Mughal ivory gunpowder flask survives. Mughal taste for the exotic is seen in a Chinese Yuan dynasty dish (217), produced between 1350 and 1400, depicting a mythical deer-like creature leaping through a plant-filled landscape. The dish was inscribed with Shah Jahan's name and the date 1653.

217
Shah Jahan's Chinese Yuan dish, c.1350–1400. Blue-and-white porcelain; diam. 46·7 cm, 18³⁄₈ in. Asia Society Galleries, New York

Shah Jahan's son Awrangzeb, who fought his way to the throne by defeating his brothers and imprisoning his father in the Agra fort, was more orthodox in his Islamic faith than his predecessors, but continued to uphold the building tradition of the Mughals. Inside Shah Jahan's Red Fort palace complex at Delhi, he added an exquisite little marble mosque, known as Moti Masjid or Pearl Mosque, as his private chapel. He also added outer defensive gates to the palace complex, evoking the disparaging remark from the imprisoned Shah Jahan: 'You have made the fort a bride and set a veil before her face.' Awrangzeb's striking architectural achievement, the Great Mosque at Lahore in Pakistan, is the largest in the subcontinent and can accommodate congregations of 60,000 people. While it continues the mosque tradition of the Mughals, in its interior decoration it replaces marble with painted plasterwork in relief.

Awrangzeb spent the second half of his reign largely in the Deccan. From his imperial camp he issued orders for campaigns against the Deccani sultans; he also waged war against the Hindu Maratha chiefs who had severed ties with the Bijapur Sultanate and established a compact kingdom that propagated a Maratha nationalism based on Hindu religion and homeland. In the Deccan town of Aurangabad, Awrangzeb built a mausoleum for his wife (218) that perhaps aimed at emulating the splendour of the Taj Mahal in sandstone and burnished stucco with a marble interior. This last of the imperial garden tombs is placed conspicuously at the centre of a *char-bagh*

218
Mausoleum for
Awrangzeb's
wife,
Aurangabad,
c.1678

garden. While its proportions may reflect an altered aesthetic, it lacks the harmony of the earlier monument. It makes no use of inlay, and its startling white appearance is the effect, not of polished marble, but of burnished stucco.

Mughal India is estimated to have had a population of 100 million people; during the 150-year rule of the Mughals, the empire supported a standard of life comparable with that of contemporary Europe. While Mughal rule continued for another 150 years after Awrangzeb, the centre became vulnerable, and by the mid-eighteenth century its territory was confined to the environs of Delhi. During this time, however, art continued to flourish in outlying Mughal provinces such as Murshidabad (see 96) or Avadh with its capital at the vibrant city of Lucknow. In 1858, the British exiled and imprisoned the last Mughal ruler, Bahadur Shah II, and made India a crown possession.

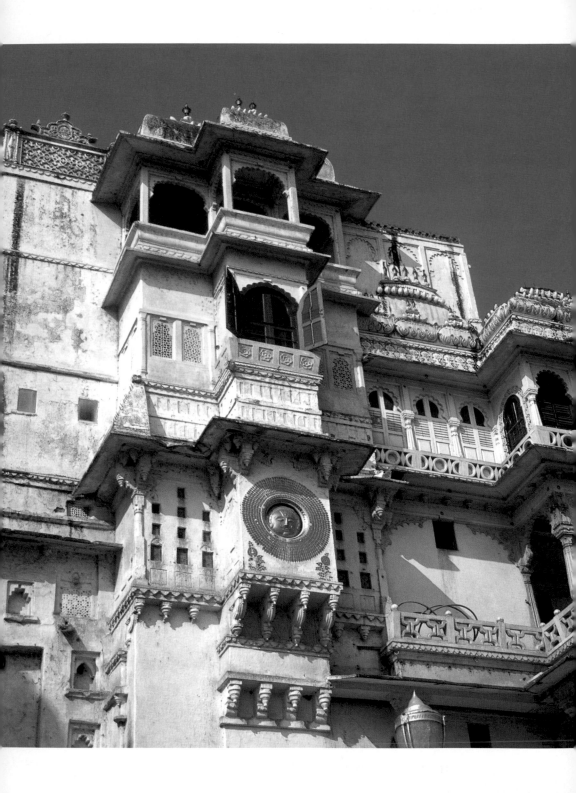

Between the fourteenth and nineteenth centuries, when much
of northern India and the Deccan was under Muslim rule, art
and culture flourished in the many Hindu Rajput kingdoms that
extended in an arc along the northwestern part of India. The
origins of the Rajputs, literally sons of kings, may lie in the
highlands of Central Asia. In western India, Rajput clans
established numerous principalities, some no larger than the
modern state of Monaco. Among the more prominent kingdoms
in the plains were Jaipur, Jodhpur, Jaisalmer, Bikaner, Kotah
and Mewar, while the hill states, termed *pahadi* (of the hills),
included Kangra, Chamba, Basohli, Kulu and Jammu. The

219
Manek Chowk,
east façade of
the City
Palace,
Udaipur,
c.1570 with
later additions.
The sun is the
emblem of the
Mewar house

largest, southernmost and most ancient kingdom was Mewar,
bounded to its west by the Aravalli hills and to the south by
jungle country inhabited by Bhil tribals, an area rich in zinc,
tin and silver. As it is impossible to discuss in detail the art of
all the Rajput kingdoms, and as Mewar's circumstances are
particularly interesting, the art of Mewar will be the focus
of this chapter.

In the past, the art of the Rajput kingdoms was largely analysed
in terms of the influence of Mughal art; it is more appropriate,
however, to speak in terms of the twin themes of collaboration
and resistance. Some Rajput kings collaborated with Mughal
emperor Akbar, and offered their daughters in marriage to the
imperial household. They were a constant presence at the
Mughal court to which they supplied troops as well as active
military service. Mewar, by contrast, remained aloof. Early
Mewari rulers put up stiff resistance and eventually won the
respect of Akbar and Jahangir. When Mewar was finally forced
to submit to Jahangir, the emperor refrained from asking for a
Mewari princess in marriage. The Mewar rulers were also
excused from attendance at the imperial court, a dispensation

that gave them a special status among the Rajputs; however, as heir-apparents, their presence was required.

In the realm of art too, the various Rajput kingdoms reveal differing degrees of collaboration and resistance. The paintings of certain states reveal admiration and emulation of Mughal perspectival rendering and naturalistic colours; local princesses married to Mughal princes may have played an important role in the dissemination of Mughal style. By contrast, resistance is evident in the distinctive painting style maintained by states such as Mewar, even after its rulers had direct access to Mughal painting. Palaces, however, were built in a typically Rajput rather than Mughal mode. Evidently, deliberate choices were made regarding the appropriation or rejection of specific features of the Mughal style. Just as Hindu and Muslim artists worked interchangeably at Islamic courts, so too Hindu and Muslim painters won fame at the Mewar court.

Studies of Rajput art and culture often draw on the three-volume work *Annals and Antiquities of Rajasthan*, produced by Colonel James Tod, who was British Political Agent at Mewar between 1818 and 1822. While admiring Tod's commitment to his task, it is judicious to put his comments in their colonial context. To the extent that the Rajput rulers were made to appear unsuitable, the importance of the British mission, and of Tod's own role within it, was enhanced. His many descriptions of the uses to which monuments were put are invaluable; but it is wise to remember his hidden agenda in disparaging such rulers as Jagat Singh II (r.1734–51):

Addicted to pleasure, his habits of levity and profusion totally unfitted him for the task of governing his country … he considered elephant fights of more importance than keeping down the Mahrattas.

The Mewar kings adopted the title 'rana', and added the honorific 'singh', meaning lion (in valour), to their names. Bardic genealogies speak of Bappa Rawal, an eighth-century chieftain who established a fortress on a vast rocky plateau at

Chitor, 150 m (492 ft) above the plains. Approached by a winding road with a series of gateways, it continued to be the Mewari capital until it was sacked by Akbar eight centuries later and a new capital was built at Udaipur. Bappa is also said to have founded a temple to Shiva at Eklingji which continues to be the dynastic shrine of the Mewar house; even today, in India's secular democracy, Arvind Singh, descendant of the Mewar line, maintains the traditional 'royal' weekly visit to the temple. A clear historical picture of Mewar emerges only in the fourteenth century, when Rana Hamir recaptured Chitor from Delhi sultan Ala al-Din Khalji and established the present line of Mewari rulers of the House of Sisodia. Hardiness and self-sacrifice were upheld as model virtues, but cultural expression was also important. Rana Kumbha (r.1433–68) not only distinguished himself in war against the Muslim sultans of Gujarat and Malwa, but also was a connoisseur of poetry and music; he wrote a major treatise on music, as well as a commentary on the *Gita Govinda*, a twelfth-century sacred poem narrating the love of god Krishna and cowherd girl Radha. He was responsible for rebuilding the thoroughly ransacked city of Chitor.

The Rajput fort-palace, whether constructed during a single period or as a result of gradual aggregation, is usually built on the slope of a hill and comprises a continuous mass of fortification and palace (220). Mughal palaces, by contrast, as we have seen at Fatehpur Sikri and Delhi, consisted of a number of independent buildings on level ground, the entire complex being surrounded by a defensive wall. Rajput palaces are asymmetrical in both plan and elevation, and quite irregular in dimensions. They present a complex, maze-like plan in which spaces are small and often of unexpected shape. Rooms and halls are located at varying levels and connected by stairs or ramps along which attendants could more easily carry royalty seated within palanquins. Ground level within a palace is not an easy matter to determine since a range of high-level courtyards may be open to the sky, several containing shrubs and flowers growing on an elevated portion of the hill. The desire to

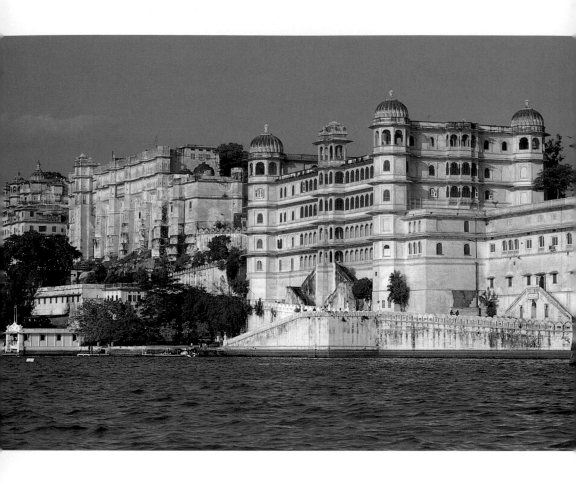

220
City Palace,
Udaipur, seen
from Pichola
Lake, *c.*1570
onwards

retain coolness resulted in chambers frequently enveloped in a half-darkness that added further to the general effect of architectural disorientation that has been termed elusion. Throughout its history, barring certain details of ornamentation, Rajput palace architecture shared little with its Mughal counterpart. Its origins must lie in an earlier Hindu tradition of palace architecture in perishable material, a tradition which is lost today. The palaces depicted in the murals at Ajanta have a sequence of small spaces, each with its own roof, separated by trees and foliage.

The Rajput palace, as indeed the Mughal, consists of two well-defined areas divided on lines of gender. The *zenana* or women's area had its own separate entrance; each apartment was occupied by a separate queen, and openings were invariably enclosed by lattice screens through which the women could look out on the world below while being themselves screened from public view. The *mardana* or men's area was divided into two sections, one for dispensing affairs of state, the other for the private use of the rana. The public section contained a hall of public audience, a hall of private audience and other structures such as an armoury and treasury. The private apartments include a glass-studded bedroom, a picture gallery with wall-paintings and a temple. Mewari paintings provide a glimpse of the interior furnishings of palaces; instead of furniture we see a range of carpets, silken bolster cushions, embroidered canopies and colourful draperies. Paintings confirm that the use of interior spaces was interchangeable; an inner courtyard could serve for the rana's private worship, as an arena for staging a variety of entertainments or as a space in which to receive formal embassies.

In addition to their main fort-palace, the rulers of Mewar frequently built themselves pleasure palaces located beside a lake, or even at its centre (222); here too the basic division of women's and men's spaces was retained. Some palace-pavilions, built of stone and marble, were little more than picnic

sites. Some so completely cover the islands on which they are built that they create the impression of floating structures.

Rana Kumbha's fifteenth-century palace at Chitor (221), with its complex grouping of small chambers, some open, others enclosed, reveals all the characteristics of the Rajput style. Sets of projecting balconies known as *jarokha*s are supported by richly decorated structural brackets. The *jarokha*, an indigenous motif already adopted by Sultanate architecture, was to become a major feature of the palaces built by the Mughals approximately a century later. Constructed of sandstone and covered with stucco decoration, Kumbha's palace uses the simple post-and-lintel method typical of Hindu India. Yet, the Islamic arch was known; Kumbha's palaces rest on a massive, vaulted substructure that creates a vast underground storage area. Apparently, the arch was valued only as a technical device, having no place in Mewari aesthetics.

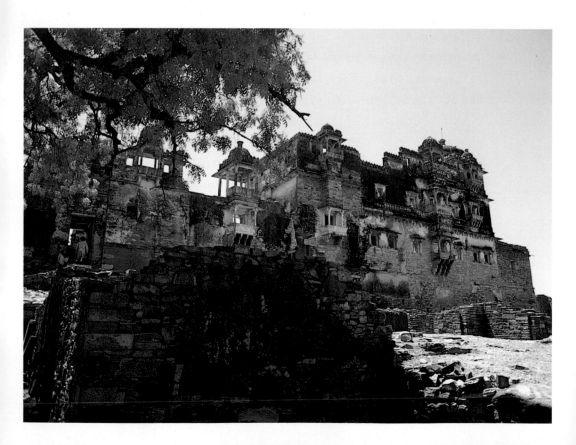

Chitor suffered two great onslaughts that sealed its fate as Mewar's capital. The first was its 1535 capture by the sultan of Gujarat, when child Udai Singh escaped because his nursemaid substituted her own child for the royal infant. Mughal emperor Akbar then laid siege to Chitor in 1567, completely destroying the fort which was abandoned by the Mewar rulers who built a new capital at Udaipur.

Udaipur, or City of Sunrise, was built by Rana Udai Singh (r.1537–72) in a natural valley ringed by hills and on the banks of the artificial Pichola Lake. Its palace at the east edge of the lake (220) continued the style seen at Chitor, with a huge, vaulted substructure supporting the palace apartments. As at Chitor, the gates open onto a wide terrace, planned as a parade ground for elephants, horses and crowds of people; but whereas Chitor's parade space was natural, here it was created on the hill slope with extensive concealed vaulting. The projecting *jarokha* balconies of the Manek Chowk (219) of the east façade of the *zenana*'s Badal Mahal or Cloud Mansion echo the visual effect of Rana Kumbha's palace (221).

In the vicinity of the Udaipur palace were the residences of the nobility and wealthy merchants who built themselves *haveli*s, which may be described as townhouses structured around a courtyard. Each *haveli* was occupied by a single, extended family consisting of a set of brothers with their wives and children; the decoration of its individual chambers imitated the palace's, but in cheaper materials, with burnished lime plaster substituted for marble facing.

221
Rana
Kumbha's
palace, Chitor,
1433–68

Special to the people of Mewar is a sixteenth-century woman poet–saint Meera, whose legend has entered Mewari sacred lore. It is believed that Meera was a Rajput princess, given in marriage in 1516 to Mewari prince Bhojraj. But Meera was a devout worshipper of god Krishna whom she considered to be her only lord. She broke all stereotypes and defied Rajput tradition, refusing to bow to her husband, her in-laws or their special deity, goddess Durga. Instead she visited the Krishna

temple where she sang and danced in praise of her dark lord Krishna, whom Mewari paintings portray as being as deep blue as the blue of infinity (223). Such behaviour was unheard of for any woman, but even more outrageous for a Rajput princess. In the context of Rajput honour, Meera's in-laws sent her a cup of poison which, however, turned into nectar. One of Meera's evocative poems refers to this incident (*Caturvedi*, no. 37):

I'm coloured with the colour of dusk, oh *Rana*,

coloured with the colour of my Lord.

Drumming out the rhythm on the drums, I danced,

dancing in the presence of the saints,

coloured with the colour of my Lord.

They thought me mad for the Maddening One,

raw for my dear dark love,

coloured with the colour of my Lord.

The Rana sent me a poison cup:

I didn't look, I drank it up,

coloured with the colour of my Lord.

While the corpus of Meera's poems suggests varied authorship, her devotees would deny this with great vehemence. A temple named for Meera, enshrining an image of Krishna, stands near Kumbha's palace at Chitor and, to this day, Meera remains a figure of consequence for devotees of god Krishna. No less than ten films have been made on her life; one of her Hindi verses became a favourite with Mahatma Gandhi, India's saintly freedom fighter.

The half century that followed the death of Udai Singh was a story of confrontation with the Mughals. Udai's son Rana Pratap, Mewar's most celebrated hero, fled to outlying hilly regions after a bitter battle against Akbar's forces in 1576. He suffered great hardships, eating off leaf plates and sleeping on straw; his privations were remembered symbolically by later ranas who, on certain days of the year, placed leaves beneath their plates and straw under their bed. Finally, in 1615, when years of intermittent warfare had greatly impoverished Mewar,

222
Jag Mandir
Palace,
Udaipur,
c.1620–30 with
later additions

Rana Pratap's son Amar Singh was obliged to make peace with the Mughals. Emperor Jahangir's son, prince Khurram, later to reign as Shah Jahan, admired Mewari resistance and treated Rana Amar with respect, giving him a range of gifts that included a dress of honour, a jewelled sword and a horse with a jewelled saddle. The next two rulers, Karan Singh and Jagat Singh, became familiar with Mughal courtly etiquette and undoubtedly with Mughal art when they attended the imperial court as crown princes. Prince Khurram became a close friend of Rana Karan to the extent that when the Mughal prince rebelled against his father, he sought refuge at Udaipur where the lake palace known as Jag Mandir (222) was set aside for his use. Its circular, marble-lined domed hall, completed soon thereafter, is unique in Mewar for its inlay work, apparently inspired by the technique of *pietra dura* that was becoming the vogue in Agra and Delhi.

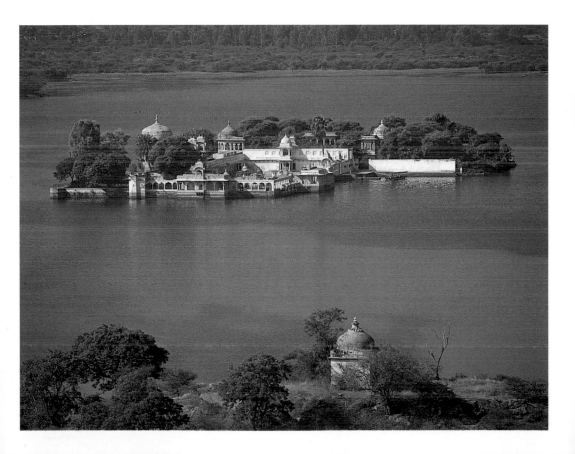

With the advent of peace with the Mughals, the ranas were free to devote themselves wholeheartedly to art, and Mewari painting reached a level of great sophistication under Jagat Singh (r.1628–52). Like the Mughals, the Mewar ranas looked upon the possession of a rich manuscript library as a mark of prestige; since the royal archives at Chitor had gone up in flames, Jagat Singh commissioned his scribes and artists to build up a new library. Important texts were copied and lavishly illustrated, several being produced by Jagat Singh's master painter Sahibdin and his workshop. Mewari manuscripts were stored in loose stacks and carefully wrapped in red cloth. Rejecting the upright Mughal (and European) page, the artist retained the horizontal paper format that had originated from the elongated palm-leaf manuscripts of earlier India. One of the most splendid manuscripts produced by Sahibdin and his workshop is a seven-volume illustrated *Ramayana*. Sahibdin was probably well aware of the techniques of naturalism, portraiture, perspective and realistic colouring perfected in the imperial Mughal workshop, but he chose to reject them in favour of a vibrant and uniquely Mewari visual language.

Western India had developed a painting style that evolved from the Jain manuscript tradition examined earlier, where pert figures dressed in richly patterned skirts with sharp folds were painted with a characteristic protruding eye (see 117). By the mid-sixteenth century, the style had evolved further as seen in an illustrated manuscript of the *Gita Govinda* (223). The artist presents formally arranged figures against a shallow background of broad areas of intense red, blue and black, flanked by stylized trees with enlarged leaves upon which perch enlarged birds. Figures are in strict profile with a single, enlarged eye, while the triangular skirt fold remains a hallmark. It was this style that Sahibdin advanced to perfection in the great illustrated *Ramayana* (224, 225). He created bold areas of saturated colour, using red, green, blue, yellow or lavender for ground, red or blue for skies, flowers that seem to be in eternal bloom, and highly stylized figures invariably shown in profile.

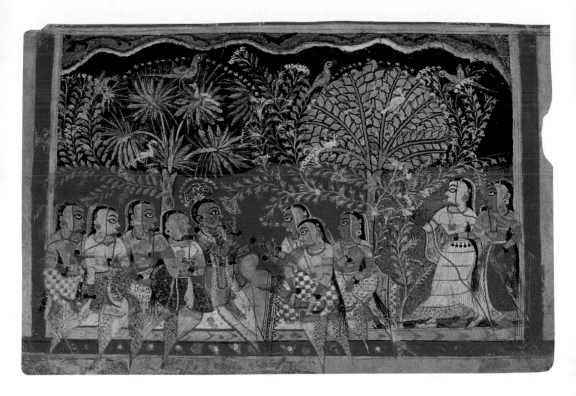

223
Krishna and the Gopis, Mewar, c.1550. Watercolour on paper; 12 × 19 cm, 4⅞ × 7½ in. Prince of Wales Museum, Mumbai (Bombay)

Sahibdin evinced no interest in the Mughal precedent of the *Akbarnama* pages in which palaces were depicted with a recognizable specificity. Nor was he concerned with any perspectival laws of receding size or vanishing horizons. Instead, he boldly opened up the palace of ten-headed demon-king Ravana, showing us all four of its gateways, as if it were a cardboard cut-out (224); viewers may look into its various interior compartments as well as view the sweep of its outer walls. Narrative was perhaps more fully explored by painters at Mewar than at any other Rajput court, and the chief actor of an incident, whether Rama, Ravana or a Mewari rana, might be repeated several times in any painting. Here monkey-king Sugriva, distinguished by the garland around his neck, is first seen wreaking vengeance within Ravana's palace, then leaping out of the palace and finally kneeling before Rama as he tenders his report. The Mughals did not favour this method of continuous narration in which several incidents from a piece of action

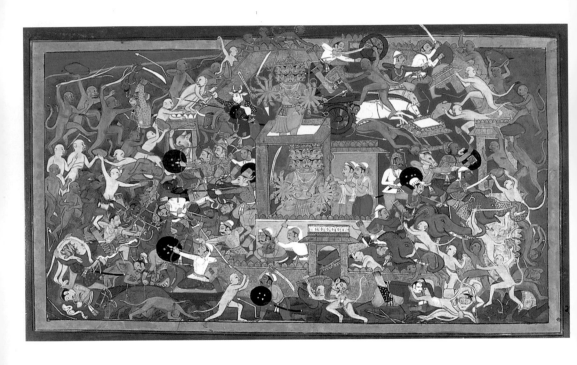

224
Ravana's Golden
Palace, from the
Ramayana
manuscript
produced by
Sahibdin and
his workshop,
Mewar,
*c.*1650–2.
Watercolour on
paper;
*c.*23 × 39 cm,
9 × 15³⁄₈ in.
British Library,
London

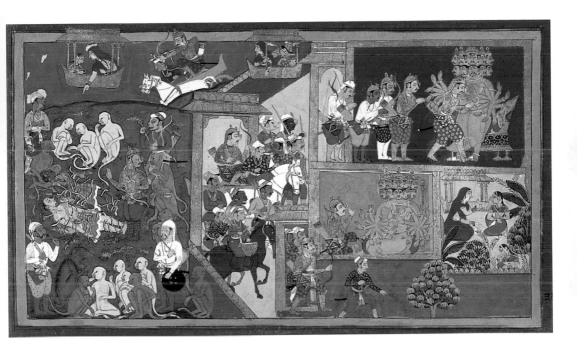

225
*Rama and
Lakshmana
Bound by Arrow-
snakes*, from the
Ramayana
manuscript
produced by
Sahibdin and
his workshop,
Mewar,
*c.*1650–2.
Watercolour on
paper;
*c.*23 × 39 cm,
9 × 15 3⁄8 in.
British Library,
London

unravel on a single page. A perusal of dozens of Mughal paintings reveals only one single instance – a murder scene in an album made for Jahangir (painted *c.*1575–80) now in Berlin – in which a figure is repeated within a page; this apparently unpopular experiment was perhaps inspired by Rajput precedent. Jagat Singh himself, for whom the *Ramayana* was created, was in attendance at the Mughal court in the days after Mewar had accepted Mughal overlordship; yet the painted manuscripts he commissioned reveal a defiantly Mewari aesthetic.

Some of the most exciting and complex of Sahibdin's paintings are contained in the *Ramayana*'s climactic Battle Book in which Rama finally defeats and kills Ravana and frees his abducted wife Sita. In one particularly complex use of the synoptic mode, in which multiple episodes are depicted within the single frame of the page itself, Sahibdin portrayed eleven scenes (225). To the lower right, Ravana and his son Indrajit confer on how to defeat Rama and Lakshmana. Having come up with a plan, Indrajit leaves the palace followed by his retinue. The left third of the page shows the execution of the plan. From his aerial chariot, Indrajit shoots arrows that turn into snakes, and Rama and Lakshmana lie on the ground, helplessly bound. Seeing them thus, monkey-king Sugriva is afraid, and has to be reassured that the heroes are not dead. Indrajit enters the city gates of Lanka, is admitted to Ravana's presence and is given a victory embrace. In the lower right corner, Sita is seen alone in the Ashoka garden where she is confronted by demoness Trijata, whom Ravana has instructed to apprise Sita of the news. Following instructions, Trijata takes Sita in an aerial chariot, which we see first immediately above the palace, and then above the battlefield where Trijata points out to Sita the figures of the bound heroes. Their release from bondage due to the snakes fleeing in terror at the approach of the divine eagle Garuda forms the subject of the next illustrated page. The rich colours and extraordinary detail make this a spectacular, if challenging, page of narrative. Clearly, Sahibdin wished to intrigue and interest his royal patron, and induce him into

active decipherment of a story he knew well. The popularity of the *Ramayana* with the ranas of Mewar may be due to their having viewed it as their dynastic history; they traced their ancestry to the divine hero prince Rama, and through him to sun god Surya. The sun's full orb is Mewar's emblem (219).

The patronage of painting and architecture went hand in hand. Towards the end of his reign, Jagat Singh built the Jagdish temple at Udaipur which in many ways harked back to the great era of temple-building prior to the arrival of Islam. The temple is in the Chandella style of Khajuraho. Jagat Singh and his successors made important contributions to the expansion of Udaipur's City Palace. Its Chandra Mahal or Moon Mansion displays an extraordinary Mewari adaptation of the cusped arch, which is actually no more than two pairs of cusped brackets that do not meet at the centre but leave the lintel visible between. Such a device, half-way between a true cusped arch and a corbelled arch, made it possible to span a wide space. Within the palace, it is often difficult to distinguish the contribution of individual rulers since their successors modified, adapted and even dramatically altered the structures of their predecessors. Thus the Mor Chowk or Peacock Square used for ceremonial gatherings (226), and the adjoining Surya Mahal or Sun Mansion, both built in the seventeenth century, were much altered by eighteenth- and nineteenth-century additions. An important late Udaipur building, the Jag Nivas palace, is situated on an island in the lake opposite the City Palace. Built by Jagat Singh II (r.1734–51), it is today a hotel.

Gradual additions transformed the City Palace into a rambling series of chambers on different levels. Unexpectedly, enclosed palace spaces open out onto sunlit courtyards, as in the Badi Mahal or Garden Mansion (227) built of sandstone and marble by Amar Singh II in 1700. This addition was built on a natural rise on the hill, so that its trees and shrubs are actually rooted in the hillside. At the centre of the paved courtyard is a square pool; its surrounding colonnade is formed of marble baluster

226
Upper level of
Mor Chowk or
Peacock
Square, City
Palace,
Udaipur, 17th
century with
19th-century
additions

columns of the type used by the Mughal rulers, but connected
by the widened Mewari cusped arches. The intimacy of the
garden, with its upper storey of small pavilions with trellis
screens, is entirely Rajput in flavour. Paintings depicting the
monarch lying in the pool while smoking his *hookah* or water
pipe confirm that the Badi Mahal was a royal pleasure garden.
However, the interchangeable use of spaces is indicated by
another painting that shows a rana worshipping a Shiva *linga* in
the colonnaded space, while musicians and dancers perform in
the courtyard (228). Multiple perspective is freely used so that
we look directly on the tiled squares in the courtyard, but are
presented an eye-level view of the trees, the rana and his
courtiers. The artist painted the shadows of figures and trees,
although they have nothing to do with the direction of the light.

Rana Sangram Singh's (r.1710–34) addition to the Udaipur
palace was a charming Chinese Picture Hall or Chini Chitra-
shala, decorated with blue-and-white tiles produced in China
for export. A few Delft tiles featuring Biblical satires and land-
scapes with windmills probably reached Udaipur through a
party of Dutch East Indian Company officials who passed
through the city in 1711. A large Udaipur painting on cloth that
immortalizes this visit portrays Johaan Ketalaar, leader of the

227
Garden
Mansion,
City Palace,
Udaipur, 1703

Dutch Embassy, seated in the Badi Mahal facing the rana;
outside gardeners tend shrubs and feed the fish in the pond.
The exotic theme of the Dutchman was picked up by Mewari
artists who used it, for instance, in a glass mosaic in a hall
adjoining the Chitrashala (229). Other imports included reverse
glass-paintings of the type China produced for the export
market from 1740; Mewari paintings occasionally depict these
exotic curiosities displayed upon the palace walls.

During the eighteenth century, a new trend arose in Mewar for
detailed visual reportage of the rana's various activities – the
celebration of festivals, hunting expeditions, watching staged
elephant fights, receiving visiting dignitaries, worship at
shrines, strolling in pleasure palaces. Court painters began to
produce large paintings, often 90 cm (3 ft) across, albeit with
small figures, using Udaipur's palaces or its natural landscape
as a backdrop. Following the typical Mewari narrative style, the
figure of the rana is repeated as the action unravels. Artists'
names are frequently inscribed on the reverse of paintings,
which also contain detailed notations on the event commemo-
rated; however, no artist seems to have acquired the stature of
Sahibdin. A painting created in the mid-nineteenth century
depicting the palace opened up like a cardboard cut-out (230)

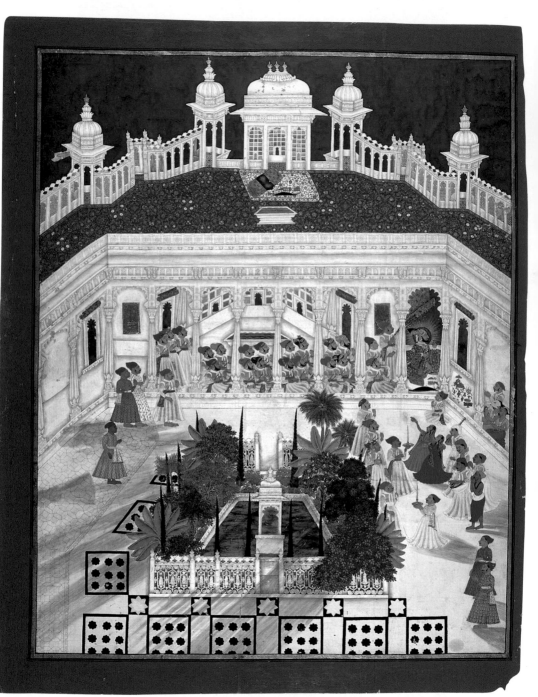

228
Rana Ari Singh at Worship in the Garden Mansion, c.1765. Watercolour on paper; 68 × 53·5 cm, 27 × 21 in. Freer Gallery of Art, Washington, DC

229 Above
Glass mosaic decoration in the City Palace, Udaipur, c.1710–34, with a view of the lake

230 Right
Rana Javan Singh at a Sacred Recitation in the Garden Mansion, c.1835. Watercolour on paper; 141 × 91·5 cm, 55½ × 35 in. City Palace Museum, Udaipur

231
*Krishna
Dallying with
the Gopis*,
Kangra,
*c.*1775.
Watercolour
on paper;
18·2 × 28 cm,
7 × 11 in.
Private
collection

confirms the persistence of the Mewari style. As we look into the Badi Mahal, with its colonnades slanted outwards in incongruous perspective, we see its trees and the rana's party in profile at eye-level. An upper pavilion has its side walls similarly slanted, while the attendants standing in the lower colonnades are portrayed in defiance of every law of perspective.

The paintings produced by Rajput kingdoms like Kangra and Bikaner present a contrast with Mewar in adopting and incorporating several characteristics of Mughal painting. The style evident in the hill state of Kangra, located at a height of 1,200–1,800 m (some 4,000–6,000 ft), was late in emerging. Its use of more varied colours and a sense of receding distance sets it apart from the aesthetic of Mewar. A page painted around 1775 that depicts god Krishna dallying lightheartedly with the *gopi*s (cowherd girls), is framed in a background of gently rolling hills of pale green; a grey-blue river winds its way through the valley, flowering trees have birds perched upon their branches and day is breaking over the far horizon (231). The dynamic interaction between Krishna and the *gopi*s along the riverbank is in striking contrast with the western India *Gita Govinda* page considered earlier (223). The fallacy of the explanation that Kangra painters were merely portraying the gentle hills of their surroundings, in contrast with the Rajasthan plains, is apparent by a glance at paintings from the adjoining hill state of Basohli (232, 233), located in similar surroundings. We are confronted with figures in profile with large, intense eyes portrayed against shallow space depicted in rich, saturated colours; green beetle wings are applied to simulate emeralds and raised white paint suggests pearls. While the intensity of the Basohli palette lessened with time, artists retained their predilection for pages with red borders within which figures were placed against a deep mustard background with the barest strip of blue at the upper margin to indicate the sky. The sudden emergence of the Basohli style around 1660 remains unexplained. While its intensity suggests connections with folk art, the Basohli paintings, as all other Rajput paintings, are part

232
The Goddess Bhadrakali Worshipped by the Gods, Basohli, c.1660–70. Opaque watercolour on paper with gold, silver and beetle wing cases; 21·7 × 21·5 cm, 8½ × 8½ in. Freer Gallery, Washington, DC

233
Crowned Ganesha, Basohli, c.1720. Watercolour on paper; 19 × 28 cm, 7½ × 11 in. British Museum, London

of a sophisticated court art tradition. Possibly the special interest of its painters in the depiction of gems may indicate connections with a jewellery tradition. One thing is certain, artists and patrons were making deliberate choices.

Perhaps the court that most closely modelled its paintings on a Mughal prototype is Bikaner in the plains; the use of restrained, naturalistic colours, the manner of portrayal of the human form, as well as the choice of themes, reveal an admiration of the imperial style. Indeed, the occasional Bikaner page may, at a casual glance, be mistaken for Mughal. Most courts developed a distinctive formula of their own. Kishangadh paintings, for example, are often large and dominated by a perspectival depiction of landscape against which small figures are placed, most often of a king and queen, or of Krishna and Radha. The figures, especially the female, are highly stylized: a sloping forehead, sharp nose, elongated lotus-petal eyes and a curl framing the face. On-going research on Rajput painting suggests that master artists were able to work interchangeably in several styles, adapting their manner of presentation to the court to which they were attached. In turn, it appears that courts used painting style, in a manner akin to the use of a flag or insignia, as a feature that individualized and distinguished them from adjoining princely courts. Within the painting style, the human figure, and most prominently the female form, became the hallmark of a state.

In the architectural context, palaces of the Rajput kingdom of Jaipur make an interesting comparison with Mewar. The fort on Amber Hill upheld the same principles of gradual aggregation, irregularity and elusion seen in Mewar. The Rajput princess who married Akbar, and whose son was to rule the Mughal empire as Jahangir, came from Amber. Subsequently ties with the Mughal court remained firm. Between 1700 and 1744, Jaipur was ruled by Maharaja Jai Singh II, who was given the title Sawai or 'one and a quarter' by Mughal emperor Awrangzeb to suggest that he was that much greater than his

234
Jai Singh,
Jantar Mantar
Observatory,
Jaipur, *c.*1740

235
Hava Mahal,
Jaipur, *c.*1799

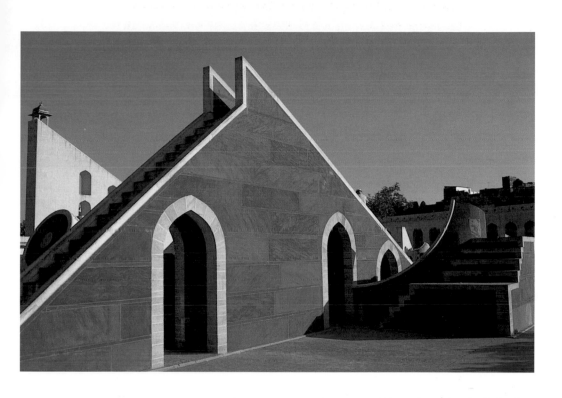

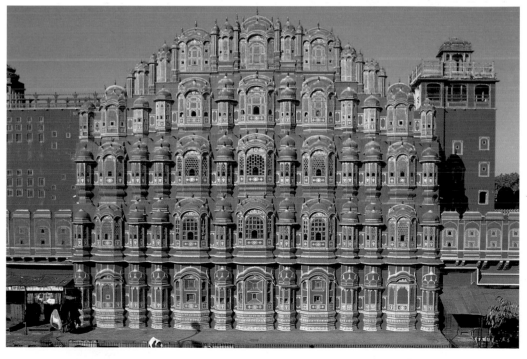

great-grandfather after whom he was named. In 1727, Sawai Jai Singh decided that his hill fortress at Amber was too small for one of his status, and he built an entire capital city named after himself on the plains 8 km (5 miles) away. The planned city of Jaipur, laid out with methodical symmetry, is startling in the Rajput context. All streets, principal or minor, meet at right angles in a grid that resulted in nine square wards. Jai Singh's desire to include within his city a lake along the hillside led to a small deviation from the regular plan and the relocation of one ward. The plan also distributed people according to their profession, allocating streets to silversmiths, potters, wood-workers and weavers. The use of rubble and plaster rather than stone made it possible to build this city in the remarkably short span of seven years; however, to simulate the much-admired red sandstone appearance of Mughal cities, all of Jaipur's monuments were painted a dusty pink. The palace at the city centre continued to be treated as a single mass of connected chambers, halls and courtyards, but is determinedly symmetri-cal. The adjoining observatory (234), with its magnificent group of great red sandstone structures as well as brass circles and instruments, was personally planned by Jai Singh who was an astronomer of repute. Jaipur's single most famous structure is its 1799 addition, the Hava Mahal or Wind Mansion (235), a *zenana* structure from which the women could enjoy the breeze while looking out on the scene below. Its façade speaks fluently of Jaipur's desire for symmetry.

In 1730, when Jaipur was under construction, the power of the Mewar ranas was in sharp decline and they were forced to pay heavy tribute to the militant Maratha chiefs, the new masters on the horizons of western India. When Rana Bhim Singh (r.1778–1828) sought British protection against the Marathas, Colonel Tod arrived at Udaipur as British Political Agent. Tod became close friends with Bhim Singh who received him with much honour; this friendship underlies the rana's gift to him of Jagat Singh's outstanding *Ramayana*, a work that now rests in the British Library in London.

Rome of the Tropics Churches of Portuguese Goa

15

Gazing adoringly at a crucifix held aloft in his hand, a life-size image of a bearded saint, made of painted wood (236), stands in the priests' sacristy or robing room of the Church of Bom Jesus or Good Jesus. The figure is framed by a halo and is clad in vestments consisting of a white lace-edged surplice over an ankle-length black cassock with an embroidered stole around the neck. The image is that of St Francis Xavier, Goa's much beloved patron saint, whose body is enshrined within a side altar of the richly decorated Church of Bom Jesus. The church's brilliant interior combination of wood and gold-leaf ornament is characteristic of what has been called the 'Indian baroque', or alternatively the Manueline, after King Manuel of Portugal. Many of the great churches of Goa, including the Bom Jesus, contain lofty decorative retables that rise, screen-like, behind the main altar to reach the height of a small Hindu temple.

236
Image of St
Francis Xavier,
painted wood.
Church of Bom
Jesus, Velha
Goa, early 17th
century

In 1498, three caravels arrived on the southwestern coast of India under the command of Vasco da Gama; the ships had left Lisbon ten months earlier. Theirs had been a long journey around Africa, since the direct Mediterranean route to Asia was controlled by the Arabs. Portugal, ruled by King Manuel (1495–1521), was a small and poor country with a population of only a million people. Yet it was able to carve out an enclave in distant India.

The ocean had not figured prominently in the power play of the Mughals, the Sultanates of the Deccan or the Hindu rulers of Vijayanagara. Only the rulers of lesser seaboard kingdoms, like the zamorin of Calicut or the rajas of Cochin, were mindful of matters of the sea.

For over 1,500 years the waters around India had been a peaceful trading zone. All this changed with the entrance of the

Portuguese. King Manuel, delighted with Vasco da Gama's 'discovery', sent out a large fleet to build forts and maintain a presence in the waters off India. In 1505, Alameida was dispatched as the first viceroy to establish the Estado da India or State of India, while his ambitious and determined successor Albuquerque was responsible for its consolidation. The coastal possession of Goa, captured in 1510, became the official capital of Portuguese India in 1530, and retained that position for over 430 years.

The Portuguese soon controlled fifty forts around the Indian ocean, in Africa, Macao and India, and with an armada of a hundred ships they established a stranglehold on Indian Ocean trade. They cut off trade via Suez so that they could establish a spice monopoly, buying cheap at source and selling in Europe at a profit of around 300 per cent; pepper, in particular, was no luxury item but a necessity for curing and preserving meat. Next, the Portuguese regulated shipping routes within Asia, deciding on the ships that would be allowed to ply specific routes, and selling cargo space at a premium. Finally, claiming to be lords of the sea in Asia, they issued permits, *cartaz*, to any ship trading in the area; ships without a *cartaz* were confiscated by the Portuguese armada. Their superior artillery and their ships that were able to withstand the recoil of cannons made their armada invincible. They became simultaneously disliked, feared and admired.

Velha (Old) Goa, the capital of the territory of Goa which has a palm-fringed coastline of 150 km (93 miles), is situated upon seven hills along the Mandovi River. The twentieth-century sociologist Gilberto Freyre described Goa as 'Rome, in the trop-ics'. It had briefly been part of the Hindu Vijayanagara empire before its capture by the Portuguese who waxed lyrical over its fields and orchards. Its fertile coastal plain is capable of yield-ing all of Goa's needs and more. But the Portuguese had no interest in farming, so before long Goa was importing much of its food, including grain. By 1600, Velha Goa extended 2·5 km

(1½ miles) along the Mandovi, and probably had a population of around 75,000 people – making it somewhat smaller than the city of Vijayanagara, which was a major market for Portuguese dealers in horses.

The Portuguese found that Christianity was no stranger to India. According to tradition, St Thomas, who is believed to have landed on the Malabar coast, south of Goa, as early as 52 AD, established a number of Syrian churches there. The Portuguese found a thriving community of Syrian Christians in the Malabar. Portuguese occupation introduced India to Roman Catholicism, which views Rome and the Pope as the centre of the Christian world. Catholics of various affiliations, including the Augustinians, Franciscans and Dominicans, now came to India. One influential group, an Italian religious order known as the Theatines, was allowed to settle in Goa once they swore allegiance to the Portuguese king. The Theatines emphasized man's dependence upon providence, a tenet that found easy acceptance among Indians who believed in the inevitability of karma. Another important Catholic group was the Jesuits, who sent three Christian missions to the court of Mughal emperor Akbar. In 1556, the Jesuits introduced a printing press in Goa, the first of its kind in Asia; however, it was closed in 1683 due to Portuguese suspicion of Jesuit activities. In 1761 the Jesuits were expelled from Goa on the charge of being involved in a plot against the king of Portugal, and they were allowed to return only in 1935. In the interim they migrated to surrounding areas, including Bombay, where they became India's most prominent and respected Catholic group; to this day, Jesuit schools and colleges are among the most prestigious in India.

The single most influential figure in Goa's sacred history was Francis Xavier (236) who arrived in Goa in 1542. He ministered to the poor, sick and infirm, and converted many people; in a month in 1544 he is said to have baptized 10,000 villagers in the state of Travancore, south of Portuguese territory. After five years in India, he travelled to China and died in 1552 on an

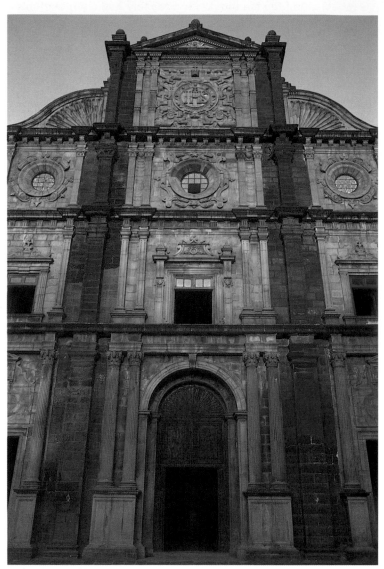

237
Church of Bom
Jesus, Velha
Goa, 1605

island off the Chinese coast where he was buried on the beach
by his Chinese servant who placed him in a wooden coffin
packed with lime to hasten the disintegration of his body. When
exhumed three months later, the body was miraculously found
to be incorrupt; it was shipped to Malacca, and finally arrived
in Goa to be housed in the Church of Bom Jesus completed in
1605. Built of laterite and plaster, the façade of Bom Jesus rises
in three storeys, and its interior displays all three classical

orders, the Doric, Ionic and Corinthian (237). In their overseas possession, the Portuguese clearly intended to make an architectural statement of the lofty and ancient origins of their heritage.

In 1614, upon the order of Pope Paul V, the forearm of the now St Francis Xavier was cut off and sent to Rome where the relic rests in the church of Il Gesù. The theologian Antonio Viera (1607–97) suggested that the entire world was embraced by the two arms of Xavier, 'One arm in the East and in Goa, the head of Christianity in Asia; the other is in the West and in Rome, the head of Christianity and the world.'

Xavier's body found its final resting place in a side chapel of the Bom Jesus, constructed in 1665, with walls decorated with large panels narrating his life and miracles. The body was placed within a silver sarcophagus designed by an Italian and executed by Goan silversmiths around 1640. Its marble pedestal, created by a Florentine master, was gifted by the Italian Grand Duke of Tuscany around 1700. Frequent public expositions of the body were held until 1952, when the shrivelled form was finally sealed within an airtight glass coffin. To Goans, Xavier is without doubt *Goencho Saib*, Lord and Master of Goa; the eventual desiccation of his body in no way lessens the sanctity of the saint, but is viewed as a sign of the deteriorating times.

The largest Portuguese monument in Goa, 76 m (249 ft) in length, is the Se Cathedral of Santa Caterina, begun in 1562 and completed ninety years later (238). Like all Goan churches, it is built of blocks of laterite covered with plaster; its ceiling, as is customary, is wooden. Begun by an unknown architect, it was modelled on the Iberian 'hall church' in which nave and aisles were of the same height; the interior of such a church remained in dim luminosity since the only openings were in its outer walls. When architect Jules Simao was despatched to Goa by King Philip some thirty-five years later, he felt the need to transform the Se into the standard clerestoried church, in

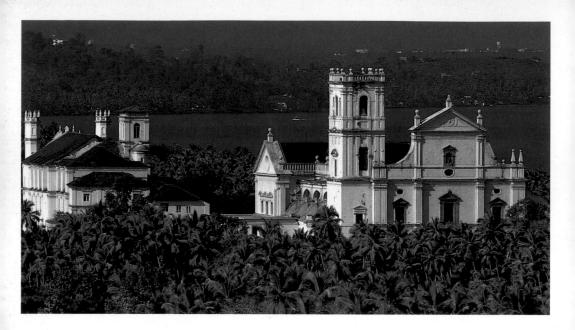

which the nave rose an entire 'storey' above the roof of the
aisles, forming an upper area filled with windows to allow light
to fill the nave. But as the Se was already under construction,
Simao could make only small modifications, replacing the
columns with tall, slender piers and thus creating an airy,
expansive interior space. The retable of the Se, created of wood
covered with gold-leaf and crowned by Christ on the Cross, is
stunning in its proportions and its gilded grandeur (239).
Within the arched niche of the central panel stands St
Catherine, while the five other niche panels of equal size carry
events from her life and legend. Along the base are the twelve
apostles and church dignitaries. Wooden trellis-work screens
within the Se are carved with exquisite arabesques, often
superimposed with painted wooden figures of angels.

A second impressive early monument, emphatically European,
is the majestic Theatine church of Our Lady of Divine
Providence. Designed by Italian architect Francesco Manco, it
has a light-filled dome based on that of St Peter's in Rome (240).
The Latin inscription beneath the cornice of the dome is a well-
known verse from the gospel of St Matthew (6:33): 'Therefore

238–239
Se Cathedral of
Santa Caterina,
Velha Goa,
1562–1651
Above
General view
Right
The interior
with the
retable

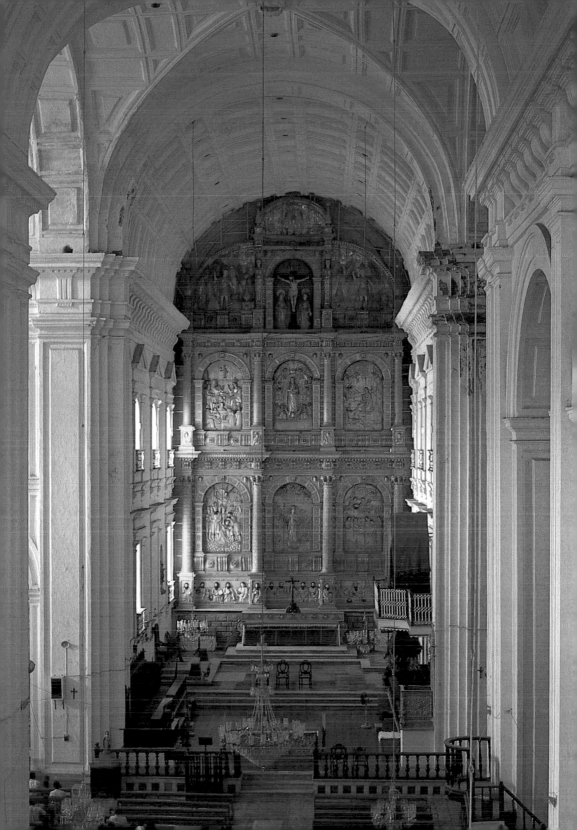

seek first the kingdom of God and His justice, and all these [that you seek] will be added to you as well.' The Portuguese spent vast sums of money on the construction of Velha Goa's many churches, the chapels of its towns and villages, and its nunneries. The Santa Monica nunnery, for instance, housed a hundred nuns in 1605, and had a considerable waiting list. It was later used as a military post, but in 1964, after Goa became a state within India, it was revived and is today Asia's largest training centre for Catholic nuns.

The Dutch arrived in Asia a century after the Portuguese, and through their successful operations in Southeast Asia ended Portuguese monopoly of the Indian Ocean. They blockaded Goa for a total of fifteen years; by 1666, the fifty Portuguese forts were reduced to a mere nine. The arrival of the British added to the woes of the Portuguese, while the expanding power of the local Maratha chiefs was yet another problem. By the end of the seventeenth century Velha Goa was in a state of commercial decline and collapsing infrastructure. Polluted drinking water, streets piled with refuse and swamps that bred mosquitoes resulted in a series of devastating epidemics that left it a ghost town.

It is ironic that some of the most splendid of Goan churches were built during this period of decline, between 1650 and

1750, although not in the fading Velha Goa. At Talaulim, the church of Santana or St Ann, constructed between 1681 and 1695, extends 51 m (167 ft) in length. The Santana moves away from strict adherence to European models, and seems to exemplify the Indian artists' predilection for multiplication. It has five interior bays; its façade is treated as five storeys; and its interior elevation creates a doubled effect with two entablatures in place of the usual single unit characteristic of Europe. The supreme glory of the Santana is its vault that, for reasons not quite clear, subverts accepted architectural categories. It commences as a traditional Gothic groined vault with pointed arches and ribs; but towards its apex its architects introduced a planed section in which surfaces are fused so that the apex of the vault is transformed into a single plane carved into a series of rectangular decorative panels. The Santana is the most exquisite of a series of no less than five churches, all begun during the phase when Portuguese power was in abeyance, and all displaying a similar treatment of their vaults.

In the early days of Portuguese rule in India, icons and paintings came from Europe, but by the seventeenth century the Portuguese were instead using the talents of local artists, despite the Church's disapproval of non-Christians creating Christian images. The Goans were skilled in wood- and ivory-carving, as evident from figures such as St Anne and the Virgin Mary as Child in painted wood (241), or an intricate ivory child Jesus as the Good Shepherd (Bom Jesus). Eighteenth-century images, with their soft, simple lines, in contrast with the sharp delineation of the Portuguese baroque, reveal the hand of local artists. Artisans working in silver and gold produced superb objects used in Catholic ritual such as chalices, incense holders, processional lanterns and crowns; dangling bells on monstrances are reminders of a Hindu milieu. In the church squares of Goa are piazza crosses of stone and stucco that seem to be miniature versions of a church-temple, while church pulpits were lavishly decorated with fantastic volutes, cartouches, pendants, flounces, tassels and canopies. The term

241
*St Anne and the
Virgin Mary as
Child*, 18th
century. Painted
wood. Museum
of Christian Art,
Rachol, Goa

rococo has been used to describe later Goan art, but it should
be noted that Goa did not receive direct aesthetic infusions
from Europe after the seventeenth century. It may be useful to
think in terms of the increasing Indianization of an imported
original.

Once the decision had been made to relocate the capital of Goa
to the town of Panjim, the residential buildings of Velha Goa
began to be demolished to provide building material for the
monuments of the new capital. Even ancient churches were
treated as little more than quarries; their roofs were removed
so that the force of the rains of the following monsoon would
result in their collapse, allowing their laterite blocks to be

reused. Such planned demolition commenced in earnest in 1820, and continued for fifty-three years. Gilberto Freyre, viewing the ruins of the monumental Goan churches in the early twentieth century, remarked perceptively: 'No European had the audacity which the Portuguese had in Goa, of confronting the monumentality of the East with the Christian.'

The regime of Goa was unabashedly Catholic and the Inquisition of 1540 resulted in the destruction of Hindu temples; Hindu priests gathered together their most sacred images and moved them to a safer place. When Goan architects re erected the temples they transformed their appearance. Abandoning the temple *shikhara* that resembled a mountain peak, they crowned the sanctum with a dome that rested on an octagonal drum; occasionally this was then topped with a ribbed *amalaka* of typical temple type. The inspiration for a crowning temple dome came partially from the Islamic tradition and partially from the Christian domed churches of Goa. Among the earliest such Goan temples is the Shiva shrine of Saptakotisvara, or Lord of Seven Crores, at Narvem, erected in 1668. As is customary in Hindu shrines throughout India, the roofs of Goan temples progressively increase in height from low porch, to higher nave-hall to sanctum dome. By contrast, the façade of a church is its highest point. The temple to Shantadurga, or peaceable Durga, relocated from its original location near Velha Goa to Kaullem in territory under Maratha control, is a fine example of later Goan temple architecture (242). Built of laterite between 1730 and 1738, its sanctum is surmounted by a set of three octagonal drums crowned by a dome. A uniquely Goan contribution to the Hindu temple complex is a lamp-tower with niches on its various levels for oil-lamps.

Four centuries after they arrived, when European colonial powers across the world were handing over power to individual nation states, the Portuguese were unable to bring themselves to leave. In 1961, independent India's first prime minister,

Pandit Nehru, dispatched the Indian army to take over Portuguese territory, ending Portuguese rule. The story of the Portuguese contribution to Indian culture has yet to be written. Christianity was one contribution; yet, generations after conversion, caste and the convert's erstwhile faith still play a significant role. To this day, Christians in India may be heard to refer to themselves as Hindu Christians or Muslim Christians, indicating that while they profess the Christian faith, they also celebrate festivities of the faith from which they converted to Christianity. As in most other historical confrontations, the local population adopted many items introduced by their rulers. Few may realize that the peanut, today an Indian staple for its oil, was brought by the Portuguese from Africa; the cashew nut, source of the feni liqueur of Goa, was imported from Brazil; and red chilli, or *lal mirchi*, that in today's popular imagination is the quintessential Indian condiment, was a Portuguese import from Pernambuco in Brazil.

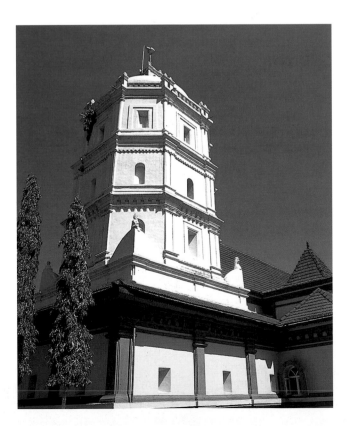

242
Tower of
Shantadurga
temple, near
Kaullem, Goa,
1730–8

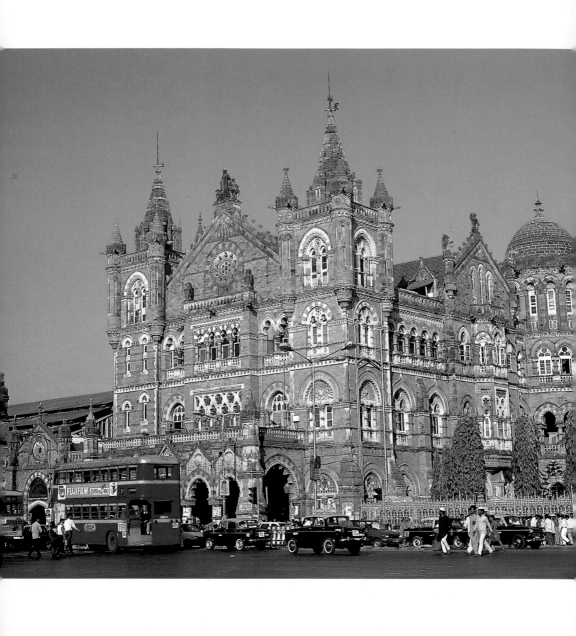

243
Frederick W
Stevens,
Victoria
Terminus,
Bombay,
1878–87

Standing in the heart of Bombay is Victoria Terminus, a vast, ornate structure with magnificent domes, pinnacles and protruding turrets, built to serve as a major railway station (243). Designed by Frederick W Stevens as headquarters for the Great Indian Peninsular railway (GIP), and built for over £250,000, it was constructed in so exotic a mode as to have merited the description 'Xanadu conceived through British eyes'. Erected between 1878 and 1887, at the height of British rule in India, this magnificent hybrid building, though created largely in the Venetian Gothic style, incorporates a few Indianized elements in a mode termed Indo-Saracenic. Victoria Terminus was opened in time to celebrate Queen Victoria's Golden Jubilee, and was a statement of British grandeur and supremacy. The sandstone masses of the building rise high, and crowning the dome of the central tower is an image of Progress, 4 m (13 ft) high, raising an arm towards the heavens. The interior, with its tall, stained-glass windows, and its groin-vaulted ceilings, has been described as a secular cathedral. Corinthian columns of polished Aberdeen granite line the staircase leading to the offices of the chairman, located directly beneath the tower. Lady Dufferin, Vicereine at the time, thought the building much too sumptuous for a purpose so prosaic as the accommodation of a bustling crowd of railway passengers. But the railways were the biggest capitalist enterprise of India, and one of which the English were proud. To understand how this building came to represent the might of the British Raj, we must look back some 250 years.

Arriving on the west coast of India in 1613, when the Mughal empire was at its peak, the British established a small trading centre termed a factory at the port of Surat. Due in large measure to Mughal distrust of the Portuguese, the British

gained access to the source of power in Delhi. Once they had demonstrated their naval superiority by defeating the Portuguese in a battle fought off Surat, they received important trading privileges from the Mughals in return for providing protection from the Portuguese for trade and pilgrimage. With this golden opportunity, the British established themselves in Madras and Calcutta, and soon thereafter in Bombay, and began to transform the face of India with grand civic buildings. Architecture held symbolic significance for the British in India, who believed that the greatness of a civilization was expressed through the grandeur of its structures. A careful selection of architectural styles, that varied over time according to prevailing notions of power, together with deliberate planning, transfigured the urban landscape of India.

The mode of British architectural expression in India went through three phases that reflect evolving notions of authority, and, indeed, the manner of constructing the 'self' in empire. At the outset, the British kept some distance from the Mughal centre of Delhi, and built forts in Madras, Calcutta and Bombay. The forts were enclaves removed from the indigenous townships, housing the military garrison and also serving as the centre of government. Smaller towns without forts had a Cantonment area where the troops resided, and an adjoining Civil Lines for the government officials; there was never any integration with the 'native' townships. During this early phase, when the East India Company was the ruling body (1772–1858), the British constructed their official buildings in an exclusively European, generally Neoclassical, style. An example is the imposing Banquet Hall that Lord Clive erected in Madras when he became governor after defeating the French forces in South India. Set on a high podium, with sphinxes guarding the steps, its façade was dominated by a row of Grecian columns rising through two storeys (244). The Banquet Hall was inaugurated in 1802 by a grand ball, attended by everyone with some standing in the English social circles of Madras.

The events of 1857, which the British termed a 'mutiny' and many Indians spoke of as the 'first battle of Independence', interrupted British rule in India, and also changed the nature of British architectural expression on the subcontinent. The sharp and brief uprising led the British to condemn Indians as dishonourable, untrustworthy and deceitful. Atrocities occurred, of course, on both sides. Taking stock of their presence in India, the British decided that events had reinforced their right to rule. In 1858, the East India Company was abolished, the last Mughal emperor was exiled to Burma and the governor general was replaced by a viceroy appointed to rule India as the direct representative of the Crown. Not long thereafter, Queen Victoria was declared *Kaiser-i-Hind*, or Empress of India.

244
Banquet Hall,
Government
House,
Madras, 1802

The British then chose to portray themselves as the legitimate, almost indigenous, rulers who had taken over from the Mughals and hence from India's past. It was necessary that their architecture reflect this mandate to rule. With this in mind, they set out to incorporate Indic features into either the Neoclassical or the current Gothic revivalist style, choosing Mughal and Sultanate architecture as their Indic prototype. The Indo-Saracenic style was the result.

The year 1911 witnessed the start of the third phase in British architectural expression. Abandoning Calcutta, they turned to Delhi, the site of Mughal power, to build a new capital that would confirm the power of the Raj, the popular term for the

British Empire in India. The vision of empire is evident in Herbert Baker's letter to fellow architect Edwin Lutyens, in which he wrote that the capital 'must not be Indian, nor English, nor Roman, but it must be Imperial'.

The first building phase began at Madras (today Chennai), where the East India Company established its earliest settlement, despite the fact there was no natural harbour and that passengers had to transfer to small boats to reach land. English mansions were built along the seafront, and faced with Madras *chunam*, a form of stucco made from burnt sea shells that lent itself to glossy polish. When artist William Hodges arrived from London in 1781, he was dazzled by Madras: 'The clear blue cloudless sky, the polished white buildings, the bright sandy beach and the dark green sea present a combination totally new to the eye of an Englishman.'

With Lord Clive's capture of the province of Bengal, Calcutta became the capital and the centre of British activity in India; it was described by early visitors as a 'city of palaces'. While town houses in the narrow streets of London were compact, the Georgian town houses built along Calcutta's grand avenues of the Esplanade and Chowringhee Road were indeed mansions. Hodges spoke of the city as offering 'an appearance similar to what we may conceive of a Grecian city in the age of

245
James Moffat, *Government House, Calcutta, 1798–1803*, c.1802. Watercolour on paper; 44 × 67·5 cm, 17 ³⁄₈ × 26 ¹⁄₂ in. India Office Library, London

Alexander'. Calcutta's Government House, situated within a park of 10·5 hectares (26 acres), and built by Lord Wellesley (245), was immeasurably grander than its predecessor in Madras, and grander too than its model, Lord Scarsdale's baroque country house in Derbyshire, Kedleston Hall. It rose in three storeys, with a grand entrance stairway, wide verandas and a purely decorative low central dome. The large central block contained the formal rooms such as the State Dining Hall, the Throne Room, the Marble Room and the State Ball Room; its four wings, which allowed vistas in all directions, suggested the expansion of central power. Government House was inaugurated by a grand ball in 1803. The East India Company directors in London were critical of the vast sum of £167,359 spent on the building, and even recalled Wellesley. However, Government House was defended with the statement that India ought 'to be ruled from a palace, not from a country house; with the ideas of a Prince, not those of a retail-dealer in muslins and indigo'. Clearly, the aim of the British in India was no longer mercantile, but openly imperial.

The British built modest churches in each of their towns, for instance, St Andrew's in Madras and St John's in Calcutta, to serve their expatriate population. In sharp contrast with the Portuguese, to whom religious conversion and the architectural grandeur of their churches was of paramount importance, the British opted for secular rule. However, as they commenced a study of pre-Mughal India, they found themselves confronted with an ancient and magnificent civilization. They took the view that Indian civilization had fallen from its one-time glory; in fact, in his 1818 history of India, James Mill described current conditions as a 'hideous state of society'. The British decided that their presence was required to provide good government and good education, and thereby 'improve' the lot of the people. There was, of course, a range of other significant incentives that included prestige, politics and their original economic motivations. By 1820, the British had convinced themselves entirely of the righteousness of their rule over India.

Several British artists travelled to India during the late eighteenth and early nineteenth centuries, among them William Hodges (in India from 1780 to 1783), and the uncle-and-nephew team of Thomas and William Daniell (1786–93). This was the age of the 'picturesque' in British landscape painting, the keynotes of which were ruggedness and wild, unkempt beauty. Artist William Gilpin wrote in 1791 of the objects to be included in a picturesque landscape, declaring 'The cottage offends. It should be a castle, a bridge, an aqueduct, or some other object that suits its dignity.' He pleaded with artists to avoid ladies with parasols, and instead to concentrate on bandits with flowing cloaks. The dramatic use of light and shade was another feature of the picturesque that required considerable ingenuity on the part of artists painting in the dull light of

246
William
Hodges,
View of Part of the City of Benares,
c.1780. Wash and ink over pencil;
60 × 101 cm,
23⅝ × 39¾ in.
Yale Center for British Art,
New Haven

Britain. India, with its vast landscape, its numerous, often ruined, monuments and its colourful people, supplied the perfect answer for the expression of picturesque beauty.

Hodges was a devoted practitioner of the picturesque and he frequently rearranged the elements of a scene to make it more evocative. He was fascinated by the atmospheric conditions of India, frequently commenting on the light. With apparent facility, he portrayed the glistening sunlight, the clear colours of the morning sky and the reflection of monuments in water. His grey wash drawing of Benares (now Varanasi) from the river, squared for transfer to canvas, has a shimmering quality (246). Thomas and William Daniell were topographical artists who worked with a *camera obscura* that transferred the scene before them onto paper; they strongly disapproved of the 'inaccuracies' of Hodges's picturesque drawings. Wishing to compile a more accurate record than Hodges, they travelled extensively and amassed a vast stock of sketches of people, animals, trees, sculptures, architectural details, etc. On their return to London they published *Oriental Scenery* in six volumes containing 144 aquatints of remarkable technical quality but of sombre hues. The neutral tones of their views of Benares do not convey the actuality of sun-drenched bathing ghats with their kaleidoscope of colours (247). While they recorded accurately what they saw, they failed to capture the spirit of the city; dramatic colour effects and mood were sacrificed for structural accuracy. Watercolourist Edward Lear painted Benares almost a century later (248), and wrote in his *Indian Journals* (28 November 1873):

How well I remember the views of Benares by Daniell RA! – pallid, – gray, – sad, – solemn. I had always supposed this place a melancholy, or at least a 'staid' and soberly coloured spot, a gray record of bygone days! Instead, I find it one of the most abundantly bruyant and startlingly radiant places of infinite bustle and movement!!! Constantinople, or Naples, are simply dull and quiet in comparison!!!

Perhaps it was the influence of the market back home that induced the Daniells to produce works with an atmosphere of

**247 Above
Thomas
Daniell**,
Benares, c.1796.
Aquatint;
46 × 61 cm,
18 × 24 in.
India Office
Library, London

**248 Above
right
Edward Lear**,
*Benares, 14
December, 1873.*
Watercolour on
paper;
34·5 × 50·6 cm,
13⅝ × 20 in,
Houghton
Library,
Harvard
University

Benares.
(63) 14 December 1873. 2.15. P M

249
English
Staffordshire
dinner plate
using Thomas
Daniell's
*Remains of an
Ancient Building
near Firoz Shah's
Cotilla, Delhi,*
c.1820.
Earthenware;
diam. 25 cm,
10 in. Private
collection

quiet composure that accorded more with the requirements of classical landscape painting. While their subject matter was novel and exotic, the manner of presentation was familiar and acceptable, and this may have been one reason for the popularity of the Daniell volumes. Their views became so popular that they inspired an entire range of Staffordshire blue-and-white porcelain featuring Indian scenes (249). Several other artists, including Johann Zoffany and Tilly Kettle, were lured to India by the prospect of securing commissions from the wealthy British 'merchants' settled in India, especially at a time when commissions in London were increasingly difficult to procure.

While British artists may have admired India's monuments for the way in which they lent themselves to the expression of the picturesque, British architect–scholars began a more serious study. James Fergusson's two-volume work, *History of Indian and Eastern Architecture* (published in 1876 and 1891), laid the foundations for art-historical study in India. Fergusson viewed early Buddhist art, represented by Sanchi (see Chapter 3) and Gandhara (see Chapter 4), to be the peak of artistic expression in India; everything that followed was a decline, the later the work, the more degraded. The expanded temples of South India (see Chapter 10) provoked the remark that without a 'tall central object to give dignity to the whole' they were 'a mistake which nothing can redeem'. Madurai, in particular, he found to be 'the most barbarous, it may be said the most vulgar' building in India. In the nineteenth century, the British assumed that the aesthetic of Europe was universally valid. Even as eminent a thinker as John Ruskin could not come to terms with Indian disinterest in naturalism, denouncing it as a wilful and resolute opposition to all the facts and forms of nature. But Islamic architecture, which the British termed Saracenic, won their admiration. Fergusson particularly admired the Gol Gumbaz (174), the domed tomb built by Bijapur Sultan Muhammad Adil Shah. 'In the East they play with their domes and make them of all sorts of fantastic forms,' he wrote, regretting that architects in Europe 'have been timid and unskilled in dome-

250
Robert Chisholm, Revenue Board Building, Madras, 1871. Wood engraving published in *The Builder* (31 December 1870)

251
Charles Mant, Mayo College, Ajmer, 1875–85. Lithograph published in *The Building News* (21 February 1879)

MAYO COLLEGE, AJMER INDIA.
MAJOR C. MANT. R. E. ARCHITECT.

GROUND PLAN

building'. The Taj Mahal was particularly admired, although partly because of its use of *pietra dura*, the British opined that it was largely the work of an Italian.

After 1858, in what might be seen as the second architectural phase, British buildings across India incorporated domes, kiosks and overhanging eaves. One of the first exercises in the Indo-Saracenic was the Revenue Board building in Madras designed by Robert Chisholm (250). Completed in 1871, this building rises in a double-storeyed arched façade, with a central tower crowned with an onion dome, and domed kiosks at its corners; such kiosks, incorporated for picturesque effect, soon became a distinctive feature of British architecture in India. While greatly admiring the Gothic mode, Chisholm expressed the hope that the Indo-Saracenic style would become the accepted mode in India and that the British would not 'import our architecture, with our beer and our hats, by every mail-steamer which leaves the shores of England!' In fact, Chisholm suggested that the style seen in Tirumala Nayak's palace at Madurai, as in other Hindu buildings, should also be part of the assimilation. With such ideas, he incorporated the sloping roofs of Malabar coast architecture into the Madras Post Office, designing it as a 'Hindoo-Saracenic' monument.

Perhaps the building that established the supremacy of the Indo-Saracenic was Ajmer's Mayo College, built as a place for the education of Rajput princes (251). Lord Mayo, Viceroy of India, intended his college to be 'Eton in India' and preferred a classical design. Ultimately a 'Hindoo-Saracenic' design conceived by British architect Charles Mant prevailed; it incorporated plain and cusped arches, kiosks, overhanging eaves and minarets, while above the whole soared a clock tower, typical of Victorian Britain. From the 1860s onwards, the English regularly introduced clock towers to towns in India, either free-standing or incorporated into major buildings. Perhaps the most outrageous of Indo-Saracenic buildings is Muir College in Allahabad, where architect William Emerson tells us he

combined the Gothic with ideas from the Taj Mahal, the Sultanate architecture of Bijapur, and the Islamic style of Egypt; the result is a riotous conglomeration (252). The purest Indo-Saracenic style may be seen in the 1909 Victoria Memorial Hall in Madras, today the National Art Gallery (253). It is an entirely Mughalized monument, based on the great gateway at Fatehpur Sikri (189), but with its parts combined in ways that the Mughals could never have imagined.

 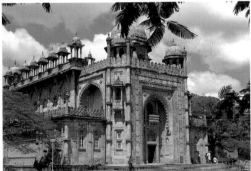

Bombay (today Mumbai) was late in developing its architectural grandeur. The island was gifted to the British by the Portuguese in 1661 on the occasion of the marriage of Portuguese princess Catherine of Braganza to King Charles II. Extensive reclamation work was undertaken by Governor Lord Elphinstone (in office from 1853 to 1860) almost 200 years later to make the swamp-ridden land suitable for building. Immediately thereafter, Governor Frere ordered the demolition of the walls of the old fort, thus opening up a spacious area for new construction; the 1869 opening of the Suez Canal added to its strategic importance. There was no looking back and, architecturally, Bombay became the jewel of jewels. In fact, the finest of Britain's 'high Gothic' is found not in England but in Bombay – in its secretariat, university library, university convocation hall, law courts, public works office, post and telegraph building, yacht club and hotels. The Gothic style, closely associated in Britain with churches and cathedrals, was favoured in Bombay over the Indo-Saracenic. Over some thirty years, Bombay

became an architectural sensation aided by enlightened and generous patronage from local residents as varied as the Parsi Sir Cowasjee Jehangir, the Hindu Premchand Roychand and the Jew David Sassoon – industrialists, bankers and merchants who amassed great wealth in collaboration and trade with the British. Stone of high quality was readily available, and architects made use of its decorative potential, wisely rejecting plaster and paint in a city of torrential monsoon rains. To locally available blue and red basalts, and red and yellow sandstone, were added buff-coloured and white stone brought from Gujarat. The judicious manipulation of coloured stone, combined with red roofing-tiles and cast-iron grilles, created an eye-catching effect.

Among the most visually satisfying buildings of Bombay are the university convocation hall (254) and the adjoining library (255), designed by Sir George Gilbert Scott in French Gothic style and built of coloured basalts and sandstone. The convocation hall has an apsidal end separated internally from the main body of the hall by a grand arch. A large, stained-glass rose window casts a magnificent kaleidoscope of colours into the interior, where a handsome timber gallery passes around three sides. The nearby university library and clock tower, completed

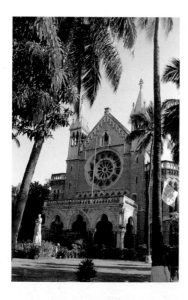

254 Left
George
Gilbert Scott,
University
Convocation
Hall, Bombay,
1869–74

255 Right
George
Gilbert Scott,
University
Library and
Rajabai Clock
Tower,
Bombay,
1874–8

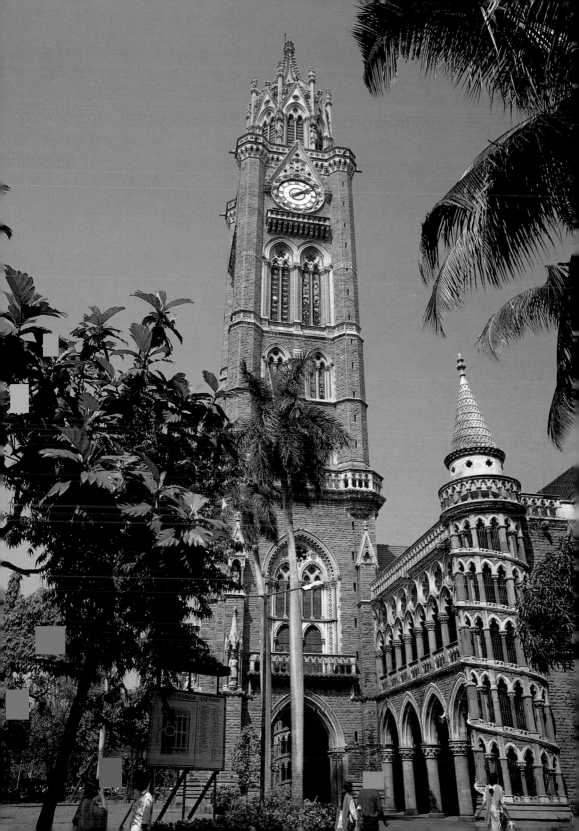

in 1878, is an inspired building with arcaded galleries crowned by a parapet of finely detailed pierced stone. The open spiral staircases at each end of the building rise to the entire height and are crowned by stone spires. The most remarkable feature of the entire structure is the highly individual Rajabai Clock Tower, named after the mother of its patron, Premchand Roychand.

Bombay's major museum (256), named the Prince of Wales after King George V who laid its foundation stone in 1905, is modelled on Bijapur's Gol Gumbaz tomb. Built of blue basalt and yellow sandstone with a monumental concrete dome, it is set in a garden of palm trees. The last great architectural addition to Bombay's skyline was the Indo-Saracenic Gateway of India (257), built as a triumphal arch through which George V and Queen Mary would pass, upon disembarkation in Bombay, on their way to Delhi for the Coronation Durbar of 1911. Across Bombay, libraries, colleges, markets, hotels and gardens arose in the high Gothic mode, and were built to impress. So definite a statement of British imperialism had Bombay become that a contemporary journalist remarked that a Briton was indeed the better after he first set eyes on Bombay.

One final outstanding building of the second phase, this one in Calcutta, remains to be examined. The Victoria Memorial Hall (258) was the brainchild of Lord Curzon, who planned it as a

256
George Wittet, Prince of Wales Museum, Bombay, c.1905

257 Above right George Wittet, Gateway of India, Bombay, c.1910

258 Below right William Emerson, Victoria Memorial Hall, Calcutta, 1906–21

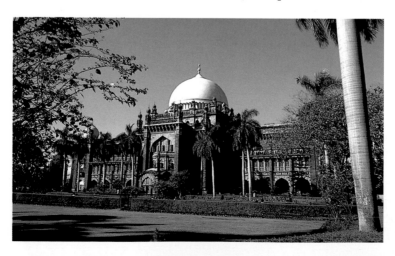

repository of Anglo-Indian art and relics – a place where the history of 300 years of the British presence in India could be effectively displayed. Curzon specified that the building had to be in quasi-Classical or Palladian style, and that the marble should be acquired from the same quarry in Rajasthan that had supplied the stone for the Taj Mahal. Its central feature is a huge crowning dome surmounted by a bronze revolving angel of victory; directly beneath, in a single, vast chamber, is a statue of Queen Victoria with scenes from her reign on the surrounding walls. The remainder of the building displays a range of objects illustrating the history of India since the end of Mughal rule. The building, completed only in 1921, was inaugurated by the Prince of Wales.

Before concluding the story of imperial architecture, a brief diversion to painting and photography reveals other models of colonial interchange. A by-product of the interaction between Indian painters and the British was the rise of a school known as 'Company painting', a term given to art produced by Indian artists to suit the taste of British patrons. A patroness of considerable significance was Lady Impey, wife of Sir Elijah Impey, the first judge of the Calcutta Supreme Court. Lady Impey was passionately interested in the flora and fauna of India and, in fact, maintained a menagerie in the spacious grounds of her Calcutta mansion. She commissioned Shaykh Zayn al-Din, an artist from Patna whose ancestors had been trained in the Mughal tradition, to make a complete record of the local birds and plants. Assisted by two other artists, Zayn-al-Din produced a portfolio of over 300 large watercolours between 1777 and 1783. Typical of this style is a painting of a curlew, a bird seen frequently in Calcutta in the winter, about to swallow a fish held in its beak (259). Local artists adjusted their style to produce meticulous, realistic drawings of the type demanded by their British patrons, whether in the field of natural history, architectural drawing or figure studies. This latter genre of Company paintings is represented in the work of artist Ghulam Ali Khan and his colleagues, and seen in an album prepared for

259
Zayn al-Din,
Eastern Curlew,
1778.
Watercolour
on paper;
73.5×50.4 cm,
$29 \times 19\frac{7}{8}$ in.
Freer Gallery
of Art,
Washington,
DC

50

William Fraser. The artists' understanding of human anatomy, their heightened sense of colour and their superb draughtsmanship are evident in the portrait of five young recruits who were part of an 'irregular force' trained to fight in the hilly terrain of northern India (260).

If painting lost its popularity in the later years of the British Raj, it was in no small measure a result of photography, which was introduced into India as early as 1840, a year after the daguerreotype was created in Paris. The first photographic society was founded in Bombay in 1854. Among the British photographers in search of the picturesque was Samuel Bourne, who arrived in Calcutta in 1863 and set up a studio with Charles Shepherd, who managed the business end. Bourne travelled extensively across India, spending large amounts of time prospecting for the perfect spot from which to take his photographs; on one occasion he waited six days for the perfect moment. Water was an essential ingredient of the picturesque

260
Five Recruits, from the *Fraser Album*, c.1815. Watercolour on paper; 26·7 × 38·9 cm, 10½ × 15¼ in. Freer Gallery of Art, Washington, DC

to Bourne and some of his lakeside photographs are among his most successful (261). Bourne and Shepherd issued a catalogue of 3,000 pictures entitled *A Permanent Record of India* from which photographs could be ordered for inclusion in the scrapbooks that the British were so fond of maintaining. Soon local photographers such as Lala Deen Dayal began to produce picturesque photographs. Equally compelling as subjects for the photographer, both British and Indian, were the many princes and princesses of India (262). Of course, photography also offered the opportunity for photo-realism as seen, for instance, in Captain Willoughby Hooper's compelling pictures of the victims of the Madras famine of 1877–8 (263).

Meanwhile, at the Delhi Durbar or Royal Assembly of 1911, which had all the trappings of the Mughal model that it had supplanted, Viceroy Hardinge stunned the nation by announcing that the British intended to move from Calcutta and create an entirely new capital at Delhi. The exact site for the capital vacillated between the old seat of Mughal power and newer virgin areas until the decision in favour of the latter was made by Hardinge himself. The question of style became of paramount importance. Thomas Hardy and George Bernard Shaw pressed for an Indian builder and an Indian style of architecture; others advocated Greece as the source. Finally, Hardinge decided on 'Western architecture with an Oriental motif'. It was Hardinge too who decided in favour of Edwin Lutyens as architect for New Delhi, partly because Lutyens had experience with planning a Garden City, which is what the Viceroy had in mind for the capital. Monumental classicism, vast ceremonial avenues and open spaces were all combined with geometrical symmetry and a grand central axis to result in a glorious composition, despite the fact that World War I forced the deletion of schemes for riverside parks and drives, as also Lutyens's grandiose plans to divert the River Jamuna back to its original course. Streets in residential areas were structured around roundabouts, which were mini-gardens that functioned as traffic circles. Rules of official hierarchy demanded that resi-

**261 Left
Samuel
Bourne**,
*Nainital,
mid-1860s.*
Albumen print.
British Library,
London

**262 Right
Lala Deen
Dayal**,
*Daughter of the
Nizam of
Hyderabad,*
1890s.
Albumen print.
Private
collection

**263 Below
Willoughby
Hooper**,
Madras Famine,
1877–8.
Albumen print.
Private
collection

dences be allotted according to official status; to this day, a street address in official New Delhi reveals an individual's precise government status.

Lutyens invited an old friend, Herbert Baker, who had been working in South Africa, to join him in the venture, suggesting that he would plan the city and design the Viceroy's House, while Baker could be in charge of the twin Secretariat buildings. The Viceroy's House, larger than the palace at Versailles in France, dominates the city from its position atop Raisina Hill; it is built in a unique Anglo-Indian Imperial style (264). Within a classical idiom, the house assimilated a few Indic features, while its gardens and fountains follow the Mughal prototype. The building is insistently horizontal, and quite different from the high Victorian Gothic buildings seen in Bombay. It is dominated by a massive central copper dome, 50 m (164 ft) from the ground, which rises from a white stone drum incised with a railing motif so that it is reminiscent of the stupa at Sanchi (see 33). The huge portico below has columns that avoid any known architectural order, fusing the acanthus leaves of the Corinthian style with four pendant Indian bells. An eave over the colonnade, to shelter the building from what Lutyens called the 'tremendous violence' of the Indian sun, is a borrowed Indian feature, but here it is executed in unique style as a crisp blade of stone that creates a deep band of shadow. Tiny kiosks punctuate the skyline, while water flows through a series of plain, circular stone basins, sometimes in stepped formation, reminding one of Mughal practice. Lutyens used the classic red and buff sandstone of nearby Mathura, employed also by the Mughals, as it would withstand the rigours of both the sharp sun and the torrential rain. An ornate iron entrance screen enhances the importance of the building, setting it off from public space. At the centre of the enclosed courtyard is a slender column topped by a six-pointed glass Star of India.

The interior of the Viceroy's House, comprising 340 rooms, is equally impressive. The central circular Durbar or Assembly

Hall beneath the dome has entrance doorways 4 m (13 ft) high, and a roof soaring to 24 m (79 ft). The apex of the dome has an inner eye that allows light to penetrate the interior and to irradiate the many varieties of marble used in its decoration – white, pink, grey and yellow from different parts of Rajasthan, green from Gujarat, and black from eastern Bihar. Each of the state and private rooms is individually designed and is unique in its rich and lavish treatment. Behind the Viceroy's House is a magnificent Mughal garden in three terraced levels, ending in a tranquil circular pool at the level of the plains. At the heart of the intersecting water channels is a spacious island, while along each channel are circular fountains created as tiered lotus leaves. Of the 2,000 staff members of the Viceroy's House in 1947, the year of Independence, 418 were gardeners, several assigned to maintain its many lawned tennis courts.

The one major flaw in the planning of the new capital was in the approach to the house, along the ceremonial King's Way (now known as Rajpath). Lutyens initially intended the Viceroy's House to occupy Raisina Hill in lone splendour, where it would be seen from all directions. But Baker's twin Secretariat buildings, each the size of London's Houses of Parliament, incorporating domes, kiosks and Indic trelliswork, needed to be accommodated. When Baker decided that these buildings should occupy the same level as the Viceroy's House, Lutyens somewhat reluctantly agreed to move the house back. The gradient leading up to the house should have been very gentle indeed, but Baker, who supervised the works, allowed the construction of too steep a slope. Alas, at the point of climax, the house disappears behind a mass of roadway, with only its dome partly visible (265). Lutyens desperately tried to instigate remedial action, but to no avail; ever after, he referred to this as his 'Bakerloo' and relations between the two men were distinctly acrimonious.

Baker's other contribution to New Delhi was the grandiose circular Council House (266) of massive proportions, 174 m

264 Above Edwin Lutyens, Garden front of Rashtrapati Bhavan (Viceroy's House), New Delhi, 1931

265 Right
Herbert Baker
and **Edwin**
Lutyens,
The Twin
Secretariats and
Rashtrapati
Bhavan
(Viceroy's
House), New
Delhi, 1931.
View from
Rajpath

266
Herbert
Baker,
Parliament
Building
(Council
House), New
Delhi, 1931

(570 ft) in diameter and occupying 2 hectares (5 acres). With a giant circular outer veranda, the interior consists of three semi-circular chambers grouped around a circular hall with a low dome. The great capital city of New Delhi, intended as a statement that the British Raj was there to stay, was inaugurated in 1931, a mere sixteen years before Lord Mountbatten, the last viceroy, handed it over to India's elected leaders.

Pandit Jawaharlal Nehru, independent India's first prime minister, firmly dismissed early objections regarding the unsuitability of an elected leader presiding from a grandiose monument over a nation where half the inhabitants lived in mud huts. Today the Viceroy's House is known as Rashtrapati Bhavan, and is occupied by the President of India; the Council House is now the seat of India's Parliament; while the Secretariat buildings continue to serve their original function.

Epilogue Art and Modernity

On the Indian subcontinent the word 'modern' underwent many
changes in meaning during the late nineteenth and early twen-
tieth centuries. In British India, the word primarily indicated
technological advances, increasing industrialization and a move
towards capitalism. In the arts, a sharp distinction became
established between the guild-oriented artisan of yore and the
new professional artist of social standing. The Indian model of
the latter was Raja Ravi Varma (1848–1906) who adopted the
European technique of oil painting and the realist conventions
of European 'history' paintings to recreate scenes from Indian
mythology and portraiture. His work was lauded by the British
as lyrical and refined, and his elevated reputation enhanced the
profession. In 1892 Ravi Varma set up an oleographic press to
reproduce his oils for popular consumption, and completely
captured the market. Throughout this period, the taste for
Western art was a signifier of status.

267
Ravi Varma,
Woman
Holding a Fan,
*c.*1895.
Oil on canvas;
53 × 35 cm,
20⁷⁄₈ × 13³⁄₄ in.
Victoria &
Albert
Museum,
London

With the rise of nationalism, the efforts of modernism were
directed towards achieving nationhood. This implied address-
ing a number of entrenched social problems in the course of
recuperating an 'authentic' self. The historical relativity of
artistic taste is apparent in the Bengal School's condemnation
of Ravi Varma's work as crass and vulgar. In particular,
Varma's portrayal of women (267) was criticized as flouting
norms of decorum. Nationalism's agenda upheld Indian women
as the prime preservers of religiosity, tradition and an authentic
'Indianness'; their portrayal had to be chaste and discreet.

Abanindranath Tagore, brother of renowned poet Rabindranath
Tagore, became the head of the nationalist art movement that
rejected both oil painting and academic realism. In the course
of his thrust towards indigenization, his work also shows an

interest in the art of other Asian countries, notably Japan, as well as leanings towards Art Nouveau. His watercolour paintings were in the format of Mughal miniatures whose influence, in both theme and style, is readily apparent. Yet his treatment of 'wash', from which colour has been almost divested, reveals his experimentation with the techniques of Japanese brush-painting. Abanindranath portrayed solitary figures, weightlessly floating in a misty, undefined space; their dreamy expressions and curved contours display his rejection of the European mode. His *Bharat Mata* or *Mother India* painted in 1905 portrays a chastely beautiful young ascetic with four arms, a halo around her head and lotuses at her feet (268). This image, not associated with any specific deity, became the artistic icon for the Indian nation.

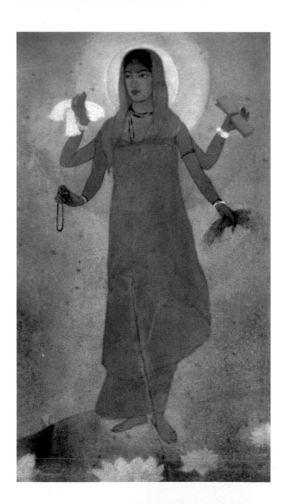

268
Abanindranath Tagore,
Mother India,
1905. Water-
colour on paper;
26·7 × 15·3 cm,
10½ × 6 in.
Rabindra Bharati
Society, Calcutta

By this time, Ajanta had been rediscovered and its paintings were celebrated as the genuine and original face of Indian art. Writers such as E B Havell and Ananda Coomaraswamy interpreted Indian art as exemplifying the highly mystical and the spiritual. But in 1941, Paris-trained artist Amrita Sher-Gil expressed disenchantment with the Bengal School, sharply criticizing it in a radio broadcast as catering exclusively to romantic notions and demanding no attention 'unlike the work of the great continental artists, or an Ajanta fresco'.

The decolonized countries of the subcontinent continued to witness negotiations over an authentic art. The issue of being modern involves establishing a sense of identity which incorporates technological and social changes while maintaining connections to the past. As Paul Ricoeur submitted in his 1961 *History and Truth*: 'This is the paradox: how to become modern and return to sources; how to revive an old, dormant civilization and take part in universal civilization.' Defining and grappling with the issue of a modern identity is an important part of being an artist, and is relevant whether a person is living in the subcontinent or elsewhere. For this reason I have included a discussion on artists sometimes excluded because they live outside the subcontinent.

The strength of any art form lies not in its ability to maintain itself in isolation but in its ability to absorb and assimilate new traits. Art has always fed on art, whether it be in the ancient Mediterranean world, in Renaissance Europe or in Asia. In this context it is useful to consider the use of the word 'derivative'. In India, Pala sculptors drew upon the forms of earlier Gupta imagery; since Pala sculpture is never termed derivative, the term clearly is not applied within a tradition. Nor is it applied when European artists adopt a non-European motif or style; no one would label as 'derivative' Picasso's African-inspired faces or Gauguin's Tahitian women. But 'derivative' comes into play when artists from the subcontinent adopt Western modes of expression. Because of the priviliged position given to Western

art, borrowings by Western and non-Western artists continue to be evaluated differently; even post-colonial art criticism often seems unable to detach itself from such values. It is also important to be clear about the process of 'influence', which is not a passive process to which the 'influenced' artist submits; rather, he or she actively selects and appropriates specific features that are then combined in a distinctive manner. Such considerations are useful in looking at developments in architecture, sculpture and painting.

Independence was accompanied by partition, with the Punjab and Bengal being divided between the nations of India and Pakistan. The gracious Punjab capital of Lahore, embellished by many Mughal emperors, became part of Pakistan. Indian Punjab needed a new capital that would be, in the words of Pandit Nehru, India's first prime minister, 'the temple of the new India … unfettered by the traditions of the past'. Two American architects were originally commissioned to execute

269
Le Corbusier,
Assembly Hall,
Chandigarh,
1951–64

and design the new city of Chandigarh (abode of goddess Chandi) on a vast plateau along the foothills of the Himalayas, but after the death of one and the withdrawal of the other, the task fell to Swiss architect Le Corbusier, the founding member of architectural Modernism. While Corbusier had spent considerable time writing about town-planning, he spent little time on the Chandigarh township itself, and its execution was left largely in the hands of a team of young Indian, Swiss and English architectural students. It was created as a grid of roads, intersecting at intervals to create 'sectors', and enclosed by the natural boundaries of two river beds. Laid out for fast motor traffic, it ignored the fact that half Chandigarh's inhabitants did not and still do not possess even a bicycle. Le Corbusier devoted his attention to crowning the city with a monumental complex of administrative buildings that exemplify his grandness of vision. The impressive buildings, created of poured concrete, were erected between 1951 and 1964. Compared with anything previous, it was startlingly modern, and rejected any pastiche which might have resulted from incorporating Indic features. Le Corbusier's Chandigarh buildings, like his creations in other parts of the world, incorporate such powerful geometric shapes as upturned curves and cylindrical elements that are sculptural in effect (269); he also incorporated clear reflecting pools of water into the overall design. If his immensely dignified buildings are to be faulted, it is for their disregard of the realities of life in India, both climatic and social. Concrete absorbs and retains heat, leaving interiors hot in the summer and cold in the winter; the High Court building's walls, which did not connect with the roof, allowed the slanting monsoon rains in; the custom-designed seats ignored the tendency of the locals to use them as rests for their bare feet. Highlighting the intrinsic problems of 'planned' cities is the fact that Chandigarh's population vastly exceeded the original estimate of 150,000, with planned extensions to accommodate 500,000. However, its plan served as a useful template for extensions to already established towns.

Partition of Bengal resulted in its capital of Calcutta being allocated to India; East Pakistan, today Bangladesh, commissioned American Louis Kahn to create a National Assembly complex at the new capital city of Dhaka. In the modern mode, and emphasizing the importance of a protective layer of secondary spaces around the main chamber, Kahn created a remarkable fortress-like structure standing on a raised platform. A centralized circular space for the Assembly proper is surrounded by a fringe of smaller spaces; at one end is a mosque with a dramatic triangular façade, while at the other is a large open presidential platform. Its appearance may partly have been the result of his viewing Rajput forts, but in large measure it was due to Kahn's stated belief that the capital should be 'a world within a world' with no reference to the outside. Built of rough brick and poured concrete between 1962 and 1970, the complex, known today as Sher-e-Bangla Nagar, has been aptly described as Kahn's 'personalized mandala'. Both masters of Modernism, Le Corbusier and Kahn, also worked elsewhere in India, especially in Ahmedabad in western India, the town that became the crucible of architectural experimentation.

It was Le Corbusier, and to a lesser degree Kahn, who provided inspiration, leadership, and a modern visual language to the subcontinent's new generation of architects. By 1970, one might have concluded that a distinctive South Asian architecture, with its insistence on decorative surfaces, on *alamkara*, was extinct. At this point, architects began to question whether an indigenous identity could be retrieved. Was it possible to assimilate Indic elements into the modern without needless nostalgia, and without creating a pastiche such as the Indo-Saracenic which, while eye-catching, could not indicate a way forward? A highly successful architect of the new school of thought was B V Doshi, who had worked personally with Le Corbusier. His office-cum-architecture school at Ahmedabad, built in 1979–80, evokes the local ethos and is created as a series of individual vaulted roofed studios that are partly sunk into the ground to enable the creation of stepped outdoor

spaces for lectures. The complex is aptly named Sangath, which means togetherness and participation.

Charles Correa, whose buildings have won him worldwide recognition, emphasized the importance of building with South Asian living patterns in mind. He stressed the need for a number of interconnected units since, in a warm climate, 'people have a very different relationship to builtform'. Another important issue was to intrude as marginally as possible upon the natural environment. His hotel at Kovalam along the south-western coast of Kerala, constructed between 1969 and 1974, is built into the hill and makes use of traditional white plastered walls and red-tiled roofs (270), with bamboo roofing for its beachside kiosks. At the same time, Correa's designs exemplify his statement that 'only a decadent architecture looks obsessively backward'. Apart from building for the élite, Correa also faced the issues of expanding urbanism, of sidewalk or pavement dwellers and of providing low-cost housing by reinterpreting Modernist architecture to suit the masses. The question was not whether to be modern or Indian, but how to be both.

270
Charles
Correa,
Kovalam
Beach Hotel,
1969–74

With a few exceptions, however, the formal and decorative vocabulary of contemporary architecture remains rooted in Western aesthetics, although contemporary architect Raj Rewal points to 'the desire to invent authenticity'. If any one building shows us a way forward, it may be artist Satish Gujral's Belgian Embassy in New Delhi (271). Perhaps because Gujral is a sculptor, painter and muralist, rather than an architect by schooling, he seems to have been free of the pressure to create an architectural synthesis between traditional and modern. The resulting building of brick and local granite, set in an immense sunken garden, seems to be a three-dimensional transformation of his abstract wood and metal sculptures that are based, somewhat loosely, on age-old mandala designs. With its curved, outward thrusting forms, Gujral's building has recreated the sculptural quality of ancient Indian buildings.

271
Satish Gujral,
Belgian
Embassy, New
Delhi, 1980–3

A totally different type of movement, though with the same aim of reviving an Indian identity, was initiated by Ganapati Sthapati (meaning master-architect) when he set up a sculpture school at Mamallapuram along the waters of the Bay of Bengal. Having researched ancient art texts written for practising architects and sculptors, he produced a compilation to be used as resource material in his art school (see 3–6). Surrounded by ancient monuments, students learned the traditional methods

of building, stone-sculpting, bronze-casting and painting, and began to produce art that duplicated the ancient examples. Ganapati Sthapati gained personal fame for reviving an art form that had suffered intensely over the previous three centuries. He was commissioned to build temples of the southern style in New Delhi and elsewhere; non-resident Indians in the United States sponsored him to travel with his team to towns as distant as Pittsburgh, Pennsylvania, and Livermore, California, to construct temples for the expatriate community. Bronze festival images of the gods were often made in India and

**272
Meera
Mukherjee**,
*Ashoka at
Kalinga*, 1972.
Bronze;
h.352·5 cm;
138³⁄₄ in.
Maurya
Sheriton Hotel,
New Delhi

shipped out to these overseas temples. Students from his school gained important commissions not only for temples but also for theme parks along the lines of Disneyland, which have become popular in South India. Such parks feature sculpted tableaux in which large individual pieces, such as a stone pleasure boat with its occupants, are created from single blocks of granite. The result is another synthesis of the modern and traditional.

Modern sculptors have reached back in time as often as they have looked forward. Meera Mukherjee, for example, draws inspiration for her works from the forms and techniques used by the tribal metal casters in the remote Bastar area of Central India; her work challenges the sharp differentiation of categories such as 'folk' and 'modern', and resists placement in any specific school, group or movement. Adapting the use of the lost-wax process, tribal craftsmen have devised a free and rapid, if complex, way of constructing images. Over a rough core of clay, they lay a series of long, thin threads of beeswax, building up a design. A sheath of clay paste is pressed over this and the entire mould is bound in metal wire, then heated over charcoal. Molten metal is poured in to take the place of the wax threads. The result is an image of extraordinary expressiveness. Mukherjee's bronze image of Ashoka at Kalinga (272) commemorates an event that occurred over 2,000 years ago; it portrays the Mauryan emperor as he comprehends the disastrous consequences of his Orissan military campaign and turns to embrace Buddhism. The figure, twice life size, was cast in twenty-six segments, which were then welded together.

Quite different is the work of London sculptor Anish Kapoor whose formal approach to art is heightened abstraction and who works in the non-traditional medium of fibreglass, but whose inspiration is drawn from the mythology, philosophy and everyday life of India. An Indian artist who has won recognition outside India, Kapoor has the advantage of easy mobility between two locales. Returning from a trip to India, during which he had been struck by the colours and shapes of mounds

273
Anish Kapoor
At the Hub of Things, 1987. Fibreglass and powdered pigment; h.163 cm, 64⅛ in. Hirshhorn Museum and Sculpture Gallery, Washington, DC

of red and yellow powders outside Hindu temples, he began using powdered pigments in his works, which often centre around Hindu themes. His dazzling blue concave sculptural form, *At the Hub of Things* (273), is made of fibreglass and covered with Prussian-blue powdered pigment that gives it a velvety texture. It is one of a series of sculptures on the theme of the deep blue goddess Kali, who represents the darker side of power.

To chart the manner in which painting balanced the challenges between the new spirit of Modernism and the need to maintain links with the past, we must turn back to the artist Jamini Roy of the 1930s and 1940s. Having mastered, then abandoned, oil painting, Jamini Roy adopted the style of the folk painters of Bengal, using indigenous pigments to paint on cloth, board and paper treated with a coating of cowdung and lime. His sharply outlined images (274), repeatedly portrayed to emphasize their themes, were intended to be part of the life of the ordinary people. In 1948, a year after Independence, the Progressive Artists Group was founded by M F Husain and others with the aim of finding terms on which they could seek equality among the family of nations. Their first exhibition embraced the visual language of modern European art. Husain drew on Abstract Expressionism and Cubism to create his numerous figural canvases and watercolours, which frequently present mythological or historical themes, while Raza embraced abstraction to portray the theme of 'Bindu' or 'Dot', the deep centre for meditation. Tyeb Mehta used disjointed forms to express doubts about breaking with the traditional and embracing the modern; his response to the divisions of the country on the basis of language, caste and community is represented by a diagonal that dramatically cuts across his canvases as an eloquent metaphor of fracture (275).

In the 1960s, a movement termed Indigenism attempted a return to roots, especially to themes related to esoteric tantra. More recently, Manjit Bawa has reached back to a variety of

274
Jamini Roy,
Gopini,
*c.*1935–40.
Watercolour
on paper;
122 × 152 cm,
48 × 60 in.
Private
collection

275
Tyeb Mehta,
Diagonal Series,
1972. Oil on
canvas,
150 × 175 cm,
59 × 69 in
Private
collection

ancient myths, particularly the theme of the god Krishna play-
ing his flute while tending cows (276). His canvases are satu-
rated with intense colours that seem to hark back to Rajput
painting; yet his forms are uniquely reconstituted and set in a
luminous coloured space that defies being tied down to any
spatial context. He reinterprets, reformulates and reinvents
tradition in a singular manner. His use of vibrant, almost star-
tling hues recalls New York costume designer Diana Vreeland's
piquant remark that 'pink is the navy blue of India'. Gulam
Mohammed Sheikh is another artist whose canvases reveal the
strength of the ancient tradition. Filled with a multiplicity of

forms, they seem to return to Rajput painting's complex narrative strategies; yet these paintings are dream visions and not strictly narrative.

A different direction, yet one that displays an active engagement with the past, is seen in the works of New York artist Natvar Bhavsar; to him, colour is not a means to an end, but the subject matter of his works. Rejecting the brush, he adds dry pigments through a strainer onto canvases prepared with a wet acrylic binder to create a panorama of colour. The use of dry powder, also part of sculptor Anish Kapoor's repertoire, harks back to the Indian practice of 'painted' designs on the threshold of homes. In the field of painting, the apparently opposing forces of revival and progress seem to have arrived at a degree of reconciliation.

Artists also have made notable contributions in a variety of other fields, with such photographers as Raghubir Singh and fashion designers as Asha Sarabhai gaining international recognition. Raghubir Singh's photographs, such as his series on Bombay (277), emphasize the startling beauty of the contradictions of modern India, juxtaposing street life with mannequins, festival statues and film posters. Sarabhai uses *kora*, an undyed fabric in which the texture of the weave reigns supreme. This fabric is pleated, folded and bunched before it is transformed into designs of understated simplicity. Thus existing craft techniques are extended into a contemporary context.

In addition to providing a fertile environment for individual artists, independent India has made a conscious attempt to revive and encourage its many traditional crafts. Today master craftsmen are acknowledged with prestigious awards. Wood- and ivory-carving, bronze-casting, rug-making, ceramics, pottery, and the production of textiles and fine jewellery are all encouraged and partially supported by the state, with the products being available for sale in the state emporiums. Wooden toys from Kondapalli in Andhra, terracotta horses from northern and eastern India that were once offerings to village deities,

277
Raghubir
Singh,
*Through a
Jewellery Store,
Bombay,* 1997

decorated bronze oil lamps from the South, ivory and sandal-wood carvings from Karnataka, and colourful embroideries from western India are a few examples of village and folk crafts that have found a new class of buyer.

For close to three centuries, the Indian subcontinent witnessed the slow but sure impact of Western thought that ultimately swept across the region, making its citizens doubt and devalue their own artistic and cultural heritage. Western ideas eclipsed the culture's hold on tradition, and artists of the twentieth century went through a period of indecision, as unwilling to cling to a strong past as to succumb to the pull of a Western modern ideology. Today a sense of resolution is evident. Artists have found an idiom in a multiplicity of media, an idiom that instills a sense of quality and confidence while invoking the strength and dignity of the past.

Glossary

Agama Ancient Sanskrit religious text.

Alamkara Ornament; also, theory of ornament.

Amalaka Fluted cushion-like element crowning the tower of the northern style temple; its shape is derived from the *amala* or myrobalan fruit believed to have purifying medicinal powers.

Artha Wealth; one of four goals of ancient Hindu life.

Bhagavad Gita or **'Song of the Lord'** An influential Hindu sacred text, inserted into the **Mahabharata** epic, in which the god **Krishna** explains several philosophical tenets that are crucial to Hinduism.

Bhikku A Buddhist monk.

Bodhi Enlightenment; the ficus tree beneath which the **Buddha** gained enlightenment became known as the bodhi tree, and later as *ficus religiosa*.

Bodhisattva ('Essence of enlightenment') This term was first applied to the princely **Buddha** prior to his enlightenment; later to a group of compassionate beings on the threshold of enlightenment.

Brahmin Priest; the highest of the four Hindu castes.

Caste system The division of early Hindu society into four classes, **brahmins** or priests, followed in descending order by *kshatriyas* or warriors, *vaishyas* or traders, and *shudras* or manual labourers, that gradually ossified into a rigid caste system without professional or social mobility.

Chakravartin Title used by Hindu rulers to indicate a 'universal king.'

Chaitya Apsidal Buddhist chapel; also a sacred spot.

Char-bagh A garden divided into four parts by four water channels which meet in the centre.

Chunam A form of stucco made from burnt sea shells that lent itself to a glossy polish.

Dakhni Local population of the Deccan. Also the Deccani language in which southern language words were incorporated into northern Urdu, itself an admixture of Persian and old Punjabi.

Darshan The dynamic act of viewing an enshrined Hindu deity; *darshan* is given by the deity and received by the worshipper.

Dhamma The doctrine of Buddhism which, together with the person of the **Buddha**, and the **samgha** or community of monks, forms the 'Three Jewels' of Buddhism.

Dharma Ethical living; one of four goals of ancient Hindu life.

Dravida Temple style which prevailed in southern India.

Garbhagriha ('Womb-house') The sanctum sanctorum of a Hindu temple.

Gita Govinda Hindu sacred poem which tells of the love of the god **Krishna** and the cowherd girl (*gopi*) Radha; this devotional text must be read on a metaphorical level as the longing of the human soul for union with the divine.

Gopura Pyramidal gate-houses of South Indian temples.

Haveli A term used to designate a set of 'townhouses' built around a central courtyard by the nobility and wealthy merchants of the Rajput courts.

Jainism A faith propogated by **Mahavira** who appears to have been an elder contemporary of the **Buddha**, with an emphasis on ethical living and non-injury to living creatures, and strict penance.

Jarokha A decorative projecting balcony that adorns a building's façade.

Jataka Name given to the story of any one of the Buddha's previous lives.

Kailasa God **Shiva**'s mountain home in the Himalayas.

Kalasha A pitcher; the pitcher-like finial that crowns a temple **shikhara** or spire.

Kalpa A cosmic era in the Hindu, Buddhist and Jain cyclical concept of time.

Kalpasutra An important Jain text that narrates the lives of the Jinas.

Kama Love; one of four goals of ancient Hindu life.

Karma The sum of an individual's deeds in this life on earth, which determines the nature of a future birth. Hindus, Buddhists and Jains subscribe to the theory of karma and rebirth.

Kaula Esoteric, unorthodox Shaiva sect.

Koran Book believed by Muslims to contain the actual word of God, as revealed through the angel Gabriel to the Prophet Muhammad.

Kuta Shrine-like unit on temple walls; aedicule.

Linga Aniconic emblem of the Hindu god **Shiva** that forms the object of devotion within the sanctum of a Shiva temple; also interpreted as a phallic symbol that represents Shiva's great ascetic and yogic power.

Madrasa A school for the teaching of Islam, that includes both lecture halls and residential accommodation for students.

Mahabharata Indian epic that narrates the great war that took place between the five Pandava brothers and the hundred members of the Kaurava clan; the war may have a historical basis sometime in the first millenium BC. The epic was passed down orally, being put into writing by the fourth century AD.

Mahaparinirvana ('Great passing away') Term for the death of the **Buddha**.

Mandala A circular cosmic diagram for meditation, in which the devotee experiences the deities in the outer areas of the *mandala* before moving inwards to concentrate on the chosen deity at its centre. According to ancient Indian architectural texts, cities and temples were to be laid out according to a *mandala* plan.

Mansabdar Official in the Mughal administrative system.

Mardana Rajput palaces were divided on lines of gender into the *mardana* or open, public areas intended for men, and the secluded women's apartments known as the **zenana**.

Masjid The Arabic word for 'mosque', literally a 'place for prostration'.

Matrika Mother goddess.

Mihrab Niche in the façade or **qibla** wall of a mosque that indicates the direction of Mecca towards which Muslims must face during prayer.

Minaret Tower attached to a mosque from which the *muezzin* or announcer calls the faithful to prayer five times a day.

Mithuna Loving couple; in Hindu, Buddhist and Jain India they were emblems of fertility, and hence represented growth, abundance and prosperity.

Moksha Salvation; one of four goals of ancient Hindu life.

Mudras Hand gestures known as *mudra*s are used to express the mood and meaning of images of the gods and the Buddha. When the right palm is raised to face the worshipper, it is the gesture of protection (*abhaya*). If the right hand is lowered and the fingers point downward, the promise is to grant the devotee's wishes (*varada*). When thumb and index finger of the right hand are joined, it is an indication of teaching (*vyakhyan*). In the case of the Buddha, the left hand joins the right to create a two-handed gesture of preaching that is intended to recall the first sermon (*dharmachakra*). When a seated image has palms upward and placed within each other in the lap, it is the gesture of meditation (*dhyana*). Other *mudra*s are more specific in their application.

Musawwir The Arabic, Islamic word for 'Creator' or God the Creator. *Musawwir* is also the word used for the 'artist' who, in the Islamic world, was frowned upon for 'creating' a human form, a task possible only for God.

Nagara Northern style of temple.

Natya shastra ('The science of dance') This work, written by Bharata around the 4th century, enunciates the viewer-response theory of aesthetics known as *rasa*.

Pahadi ('Of the hills') Name given to paintings from the states of the Punjab hills.

Panchamakaras 'The Five Ms' of the esoteric tantric sects, consisting of *matsya* (fish), *mamsa* (meat), *mudra* (parched grain), *mada* (wine) and *maithuna* (sex).

Pancharatra Vaishnava philosophy of emanation from transcendence to materiality.

Pradakshina Ritual circling of a sacred monument or image.

Puja Ritual Hindu worship, whether in a home shrine or at a temple.

Punya Spiritual merit; hence *punya-keshtra* or field of spiritual merit.

Purana Religious literature compiled during the first millenium that is the basis for modern Hinduism.

Qibla The wall of a mosque that marks the direction of Mecca towards which a Muslim must face during prayer; in India, this is the western wall.

Raga A musical mode.

Ragamala A unique genre of painting that could be termed 'pictorial music'. Musical modes are personified and painted as male (*raga*) or female (*ragini*) to represent a variety of emotions, especially love and devotion.

Ramayana Great Indian epic, the 'Story of Rama', tells the tale of the exile of **Rama**, prince of Ayodhya, together with his wife Sita and brother Lakshmana; the abduction of Sita by the demon king **Ravana** of Lanka; the immense search that ensued; and the climactic battle resulting in the death of Ravana and the final rescue of Sita from captivity. The epic seems to have had some historical basis; it was passed down orally for centuries and was finally committed to writing by the fourth century AD.

Rasa The viewer-response theory of art and aesthetics. Its nine *rasa*s are the erotic (*shringara*), comic (*hasya*), pathetic (*karuna*), fearsome (*raudra*), heroic (*vira*), frightening (*bhayanaka*), odious (*bibhatasa*), marvellous (*adbhuta*) and peaceful (*shanta*). The responsive viewer is known as a *rasika*.

Samgha The community of Buddhist monks.

Shaiva Siddhanta Shaiva philosophy of emanation from transcendence to materiality.

Shala Barrel-vaulted shrine-niche or aedicule on temple walls.

Shikhara ('Mountain peak') The term also means the spire of a Hindu, Buddhist or Jain temple.

Shilpa The Sanskrit word for art; hence *Shilpa Shastras*, or 'texts on art', which set out guidelines for architects, sculptors and painters.

Stupa A solid earthen memorial mound, enshrining a relic casket containing the cremated remains of the **Buddha**, or venerated Buddhist teachers.

Stupi The rounded architectural unit crowning the tower of the southern, or **Dravida**, style of temple.

Sufi Mystic saint of the Islamic tradition.

Sura Chapter of the **Koran**.

Tantra Term used to designate an esoteric form of religion, Hindu and Buddhist, that was associated with secret rites of a magical nature. Hence tantric: of, or having to do with, tantra.

Upanishads Sacred Hindu texts of a philosophical nature.

Urna One of the marks of the **Buddha**'s perfection: a tuft of hair between the eyebrows.

Ushnisha A cranial bump – one of the marks of the **Buddha**'s superhuman perfection.

Vajra Double-headed thunderbolt of god Indra, and of a range of tantric deities.

Veda ('Knowledge') The sacred literature of the Aryas that began to be composed around 1300 BC and was transmitted orally for centuries. The four Vedas, listed in order of their composition: *Rigveda*, *Samaveda*, *Yajurveda* and *Atharvaveda*.

Vesara Temple type of mixed character.

Vihara Monastic residential hall for Buddhist monks.

Yakshi/Yaksha Semi-divine beings of an elemental nature, associated with fertility. The *yakshi* (female) and *yaksha* (male) were considered auspicious beings.

Yavana Ancient Indian term used initially to refer to Greek merchants, and later extended to include most foreigners.

Yoga Ancient system of philosophy in which the physical yoga exercises are one of eight steps towards salvation. The experienced practitioner of yoga is known as a yogi (male) or yogini (female).

Zenana Section of a palace, Rajput or Mughal, reserved for the royal women. See also **mardana**.

Religious and Mythical Figures

Appar Seventh-century Tamil Shaiva saint.

Ardhanari ('Half-Woman') A composite bodily manifestation of the god **Shiva** combined with his wife, the goddess **Parvati**.

Bhikshatana Manifestation of the god **Shiva** as Enchanting Mendicant.

Buddha ('Enlightened One') The title was given to the chieftain Siddhartha who lived in the fifth/fourth century BC, rejected the Hindu Vedic tradition and propogated a new path of simple ethical living known as Buddhism. The Buddha was soon deified and worshipped as a god.

Devi The Great Goddess who has numerous names and forms; **Parvati**, spouse of **Shiva**.

Ganesha Elephant-headed god who is the elder son of the god **Shiva** and the goddess **Parvati**, and brother of the god **Skanda**; he is the god of beginnings and invoked at the start of any new undertaking.

Ganga Goddess who is a personification of the once heavenly River Ganges; she agreed to descend to earth in response to pleas that the ashes of ancestors would be liberated only by immersion in Ganges waters.

Kalyanasundara Name given to images of **Shiva** taking **Parvati**'s hand in marriage.

Krishna Popular Hindu god, incarnation of **Vishnu**, celebrated in three major contexts (1) He is the beloved infant who grows up in a cowherd village. (2) He is the divine lover of the **Gita Govinda** poem, who enchants the cowherd girls (*gopis*) and is himself entranced by Radha. (3) He is the wise counsellor of the epic **Mahabharata**, and its embedded poem **Bhagavad Gita** or 'Song of the Lord'.

Lakshmi Consort of the god **Vishnu**, and goddess of wealth and fortune.

Lingodbhava Manifestation of the god **Shiva** within a **linga** to establish his superiority over Brahma and **Vishnu**.

Mahavira Fifth-century BC propagator of the Jain faith, known as a Jina or 'victor', and believed to be the twenty-fourth and last of a series of prior Jinas.

Mahishamardini Slayer of the buffalo-demon; name given to **Devi**, the Great Goddess.

Mara The evil one of Buddhism who opposed, tempted and attacked the **Buddha**, trying to prevent him from achieving enlightenment.

Nataraja ('King of Dance') This term refers to the god **Shiva** in his form of the cosmic dancer whereby he destroys the world only to create it once again.

Parvati Consort of the god **Shiva**, and mother of their two sons – elephant-headed god **Ganesha**, and warrior youth **Skanda**. She is also an independent goddess in her own right. See **Devi**.

Rama Incarnation of the god **Vishnu** and divine hero of the epic **Ramayana**, or 'Story of Rama', he was prince of Ayodhya, and is viewed as the ideal monarch and the paradigm for all Hindu rulers.

Ravana Demon king of Lanka of the epic **Ramayana**. He also plays a role in the mythology of the god **Shiva** since he attempted to uproot **Kailasa**, Shiva's mountain home, to use it as a dynamo of magic energy in his battle against **Rama**.

Sadashiva A name for **Shiva** in his Unmanifest-Manifest form; name given to Shiva **linga** with five heads carved against it.

Sarasvati Hindu and Jain goddess of learning and music.

Shiva ('Auspicious') This major Hindu god carries a trident, wears a serpent as a scarf, sports a skull and crescent moon in the matted locks piled upon his head, has a third eye to indicate his all-seeing nature and rides a bull. He lives on Mount **Kailasa** in the Himalayas with his wife, the goddess **Parvati**, and their two sons, the elephant-headed god **Ganesha**, and the warrior youth **Skanda**.

Skanda Youthful warrior god who is the younger son of the god **Shiva** and the goddess **Parvati**, and brother to the god **Ganesha**.

Surya God of the Sun.

Tripurantaka A victorious form of **Shiva** in which he destroys the forts of three demons.

Trivikrama Gigantic form assumed by the god **Vishnu** as part of his dwarf incarnation.

Vishnu Distinguished by the war discus (*chakra*) and conch-shell trumpet (*shankha*) that he holds, the god Vishnu wears a tall crown, rides the divine eagle Garuda, and is often accompanied by his wife **Lakshmi**, goddess of fortune. A theory of ten incarnations is associated with Vishnu, who is believed to have been born nine times in the forms of Matsya (fish), Kurma (tortoise), Varaha (boar), Narasimha (man-lion), Vamana (dwarf), Parashurama, **Rama**, **Krishna** and **Buddha**; Kalki, the tenth is yet to come.

Yama The god of death who was defeated by the god **Shiva**.

Yamuna Personified goddess of the River Yamuna, known today as Jamuna.

Major Dynasties and Empires

Numbers in square brackets refer to illustrations

Adil Shahi Line of Muslim sultans of Turkish origin who ruled the Deccani Sultanate of Bijapur between 1538 and 1686 and made significant contributions in the fields of architecture and painting [172–5].

British A British trading company, the East India Company, established its first trading station in India at Surat on the west coast in 1613. By 1800 the Company was effectively ruling large portions of India and was constructing forts, mansions and a range of civic buildings [244–5]. In 1858 the British Crown supplanted Company rule, with a viceroy replacing the governor general. Building activity continued, culminating in the design of a new capital at New Delhi [243, 250–7, 264–5]. In 1947 the British handed over rule to India's first Prime Minister, Jawaharlal Nehru and Pakistan's first governor general, Muhammad Ali Jinnah.

Chandella Rulers of central India between 925 and c.1308 who were renowned for the spectacular group of temples they sponsored at their capital of Khajuraho [7, 102–11].

Chola Between 862 and 1310 all of South India was under the rule of this dynasty and for a while the island of Sri Lanka was one of its provinces. The Cholas were great patrons of the arts, in particular of temple building and bronze casting [2, 138–53].

Eastern Ganga A dynasty that ruled eastern India between the eighth and thirteenth centuries. During the reign of Narasimhadeva (1238–64) the great chariot temple of the Sun was erected at Konarak [120–2].

Gupta Between c.320 and 647 (including the reign of Harsha) most of northern India was under the rule of this dynasty under whom literature, mathematics, astronomy and the plastic arts reached great heights. The Gupta Buddha image became the model for artists across the Buddhist world [69–70], while the form of the Hindu temple coalesced and took shape [97–9].

Kalachuri A dynasty that ruled the western coastal region during the sixth century and who may have been responsible for initiating rock-cut Hindu architecture. The Shiva cave at Elephanta was probably a creation of Krishnaraja I who ruled from c.550 to 575 [1, 90–2].

Kushan A dynasty of central Asian origins that ruled a vast empire extending from the River Oxus to Mathura in the plains of northern India from the mid-first century to the third century AD. Their patronage resulted in the creation of two very different Buddha images,

a Hellenized image in the northwestern region of Gandhara, now Pakistan, and an indigenous Buddha image at Mathura [47, 49–53, 57–66]. Its rulers also sponsored Hinduism [48] and built dynastic shrines [67].

Maurya The first Indian empire founded by Chandragupta Maurya as Alexander the Great withdrew from India in 326 BC and which at its height controlled most of the subcontinent except its deep south. Emperor Ashoka who ruled c.272–31 sponsored the first monumental art in stone by creating free standing columns inscribed with his edicts of Buddhist persuasion [28–30], as well as the very first rock-cut caves [74, 77].

Mughal Descended from the Mongols, this Islamic dynasty ruled northern India between 1526 and 1858 at which date the British Crown assumed control. Its rulers sponsored the creation of magnificent garden tombs, palaces and mosques, painted manuscripts, and a range of jewellery and luxury items [187–216, 218].

Nayaks Originally governors of the **Vijayanagar** emperors, the Nayaks declared their independence (1529–1736), making Madurai their capital. They were responsible for the addition of vibrantly sculpted pillared halls to most of the expanded temples of southern India [155–62].

Pala-Senas These two dynasties successively controlled much of eastern India between c.750 and 1200. They were responsible for patronage of both Hindu temples and Buddhist monastic establishments [71].

Pallava The line of imperial Pallavas who ruled the Tamil country of South India from c.550 to 728, and initiated the production in stone of the **Dravida** temple. Their port of Mamallapuram is the first southern instance of large-scale sculpture in stone, and it exhibits an astonishing variety of forms [123–37].

Portuguese A dominant presence on the west coast between 1498 and 1961, the Portuguese established the Estada da India or State of India in Goa, building impressive churches and creating portable objects of sacred significance [236–41].

Rashtrakuta A Hindu dynasty whose rule extended over the northern Deccan; the monarch Krishna I, who ruled between 757 and 783, was responsible for the spectacular rock-cut monolithic Kailasa temple at Ellora [93–5].

Satavahana This dynasty ruled parts of the Deccan plateau between the first century BC and the second century AD. During their rule

citizens sponsored the creation of Buddhist monuments such as the great stupa at Amaravati [41–6] and rock-cut Buddhist monasteries.

Sisodia The line of Mewar Ranas established in the fourteenth century. When their early capital of Chitor was destroyed, they moved to Udaipur where they once again built splendid fort-palaces and sponsored the creation of painted manuscripts [219–30].

Solanki A dynasty that ruled western India between *c.*950 and *c.*1304, under whose patronage great monuments were built, including the Queen's step-well at their capital of Patan [9–10] and a marble Jain temple on the hills of Mount Abu [112–16]. Jain patronage resulted in the production of some of India's earliest painted manuscripts [117].

Sultanate Term given to Muslim Turkish rule of northern India between 1206 and 1526 under five separate dynasties: the 'Slave', Khalji, Tughlak, Sayyid and Lodi. Builders and painters adapted their indigenous mode to work for their new patrons, producing mosques, tombs and forts, as well as painted manuscripts [163–9]. In the Deccan, the Bahmani Sultante was in power from 1347 to 1538, when it broke up to form the five smaller sultanates of Bijapur, Ahmadnagar, Bidar, Berar and Golconda, which were absorbed into the Mughal empire in 1686. Muslim sultans also ruled parts of Gujarat in western India and Bengal in the east.

Sungas A Hindu dynasty (*c.*185–75 BC) which, with its short-lived successor, the Kanva rulers (up to *c.*25 BC), took over the central Indian portions of the Mauryan empire upon its collapse. Under their rule Buddhist art flourished at monasteries such as Bharhut and Sanchi [33–40].

Vakataka A Hindu dynasty that ruled over the central Deccan during the fourth and fifth centuries. During the reign of Harisena between *c.*462 and 491 officials and aristocrats sponsored the creation of the lavishly sculpted and painted Buddhist monastery at Ajanta [73, 82–9].

Vijayanagar Under three separate dynasties, the Vijayanagar emperors ruled portions of the Deccan and South India between 1336 and 1565. While their temples followed the indigenous mode, their royal structures incorporated Islamic building techniques and motifs, resulting in a remarkably eclectic style [176–86].

Key Dates

Numbers in square brackets refer to illustrations

Dates are mostly approximate

Indian Art

2600 BC Indus seals and material culture (to 1900) [11–27]

272 Ashokan stone columns [28–30]; first rock-cut caves [74, 77]

100 Early Buddhist rock-cut monasteries (up to 200 AD) [75–6, 79–80]; Stone decoration and expansion of stupas [33–40]

78 AD Early Buddha images and monasteries in Hellenistic Gandhara and Indian Mathura [47, 49–50, 57–65]

200 Amaravati's main stupa complete [41–6]

432 Gupta Buddha images [69–70]

500 Ajanta cave monastery complete [73, 82–9]; development of North Indian stone temple [97–9]

550 Development of Hindu cave-temples; eg Elephanta [1, 90–2]

600 Rock-cut caves commence in South India [123]

650 Development of the South Indian temple at Mamallapuram [128–30, 136–7] and Kanchipuram [134–5]

783 Rock-cut Hindu temple at Ellora [93–5]

850 Chola temple style starts [139–41]

925 Khajuraho temple-building starts [7, 102–11]

1012 Tanjavur Rajaraja temple complete [138, 142–8]; Efflorescence of bronze-casting [2, 149–50, 153]

A Context of Events

2600 BC Mature Phase of the Indus cities (up to 1900)

1300 *Rigveda* composed

486 Indian troops in Persian army

430 Parthenon completed in Athens

400 Death of the Buddha

326 Alexander the Great in India

321 Maurya dynasty founded

33 AD Jesus of Nazareth crucified at Jerusalem

78 Saka era established by the Kushan ruler Kanishka

242 Shapur I of Iran defeats the Kushans

320 Gupta dynasty begins (to 647)

450 Hun invasions of northern India

603 Chinese pilgrim Xuanzang begins trip to India

632 Death of the Prophet Muhammad

1000 Raids of Mahmud of Ghazni

Indian Art	A Context of Events
1032 Mt Abu's Jain marble temple complete [112–16]	
	1066 Battle of Hastings: Normans invade Britain
1070 Queen's step-well at Patan under construction [9–10]	
1192 Mosque-building in India. Qutb mosque [163–6]	**1192** Muhammad of Ghor invades India
	1206 Delhi Sultanate established
	1215 Magna Carta signed in England
1238 Sun temple at Konarak begun [120–22]	
1336 City of Vijayanagara founded [176–82, 184–6]; start of expanded temples at Madurai and Srirangam [155–62]	**1336** Foundation of Hindu kingdom of Vijayanagara
	1398 Timur (Tamerlane) sacks Delhi
1451 Lodi tombs of the Delhi Sultanate [169]	**1492** Columbus sails to New World
	1498 Vasco da Gama reaches India by sea
	1510 Goa becomes capital of the Portuguese Estado da India (to 1961)
	1526 Mughal dynasty founded by Babur
1534 Udaipur city-palace commenced [219–20, 226–7]	
1556 The emergence of Mughal painting [195–199]	**1556** Mughal emperor Akbar comes to power (to 1605)
	1558 Accession of Elizabeth I of England (to 1603)
1562 Christian churches of Goa began to be built. Se Cathedral [238–9]; Church of Bom Jesus [237]; Our Lady of Divine Providence [240]. Tradition of Mughal garden tombs commences with Humayun's tomb [188]; Akbar's tomb [202]; culminates with Taj Mahal [203–6]	
	1565 Vijayanagara empire defeated by confederacy of Deccan Sultanates
1571 City of Fatehpur Sikri begun [189–94]	
1579 Great Deccani tombs at Bijapur. The Rauza [172]; Gol Gumbaz [174]	
	1600 Elizabeth I grants charter to the East India Company
	1605 Mughal emperor Jahangir comes to power (to 1627)
	1613 British establish trading station at Surat
	1620 Pilgrim Fathers arrive in Massachusetts
	1627 Mughal emperor Shah Jahan comes to power (to 1658)
1632 Taj Mahal built (to 1643)	
1648 City of Shahjahanabad complete [207–10], followed by Jama Masjid mosque [211] Famous Mewar *Ramayana* painted [224–5]	
	1661 Island of Bombay gifted by the Portuguese to the British as part of the dowry of Charles II's queen
1668 New temple style in Goa [242]	
	1686 Deccan Sultanates included in Mughal empire

Indian Art	A Context of Events
	1690 British East India Company establishes trading station at Calcutta
1727 City of Jaipur commenced [234–5]	
	1757 Robert Clive defeats the Nawab of Bengal at the Battle of Plassey and thereby lays the foundation of British ascendancy in India
	1772 Warren Hastings becomes first governor general of East India Company's domains in India
	1776 American Declaration of Independence
1780 British artists arrive in India, *eg* Hodges [246]; the Daniells [247]; Lear [248]	
	1789 Sack of the Bastille and start of the French Revolution
1802 British civic architecture commences in Madras and Calcutta [244–5]	
	1837 Accession of Queen Victoria (to 1901)
1840 First daguerrotype photographs in India	
	1857 Indian rebellion
	1858 British Crown exiles last Mughal emperor and assumes direct rule of India through a viceroy
1860 Building of British Bombay [243, 254–7]	**1860** American Civil War (to 1865)
	1869 Suez Canal opens
	1877 Queen Victoria proclaimed Empress of India
1880 Raja Ravi Varma paints with oil on canvas	
1905 Abanindranath Tagore of the Bengal school paints 'Bharat Mata' [268]	**1885** Indian National Congress founded
	1911 George V first British monarch to visit India. Capital transferred from Calcutta to Delhi
	1914 World War I begins (to 1918)
1931 Inauguration of New Delhi [264–6]	
	1939 World War II begins (to 1945)
	1947 Britain grants independence to India and Pakistan
1948 Progressive Artists Group founded in Bombay to promote modern painting [275]. Indian sculptors work in the modern mode [272–3]	**1948** Mahatma Gandhi assassinated
1951 Foreign architects invited to create new capital cities. Le Corbusier at Chandigarh [269]; Louis Kahn at Dhaka	
	1961 Indian army reclaims Goa from Portugal
	1971 After a civil war, East Pakistan becomes the independent republic of Bangladesh
1972 Indian architects re-evaluate practice of modern architecture, advocating designing for Indian conditions [270–1]	
1987 Completion of 'unfinished' gopuram of Srirangam temple	

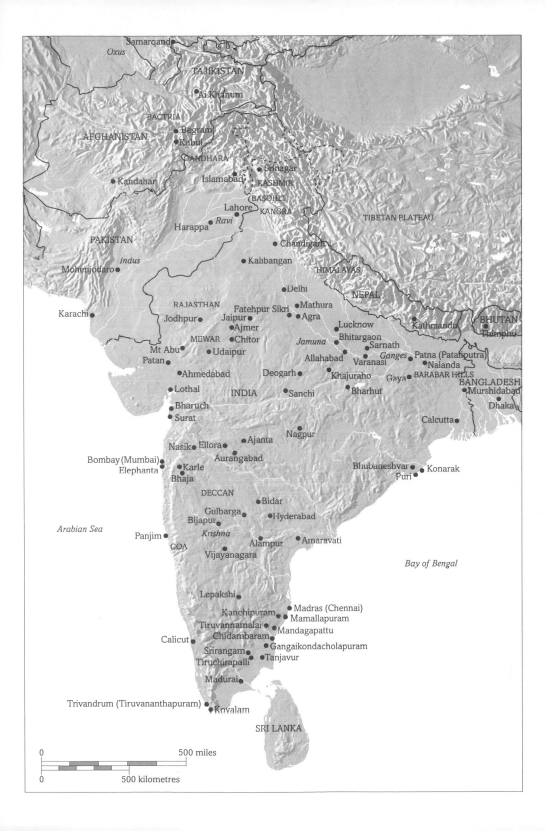

Samarqand

Oxus

TAJIKISTAN

Ai Khanum

BACTRIA

Begram
Kabul

AFGHANISTAN

GANDHARA

Srinagar

Kandahar Islamabad KASHMIR

BASOHLI

Lahore KANGRA

Harappa *Ravi*

PAKISTAN

TIBETAN PLATEAU

Chandigarh

Indus Kalibangan

Mohenjodaro HIMALAYAS

Delhi

NEPAL

Karachi RAJASTHAN Fatehpur Sikri Mathura

Jodhpur Jaipur Agra Lucknow Kathmandu BHUTAN

Ajmer Bhitargaon Thimphu

MEWAR Chitor *Jamuna* Sarnath

Mt Abu Udaipur Allahabad Varanasi *Ganges* Patna (Pataliputra)

Patan Nalanda

Ahmedabad Deogarh Khajuraho Gaya BARABAR HILLS

INDIA Bharhut BANGLADESH

Lothal Sanchi Murshidabad

Bharuch Dhaka

Surat Calcutta

Nagpur

Nasik Ellora Ajanta

Bombay (Mumbai) Aurangabad

Elephanta Karle Bhubaneshvar Konarak

Bhaja Puri

DECCAN

Bidar

Gulbarga

Bijapur Hyderabad

Krishna

Panjim GOA Alampur Amaravati

Vijayanagara

Arabian Sea

Bay of Bengal

Lepakshi

Madras (Chennai)

Kanchipuram Mamallapuram

Tiruvannamalai Mandagapattu

Calicut Chidambaram

Srirangam Gangaikondacholapuram

Tiruchirapalli Tanjavur

Madurai

Trivandrum (Tiruvananthapuram) Kovalam

SRI LANKA

0 500 miles

0 500 kilometres

Further Reading

General

The traditional division of the field of Indian studies into ancient (Hindu, Buddhist, Jain), medieval (early Islamic, Mughal, Rajput, later Hindu art) and modern (colonial and post-colonial) has resulted in few, if any, books encompassing the field covered here. Those that do are written in two volumes, frequently authored by two specialists. The field of Indian art has generally favoured the ancient over the less ancient so that books titled 'Art of India' are frequently deceptive since they restrict their coverage to the ancient period.

Catherine B Asher and Thomas R Metcalf (eds), *Perceptions of South Asia's Visual Past* (New Delhi, 1994)

Percy Brown, *Indian Architecture*, 2 vols: 1, *Buddhist and Hindu Periods*; 2, *Islamic Period* (Bombay, 1959)

Vidya Dehejia (ed.), *Representing the Body: Gender Issues in Indian Art* (New Delhi, 1997)

Ainslie T Embree (ed.), *Sources of Indian Tradition*, vol. I (New York, 1988)

Brijen N Goswamy (ed.), *Indian Painting: Essays in Honour of Karl J Khandalvala* (New Delhi, 1995)

J C Harle, *The Art and Architecture of the Indian Subcontinent* (Harmondsworth, 1986)

A History of India, 2 vols: 1, by Romila Thapar; 2, by Percival Spear (Harmondsworth, 1965–6)

Susan L Huntington, *The Art of Ancient India* (New York, 1984)

Ronald Inden, *Imagining India* (Cambridge, MA and Oxford, 1990)

George Michell and Antonio Martinelli, *The Royal Palaces of India* (London, 1994)

Barbara Stoler Miller (ed.), *The Powers of Art: Patronage in Indian Culture* (New Delhi, 1992)

Partha Mitter, *Much Maligned Monsters* (Oxford, 1977)

Pratapaditya Pal, *Indian Sculpture*, vols 1 and 2 (Los Angeles, 1986 and 1988)

The Penguin Guide to the Monuments of India, 2 vols: 1, *Buddhist, Hindu, Jain*, ed. George Michell; 2, *Islamic, Rajput, European*, ed. Philip Davies (London, 1989)

Christopher Tadgell, *The History of Architecture in India: From the Dawn of Civilization to the End of the Raj* (London, 1990)

Romila Thapar, *Time as a Metaphor for History* (New Delhi, 1996)

Stanley Wolpert, *A New History of India* (4th edn, New York, 1993)

Chapter 1

Frederick M Asher and G S Gai (eds), *Indian Epigraphy: Its Bearing on the History of Art* (New Delhi, 1985)

The Bhagavad-Gita: Krishna's Counsel in Time of War, trans. by Barbara Stoler Miller (New York, 1986)

Brijen N Goswamy, *Essence of Indian Art* (exh. cat., Asian Art Museum of San Francisco, 1986)

Stella Kramrisch, *The Art of India* (London, 1954)

Kirit Mankodi, *The Queen's Stepwell at Patan* (Bombay, 1991)

Michael W Meister (ed.), *Making Things in South Asia: The Role of Artist and Craftsman* (Philadelphia, 1988)

R N Mishra, *Ancient Artists and Art-Activity* (Simla, 1975)

Philip Rawson, 'An Exalted Theory of Ornament', in Harold Osborne (ed.), *Aesthetics in the Modern World* (London, 1968), pp.222–34

Chapter 2

Bridget Allchin and Raymond Allchin, *The Rise of Civilization in India and Pakistan* (Cambridge, 1982)

Frederick M Asher and Walter Spink, 'Maurya Figural Sculpture Reconsidered', *Ars Orientalis*, 19 (1989), pp.1–26

John Irwin, ' "Asokan" Pillars: A Reassessment of the Evidence: Parts I–IV', *Burlington Magazine* (November 1973), pp.706–20; (December 1974), pp.712–27; (October 1975), pp.631–43; (November 1976), pp.734–53

Jonathan M Kenoyer, *Ancient Cities of the Indus Valley* (New Delhi, forthcoming)

The Rig Veda, trans. by Wendy O'Flaherty (Harmondsworth, 1981)

Romila Thapar, *Ancient Indian Social History* (New Delhi, 1978)

Chapter 3

Buddhist Suttas, trans. by T W Rhys Davis (New York, 1969)

Edward Conze *et al.* (eds), *Buddhist Texts Through the Ages* (New York, 1964)

Ananda K Coomaraswamy, *Yaksas* (Washington, DC, 1928–31 [in 2 parts], repr. New Delhi, 1971)

Anna L Dallapiccola (ed.), *The Stupa: Its Religious, Historical and Architectural Significance* (Wiesbaden, 1980)

Vidya Dehejia, 'On Modes of Narration in Early Buddhist Art', *Art Bulletin,* 72 (1990), pp.374–92

—,'Aniconism and the Multivalence of Emblems', *Ars Orientalis,* 21 (1991), pp.45–66

—, 'Collective and Popular Bases of Early Buddhist Patronage: Sacred Monuments, 100 BC–250 AD', in Barbara Stoler Miller (ed.), *The Powers of Art,* op.cit., pp.35–45

— (ed.), *Unseen Presence: The Buddha and Sanchi* (Bombay, 1996)

Susan L Huntington, 'Aniconism and the Multivalence of Emblems: Another Look', *Ars Orientalis,* 22 (1992), pp.111–56

Robert Knox, *Amaravati: Buddhist Sculpture from the Great Stupa* (London, 1992)

Susan Murcott, *The First Buddhist Women: Translations and Commentary on the Therigatha* (Berkeley, 1991)

Gregory Schopen, 'On Monks, Nuns, and Vulgar Practices: The Introduction of the Image Cult into Indian Buddhism', *Artibus Asiae,* 49 (1988 9), pp.153 68

Romila Thapar, 'Patronage and the Community', in Barbara Stoler Miller (ed.), *The Powers of Art,* op.cit., pp.19–34

Chapter 4

Ananda K Coomaraswamy, 'The Origin of the Buddha Image', *Art Bulletin,* 9 (1927), pp.287–328

Stan Czuma, *Kushan Sculpture: Images from Early India* (exh. cat., Cleveland Museum of Art, 1985)

Alfred Foucher, *The Beginnings of Buddhist Art and Other Essays in Indian and Central-Asian Archaeology* (London, 1917)

J C Harle, *Gupta Sculpture: Indian Sculpture of the Fourth to the Sixth Centuries AD* (Oxford, 1974)

Deborah Klimburg-Salter, 'The Life of the Buddha in Western Himalayan Monastic Art and its Indian Origins: Act One', *East and West,* 38 (1988), pp.189–214

Pratapaditya Pal, *The Ideal Image: The Gupta Sculptural Tradition and its Influences* (exh. cat., Asia Society Gallery, New York, 1978)

—, *Art of Tibet: A Catalogue of the Los Angeles County Museum of Art Collection* (Berkeley and Los Angeles, 1984)

Joanna Gottfried Williams, *The Art of Gupta India: Empire and Province* (Princeton, 1982)

Sally Hovey Wriggins, *Xuanxang: A Buddhist Pilgrim on the Silk Road* (Boulder, 1996)

Chapter 5

Carmel Berkson, *Ellora: Concept and Style* (New Delhi, 1992)

Charles D Collins, *The Iconography and Ritual of Siva at Elephanta* (Albany, 1988)

Vidya Dehejia, *Early Buddhist Rock Temples* (London, 1972)

—, *Discourse in Early Buddhist Art: Visual Narratives of India* (New Delhi, 1997)

S Dutt, *Buddhist Monks and Monasteries of India* (London, 1962)

Karl Khandalwala, 'The History and Dating of the Mahayana Caves at Ajanta', *Pathik,* 2 (1990), pp.18–21

Stella Kramrisch, 'The Great Cave Temple of Siva on the Island of Elephanta', in *The Presence of Siva* (Princeton, 1981)

Wendy O'Flaherty, George Michell and Carmel Berkson, *Elephanta: The Cave of Shiva* (Princeton, 1983)

Dieter Schlingloff, *Studies in the Ajanta Paintings: Identifications and Interpretations* (New Delhi, 1988)

Walter Spink, 'The Splendour of Indra's Crown: A Study of Mahayana Developments at Ajanta', *Royal Society of Arts Journal* (October 1974), pp.743–67

—, *Ajanta: A Brief History and Guide* (Ann Arbor, 1990)

Chapter 6

T Richard Blurton, *Hindu Art* (London, 1992)

Vidya Dehejia, 'Brick Temples: Origins and Development', in Amy G Poster (ed.), *From Indian Earth: 4000 Years of Terracotta Art* (exh. cat, Brooklyn Museum, 1986), pp.43–56

Diana L Eck, *Darsan: Seeing the Divine Image in India* (Chambersburg, PA, 1981)

C J Fuller, *The Camphor Flame: Popular Hinduism and Society in India* (Princeton, 1992)

Adam Hardy, 'The Hindu Temple: A Dynamic Microcosm', in Emily Lyle (ed.), *Sacred Architecture* (Edinburgh, 1992), pp.41–57

Alexander Lubotsky, 'The Iconography of the Vishnu Temple at Deogarh and the Visnudharmottara Purana', *Ars Orientalis,* 26 (1996), pp.65–80

Michael Meister (ed.), *Ananda K Coomaraswamy: Essays in Early Indian Architecture* (New Delhi, 1992)

George Michell, *The Hindu Temple* (Chicago, 1998)

Joanna Gottfreid Williams, *The Art of Gupta India: Empire and Province* (Princeton, 1982)

Chapter 7

Alice Boner and Sadasiva Rath Sarma (trans. and ed.) *Ramacandra Kaulacara: Silpa Prakasa* (Leiden, 1966)

—, New Light on the Sun Temple of Konarka (Varanasi, 1972)

Pramod Chandra, 'The Kaula and Kapalika Cults at Khajuraho', Lalit Kala, I:2 (1955–6), pp.98–107

Richard H Davis, Lives of Indian Images (Princeton, 1997)

Devangana Desai, Erotic Sculpture of India: A Socio-Cultural Study (Bombay, 1975)

—, The Religious Imagery of Khajuraho (Mumbai, 1996)

Thomas E Donaldson, 'Propitious-Apotropaic Eroticism in the Art of Orissa', Artibus Asiae, 37 (1975), pp.75–100

Phyllis Granoff, '"Halayudha" Prism: The Experience of Religion in Medieval Hymns and Stories', in Vishakha Desai (ed.), Gods, Guardians and Lovers: Temple Sculpture from North India AD 700–1200 (exh. cat., Asia Society Galleries, New York, 1993), pp.67–93

Michael W Meister, 'Juncture and Conjunction: Punning and Temple Architecture', Artibus Asiae, 41 (1979), pp.226–34

Upanishads, trans. by Patrick Olivelle (New York, 1996)

Chapter 8

R Champakalakshmi, 'The Urban Configurations of Tondaimandalam: The Kancipuram Region, c.AD 600–1300', in Howard Spodek and Doris Meth Srinivasan (eds), Urban Form and Meaning in South Asia: The Shaping of Cities from Prehistoric to Precolonial Times (Hanover, 1993), pp.185–208

Marilyn Hirsch, 'Mahendravarman I Pallava: Artist and Patron of Mamallapuram', Artibus Asiae, 48 (1987), pp.109–30

Susan L Huntington, 'Iconographic Reflections on the Arjuna Ratha', in Joanna Williams (ed.), Kaladarsana (New Delhi, 1981), pp.57–67

Padma Kaimal, 'Playful Ambiguity and Political Authority in the Large Relief at Mamallapuram', Ars Orientalis, 24 (1994), pp.1–29

Michael Lockwood, Mahabalipuram Studies (Madras, 1974)

—, Mamallapuram and the Pallavas (Madras, 1982)

R Nagaswamy, 'New Light on Mamallapuram', Transactions of the Archaeological Society of South India (1962), pp.1–50

—, Gangaikondacholapuram (Madras, 1970)

—, 'Innovative Emperor and his Personal Chapel: Eighth Century Kanchipuram', in Vidya Dehejia (ed.), Royal Patrons and Great Temple Art (Bombay, 1988), pp.37–60

Chapter 9

Vidya Dehejia, Slaves of the Lord: The Path of the Tamil Saints (New Delhi, 1988)

—, Art of the Imperial Cholas (New York, 1990)

Padma Kaimal, 'Passionate Bodies: Constructions of the Self in Some South Indian Portraits', Archives of Asian Art, 48 (1995), pp.6–16

Pierre Pichard, Tanjavur Brhadisvara: An Architectural Study (New Delhi, 1995)

David T Sanford, 'Ramayana Portraits: The Nageshvara Temple at Kumbakonam', in Vidya Dehejia (ed.), The Legend of Rama: Artistic Visions (Bombay, 1993)

Gary J Schwindler, 'Speculations on the Theme of Siva as Tripurantaka as it Appears During the Reign of Rajaraja I in the Tanjore Area c.AD 1000', Ars Orientalis, 17 (1987), pp.163–78

B Venkataraman, Rajarajesvaram: The Pinnacle of Chola Art (Madras, 1985)

Chapter 10

J C Harle, Temple Gateways in South India (Oxford, 1963)

D Dennis Hudson, 'Madurai: The City as Goddess', in Howard Spodek and Doris Meth Srinivasan (eds), Urban Form and Meaning in South Asia: The Shaping of Cities from Prehistoric to Precolonial Times (Hanover, 1993), pp.125–44

George Michell (ed.), Temple Towns of Tamil Nadu (Bombay, 1993)

Chapter 11

Alberuni's India, ed., introduction and notes by Ainslie T Embree, trans. by Edward C Sachau (New York, 1971)

Mulk Raj Anand (ed.), Homage to Amir Khusrau (Bombay, 1975)

Catherine B Asher, 'Delhi Walled: Changing Boundaries', in James Tracy (ed.), City Walls: Form, Function and Meaning (forthcoming)

Richard M Eaton, Sufis of Bijapur 1300–1700: Social Roles of Sufis in Medieval India (Princeton, 1978)

H M Elliot and John Dowson, History of India as Told by Its Own Historians, 2 vols (Bombay, 1960)

Amitav Ghosh, In an Antique Land (New Delhi, 1992)

Oleg Grabar, The Formation of Islamic Art (New Haven, 1973)

George Michell (ed.), Islamic Heritage of the Deccan (Bombay, 1986)

Annemarie Schimmel, Calligraphy and Islamic Culture (New York, 1984)

Mark Zebrowski, Deccani Painting (London, 1983)

Chapter 12

John M Fritz and George Michell, City of Victory: Vijayanagara: The Medieval Hindu Capital of Southern India (New York, 1991)

John M Fritz, George Michell and M S Nagaraja Rao, *Where Kings and Gods Meet: The Royal Centre at Vijayanagara, India* (Tucson, 1984)

George Michell, *Architecture and Art of Southern India* (Cambridge, 1995)

V Narayana Rao, 'Kings, Gods, and Poets: Ideologies of Patronage in Medieval Andhra', in Barbara Stoler Miller (ed.), *The Powers of Art*, op.cit. pp.142–59

Burton Stein, *Vijayanagara* (Cambridge, 1989)

Phillip B Wagoner, '"Sultan among Hindu Kings": Dress, Titles, and the Islamicization of Hindu Culture at Vijayanagara', *Journal of Asian Studies*, 55 (1996), pp.851–80

Chapter 13

Abu 'L-Fazl Allami, *Ain-i-Akbari* (3rd edn, New Delhi, 1977)

Akbarnamah, trans. by Henry Beveridge (Calcutta, 1907–39)

Catherine B Asher, *Architecture of Mughal India* (Cambridge, 1992)

Milo C Beach, *Early Mughal Painting* (Cambridge, 1987)

—, *Mughal and Rajput Painting* (Cambridge, 1992)

Wayne E Begley, 'The Myth of the Taj Mahal and a New Theory of its Symbolic Meaning', *Art Bulletin*, 56 (1979), pp.7–37

Wayne Begley and Z A Desai, *Taj Mahal: The Illumined Tomb. An Anthology of Seventeenth-Century Mughal and European Documentary Sources* (Cambridge, 1989)

Henry Beveridge (ed.), *Tuzuk-i Jahangiri* (3rd edn, New Delhi, 1978)

Michael Brand and Glenn D Lowry, *Akbar's India: Art from the Mughal City of Victory* (exh. cat., Asia Society Galleries, New York, 1985)

Ellison Banks Findly, *Nur Jahan: Empress of India* (Oxford, 1993)

John M Fritz and George Michell, *City of Victory*, op.cit.

Ebba Koch, *Mughal Architecture* (Munich, 1991)

The Koran, trans. by Arthur John Arberry (New York, 1955)

Elizabeth B Moynihan, *Paradise as a Garden* (1979)

Pratapaditya Pal (ed.), *Master Artists of the Imperial Mughal Court* (Bombay, 1991)

—, Janice Leoshko, Joseph M Dye III and Stephen Markel, *Romance of the Taj Mahal* (exh. cat., Los Angeles County Museum of Art, 1989)

S A Abbas Rizvi, *Fatehpur Sikri* (New Delhi, 1972)

Giles H R Tillotson, *Mughal India* (London, 1990)

Chapter 14

Molly Aitken, 'Style and the State in 18th-century Mewar Painting', PhD dissertation in progress, Department of Art History and Archaeology, Columbia University, New York

Vidya Dehejia, 'The Treatment of Narrative in Jagat Singh's Ramayana: A Preliminary Investigation', *Artibus Asiae*, 56 (1996), pp.303–24

Vishakha Desai, 'Painting and Politics in Seventeenth-Century North India: Mewar, Bikaner and the Mughal Court' *Art Journal*, 49 (1990), pp.370–8

— (ed.), *Life at Court: Art for India's Rulers, 16th–19th Centuries* (exh. cat., Museum of Fine Arts, Boston, 1985)

John S Hawley and Mark Juergensmeyer, *Songs of the Saints of India* (New York and Oxford, 1988)

Stella Kramrisch, *Painted Delight* (exh. cat., Philadelphia Museum of Art, 1986)

Jeramiah P Losty, *The Art of the Book in India* (London, 1982)

Karine Schomer *et al.* (eds), *The Idea of Rajasthan: Explorations in Regional Identity*, 2 vols (New Delhi, 1994)

Giles H R Tillotson, *The Rajput Palaces: The Development of an Architectural Style, 1450–1750* (New Haven and London, 1987)

James Tod, *Annals and Antiquities of Rajasthan*, vol.1 (London, 1829)

Andrew Topsfield, *The City Palace Museum Udaipur* (Ahmedabad, 1990)

Chapter 15

Mulk Raj Anand (ed.), *In Praise of Christian Art in Goa* (Bombay, n.d.)

Mario Cabral e Sa and Jean-Louis Nou, *Goa* (New Delhi, 1993)

M N Pearson, *The Portuguese in India* (Cambridge, 1987)

Jose Pereira, *Baroque Goa* (New Delhi, 1993)

Chapter 16

Mildred Archer, *India Observed: India as Viewed by British Artists 1760–1860* (exh. cat., Victoria and Albert Museum, London, 1982)

C A Bayly (ed.), *The Raj: India and the British 1600–1947* (exh. cat., National Portrait Gallery, London, 1991)

Philip Davies, *Splendours of the Raj* (Harmondsworth, 1985)

William Hodges, *Travels in India During the Years 1780, 1781, 1782 and 1783* (London, 1793)

Robert Grant Irving, *Indian Summer: Lutyens, Baker and Imperial Delhi* (London, 1981)

Thomas Metcalfe, *An Imperial Vision: Indian Architecture and Britain's Raj* (Berkeley and Los Angeles, 1989)

Jan Morris with Simon Winchester, *Stones of Empire: The Buildings of the Raj* (Oxford and New York, 1983)

Ray Murphy (ed.), *Edward Lear's Indian Journal* (London, 1953)

Pratapaditya Pal and Vidya Dehejia, *From Merchants to Emperors: British Artists and India, 1757–1930* (Ithaca, 1986)

Giles H R Tillotson, *The Tradition of Indian Architecture* (New Haven, 1989)

Clark Worswick and Ainslie Embree, *The Last Empire* (exh. cat., Asia House Gallery, New York, 1976)

Epilogue

Architecture in India (exh. cat., École National Supérieur des Beaux-Arts de Paris, 1985)

William J R Curtis, 'Authenticity, Abstraction and the Ancient Sense: Le Corbusier's and Louis Kahn's Ideas of Parliament', *Perspecta*, 12 (1983), pp.181–94

Norma Evenson, *The Indian Metropolis: A View Towards the West* (New Haven and London, 1989)

Tapati Guha-Thakurta, *The Making of a New 'Indian' Art* (Cambridge, 1992)

Jyotindra Jain and Aarti Aggarwala, *National Handicrafts and Handlooms Museum* (Ahmedabad, 1989)

Geeta Kapur, *Contemporary Indian Artists* (New Delhi, 1978)

Partha Mitter, *Art and Nationalism in Colonial India 1850–1922* (Cambridge, 1994)

Madhu Sarin, *Urban Planning in the Third World: The Chandigarh Experience* (London, 1982)

Geeti Sen, *Image and Imagination: Five Contemporary Artists in India* (Ahmedabad, 1996)

Giles H R Tillotson, *The Tradition of Indian Architecture* (New Haven and London, 1989)

Neville Tuli, *The Flamed-Mosaic: Indian Contemporary Painting* (Ahmedabad, 1997)

Herbert J M Ypma, *India Modern: Traditional Forms and Contemporary Design* (London, 1994)

Index

Numbers in **bold** refer to illustrations

Acknowledgements

A work as wide-ranging in scope as this inevitably owes a large debt to the scholarship of others, only some of whom can be acknowledged in the appended reading list. It draws, in addition, upon the thought-provoking discussions that I have had with students over the years, particularly those at Columbia University in New York, some of whom are now my young colleagues. I must also thank my official readers and editors, as well as friends and family, for their comments which have helped improve the quality of the book. But I remain responsible for its limitations, its choice of topics from so vast a range of material and its emphasis.

V D

Photographic Credits

al-Sabah Collection, Dar al-Athar al-Islamiyyah, Kuwait: 214, 215; American Committee for South Asian Art (ACSAA), University of Michigan: 46, 108, 147, courtesy of Mathura Museum 67, courtesy of Bharat Kala Bhavan, Varanasi 117; Ancient Art and Architecture Collection, Pinner: 164; Clare Arni: 143, 151; The Asia Society, New York: Mr and Mrs John D Rockefeller 3rd Collection, photo Lynton Gardiner 2, 217; Patricia Barylski: 124, 130, 226, 270; Benoy K Behl: 34, 37, 165, 167, 177, 192, 193, 208, 211, 240, 254, 271, 272; Carmel Berkson: 91, 92; Bridgeman Art Library, London: 19; British Library, London: 28, 63, 96, 224, 225, 245, 247, 261; British Museum, London: frontispiece, 42, 43, 44, 45, 47, 48, 49, 50, 51, 52, 53, 68, 199, 233; The Brooklyn Museum, New York: 72, 195; *The Builder*, London: 250; J Allan Cash, London: 94, 107, 154, 163, 174, 242; Centre of International Modern Art, Calcutta: 276; Christie's Images, London: 275; Corbis UK, London: 104, 203, 207; Vidya Dehejia: 8, 36, 57, 97, 115, 116, 127, 132, 140, 141, 145, 146, 150, 153; by courtesy of the Department of Archaeology & Museums, Government of Pakistan: photo J Mark Kenoyer 13, 14, 18, 22; École Française d'Extrême-Orient, Pondicherry: 142, 148; E T Archive, London: 20; John Eskenazi Ltd, London: 32; Freer Gallery of Art, Smithsonian Institution, Washington, DC: 59, 60, 61, 62, 187, 190, 232, 259, 260; Madhuvanti Ghose: 31, 77; John Gollings: 176, 178, 179, 185; Adam Hardy: 100; Robert Harding Picture Library: 101, 102, 106, 113, 120, photo G Hellier 190, photo J H C Wilson 7; Graham Harrison: 39; Julia A B Hegewald: 9; Georg Helmes: 11, 12, 15, 16, 17, 23, 24, 25, 26, 27; Dr R K Henrywood: 249; Hirshhorn Museum and Sculpture Garden, Smithsonian Institution, Washington DC: gift of the Marion L Ring Estate, by exchange, 1989, photo Lee Stalsworth/Ricardo Blanc 273; Howard Hodgkin: 175; Houghton Library, Department of Printing and Graphic Arts, Harvard University: 248; Hutchison Library: photo Michael Macintyre 136, photo Sarah Murras 189, 218; Images of India Picture Agency, London: 121, 160, 191; Institute of Oriental Studies of the Russian Academy of Sciences, St Petersburg: 173; Ken Jacobson & Clark Worswick: 262; Ebba Koch: 209, 210; La Belle Aurore, London: photo Steve Davey 131, 220, 235; Maharana of Mewar Charitable Foundation, Udaipur: 230; J R Marr: 10, 78, 152; Antonio Martinelli: 93, 95, 138, 158, 161, 180, 181, 182, 194, 227, 229, 238, 239, 269; Metropolitan Museum of Art, New York: 212; George Michell: 184, 186; Mountain High Maps, © 1995 Digital Wisdom Inc: p.435; Museo Archeologico Nazionale, Naples: 81; Museum of Fine Arts, Boston: gift of Mrs Frederick L Ames in the name of Frederick L Ames 200; Museum Rietberg, Zurich: photo Wettstein & Kauf 170; Jean-Louis Nou, Paris, courtesy of Monique Nou: 21, 29, 35, 28, 40, 65, 66, 69, 70, 83, 84, 85, 86, 87, 88, 89, 99, 149, 156, 159, 183, 236, 241; Ann & Bury Peerless Picture Library, Birchington: 30, 82, 114, 126; Pierpont Morgan Library, New York: courtesy of Ken Jacobson and Clark Worswick 263, courtesy of Paul Walter 266; by courtesy of the Trustees of the Prince of Wales Museum of Western India, Mumbai (Bombay): 223; private collection: photo Wettstein & Kauf 231; RMN, Paris: 56, photo Richard Lambert 54, 55, 58, 64; Rossi & Rossi Ltd, London: 71; British Architectural Library, RIBA, London: 251; Arthur M Sackler Gallery, Smithsonian Institution, Washington, DC: 201, 213; Scala, Florence: 1, 73, 103, 109, 137; Raghubir Singh: 277; Sotheby's Inc., New York: 274; Spectrum, London: 119, 166, 172, 204, 205, 206, 219, 243, 258, 265; Tony Stone Images, London: 257; Christopher Tadgell: 33, 98, 118, 123, 168, 171, 100, 202, 221, 234, 244, 253, 256, 264; G H R Tillotson: 252; Trip Photographic Library, Cheam: photo T Bognar 222, photo F Good 125, 128, 139, 155, photo Eric Smith 133, Trip/Dinodia 80, 111, 112, 122, 135; by courtesy of the Board of Trustees of the Victoria & Albert Museum, London: 196, 197, 216, 267; Yale Center for British Art, Paul Mellon Collection: 246.

Phaidon Press Limited
Regent's Wharf
All Saints Street
London N1 9PA

First published 1997
© 1997 Phaidon Press Limited

ISBN 0 7148 3496 3

A CIP catalogue record for this book is available
from the British Library.

Typeset in Amasis

Printed in Italy

Cover illustration *Crowned Ganesha, c.*1720
(see pp.358–9)